Math and the Mona Lisa

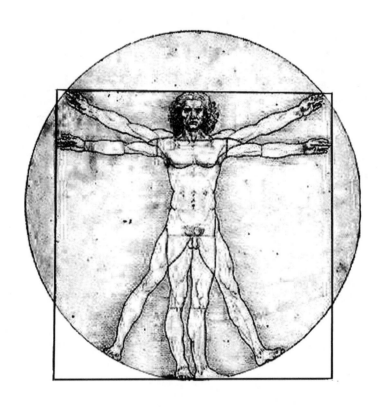

BÜLENT ATALAY

Math and the Mona Lisa

The Art and Science of Leonardo da Vinci

 Smithsonian Books

Collins
An Imprint of HarperCollinsPublishers

HarperCollins books may be purchased for educational, business, or sales
promotional use. For information, please write: Special Markets Department,
HarperCollins Publishers, 10 East 53rd Street, New York, NY 10022.

Published 2006 in the United States of America by Smithsonian Books
in association with HarperCollins Publishers.

Library of Congress Cataloging-in-Publication Data has been filed for.
ISBN-10: 0-06-085119-8
ISBN-13: 978-0-06-085119-4

06 07 08 09 10 ❖/RRD 10 9 8 7 6 5 4 3

Title page: Leonardo da Vinci, *The Proportions of the Human Body According to
Vitruvius (The Vitruvian Man)* (detail). Pen and brown ink, brush and wash over
metalpoint, Gallerie dell'Accademia, Venice.

To the memory of an extraordinary man
—soldier, statesman, father—
General Kemal Atalay (1910–2003)

Contents

Acknowledgments

Numerous people contributed to the making of this book. I am indebted to Captain Carl Keske USN (retired) and his wife, Carol, for applying gentle but steady pressure on me to write this book and for proofreading an earlier version of the manuscript. They, more than anyone else, served as the catalyst for me to put into print what I have long offered in lectures. For the opportunity to give lectures at a variety of venues I am grateful to David Stewardson of Crystal Cruises, Pat Higgins of Silversea Cruises, Marta Marschalko, formerly of the National Geographic Society, and Royal Viking line;

also to Lester and Brenda Crain, John and Lynda Shea—all from Memphis, Tennessee; Harvey and Brenda Blatt from Montreal; Robert and Betty Ann Jordan from Tampa, Florida; Bernie and Judy Franklin, Beverly Hills, California; Jonathan O'Brien, Headmaster emeritus, and Robert Stegeman, Dean, emeritus at St. Andrew's School, Middletown, Delaware. Finally, I am also grateful to Faruk Loğoğlu, the present Turkish ambassador to the United States, a friend of three decades and, with a Ph.D. from Princeton, one of the best-educated members of the Washington Diplomatic Corps.

Numerous other individuals contributed to the creation of this book. I am especially grateful for advice from friends at the National Gallery of Art, Washington, D.C.: David Alan Brown, curator of Italian Renaissance Art; Ann Bigley Robertson, exhibition officer; and David Bull, formerly the chief restorer and conservator of the National Gallery and currently president of Art Conservation Foundation. Thanks are also due to Carmen Bambach, curator of drawings and prints at the Metropolitan Museum of Art, New York; Thomas Somma, director of the Mary Washington College Art Galleries; and Sarah Trible, his excellent assistant. Special thanks are also due to a good friend, Lindy Hart, widow of the superb sculptor Frederick Hart, for information on her husband's works, and also to Jamie Wyeth and Beverly Doolittle, two exceedingly talented contemporary artists, for allowing me to include their works. Mr. Wyeth, moreover, was generous with his time in reading the manuscript and offering encouraging words.

Among managers of rare book collections two individuals were immensely gracious in allowing me to examine their treasures: Marilyn Ogilvie, curator of the History of Science Collections at the University of Oklahoma, for allowing me to photograph pages of Galileo's personal copies of his two books, the *Sidereal Messenger* and *Dialogue on the Two Chief World Systems*; and Neal Turtell, executive librarian at the National Gallery of Art, for allowing me to examine and photograph the priceless books *De divina proportione* and *Trattato di pittura*, as well as the facsimiles of the Leonardo manuscripts. I am

deeply indebted to Andrew Rush and Kate Cooke, computer technologists, who have been generous with their time and skills, and also to Laurie Preston, Instruction and Science/Business Librarian, for assistance in tracking down a variety of crucial sources and references.

My physicist friends have been wonderful foils, listening and commenting on many topics: Nikola Nikolic, professor emeritus at the University of Mary Washington; Marcelo Alonso, professor emeritus at Georgetown University; and Ady Mann, coauthor and colleague at Oxford, the Technion in Haifa, and at the Institute for Advanced Study in Princeton. All three are exceptionally cultivated individuals, conversant in the arts as well as the sciences. I gained insight into symmetry in elementary particle physics and into the structure of quasicrystals from two of Israel's most eminent scientists, Yuval Ne'eman and Danny Shechtman, while participating in a symposium on various aspects of symmetry (Washington, D.C., 1997). Of immense help also were David Goodstein, professor of physics and vice provost at Caltech; Michael Higattsberger, professor and director emeritus at the Boltzmann Institute of the University of Vienna; Norman Ramsey, professor emeritus of physics at Harvard University; William Phillips, head of Laser Trapping and Cooling at the National Institute of Standards and Technology (and currently serving as the George Eastman Professor at Oxford); and William Ott, deputy director of the physics branch at NIST. All are eminent physicists; Ramsey and Phillips are Nobel Prize-winners. Professor Ramsey supplied wonderful anecdotes on physicists that he has known during his long career. Professor Phillips, a man as gracious as he is brilliant, read the entire manuscript with the inordinate precision that characterizes all his work, and offered valuable suggestions. The others invited me to speak or give colloquia at their respective institutions.

Attempting to follow Leonardo's model I benefited from consulting academic friends outside physics: professor of religion Mehdi Aminrazavi, for insights into Islamic culture; professor of classics Liane Houghtalin, for information on early Greek philosophers;

professor of Italian Clavio Ascari, on enlightening discussions relating to the Italian Renaissance and for expert translations from the early modern Italian; professor of business administration Daniel Hubbard for information on Luca Pacioli's contributions to double-entry accounting; and professor of art Joseph Dibella, for the mechanics of painting. George Hart, computer scientist at Stony Brook University, advised me on a number of corrections for the paperback.

On the topics of psychology and physiology I am indebted to Christopher Tyler, Michael Nicholls, Robert "Rick" Ricketts, and Michael Atalay. In February of 2000 we collaborated in a symposium in Seoul, Korea, presenting papers on "Symmetry in its Various Aspects: Search for Order in the Universe." The four individuals have made seminal contributions in their respective fields, and they are cited in a number of chapters in the book. Aesthetic surgeon Steven Marquardt, whose investigation of facial aesthetics and the divine proportion parallels the work of Dr. Ricketts, has created a mask that gauges human beauty. He has been gracious in allowing me to use the mask in the context of "Art of Nature." For results of studies of the brain of the artist versus the brain of the nonartist, the topic of Chapter 8, I am grateful to artist Humphrey Ocean; scientists John Tchalenko, Christopher Miall, and Robert Solsa; also to my niece, Billur Tansel, who brought this important work to my attention; her mother, Gülseren Tansel; and to my uncle, Jeff Kokdemir, for helpful advice on so many aspects of the book.

Professor Julian Stanley, founder of the Johns Hopkins Center for Talented Youth (JHCTY), gave me invaluable material on the topic of gifted youth. Over the years I've had the opportunity to meet exceptionally gifted students at sessions of the JHCTY, at Thomas Jefferson High School for Science and Technology, and at the Oklahoma School of Science and Math. The interaction with some of these students has been a source of inspiration. I am grateful to the noted psychoanalyst Gerald Aronson of Los Angeles, with whom I have maintained an intellectually edifying correspondence

on topics of mutual interest, specifically on physics and the brain. Indeed, Dr. Aronson read the manuscript of the book and advised me on the subject of the tortured genius.

A number of my former students maintained an interest in the project over the years and contributed valuable ideas. I am grateful to Gilbert Schor, who allowed me to read his graduate thesis on the mathematics of the Fibonacci series; to Abbey Delk, who assisted me in selecting Leonardo drawings from the facsimile collection of the National Gallery of Art; and to Betty W. Jones; Lisa L. Wu; Rochele Hirsch, née Betty Stansell; Davis Lee; Bonnie Norris; Mohamed Chakhad; Justin Conroy; and Matthew Welz for many inspiring discussions and helpful suggestions.

I would like to single out for special gratitude my good friend Keith Wamsley, who in an earlier life trained in classics and English literature at Cornell, but is now training for a career in physics and mathematics. It was when he was enrolled in my graduate course Character of Physical Law during the summer of 2000 that I recognized his insatiable curiosity, his skills as a writer, and his latent talent as an editor. Since first agreeing to serve as my unofficial copy editor, he began to encounter the chapters of the manuscript in the random order in which I wrote them. Nonetheless, he never complained, never argued about that particular inconvenience. He did, however, argue about every other aspect—each sentence, each phrase—until we were *both* satisfied that the ideas were clearly explained, and the level of the book was consistent and accessible to the intelligent layman. This is appropriate, since Keith is an exceptionally intelligent layman, neither artist nor scientist, but harboring passion for the arts and the sciences.

In the context of unofficial copy editing, I am very grateful to Nick Murray, a wordsmith extraordinaire, who read the entire manuscript and made numerous helpful suggestions. I would also like to express my deepest gratitude to Sherwin Nuland, professor emeritus of surgery at Yale University—winner of the 1994 National

Book Award and the author of the recent indispensable short biography of Leonardo da Vinci in the Penguin Lives series—for reading the manuscript of my book and offering inspiring comments.

I am indebted to the former science editor at Smithsonian Books, Vincent Burke, who recognized early the value of a book on Leonardo's model. Vince, a man of inordinate patience and exceptional editorial skills, guided me in achieving a tight book. He, along with his able assistant Nicole Sloan, held in check my tendency to go off on tangential topics—useful in informal lectures, but not in a well organized book. The book holds together much better thanks to their mediation. In the final phases of the book's production Mary Christian (copy editor), Robert Poarch (production editor), and Scott Mahler (acquisitions editor and Vince Burke's successor) were eminently helpful. A trained art historian, Mary especially brought not only her editorial skills, but also her knowledge of art into the scheme.

I am deeply indebted to my extended family members, Roy and Lolly Weinstock, friends of three decades, for putting up with interminable discussions and for offering unfaltering support. Finally, I am most grateful to my immediate family—wife Carol Jean, daughter and son, Jeannine and Michael, and their spouses, Mike Harvey and Elizabeth Atalay, for serving as resilient sounding boards on so many topics in the book and for being infinitely patient. My daughter, who trained as an artist, and my son, a scientist, were both helpful on so many topics in the arts and the sciences.

This book would have been much longer had it not been for the wisdom of true friends (and editors) who admonished me to just stop writing, all ultimately echoing the sentiment of a cartoon appearing in the *Chronicle of Higher Education*. An editor is penning a letter to his famous author: "Dear Dostoevski—We feel your new manuscript, 'Crime, Punishment, and Repentance' is much too long. You should cut it by a third."

Prologue

In the late 1950s the British scientist and writer C. P. Snow delivered the Rede Lecture at Cambridge University and identified two disparate intellectual cultures: the intellectuals among the humanists (including artists and writers) and the intellectuals among the scientists (natural scientists and mathematicians).[1] Snow claimed that communication between the two groups was strained at best and nonexistent at worst. At the beginning of the twenty-first century we find ourselves still discussing the chasm dividing Snow's two cultures.

My own passions have always been varied. I am an artist, an

occasional archaeologist, but primarily, a physicist—teaching and doing research in atomic physics, astrophysics, and nuclear physics. In art, my works were displayed in a number of exhibitions, including one-man shows in London and Washington, D.C., and collections of my lithographs found their way into Buckingham Palace (a gift of United States Ambassador Walter Annenberg to the Queen), the White House, and the Smithsonian Institution. As a theoretical physicist I have trained or taught at a number of universities—including Georgetown, Berkeley, Princeton, Oxford, and the Institute for Advanced Study. I am a person, I like to think, who lives in both cultures.

Five hundred years ago in Italy there were many intellectuals who developed expertise in diverse fields, and a number of these individuals were spectacularly good in many fields. The expression "Renaissance man" entered the Western vocabulary precisely to describe such people. One person, Leonardo da Vinci, more than any other, embodied that spirit, indeed transcended it. He was quite simply the best in the myriad fields with which he preoccupied himself.

Leonardo was a part-time artist, who might have worked on twenty paintings, a dozen of which survive; of these, only seven are of unchallenged provenance. Nonetheless, it is first as an artist that he is remembered. Indeed, one might argue about who is the third greatest artist in history—perhaps Rembrandt or Raphael, Monet or Picasso? About the first two, there is no argument. One can take Leonardo or Michelangelo, in either order. The level of their influence, their role as drivers, is that significant. As an engineer, Leonardo's legacy includes a long list of actual and mental inventions that foreshadow future technologies by hundreds of years. Leonardo is inventing the future. Thus, he is the first and preeminent futurist.

The most extraordinary aspect of his genius, however, may just be that his general modus operandi actually prefigures the methodology of modern empirical science. Accordingly, I join in the trum-

peting of a theme beginning to be heard among scientists, that Leonardo was the first modern scientist. There have been individuals with greater scientific legacies than Leonardo. Certainly Galileo, Newton, and Einstein are more prominent figures in the history of science, but science is the only reason for their attaining prominence. They made unprecedented discoveries and they published their results. In Leonardo's day printing was in its infancy, and he had a relatively minor role in the production of only one book, *De divina proportione*. Had he been able to publish the scientific ruminations found in his manuscripts in his own time, our present level of sophistication in science and technology might have been reached one or two centuries earlier.

Leonardo's Model

For Leonardo, the paragon artist-scientist-engineer, the astonishing variety of his interests are like the knots of a magnificent tapestry. Uncovering the internal dynamics of each of these interests and establishing the connections between them were his quest, and systematic experimentation, his method. Ultimately, in every aspect of his life—while doing science, engineering, and on the infrequent occasions when he did art—he was operating as the consummate scientist. And it was the cross-fertilization of ideas and their seamless integration that led to many of his astonishing achievements. The transcendent unity of science and art, and the expansive cross-semination, are the essence of Leonardo's model.

Five hundred and fifty years after Leonardo's birth we use Leonardo's model to seek again the consilience of science and art—painting, architecture, sculpture, music, mathematics, physics, biology, and engineering—and to remedy as far as possible the disassociation that exists between cultures. We examine common themes and grounds among the interests of the artist and the scientist and

the modes of expression adopted by each. The task involves applying elements of modern science and mathematics to the analysis of perspective, proportion, patterns, shapes, and symmetries underlying art and nature. It is important to point out at the outset, however, that in the case of the artist it is almost always unwittingly (but intuitively) that he imbues his works of art with these technical devices, often picked up as subliminal messages from nature. But in Leonardo's case, it was most likely done with total awareness and forethought— in his art as well as his science. And so it is in the sciences now. The underlying mathematics and the principles of symmetry are not just useful, they are indispensable.

The chapters of *Math and the Mona Lisa* follow the development of fundamental science from the dawn of civilization, when numbers were invented, to ancient Greece, where science was born. We shall examine the significant role of Muslim scholars, who not only served as a conduit for the transfer of knowledge from the philosophers of antiquity to the scholars of the Renaissance, but who also invented some powerful tools of science and mathematics. The journey will take us through the Renaissance into the Scientific Revolution of the seventeenth century, through Galileo's discoveries of the law of the pendulum and the law of free-fall and Newton's discoveries of the universal law of gravitation and the formulation of the calculus. The scientific methodology of Leonardo continued into the twentieth century with Einstein formulating the theory of relativity and a number of extraordinarily gifted young physicists creating quantum mechanics.

Only after we establish the framework of the science and mathematics underlying art and science, and the differing approaches the artist and scientist take in describing nature, will we return to examine Leonardo's modus operandi and his legacy as artist, scientist, and engineer. Thus, although Leonardo's system, the "model," serves as a unifying theme throughout the book, only three chapters are

devoted exclusively to Leonardo. But if he were alive now, it is likely that it would have been many of the other chapters that he would have found especially interesting. The quintessential futurist, Leonardo would have glimpsed the whole from the vantage point of the modern scientist.

Math and the Mona Lisa presents science through art, and art through science, and approaches the larger goal of achieving a synthesis of the two fields. The qualities of timelessness and universality in Leonardo's astonishing works speak eloquently for themselves. With Leonardo's model providing the unifying thread, however, it becomes possible, first, to glimpse the man's restless intellect, that extraordinary psyche; second, to see whence the ideas for his works of art came; and ultimately, to appreciate his art at a different level.

Math and the Mona Lisa

The water you touch in a river is the last of that which has passed and the first of which is coming. Thus it is with time present. Life, if well spent, is long.

—Leonardo da Vinci

Chapter 1

Leonardo Fiorentino: A Life Well Spent

ate medieval and early Renaissance Italy witnessed many changes, including a revival of the mercantile economy, the emergence of a vernacular literature, and the first serious efforts to recover the classical tradition of learning. Feudalism, with the landed nobility controlling the lives and destinies of the populace, began to lose its grip. The Holy Roman Empire and the Roman Catholic Church increasingly failed to provide social and political stability. National monarchies, especially those of France and England, rose in importance, and in Italy, the city-state became the

preferred form of political organization. One city-state, Florence, located in north central Italy, took the lead in projecting the new indefatigable spirit of humanism, a return to the classical ideal of man being the measure of all things; it became the incontestable intellectual capital of Renaissance Europe. The city's preeminence was displayed in literature—with Petrarch, Dante, and Boccaccio—but most prominently in painting, sculpture, and architecture. The brilliant painter Giotto appeared early in this remarkable period. The next hundred years gave rise to the artist Masaccio and architects Alberti and Brunelleschi; then, toward the end of the fifteenth century, the matchless trio of Leonardo, Michelangelo, and Raphael burst onto the scene.

An explosive catalyst for the change was the invention, by Johannes Gutenberg, of the printed book in 1455.[1] Before the print revolution, Europe's libraries contained 30,000 volumes. Within fifty years the number of books had increased to three million. The Renaissance also saw the European voyages of discovery, resulting in dramatic expansion in the size of the known world. The Protestant Reformation ignited further intellectual commotion, with an attendant eruption of various dissident sects. Finally, the Renaissance artist, who saw the need to describe nature in the way it really presented itself and not in some idealized or ecclesiastically dictated way, was instrumental in the launching of modern science.

The changing intellectual milieu of the Renaissance spread quickly to Rome, Milan, and Venice. One ingredient for its accelerated development in Italy came with the conquest of Constantinople by the Ottoman Turks in 1453. A number of significant Byzantine scholars migrated to Italy at the invitation of the Italian humanists, among them, Theodore Gaza, John Argyropoulos, and the most influential of all, Demetrius Chalcondyles. These scholars brought with them the first serious efforts to recover the classical tradition of learning and afforded Italian humanists access to the classic Greek texts and manuscripts preserved in Constantinople.

Any discussion on the ascent of civilization must necessarily include the rise of the university. Toward the end of the eleventh century the first of the *studia generalia*, precursors of universities,[2] had appeared in Bologna. In the twelfth century others began in Paris, Oxford, Modena, and Parma, and in the thirteenth century in Cambridge, Padua, Siena, Salamanca, Perugia, and Palermo. The universities did not give rise to the Renaissance, but they benefitted significantly from it. While the Italian universities were the first to be founded in Europe they were the last to be liberated from the scholastic tradition grounded in the works of Aristotle. Their doctrine was salutary for the rebirth of rigorous intellectual discourse in the manner of the ancient philosophers, but it focused mostly on theological issues in a doctrinaire way. Thus the early emergence of universities in Italy with their scholastic tradition has to be regarded as a red herring for the development of science in Italy.[3]

Not much is known about Leonardo da Vinci's personal life. According to his earliest biographer, Giorgio Vasari, he was an uncommonly handsome man, well-built, full of charm and grace, but he left no definitive image of himself. One reasonable candidate for a Leonardo likeness is a red chalk drawing, found in Turin in the mid-nineteenth century and believed by many to be a self-portrait of Leonardo in his old age. There is a mesmerizing quality in the eyes, simultaneously exuding wisdom, sadness, and acute intelligence that only a truly insightful psychologist-artist could capture (Plate 1). Another possible likeness, also from his mature years, is a colored chalk profile portrait thought to be by one of his pupils; David Alan Brown, of the National Gallery of Art, Washington, D.C., makes a compelling case for the subject of this work.

Leonardo lived his sixty-seven years in a time of frequent wars and political and social upheaval, but also in a period of artistic and intellectual ferment unrivaled since the Golden Age of Greece. He embodied the Renaissance spirit. In his own time he was known

as Il Fiorentino (the Florentine), although by the late sixteenth century Giorgio Vasari was already referring to him as "Leonardo da Vinci."

It is not known exactly where Leonardo was born, but convincing arguments have been offered by a number of biographers that he was born on April 15, 1452, in the Tuscan village of Anchiano, near the town of Vinci, on the outskirts of Florence. He was the illegitimate son of Ser Piero di Antonio da Vinci and a peasant girl named Caterina. The young couple never married, the boy living the first five years of his life with his mother, grandmother, and a peasant from Anchiano, whom the mother eventually did marry. Meanwhile, Ser Piero married Donna Albieri, a woman of his own station, and only when he found that his wife was infertile did he seek and gain guardianship of Leonardo.

During the next ten years the boy lived in his father's family home in Vinci, never gaining formal adoption or the benefit of the respected family name. There have been speculations by a number of authors—including Sigmund Freud—that in the home of his mother and maternal grandmother, and later in the home of his stepmother and step-grandmother, the boy perhaps received attention bordering on the worshipful. These factors have been offered as possible ingredients for his unusual psyche, his exquisite sensitivity, superhuman drive, surpassing intelligence, and probable homosexuality—although this is all conjecture.

Ser Piero eventually married two more times, fathering twelve other children, but none exhibited similar gifts, nor left the slightest mark on civilization. A rare reference to Leonardo's siblings dates to 1504, when Ser Piero died at the age of seventy-seven, when the siblings launched a successful conspiracy to cut Leonardo off from any share of his father's estate.

Had Leonardo been born legitimate he most likely would have been groomed to become a notary—just as his father, grandfather, and great-grandfather had been. That option was not open to children born out of wedlock. He had no formal schooling, although he

had some private tutoring, what we might call "home schooling." His unconventional education did not include the study of Latin or Greek, and he seems to have felt inadequate in never being able to read the works of the classical authors in their original languages. With a lack of formal education he did not benefit from many of the great classical ideas, but neither was he saddled with the bad ones. Leonardo, untutored by a university education, was thus also uncontaminated by it.

The choice of a vocation for the young boy presented his father with a quandary. From the beginning Leonardo displayed certain talents for art and music, and accordingly Ser Piero's decision was simplified. When Leonardo was fifteen, he moved with his paternal family to Florence, and two years later, was apprenticed to the painter's workshop of Andrea del Verrocchio, a talented goldsmith, sculptor, and painter. Verrocchio—whose name means "true eye"— was one of Florence's most influential artists.

Leonardo flourished in Verrocchio's workshop, developing the skills that would serve him throughout life. He mastered the techniques for grinding rare-earth elements to create colors, making brushes, even casting bronze, as well as the latest principles of perspective and composition. He also learned from the master the techniques of *chiaroscuro,* using light and shade in pictorial representation, and *sfumato,* the blending of chalk strokes to make a seamless, smoky shadow, the latter a procedure that Verrocchio developed himself. And he learned the importance of understanding anatomy, so that he could build the body from the inside out. It was clear from the start, however, that Leonardo wanted to build on what was known, and experimentation with all of the elements of art became his modus operandi. In his early days in the workshop Verrocchio assigned Leonardo one of the two kneeling angels in the *Baptism of Christ* (Florence, Uffizi). Although masters often gave a student a secondary figure to paint, this proved to be a strategic mistake, because here that single angel becomes the painting's

visual focus. Verrocchio, overwhelmed by Leonardo's mastery, never picked up a brush again.

Leonardo acquired his wonder and passion for nature in his childhood in the verdant hills of his native Tuscany, observing nature as both an artist and a scientist. He had a "mysterious cave" in the hills that inspired his life-long passion for geology.[4] Indeed the peregrinations convinced him that the earth was much older than the contemporary view—an early triumph of observation over orthodoxy. His earliest known landscape drawing, a pen and ink study from 1473 (Florence, Uffizi) made when he was twenty-one years old and living in Florence, depicts the Arno valley seen from a hilltop. The scene is rich with artistic devices—impeccable perspective, draftsmanship, and shading. But also present is the degradation in the quality of light with distance seen through the eyes of the physicist, and the rock formations seen through the eyes of the geologist. In his codices he classified rocks and pondered their origin, identifying sedimentary rocks—long before the invention of geology and its classifications. In the striations and strata in rocks—some presenting horizontal, others oblique configurations—he wondered about the possibility of "uplifting" as a mechanism for their formation, anticipating the development four centuries later of the theory of plate tectonics with its attendant process of uplifting as the established explanation for mountain chains. In Leonardo's drawings and in several of his greatest paintings, geologically interesting topographies become commanding backdrops.

If science—searching out nature's secrets—was a noble cause for Leonardo, so was technology—the building of inventions to make life more efficient, more comfortable, more interesting. The conviction, however, that nature's own inventions were by far the most beautiful ("nothing is lacking, and nothing is superfluous") meant that we should begin by trying to emulate nature's own creations. "If birds can fly, so should humans be able to fly," he wrote, a belief that fueled his life-long interest in creating machines that

could carry man aloft. Some of his mental inventions may have been produced, but most remained just theories. Among the designs that fill the notebooks one can see that he prefigured, among other devices, the bicycle, the automobile, the tank, the collapsible bridge, the parachute, the underwater diving mask, the flamethrower, scissors, and the submarine. To satisfy his scientific curiosity he performed ballistic experiments in order to determine projectile trajectories and painstaking dissections to understand anatomical structure. With seamless facility he functioned as anatomist, botanist, geometer, physicist, architect, mechanical engineer, hydraulic engineer, civil engineer, and even aeronautical engineer. His drawings of anatomical and botanical subjects are especially unmatched for their virtuosity and insight, which in some cases would not be surpassed for two or three centuries.

Leonardo's drawings reveal a negative slope (top left to bottom right slant) in the shading. Most scholars believe this is evidence that he was left-handed or possibly ambidextrous. He is also famous for his use of mirror text; the right-to-left direction in the handwriting is more natural for a born left-hander, since pulling a pen rather than pushing it avoids smearing the freshly laid ink. Leonardo annotated his sketch of an old man using his characteristic mirror text. The left image is a digitally produced reflection of the original at the right, and reveals the familiar letters of Latin script. The symbols identifying various subdivisions in the right image are also in the mirror text, as clarified in the reflected image on the left (Figure 1.1).

Leonardo never married, and he may never have had a sexual relationship with a woman; there is no evidence that he had any children. His only interest in women seems to have been as subjects for commissioned portraits—three of which became pivotal masterpieces of Western art. That he may have been a homosexual was long suspected by art historians. Relationships between masters and young apprentices may have been quite common in Leonardo's day, and on

April 9, 1476, Leonardo was denounced anonymously to the Ufficiali di Notte in Florence, the official in charge of public morals, leading to sodomy charges against him. These charges were eventually dropped for lack of evidence, but the toll on Leonardo made the period excruciatingly painful for him. Commissions from wealthy patrons dried up, although this was perhaps also due to his growing reputation for not finishing works on time.

In 1481 Lorenzo de' Medici (the "Magnificent"), the visionary patron of Florentine artists, received a request from Pope Sixtus IV to send Florence's leading painters to collaborate on the murals in the newly erected Sistine Chapel. Lorenzo complied, submitting a team that included Botticelli, Ghirlandaio, Perugino, Piero di Cosimo, and Cosimo Rosselli, but glaringly omitted Leonardo's name. In July of the same year Leonardo had to settle for painting the *Adoration of the Magi* for the monastery of San Donato a Scopeto near Florence, which required him "to supply all his materials and complete the commission within 24 or at the most 30 months"[5] or

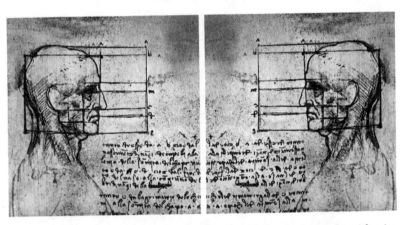

Figure 1.1. *(right)* Portrait in profile of an old man by Leonardo, with mirror text, Windsor Castle, Royal Library; *(left)* digitally generated reflection of the image

else forego the commission. True to form, he became sidetracked, did not complete the work on time, and failed to receive the compensation. But the painting, although unfinished, was so magnificent and revolutionary in its conception that Leonardo's contemporaries—including his rivals, back from decorating the Sistine walls—stood in front of it transfixed and awestruck.

By 1482 Leonardo, dispirited from the humiliation of his last few years in Florence, moved to Milan. It was known among artists that its ruler, Duke Ludovico Sforza, wanted to erect a massive bronze equestrian monument in memory of his father. Leonardo wrote to the duke, applying for the position of court engineer, a capacity in which he could design buildings, sanitation systems, portable bridges, and a variety of terrible weapons; only as an afterthought did he mention that he also was an artist.

Leonardo was hired and moved to Milan, where he would spend the next sixteen years. Sforza had launched a program of importing artists and intellectuals to transform the wealthy city in the Lombard hinterland to one that would rival Florence as a cultural capital. Among Leonardo's contemporaries in Milan were the architect Bramante, who would later design Saint Peter's Basilica in Rome, and the mathematician Luca Pacioli, whose *De divina proportione* Leonardo would illustrate.

Leonardo envisioned the colossal equestrian monument as a possible crowning glory for his artistic endeavors. Once he received Ludovico's final approval to proceed, he moved quickly to finalize his design from myriad possibilities he had contemplated. He toiled feverishly, sculpting a full-size model out of clay in preparation for casting the final product in bronze. But as fate would unfold, the French chose just that moment to lay siege to Milan. Ludovico, desperate to stave off the better-armed enemy, had the metals allocated for the bronze horse cast instead into cannons. The Milanese were unable to stop the French, whose troops entered the city with relative impunity. When they came upon Leonardo's clay model, the

Gascon archers among them immediately identified it as an object for target practice. Exceedingly disheartened by the ignominious end to his dream, Leonardo could do nothing. He understood the desperation for survival of the Sforza, their dynasty rapidly drawing to an end. Ludovico, disguised as a Swiss pikeman, tried to flee, but was arrested by the French, who placed him in a dungeon, where he lived out the last decade of his life. Meanwhile, Leonardo, with his assistant Andrea Salai and his mathematician friend Luca Pacioli, moved first to Mantua, and from there on to Venice for several months. It must have been in this period that the seeds of *De divina proportione* were sown. The book, published in 1509 in Venice, reveals Leonardo's lifelong preoccupation with geometric shapes and patterns—the informal doodling, finally found its way into print.

In his Milanese period from 1482 to 1500, Leonardo was at his inventive peak, especially regarding science and engineering. When the French defeated Milan and the residents of the city overthrew Ludovico, he was forced to abandon the city with approximately six hundred florins. He was not paid for the last two years of his work, and the equestrian statue would never be finished. He had produced a few paintings, including his *Lady with the Ermine (Portrait of Cecilia Gallerani)*, the second of only three secular portraits of women, and the *Last Supper*, which Kenneth Clark called "the keystone of European art." In addition, he accumulated countless sketches of his mental inventions, in notebooks or on unbound sheets.

Leonardo returned for a short time to Florence, where writers, poets, artists and architects received him with deference, but did not accord him the adulation given to the younger and exceedingly talented sculptor and painter, Michelangelo. He came very close to taking a court engineer position in Constantinople, similar to his post in Milan, and to painting a portrait of the Ottoman sultan Bayezid II. In his application he contemplated preliminary designs for a bridge over the Golden Horn and a pontoon bridge across the

far more expansive Bosporus. As events unfolded, however, the position fell through and Leonardo went to work in Urbino, under the patronage of the city's new leader, Il Principe, Cesare Borgia. Leonardo saw in Borgia a potential unifier of the scattered city-states of Italy. Also in Urbino he met and befriended Niccolò Machiavelli, author of *The Prince*, a book modeled largely on the career of Borgia. Within five years, however, disillusioned by the unbridled tyranny of the Borgia family, Leonardo was ready to leave Urbino. Through Machiavelli Leonardo received a commission from Florence, where he and Michelangelo were each to paint a mural on facing walls of a hall in the Palazzo Vecchio. The massive mural by Leonardo was to celebrate the *Battle of Anghiari*, in which Florence defeated Milan in 1440. Although some thoughts began to take shape in his notebooks, the commission was withdrawn. The prospect of a double mural in the same room by the two titans of the Renaissance evaporated as quickly as it had appeared.

Leonardo had even briefer stays in his next few towns. In 1506, upon an invitation from Milan's French occupiers, he returned to Milan, where for a time Louis XII became his protector and patron, according him the title Painter and Engineer of the King. It was at this time that Leonardo also met two young men who were to have a lasting effect on him. The first was Marcantonio della Torre, the brilliant young professor of anatomy at the University of Pavia, who gave Leonardo some direction for his future anatomical studies, and the second was the aspiring young artist Francesco Melzi, son of Leonardo's landlord, Girolamo Melzi. His relationship with young Melzi, who would become his apprentice and closest disciple, has been described as one of mutual devotion, approaching that of father and son. He was only six years in Milan the second time, for when the French were evicted after their defeat in the Battle of Pavia, a Sforza heir, Maximiliano, took over the city and saw in its future little need for art, learning, or universal genius. Leonardo, accepting a commission from Pope Leo X, went to Rome in 1513. But

his preoccupation with producing a new type of varnish instead of a new painting was another personal downfall, and resulted in the pope shifting his focus to the talents of the young Raphael. Soon afterward Leonardo suffered a stroke that left him partially paralyzed in his right arm, effectively ending his career as a painter.

In 1516 the king of France, Francis I, befriended Leonardo and invited the aging artist and his two assistants to France. Leonardo and his tiny entourage journeyed to Amboise, about sixty miles south of Paris. He brought chests, bulging with manuscripts, his collection of books, the scale drawing for *Virgin and Child with Saint Anne, Saint John the Baptist* (now thought to be *Bacchus*), and the one painting with which he would not part, the *Mona Lisa,* created a decade earlier in Florence. The group moved into the manor house at Cloux, a short walk from the Chateau d'Amboise, the king's own abode.

Leonardo died three years later, on May 2, 1519. He was in the care of a genuinely devoted king, who rushed down from Paris upon having heard of Leonardo's impending death. A generous benefactor who had asked for little in return, Francis I inherited the *Mona Lisa,* and Leonardo's manuscripts and books were bequeathed to Melzi.

The most praiseworthy form of painting is the one
that most resembles what it imitates.

—Leonardo da Vinci

Chapter 2

The Confluence of

Science and Art

ike the artist, the scientist is a lover of nature. Just as the artist is restricted only by his imagination and his facility with his chisel or brush, the scientist is restricted only by his imagination and his facility with his mathematics. The artist uses imagery and metaphor; the scientist, numbers and mathematics.[1] The artist is more interested in the whole of his composition than in its very fine details. And the scientist is more interested in the generality of nature's laws than in its particulars. However, it is from scrutiny of

a very small section of the universe, the earth, that he tries to explain the whole. A "beautiful law" of nature, one whose fundamental symmetries have been deciphered, one that is simple and yet general, evokes the image of an ornate tapestry, and in physicist Richard Feynman's words, "Nature uses only the longest threads to weave her tapestry, so each small piece of her fabric reveals the organization of the entire tapestry."[2]

For mathematicians and physicists it is undeniable that there exists inherent beauty in mathematics. This is the *aesthetics of mathematics*. Perspective, proportion, and symmetry in any context are quantifiable. Accordingly, art indeed possesses quantifiable aspects. There is the symmetry expressible in mathematical terms, and then there are "nature's numbers." These notions figure into the *mathematics of aesthetics*. The associated quantification can be formulated at various levels of mathematical sophistication. In this book the mathematical authority—embodied in a modest number of equations—will be relegated to the endnotes. The Fibonacci series gives rise to the notion of dynamic symmetry, the golden section, or the "divine proportion," which Fibonacci himself could not have anticipated. Three hundred years after Fibonacci formulated his series Leonardo da Vinci illustrated a book called *De divina proportione*. But the integration of science and art has many more strands than Fibonacci's mathematics and Leonardo's art: It also draws in elements of architecture, astronomy, biology, chemistry, geology, engineering, mathematics, philosophy, physics—encompassing the extraordinary range of Leonardo da Vinci's interests. For him these were branches of the same tree, part of a grand unified structure, the universe.

In nature we observe symmetric shapes at the macroscopic level in both animate and inanimate objects. At the microscopic level and at the supramacroscopic, both beyond the capabilities of our senses, some of the same shapes, symmetries, and regularities emerge. When magnified one hundred thousand times, the spirals seen in the cross-section of the microtubules of the heliozoan resemble, in scale and

shape, the spirals seen in the horns of the ram. This shape, magnified another hundred billion billion times, resembles the arms of a spiral galaxy. At one extreme the observing apparatus may be an electron microscope or its more powerful cousin, the scanning-tunneling microscope, and at the other, an optical or radio telescope.

X-ray diffraction technology reveals certain symmetries in crystals that also manifest themselves at the macroscopic level. Crystallographers identify five possible Bravais or space lattice types in two dimensions and fourteen types in three dimensions. All of the two-dimensional and some of the three-dimensional types are found in man's artistic creations. A millennium before crystallography became a science, Moorish artists—especially Sunni Muslims, forbidden to produce the human likeness—were creating magical calligraphic and geometrical designs displaying intuitive understanding of the space lattices. This is nowhere more dramatically illustrated than in the mosaics and stone carvings at the Alhambra Palace in Granada and at the Great Mosque in Córdoba.

In the physical and mathematical sciences the recognition of symmetries in nature plays a central role in seeking new laws. The physicist observes symmetries in physical laws; however, he is often more interested in partial or incomplete symmetries than in perfect symmetries—because it is in the former that one can look for a deeper story, a more fundamental or profound insight into the laws of nature. The same is true in art, where an off-centered location of the focal points makes the picture more intriguing than would a centered location.

In modern physics one finds that some of the most abstract and arcane areas of pure mathematics, the elements of which often appear entirely unconnected to the laws of nature, in time prove to be the basis of fundamental physical laws. (Linear algebra, differential geometry, and algebraic topology are three such areas of mathematics that have helped theoretical physicists express the fundamental workings of nature.) From this experience emerges an

appreciation of the aesthetics of mathematics and an abiding faith among physicists: Mathematics is indeed the tool to unravel those subtly hidden laws, to explain why a particular experiment yielded the results it did or, still better, what is yet to be observed. But *why* there should exist this remarkable effectiveness of mathematics in describing the laws of nature has never been shown. Princeton's ineffably wise Eugene Wigner, one of the greatest theoretical physicists of the twentieth century, wrote: "The miracle of the appropriateness of the language of mathematics for the formulation of the laws of physics is a wonderful gift, which we neither understand nor deserve. We would be grateful for it and hope that it will remain valid in future research and that it will extend, for better or for worse, to our pleasure, even though perhaps also to our bafflement, to wide branches of learning."[3]

Wigner, seen in my 1978 ink sketch (Figure 2.1), described the failure of science to answer the question of the mathematical nature of the universe as "a scandal . . . an enormous gap in human understanding." No one could have spoken with greater authority on the subject. No one had earned the right to be as boastful and haughty, and yet no one was more gentle and humble in his demeanor. His most important work had been the introduction into physics of group theory with its attendant symmetry considerations, a formalism that turned out to be a transcendent contribution to our quest to understand nature.[4]

Just as symmetry can produce a sense of harmony, balance, and proportion, too much symmetry in certain contexts, such as in an endless line of row houses or identical statues, can have negative emotional impact. Similarly, *asymmetry* can produce a sense of discord and lack of proportionality. But in some instances, such as in the shape of an egg (as opposed to a smooth sphere), it can generate a positive emotional response, a sense of release, freedom, and mystery. Thus, released from the prejudice of viewing only perfect symmetries as ideal, we have come to regard the Alps as uncom-

Figure 2.1. Portrait of Princeton Nobel Laureate Eugene Wigner. Ink drawing by the author, 1978

monly beautiful creations of nature.[5] Likewise, the finest examples of visual art and music are anything but endlessly regular. Indeed, the notion of "the monotonous" is one of artistic and social aversion. In the seventeenth century, a younger contemporary of Shakespeare's captured this message:

A sweet disorder in the dress
 Kindles in clothes a wantonness.
A careless shoestring, in whose tie
 I see a wild civility:
Do more bewitch me, than when art
 Is too precise in every part.
—Robert Herrick (1591–1674)

It is not the purpose of this book to present an exhaustive inventory of examples of natural and artistic phenomena that demonstrate the same patterns, but rather to scrutinize the symmetries and patterns at a fundamental level, and to examine possible forces that would produce similar shapes at wildly disparate scales. We will also review the notion of aesthetics, and the mathematics underlying aesthetics. By studying the interdynamics of art and science one gains a sense of the confluence of the two, and to a lesser extent, the psychology underlying the human affinity for symmetry.

The Power of Observation

The observational skills necessary to perform modern science come from the skills introduced by artists in the Renaissance. It has been said that the greatest discovery of science is science itself.[6] Yet it was the artist, in his attempt to mirror nature, who first learned to observe nature as it really presented itself. And, in turn, for the artist the greatest discovery of the Renaissance—actually a rediscovery— was the notion prevailing in classical antiquity that man was the measure of all things.

Twenty-five years before Leonardo was born, a few discerning artists began to develop a new approach to observing and representing nature with correct perspective. Leonardo, however, made a science of linear perspective, and as a part-time artist, he produced among a handful of paintings the two most famous paintings in history (the *Last Supper* and the *Mona Lisa*). He also left behind thousands of pages

of personal observations, ruminations, and sketches on every subject conceivable. In the last few years, as scientists—physicists, mathematicians, engineers, anatomists, botanists—have undertaken examinations of Leonardo's work in science and technology, they have returned to pronounce Leonardo the first modern scientist.[7] His methodology prefigures Galileo's work by more than a century. Ultimately, it is the originality of his questions and the prescience of the solutions that still impress us after five hundred years.

The Sculpture Model of Science

An unfortunate banality in philosophy ascribes to science the exclusive process of analysis, and to art, the exclusive process of synthesis. The scientist, this platitude explains, takes apart his subject. The artist, puts it together. Jacob Bronowski brings this misconception to task: in reality the scientist engages in both processes, as does the artist. For each, imagination begins with a very close scrutiny and analysis of nature, and ends in synthesis, putting together a "form by which the creative mind transcends the bare limits, the bare skeleton that nature provides."[8] Bronowski offers sculpture for the model of science. Sculptors from Phidias onward imagined the existence of the statue in the rough-hewn block, the figure beckoning to be released, to be discovered. In Michelangelo's words,

> When that which is divine in us doth try
> To shape a face, both brain and hand unite
> To give, from a mere model frail and slight,
> Life to the stone by Art's free energy.
> The best artists hath us thought to show
> Which the rough stone in its superfluous spell
> Is all the hand that serves the brain can do.[9]

Likewise, the scientist operates as if physical laws already exist, in unique form, and only need to be discovered, or to be extricated from

nature. But in reality, the physical laws no more exist in unequivocal manner than the statue in that rough block. In the hands of different sculptors the block is destined to yield different forms. And in the hands of different scientists the laws are destined to emerge in different form, although ultimately perhaps susceptible to a demonstration of equivalence. Depending on how exactly the questions are asked, the results can appear differently, but correctly.

Radical Reductionism

Progress in certain areas—in the arts and the sciences especially—involves vicissitudes along the way, bumps, forward surges, occasionally retrograde slippage, before true understanding occurs. At the risk of oversimplifying, offered here are a pair of converse views. James Burke, who starred in the BBC series *Connections,* claimed that at the roots of the progress of civilization were incremental steps. Bronowski, a one-time colleague of Burke, had argued in an earlier series, *The Ascent of Man,* that progress came in the form of phase transitions, revolutions. The contention in this book is that both types of change are necessary. Certainly the incremental changes represent the norm, but then a need for a radical reductionism, a synthesis, becomes a periodic necessity in order to put some order into the incremental progress. This type of transformation has occurred in science, in art, and in other fields. Bronowski expressed this message succinctly: "Although science and art are social phenomena, an innovation in either field occurs only when a single mind perceives in disorder a deep new unity."

Radical reductionism has its purpose in the sciences and in art. In the sciences, one tries to reduce the laws to their bare essence. The unification or synthesis of the laws of physics represents a radical reduction into a single sublime formalism, a Holy Grail of physics. Reductionism in art occurred naturally and in a most healthy manner—progressively. Certainly it was underway with

Vermeer in the seventeenth century, gained momentum with the great colorist J.M.W. Turner in the nineteenth, and came to full fruition in the twentieth century with geometric abstractionists like Mark Rothko. This movement, however, started even earlier when Michelangelo, toward the end of his incomparable career, carved the series of sculptures called the *Captives*, depicting bodies emerging from rough hewn stone, statues that now line the long room leading to his *David* in the Gallerie dell'Academia in Florence. In another late work, his *Rondanini Pieta* (c. 1550–53), Michelangelo abandoned realism, depicting his figures with elongated limbs in the fashion of Mannerism, a style in which the work evokes previous art rather than nature. These works are magnificently finished in their seemingly unfinished states, as is Schubert's Unfinished Symphony. Only half a century after Michelangelo's death, Rembrandt began to create some of the most powerful portraits in the history of art, having discarded fine brushes and minute close-up detail, while capturing the soul and character of his subjects with his bold multi-layered brushwork.

The Ambiguous Role of Religion in Art and Science

While science and art share similarities in their patterns of inspiration and creativity, there are also glaring differences. Although there exist instances where the artist consciously draws on some of the symmetries and proportions that we shall express in quantifiable terms in this book, the vast majority of art is ultimately produced intuitively, emotionally, and created with imagination and subjectivity, with no interest in such quantification. And this is as it should be. The scientist, for whom scientific or physical intuition and imagination can be a powerful asset, avoids emotion, constrained by drawing on analysis and objectivity—working within the boundaries dictated by the principles of science, and ultimately by the laws of physics. It is not only acceptable for an artist to draw

from religious inspiration, but historically religion has been art's driving force, providing content and theme (and often the cleric's patronage). Indeed, it has been in the name of God(s) that virtually all of the most enduring works of art and architecture were created.

The decoupling of art and religion began anew in the Renaissance. When Leonardo painted his incomparable psychological portraits of the "three women"—the *Ginevra de' Benci, Cecilia Gallerani,* and the *Mona Lisa*—it was again the beginning of a break from the accepted norm—religious art. By the early seventeenth century the great Dutch artists, including Rembrandt and Vermeer, were more interested in nonreligious subjects than religious. Today, whether secular or nonsecular, good art is simply good art.

Science, in contrast to art, can at best coexist with religion, even in this presumably more liberal and enlightened age. In the past, the two were at constant loggerheads. Even in antiquity the adversarial nature of the relationship between science and religion was apparent. The natural philosopher Anaxagoras, an advisor to Pericles, would have been lynched by a mob for ridiculing the gods of the pantheon had Pericles not intervened. As it was, he was simply allowed to retreat into exile, becoming one of the first intellectuals persecuted for his religious views. Similar danger existed in the Middle Ages for philosophers challenging the authority of the Church, and this remained the case well into the Renaissance. In modern times, however, mixing the two would be anathema for the serious scientist, and probably discouraging for the religious fundamentalist. Creation science, for instance, is frankly an oxymoron, a contradiction in terms.

When the great scientists of the Scientific Revolution—Newton and Galileo, both religious men—performed their experiments in physics, their mode of questioning was no different than it would be for a scientist today. They did not mix their science and religion. Modern science is performed in a secular manner, detached from

religion. Among pure scientists today, one still encounters individuals with a deep spiritual side, but even they do not mix their science with religion. There appears to be no reasonable way to reconcile science and religion. In short, one is not testable by the other. Each requires a certain kind of faith. In the case of science, there is, first, that there exist laws of nature; second, that the laws of nature can be extracted from her, and third, that they can be expressed mathematically. As a metaphor for the order in the universe—the cosmos—scientists have frequently invoked the name of God. Einstein, giving a guest lecture at Princeton University in 1930, expressed this circumstance in his native German, "Raffiniert ist Herr Gott, aber Böshaft ist er nicht!" (Subtle is the Lord, but malicious he is not!) The laws of nature are there for us to decipher. The task may not be easy, but unlike the Mad Queen in *Alice in Wonderland*, he does not change the rules of the game already in progress. Paul Dirac, a central player in the development of quantum mechanics, was known for his frequent reference to the value of "beautiful equations," and the pronouncement, "God is the greatest mathematician of them all." But as we have seen, for Einstein and Dirac, God was the order of the universe.

Asking God Questions

Once I was in Cleveland, Ohio, for an interview on a CBS affiliate station. I had been speaking about the birth and death of the universe, being mindful not to trample on the religious sensibilities of anyone in the listening audience. The call-in nature of the program brought forth a question that put me in difficult straits, "How does a physicist reconcile science and religion?"

I was there to answer questions about the physicist's view of the origin of the universe, not about the place of God in the scheme of things. Reflexively, I blurted out, "Physics and religion are orthogonal functions. They are linearly independent."

The moderators looked puzzled, trying to figure out what I said. And *I* tried to figure out what I had said. My answer pertained to wave functions, and had come straight out of quantum mechanics, a subject I had taught for many years. Trying to gain some time, or to deflect attention away from what to me was an intractable question, I invoked a story about the great nineteenth-century physicist Joseph Henry, the inventor of the electromagnet.

In 1846 President James K. Polk wrote to the Royal Society of London, asking for the name of the world's greatest scientist. (The Royal Society at the time functioned as a clearinghouse for matters scientific.) Polk explained, "[W]e would like to offer him the position of Secretary of the Smithsonian Institution in Washington, D.C." The Royal Society wrote back, identifying Joseph Henry,[10] professor of physics at Princeton University, as the leading scientist. (This was also the time Michael Faraday was operating in England, and with a much greater scientific legacy than Joseph Henry, but clearly the British did not want to send their greatest scientist to the hinterland of the United States.) Polk's assistant was immediately dispatched to Princeton to offer Mr. Henry the job. The man found Henry just getting ready to begin an experiment with one of his electromagnets. Henry invited Polk's assistant to observe the experiment, but then suddenly stopped, proposing, "Let's get a few more witnesses." Then he stepped into the hallway and rounded up some graduate students. Everyone watched curiously, as Henry, just before turning on the power, pronounced, "We are going to ask God a question. Let us pray that we do not miss his answer when He gives it to us."

Henry had reduced performing scientific experiments to asking God questions. The magnificence and genius of the Creator was ultimately embodied in nature's laws, and it was precisely by extracting these laws that he was honoring God. Though he thought his answers came from God, he asked his questions according to the same scientific method that had taken shape in the seventeenth

century and had been followed by the great early scientists of that era, most notably Galileo and Newton, and Leonardo before them. This mode of questioning nature did not *require* any appeal to God or a Creator or any other supernatural force or being. Henry was a devout and simple man who happened to be immensely gifted as a scientist. When Henry (or for that matter, Faraday, who was also an intensely religious man) performed his experiments, his mode of questioning was no different than it would be for a scientist today. These men did not mix their science and religion, although ultimately both were convinced that by uncovering the truth and beauty of nature they were glorifying God.

In *Rocks of Ages,* the evolutionary biologist Stephen Jay Gould compared the domains of science and religion: "The net, or magisterium, of science covers the empirical realm: what is the universe made of (fact) and why does it work this way (theory). The magisterium of religion extends over questions of ultimate meaning and moral value. These magisteria do not overlap . . . science gets the age of rocks, and religion the rock of ages; science studies how the heavens go, religion how to go to heaven."[11]

Leonardo was the most impious of the thinkers of his time (although there exists no evidence that he was not a believer) and operated without ever appealing to divine providence in either his science or his art. Nonetheless, he created in the *Last Supper* one of the two most important religious works in all of Western art (the other being Michelangelo's Sistine Ceiling). His working dictum extended to other fields where blind faith ran counter to experimental and mathematical demonstration. He abjured astrology, which even the later scientists Kepler and Galileo did not reject, and he renounced alchemy, which Newton secretly embraced. In this sense, Leonardo's perspective was even more modern than those of the luminaries of the Scientific Revolution.

The principles of mathematics . . . deal with discon-
tinuous and continuous quantities with the utmost
truth. Here no one hazards guesses to whether two
threes make more or less than six, or whether the
angles of a triangle less than two right angles. Here
all guesswork remains destroyed in eternal silence,
and these sciences are enjoyed by their devotees in
peace, which is not possible with delusory sciences of
wholly cerebral kind.

—Leonardo da Vinci

Chapter 3

Painting by Numbers

Leonardo often criticized the intellectual who would prefer to intro-
spect in the search for scientific truth, instead of seeking it with
experimentation and mathematical demonstration. Four hundred
years after Leonardo, the prominent physicist Lord Kelvin, also speak-
ing for the scientist, expressed the need to be exact when he made the
pronouncement: "When you can measure what you are speaking
about and express it in numbers, you know something about it; but
when you cannot measure it, when you cannot express it in numbers,
your knowledge is of a meager and unsatisfactory kind."

The knowledge may be "meager," but the experience can be rich. Lord Kelvin's dictum is true for the sciences, and that is the context in which it must be taken, but because of its absolutist nature it would meet violent opposition from the practitioners of the arts, and it should. It would be a sacrilege to judge the beauty and power of an ode by Keats, a sonnet by Shakespeare, or a symphony by Beethoven in terms of numbers. Nonetheless there often exist quantifiable aspects in architecture, sculpture, poetry, and music that serve to describe their structures. And there exist quantifiable aspects in the graphic arts—in painting—specifically in issues of perspective, proportion, symmetry and shape, with which the painter has informed the work (wittingly or unwittingly). Putting numbers on a painting does not turn the process into painting by numbers. In the same way that Lord Kelvin's message may be an anathema for the humanist, a statement by the eighteenth-century British statesman Edmund Burke, "It is the nature of all greatness *not* to be exact," would be meaningless gibberish if taken out of context—a source of disdain for the scientist.

"Painting by numbers" may not be as egregious a pursuit as one might imagine. Leonardo himself invented a form of it, assigning assistants to paint areas on a work that he had already sketched out and numbered. Most likely while painting a ceiling in the Vatican, Michelangelo also assigned numbers to areas for his thirteen assistants, many brandishing their own brushes. But this is not the sense in which I intend to use numbers; rather it is in seeking the quantifiable aspects of art and science. Numbers and mathematics are indispensable in the sciences, and any attempt to seek a confluence of art and science invariably summons the search for the quantifiable common ground of the two.

The Slavy Indians of north central Canada have never abstracted the notion of numbers. They convey approximations for quantities by proportionately drawing out the articulation of the word *Netlo*. If they are asked how many geese they shot, the answer may be

confusing to us. If they've shot one or two geese, they may say, "Netlo." If they've shot several, they may express this circumstance as "Nee . . tlo." In the event that an entire flock has been bagged, it might be, "Neeee tlo!" Members of the Slavy Indian audience, however, all get a sense of the size of the kill, and respond with ovation or commiseration accordingly. The Slavy Indians' practice is evocative of the different meanings an expression can take depending on where the stress falls: for example in "quite a *few*," "quite a few" and "*quite* a few."[1]

Among the aborigines of New Guinea and North Borneo the abstract notion of numbers has also never emerged. There might be a word for "one dog," another word for "two dogs." And a pack of dogs numbering more than two might be referred to by an entirely different word still, with no distinction between three, or four, or five. The Bushmen of South Africa's Kalahari use pairs of similar objects, and group the pairs until they reach five pairs, for a total of ten. Any number beyond that becomes too many to reckon.

The Origin of Numbers

Mathematics comprises more than just numbers. The abstraction of numbers and the formulation of basic operations for them, such as addition, subtraction, multiplication, and division, signal the birth of mathematics. Among our ancestors of the Paleolithic period—approximately 30,000 years ago—there is already evidence of reckoning with numbers, and even grouping these numbers, that is, a rudimentary use of bases. A wolf shin bone excavated in Czechoslovakia in 1937 reveals cut notches arranged in groups of five, evocative of how in modern times one might count a small sample in a straw poll with four vertical lines, crossed by a fifth— a diagonal line. They were counting in the base-five or the *quinary* system. There have been experiments with different bases, but some of them appear to have been more natural and consequently

more enduring than others. According to the historian of mathematics Carl Boyer,[2] of the three hundred native American tribes whose quantitative reckoning has been identified, roughly one-third use base ten (decimal system); another one-third use a combination of base five and base ten; about ten percent employ the base twenty (vigesimal system) and a negligibly small number (about one percent) use the base three (ternary system). An accident of evolution which gives us five fingers per hand, with ten fingers total, plus another ten toes make the quinary, decimal, and vigesimal bases natural, and the base three or four, or seven, contrived.

COUNTING IN ANCIENT MESOPOTAMIA

Among the Babylonians, and the Sumerians before them, the common base was sixty (the sexagesimal system). The inspiration for the base sixty has been lost in the mists of time. It could have been formed from melding the base five and base twelve (duodecimal), both of which have been seen through history, or it could have been derived from the number of days, 360, then thought to constitute a year. Or perhaps it is because 60 can be divided by 1, 2, 3, 4, 5, and 6. Although the sexagesimal base became extinct in the distant past, it left behind vestigial remains—the sixty seconds in the minute and the sixty minutes in the hour.

Starting in the fourth millennium B.C., Sumerian scribes, working in wet clay, were writing and computing in the style called *cuneiform*. The system showed such remarkable longevity that it was still in use two millennia later. The earliest known peace treaty between two nations, inscribed in a variation of cuneiform, is seen on a tablet in the Archaeological Museum, Istanbul. The numerical system employed in cuneiform is comprised of two symbols—"< " and "I "— representing ten and one. The entries are arranged in columns (reading from right to left) of $60^0, 60^1, 60^2, 60^3, 60^4, \ldots$ (or *1, 60, 3600, 216 000, 12 960 000, . . .* respectively). Thus the symbols grouped as "<<<III *[gap]* <<III " *could* represent *33 × 60 + 23 × 1 = 2 003.*

I say, "could," because the multipliers might just as easily have been 60^3 and 60^2, instead, making the total number $33 \times 216\,000 + 23 \times 3\,600$, or $7\,210\,800$. Although the Babylonians used the place value system, they did not have a symbol for zero, and one has only the context as a clue. They had not seen the need to introduce a symbol representing "nothing." According to Robert Kaplan[3] at least one scribe about the seventh century B.C., however, used a pair of back-slashes "\\" to represent a gap or a missing power of 60. Thus the combination of symbols "< \\ < \\" would have been $10 \times 3\,600 + 0 \times 60 + 12 \times 1 = 36\,012$.

Although the Babylonian mathematicians did not develop zero as a formal symbol for *nothing*, they showed considerable mathematical sophistication in their calculations, recognizing for example that $3^2 + 4^2 = 5^2$, often associated with the Pythagorean theorem. For the particular Pythagorean triad or "triple" $(3, 4, 5)$ at least, they had made this connection. They may or may not have discovered other triads, such as $(5, 12, 13)$, and evidence for their recognition of the general rule, $a^2 + b^2 = c^2$, is lacking. Their mathematical achievements predated the work of Pythagoras by centuries.

RECKONING NUMBERS AMONG THE MAYA

In ancient Central America the number system used was always the vigesimal system. The fact that the inhabitants wore no shoes may have made the base-twenty system entirely natural. The Olmecs, living around La Vente in Mexico around 1000 B.C., left no written script. But a multitude of successors—the Teotihuacán from around the time of Christ, the Mixtecs, the Zapotecs, the Maya, the Toltecs and the Aztecs—all used the vigesimal system. It was under the Maya, a civilization of gifted astronomers, mathematicians, and master builders, that the base twenty—complete with a zero—was formalized. Accordingly, it is the Maya who are generally given credit for the discovery of the zero in the Americas. (The French have used the decimal system as long as have other European nations. But their word for

eighty, *quatre-vingt*—"four twenties"—may be the distant memory of a base twenty system.) The classic period of the Maya fell between the third and ninth centuries A.D., when the Europeans of the same time were mired in the darkest period of the Dark Ages. In city-states like Chichén Itzá, Tikal, Copán, Kabah, and Uxmal the astronomer-priests performed astronomical calculations of uncanny sophistication.

Among the Maya there existed a number of different ways to express numbers, some of them stylized and decorative, and consequently difficult to decipher. The most common form, however, utilized three symbols: a hollow dot "⊙" representing the one, a thick horizontal bar "═" representing five, and a stylized seashell, seen in the last column of the last row, representing the zero. The symbols were generally arranged in boxes in vertically ascending order, with values of the boxes employed as multipliers, 20^0, 20^1, 20^2, 20^3, . . . (or 1, 20, 400, 8,000, . . .).

A SUBLIME LEGACY OF
THE HINDUS AND THE ARABS

The invention of a symbol for nothing eluded the Greeks, as well as the Egyptians, the Hittites, the Assyrians, the Phoenicians (often credited as inventors of the phonetic alphabet), and the Romans. Nonetheless, the formal notion of nothing was eventually invented, indeed not once but twice, and in vastly different geographic regions. The Maya invented zero around the first century B.C., but earlier, in fifth-century B.C. India, the zero was used by the mathematicians and astronomers in a decimal system. By 400 B.C. the astronomer Aryabhata had formalized the concept of zero as one of a set of ten symbols of the decimal system. We shall return to the decimal system after the next section.

Around A.D. 750 the Arabs, while engaged in spreading Islam, made an early incursion into India. It was in that encounter with the Hindus that they first saw the decimal system, consisting of the nine symbols 1 through 9, plus a tenth, the zero. There they

mastered the skill of making paper, developed six centuries earlier in China. They brought a compendious knowledge of practical and academic treasures back with them to the Middle East and North Africa. Muslim astronomers were already familiar with the works of Ptolemy and the great philosophers of antiquity. Their mathematicians developed the elements of algebra, trigonometry, and number theory, and their natural philosophers made strides in astronomy, medicine and alchemy (a precursor of chemistry). Words with the prefix al for "the"—*algebra, alcohol, almanac, algorithm, alkali,* etc.—are, more often than not, Arabic creations. (An exception exists in the word *alimony,* strictly a Western invention.) Islamic scholars obeying the directive of the Koran that they should study nature in order to glorify God were foreshadowing the modus operandi of those great scientists later to emerge in Europe.

Among the noteworthy Islamic mathematicians and scientists was al-Khawrazmi, whose name gives us the word *algorithm.* A scholar in the Dar al-ulum (House of Wisdom) in Baghdad in the ninth century, al-Khawrazmi performed pivotal work in astronomy and mathematics. Borrowing from the Greek mathematician Diophantus, Babylonian sources that he accessed through Hebrew translations, as well as knowledge gleaned from Hindu mathematicians, al-Khawrazmi succeeded in formulating a self-consistent *al-jabr* or algebra.[4] And algebra certainly increased the analytical power of mathematics by orders of magnitude, preparing the stage for the introduction of analytic geometry and calculus in the seventeenth century. The expressions *al-jabr* and the process of manipulating equations, *muqabalah* ("give-and-take" or "a balancing") have their roots in Arabic. A number of other Muslim scientist-mathematicians of the period—Habash al-Hasib ("He who calculates"), Abul'l-Wafa al-Buzjani, Abu Nasr al-Iraq and Ibn Yunus—formulated trigonometry (including all six trig functions) at a level of sophistication far above that introduced by the Greek astronomer-mathematician Hipparchus in the third century B.C.

In the eternal cycles that mark the rise and demise of cultures, by the mid-ninth century European science had hit abysmal depths just as Islamic science was ascending to new heights. So dramatic was the disparity that the Arab geographer Ibn Khurradadhbeh was moved to describe western Europe as "a source of eunuchs, of slave girls and boys, of brocade, beaver skins, glue, sables, and swords . . . and not much more." Another Muslim geographer, Masudi, was equally contemptuous when he remarked, "Europeans are dull in mind and heavy in speech." The supremacy in science and mathematics would be inverted again, but not for another six centuries.

Al-Haytham's study of optics and vision compares favorably with the work performed by Leonardo da Vinci five centuries later. And indeed, not until the Scientific Revolution in the seventeenth century—with the work of Isaac Newton and Christian Huygens— was the study of geometric optics to yield a higher level of fundamental understanding in the field. The Persian scholar Omar Khayyám (c. 1048–1131) left behind the most distinguished legacy of any scientist-mathematician of Islamic culture. In the service of the Kurdish-Turkish Sultan Salāh ad-Din ibn Ayyūb (known in the west as Saladin), the nemesis of Richard the Lionheart during the second crusade, Khayyám published a definitive treatise on algebra in which he classified algebraic equations up through the third degree and showed how geometric solutions to the equations could be obtained. With astronomical observations of extraordinary precision, he devised a solar calendar significantly superior in accuracy to the Gregorian calendar introduced in Europe almost six centuries later and still in use today.

Ironically, the source of Khayyám's most enduring legacy is neither his mathematics nor his science, but rather his poetry. The nineteenth-century British poet Edward Fitzgerald dedicated most of his life to translating, some might say *recomposing*, Khayyám's poetry. The *Rubaiyyat*, published initially in 1859, and then in three successive versions, presents numerous bittersweet quatrains, all

melancholic ruminations about the irreversibility of fate and the fleeting nature of life. In the present context we might even take his message (although unintended) as a reflection of the finite life expectancies of civilizations themselves. In one such stanza Khayyám is found to ruminate,

Ah, make the most of what we yet may spend,
Before we too into the dust descend,
Dust into dust, and under dust to lie,
Sans wine, sans song, sans women, and sans end.[5]

In the thirteenth century there was another gifted astronomer-mathematician, Nasr al-Din al-Tusi, who was a character of decidedly flexible political loyalties. His town having been overrun by the Mongol hordes of Genghis Khan, al-Tusi took up residence with the Isma'ilis, founded in the 11th century by Hasan Sabbah, also known as the "Old Man of the Mountain," in Alamut, near the Caspian Sea in northwestern Iran. There the members of a cult given to political assassinations of rival tribal leaders would be trained for their dastardly assignments. They would be given hashish along with assurances that carrying out the will of the cult leader—often an assassination—was also the will of God. It would gain them immediate entry into *Jannet*, or paradise. The word *assassin* has its roots in *hashishinn*, the term identifying the cult's members. Al-Tusi benefited from the rich collection of scholarly books belonging to the sect.[6]

In 1256, when Halagu, the grandson of Genghis Khan, began a siege of Alamut, al-Tusi found it expedient to change sides. He accepted a position as a scientific scholar with Halagu. In grateful appreciation Halagu built for al-Tusi a magnificent new astronomical observatory in Maragha, in northwestern Iran. For generations thereafter, al-Tusi's followers at the observatory carried out systematic observations, keeping copious records. Similar observations and research were carried out at the even more elaborate observa-

tory established by the Ulugh Beg in Samarkand in the fifteenth century, and they all appeared to function with a dictum meant to challenge Ptolemy's geocentric picture of the universe that the Church in Europe had decided to sanction. Although there is no evidence that Copernicus knew much about Islamic science when he published his monumental treatise *De revolutionibus orbeum coelestium* in the mid-sixteenth century, his work was certainly driven by a spirit of challenging the Ptolemaic order. There may, however, be a connection here. Although in the final copy of *De revolutionibus* Copernicus made no mention of Aristarchus, the third-century B.C. astronomer from Samos who had first proposed the heliocentric picture, Copernicus had referred to him in the foreword of an earlier draft of his book. Islamic scholars, keeping alive Greek teachings, had access to the work of Ptolemy and most likely to the earlier teachings of Aristarchus, to be examined in Chapter 11.

This creative period of Islamic science and mathematics continued to bear fruit several centuries after Khayyám, and into the Ottoman Turkish period in the fifteenth century. Without question for the better part of a millennium Muslim scientist-mathematicians had been far ahead of their European counterparts, but this circumstance showed signs of reversal beginning in the late fifteenth and early sixteenth centuries in Florence, and subsequently accelerated with the Scientific Revolution in the following century. A number of conjectures seek to explain the decline of science in Islamic civilization. One explanation has it that a general fatalism pervaded Islamic culture, revealed in the melancholia and pathos of Khayyám's quatrains. Another and quite compelling argument involves the emergence in twelfth-century Baghdad of an intellectual movement that favored faith and dogma over reason and direct evidence. This was a movement spearheaded by al-Ghazálî, a contemporary Persian compatriot of Khayyám's, who, much like the modern-day Taliban, argued on behalf of fundamentalism.

One final contributor to the decline, or at least to the passing of

the baton, may be found in a metamorphosis that took place in Islamic cultural philosophy. In an earlier age the Romans had been great builders (indeed also empire-builders) preferring application to theory, whereas their cultural antecedents, the Greeks, had been more cerebral and better theorists—superior philosophers, mathematicians, and scientists. So it was with the Ottoman Turks. Unlike the earlier Muslims—the Arabs, the Persians, and the Selçuk Turks, who had an affinity for philosophy, mathematics, and science—the Ottomans preferred architecture, engineering, and expanding an already vast empire. As one would expect of such an empire, the applied science of cartography was also given extraordinary prominence. The earliest known map showing the east coast of South America, the West Indies, and the west coast of Africa was drawn by the Ottoman map maker Piri Reis in 1513, just twenty-one years after Christopher Columbus's momentous discovery.

With the publication of Piri Reis's map serving as a time post, we can put events of the period into historical perspective. Leonardo da Vinci, who was forty years old when Columbus discovered America, died in 1519 at sixty-seven. Just two years earlier, in 1517, Martin Luther had posted his Ninety-five Theses on a church door in Wittenberg, launching the Protestant Reformation the same year Ferdinand Magellan had set sail from Spain, aspiring to circumnavigate the earth. The hapless Magellan died in 1521 as a result of a squabble with natives in the Philippines, but his crew completed the feat just a year later. The size and shape of the earth began to come into view much as Eratosthenes had envisioned it almost eighteen hundred years earlier (see Chapter 11).

The Second Leonardo: "Il Pisano"

Another Leonardo, far less familiar than his latter-day compatriot and namesake, also left a surprisingly enduring legacy. A mathematician, Leonardo Fibonacci di Pisa (also known as Leonardo Pisano) lived

three centuries before da Vinci. In his *Liber Abaci*, a seminal book published in 1202, he introduced into Europe, just beginning to awaken from almost seven centuries of lethargy and intellectual recession, the decimal system of numbers, complete with the zero. In his book Fibonacci pulled another rabbit out of his hat, and then another one. In fact, virtually as an afterthought, he threw in a mathematical problem involving the reproduction of rabbits confined in an enclosure. The problem was presented in the last chapter of a book of thirteen chapters and has given us the mathematical series that bears his name—a series that yields an enigmatic ratio with significance far beyond the artifice of mathematics.

Fibonacci's name, literally "the son of the innocent," was a euphemism for "the son of the simpleton." His nickname, "Bigalone," was even more disparaging—"block head." But then, the position on the social ladder in medieval Europe for a mathematician would have been below that of the barber-surgeon, and well below that of the sorcerer. Certainly that would have been the sentiment of Saint Thomas Aquinas (1225–1274), a rationalist whose religious doctrine still provides the underpinnings for Catholicism, and who is known to have offered the questionable admonishment that "the good Christian should beware of mathematicians."

Very little is known about the personal life of Fibonacci (c. 1170–1240). He received the preponderance of his mathematical education from Arab scholars in North Africa, where his merchant father often took the family. As a young man he continued to travel, living briefly in Constantinople and Alexandria, and finally settling in his boyhood town of Pisa and practicing mathematics. Mathematics in medieval Europe is often characterized as having been practiced in two different settings: by clerics doing academic mathematics and by the merchants doing practical or applied mathematics. The title of the book, *Liber Abaci* (Book of the abacus), suggests that it is about practical computations, especially for commerce. In fact, it is a book about algebra and abstract mathematics.

Indeed, the "son of the simpleton," the "blockhead" Leonardo Fibonacci was the preeminent mathematician of medieval Europe.

In the beginning of his book, Fibonacci presented a number in Roman numerals, demonstrating that it can be written in many different ways. Let us consider an example of our own, the number 1999. The number can be written MCMLIL, MCMIC, MDCCCCIC, MIM, and in a number of other possible ways. The last of these choices is the most economical form, and accordingly the one of choice. Nonetheless, it is obvious that the notation is not unequivocal.

Following the Arabs, Fibonacci introduced the ten symbols, 0 through 9. In two instances (for 0 and 9) he borrowed the symbols directly from an early version of Arabic numerals. For others, he created his own symbols, adhering roughly to the recipe: *The value represented must be proportional to the number of straight lines in the symbol.* The 2 and 3 consist of two and three horizontal lines, respectively, tenuously connected. Although Fibonacci's symbols were inspired by the symbols used by the Arabs, only a slight resemblance exists between the two sets of symbols now. The 1 is the same; the 2 and 3 of the Arabic system, if rotated 90 degrees counterclockwise, are evocative of Fibonacci's symbols and those that we still use (Figure 3.1).

Also following the Arabs, Fibonacci introduced the place-value concept, each position representing a different power of ten, and these arranged in ascending order from right to left. Each position has a power of ten as a multiplier. Thus the number *12 345.67* has its particular value, because the *1* has a multiplier of 10^4 (or *10,000*); the *2* has a multiplier of 10^3 (or *1,000*), the *3* has a multiplier of 10^2, . . . the *7* has a multiplier of 10^{-2}.

10^4	10^3	10^2	10	10^0	10^{-1}	10^{-2}
1	*2*	*3*	*4*	*5*	*6*	*7*

Scientists, dealing with wildly disparate scales, generally use sci-

Figure 3.1. Symbols in the decimal system: *(top)* the symbols proposed by Fibonacci in the Hindu/Arabic notation. *(bottom)* Arabic numerals

entific notation, or powers of ten—10^3 or "kilo" (one thousand); 10^6 or "mega" (one million), 10^9 "giga" (one billion), 10^{12} or "terra" (one trillion), all used for large measures. And there are the 10^{-3} "milli" (one thousandth); 10^{-6} "micro" (one millionth); 10^{-9} "nano" (one billionth); and 10^{-12} "pico" (one trillionth), and so on, for small measures.

THE PROBLEM OF THE RABBITS AND THE FIBONACCI SERIES

In Fibonacci's problem of the rabbits the rules are stipulated as follows: (1) One pair of immature rabbits is placed in an enclosure. (2) The rabbits must mature for two months before they can reproduce. (3) A mature pair of rabbits *must* combine to produce one new pair each month. (4) The offspring, subsequently, must mature for two months before they can begin to reproduce. (5) No new rabbits can be introduced from outside, and no rabbits can leave the enclosure. In this deterministic utopian world of rabbits there is no immigration, emigration, shortage of food, shortage of space, overcrowding or death. For example, in the third month there should be two pairs of rabbits: the original pair, now fully matured, plus one infant pair. The number of pairs in each successive month can be seen in the following table.

Month	Number of Pairs
first	1
second	1
third	2
fourth	3
fifth	5
sixth	8
seventh	13
eighth	21

The question that Fibonacci posed at this juncture was "How many pairs of rabbits would there be at the end of the year?" Applying Fibonacci's rules, one would arrive eventually at the twelfth number (or "term") in the series as 144 pairs (i.e., 288 rabbits). Fibonacci, in examining the column labeled "Number of Pairs," must have recognized the pattern quickly. The sum of the first and second terms, *1* and *1*, respectively, produces the third term, *2*; the sum of the second term, *1*, and third, *2*, produces the fourth term, *3*, and so on . . .

> 1, 1, 2, 3, 5, 8, 13, 21, 34, 55, 89, 144 (the twelfth term), 233, 377, 610, 987, 1597, 2584 (the eighteenth term), . . .
>
> 535 835 925 499 096 640 871 840 (the 120th term), . . .
>
> 185 477 076 894 719 862 121 901 38 521 399 707 760 (the 180th term), . . .

These numbers will be seen to have significance for the sciences (and accordingly are sometimes called "nature's numbers"); and a ratio ensuing from the series will be seen to have significance for the arts. Examining the ratios of sequential terms in Fibonacci's series—for any pair in sequence, the second term divided by the first—one sees a pattern emerging: *1, 2, 1.5, 1.666, 1.60, 1.625, 1.615,* values oscillating

up and down around approximately *1.62*. After the first dozen terms the ratio rounds off to *1.618 056*. By the seventeenth and eighteenth terms, the ratio has a value of *2584/1597* ≈ *1.618 033 813*, but rounded off to six places, still *1.618 034*. In reality this number approximates an irrational number[7] denoted by ϕ (called "phi"), and variously known as the "golden mean," the "golden ratio," the "golden section," "sectio aura," the "divine proportion."

The 120th as well as the 180th terms in the Fibonacci series (representing the number of pairs of rabbits after ten and fifteen years, respectively) were computed on a mainframe computer with the aforementioned method, that is, by adding pairs of terms in sequence. The formula for computing the general or nth term of the series directly, as well as the formula for computing the ratio $(n+1)^{st}/n$th terms are well-known manifestations of number theory. In this book these formulae and a simple derivation are relegated to the endnotes.[8] With the algorithms derived there it is possible to compute a specific term of the series without knowing the previous two terms.

If we start with *any* pair of integers, add the first and second to get a third number, add the second and third to get a fourth number, and so on, generating a series similar to Fibonacci's original series that began with the pair 1 and 1, we will discover that the ratio of successive pairs of numbers in any such series will ultimately converge to the magic 1.618 034. . . . The reader might want to experiment with an individual birthday. My own birthday—June 10, taken as 6, 10 or 10, 6—is especially conducive to producing that ratio rapidly. Thus 6, 10, 16, 26, 42, 68, 110, . . . the ratios reduce to 1.618 after just five or six terms. George Washington's birthday, February 22· yields the series: 2, 22, 24, 46, 70, 116, 186, 302, 488, 790, 1278. . . . At least ten terms must be generated in this instance before the ratio emerges with six-place accuracy.

A number of other curious properties of ϕ exist. Along with ϕ, here are the inverse and a square of ϕ:

$\phi = 1.618\ 034\ \ldots$ $\phi^{-1} = 0.618\ 034\ \ldots$ $\phi^2 = 2.618\ 034\ \ldots$

For a short table of common powers associated with ϕ see the endnotes.[9] There is no evidence that the mathematicians of antiquity were familiar with the Fibonacci series, but the value of ϕ associated with the series is another story. The number had been in common use for millennia before Fibonacci came along. Euclid gave a geometric construction for a rectangle with proportions of ϕ. Most likely the proportion was an intuitive creation of artists and architects even earlier.

Geometric Constructions Associated with ϕ: The Golden Rectangle, Golden Triangle, Golden Point, Golden Pyramid, and the Logarithmic Spiral.

A series of geometric constructions will be demonstrated here (Figure 3.2). Starting with the square *ABCD* with sides of unit length, one can readily construct the golden rectangle. First, bisect the square vertically. Then draw the diagonal *MC* and use it as the radius of an arc *CF*. Next, extend *AB* horizontally to intersect the arc *CF*; draw a vertical line *FG* at this intersection, and finally extend *DC* to complete the rectangle *AFGD*. Since *BC* has a length of unity, and *MB* of 0.5, the Pythagorean theorem yields *MC* as $\sqrt{1.25}$ or *1.118 034*. Adding *AM = 0.5* to *MC = MF = 1.118 034*, one immediately arrives at *AF = 1.618 034*. The rectangle *AFGD* is then the golden rectangle, possessing the length-to-width ratio of ϕ.

Moreover, *BF = MF – MB = 1.118 034 – 0.5 = 0.618 034*. The ratio BC/BF is equal to *1/0.618 034 = 1.618 034*, which renders the rectangle BFGC a golden rectangle also. Within BFGC, if one were to partition off another square, still another golden rectangle would be formed. Accordingly, a simple pattern emerges.

This relationship codifying the statement, "the whole is to the

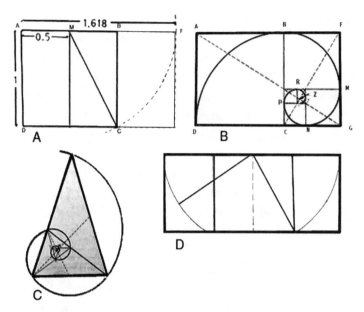

Figure 3.2. The golden rectangle, the golden triangle, the logarithmic spiral, and the double golden rectangle. (A) Construction of the golden rectangle, the length-to-width ratio of the rectangle yielding ϕ. (B) Construction of the logarithmic spiral. (C) The golden triangle defined by the angles 72°—36°—72° is closely related to the logarithmic spiral. (D) Construction of the double golden rectangle

major part as the major part is to the minor," is known as the law of divine proportion.

$$\frac{AB+BF}{AB} = \frac{AB}{BF} = \phi \, (=1.618034)$$

Partitioning off a square within the golden rectangle, and in the process generating a new golden rectangle, can be repeated ad infinitum, each time creating a square plus a new golden rectangle. Finally, if one were to connect either the leading corners of squares (or the

centers of the squares), with a smooth continuous curve, one would obtain the logarithmic spiral, as well as an image of whirling squares.[10]

As a preview of things to come, specifically when perspective, symmetry, and shape are discussed in detail, we present a stained glass window created in the mid-twentieth century by Marc Chagall for the United Nations Building in New York (Plate 2, top left). Assembled from square pieces, the window consists of 5×8 squares (5 and 8 comprise a pair of sequential terms in the Fibonacci series). Then, if a 5×5 square is isolated within the rectangle, the remaining rectangle will be 3×5, another golden rectangle. If a 3×3 square is delineated within the 3×5 rectangle, the remaining part will be 2×3. Each of those values cited—2, 3, 5, 8— are terms of the Fibonacci series, and each of the delineated sections, approximates the golden rectangle.

A logarithmic spiral can be used in generating the golden triangle, an isosceles triangle with the angles 72°—36°—72°. In such a triangle $AB/BC = \phi$. Moreover, the points $D, E, F, G \ldots$ used in generating additional golden triangles help define the segments $AB, BC, CD, DE, EF, \ldots$ and the ratios

$$AB/BC = BC/CD = CD/DE = DE/EF = \ldots = \phi.$$

As it is with the golden rectangle, artistic significance can be attached to the golden triangle. More immediately, the 36° vertex at the top forms one prong of a five-point star, the *pentagram,* which in turn, yields the pentagon when the points are connected. The latter figure was known as the magic pentagram to the Pythagoreans of ancient Greece, and later it became a favorite conjuring device for magicians; and in less savory ways, as the magic pentacle, it was adopted by devil worshipers. In these capacities it has endured for centuries.

The double golden rectangle can be constructed in a manner evocative of that employed in creating the golden rectangle. A square is vertically bisected creating a pair of rectangles 1:0.5. At

the point where the bisector meets the upper edge of the square a compass pin is planted, and with a radius equal to the diagonal of one of the rectangles, arcs are drawn in opposite directions. The square is then extended horizontally to meet the arcs. The new rectangle will exhibit the ratio of the sides $1:\sqrt{5}$ or $1:2.236$. While still a member of Verrocchio's workshop, the young Leonardo painted the *Annunciation* (1472–73), closely approximating the proportions of the double golden rectangle.

The golden rectangle can be subdivided in different ways in order to present a work of art with its most salient features (Figure 3.3). Each of these geometric constructions shown here has been employed by artists as the organizing structure in graphic composition; but to reiterate a frequent message, artists have usually adopted such constructions intuitively, relying on aesthetic intuition, and only occasionally with knowledge and premeditation.

Although the logarithmic spiral is the one that nature appears to favor strongly, spirals other than the logarithmic do exist in nature: they include the Archimedean, the hyperbolic, the parabolic. The Archimedean spiral describes the shape of a ribbon or tape of uniform thickness wrapped uniformly around a cylindrical core. The ordinary garden hose coiled on the ground and a video tape on a spool are examples of the Archimedean spiral. The hyperbolic spiral resembles the logarithmic spiral initially, but as it unwinds the spiral opens up and becomes a straight line. The parabolic spiral, also called the Galilean spiral after the physicist-mathematician who first described it mathematically, is reminiscent of the logarithmic spiral in that it increases in thickness in unwinding, but not with the same spacing of the logarithmic spiral.

In addition to spirals that are curves on a plane (two-dimensional space), there exist helical shapes manifested in three-dimensional space. Coiled springs and threads on screws are helical. So are the spirally fluted marble columns, sometimes found at classical sites on the Ionian coast of Turkey, and the Archimedean screw

Figure 3.3. Subdivisions of the golden rectangle. In A and B squares are delineated within the golden rectangle and diagonals are constructed of both the original golden rectangle and the squares. The shaded quadrangles defined by the intersections of the diagonals represent the "sweet spots" of the diagrams. In C a golden rectangle is subdivided vertically and horizontally in proportions of 1:1.618, creating two squares, three golden rectangles and two double golden rectangles. The intersection of the vertical and horizontal dividers defines the "golden point." In D the geometric constructions in figures A, B, and C are merged to create this diagram with vertical and horizontal reflection symmetries.

(the ancient apparatus for raising water from one elevation to a higher one). A circular staircase (usually helical in shape), when viewed along its axis from above or from below, will appear to converge in the form of a logarithmic spiral.

Human affinity for the variety of geometric figures developed in this section all manifest themselves as patterns in nature. In this chapter that started with a presentation of the origin of numbers and the contributions to number theory of the medieval mathematician Leonardo Fibonacci, we shall conclude by briefly examining the notion of fundamental indefinables.

Quantifiable Parameters and Fundamental Indefinables

Let us return briefly to Lord Kelvin's pronouncement found in the opening of this chapter—"Unless you can measure what you are talking about and attach some numbers to it, your knowledge is of a meager and unsatisfactory kind." What is it that we are measuring? In the natural sciences the centrality of quantitative analysis would never be in question, the quantified parameters representing the ingredients of mathematical formulae. In physics, these are physical parameters such as length, mass, time, energy, momentum, force, acceleration, temperature, wavelengths, etc., and in chemistry, the pH level, or some molecular parameter, as well as many of those in physics. In biology the mathematical formalism of probability is used in understanding heredity, and mathematical algorithms are employed in mapping genomes. Even the social sciences increasingly call for quantitative skills in their practitioners. Economists quote rates of growth, the gross national product (GNP), and they examine economic indicators. Linguists, studying the evolution of languages, rely on quantitative and logical methods. Historians and political scientists rely on data from surveys and censuses; archaeologists infer life styles of ancients from statistical analyses of pollen, potsherds, and human and animal bones, and they use radiocarbon dating technology grounded

in mathematical physics. Even the visual arts increasingly use computer graphics—drawing on the need for calculus, geometry, and computer algorithms. In the culinary arts, the expression "a pinch of salt" rings quaint, but lacks the reproducibility of "a gram of salt." In short, a denumerable infinity of parameters crowd modern life—beyond just salaries and expenses, temperatures and calories, prices and sizes—all eliciting some measure of precision.

According to epistemology—the area of philosophy that deals with the nature, validity, and limitations of knowledge—in any field of study one must first identify the *fundamental indefinables*. These are concepts and notions so basic that any attempt to define them leads to circular arguments. For example, in geometry a point can be described as the intersection of a pair of lines, and a line can be described as a collection or *locus* of points. To avoid such conundrums, a point is taken as a fundamental indefinable. In physics, there are three fundamental indefinables: length, mass, and time. They are physical observables taken from one's simpler experiences. (When electromagnetism is included, the concept of "charge" is taken as a fundamental indefinable also.) But why are other simple physical observables, such as area, volume or momentum not fundamental? The answer is that areas and volumes are obtained by multiplying lengths by each other; momenta, by multiplying mass by velocity; and velocity, in turn, is a distance divided by time. Thus area, volume and momentum, all composites of fundamental indefinables, are all more complex physical observables than the constituents that helped define them in the first place. In the following we shall examine two of the fundamental indefinables, length and mass, relegating the discussion of the most enigmatic of the fundamental indefinables, *time*, to a later chapter.

LENGTH: A BRIEF HISTORY

A measure of length (or distance) is the answer to the questions, "how far?" "how long?" "how tall?" The first recorded unit of length

in history is the *cubit*. This is the distance between the tip of the middle finger on one's outstretched hand and one's elbow, and may have been introduced as far back as 6000 B.C. The Greek historian Herodotus of Halicarnasus on a visit to the valley of Giza took some measurements on the Great Pyramid (the pyramid of Khufu, or in the Greek, Cheops) and recorded the perimeter of the square base as 2,000 cubits. The 500 cubits he measured for each side corresponds to the 230 meters we measure now. The length of a cubit translates to 0.46 meters, 46 cm, or 18 inches. In Genesis, the length of Noah's ark is given as 300 cubits, or around 140 meters.

A unit introduced by the Romans and handed down to the inhabitants of England, then brought to America by the English colonizers, was the mile. This was based on 1,000 ("mille") double-steps (about 5 feet) of the Roman legionnaire. A unit that had some statistical (and democratic) legitimacy was the foot. It was based on the length of 40 Anglo-Saxon right feet (of the first 40 men emerging from church one Sunday morning).

The units of length that existed at the turn of the sixteenth century in England consisted of a mind-boggling jumble of units with no consistent base:[11] 3 barley corns = 1 inch; 12 inches = 1 foot; 3 feet = 1 yard; 9 inches = 1 span; 5 spans = 1 ell; 5 feet = 1 pace; 125 paces = 1 furlong; 5 $^1/_2$ yards = 1 rod; 40 rods = 1 furlong; 8 furlongs = 1 statute mile, while 12 furlongs = 1 league. At approximately the same time in Leonardo's Italy units in common use were the *piede* (the foot) and the *braccio* (an indeterminate unit that could vary between 15 and 39 inches depending on the region in which the measurement was made). A century later, in Galileo's time, there existed the *punto* (where 828 *punti* = 777 mm). The braccio and the punto have mercifully gone the way of the cubit, the ell, and many other units with dubious provenance or of only provincial acceptance.

In 1670 the Frenchman Gabriel Mouton determined with "reasonable" precision the circumference of the earth and proposed employing a terrestrial parameter for a standard of length based on a

fraction of the circumference of the earth. In 1791 the meter was defined as "one part in ten million (10^{-7}) of the distance between the North Pole and the equator, *on the longitude passing through Paris.*" In accompaniment with this standard was the proposal to use decimal multiples and fractions of the meter as the standard of length, thus the "centimeter" ($1/100$ of a meter) and the "kilometer" (1,000 meters), etc. Shortly after the Revolution France "went metric" in response to the strong lobbying by the great chemist Antoine Lavoisier. During the Reign of Terror that followed the Revolution, however, Lavoisier was beheaded—for having been associated with tax collecting under the deposed Louis XVI, not for introducing the metric system. At approximately the same time, the United States Congress rejected the lobbying of Thomas Jefferson to have the United States adopt the metric system.

In the early 1970s the British, the Canadians, and most other former British Colonies began to convert to the metric system. The United States along with the African nation of Burkina Faso (formerly known as "Upper Volta") remain steadfast holdouts for the imperial system. How much sense does it make to use a decimal system for our number system and still adhere to an ever-varying base for our system of measurement, where an inch is divided into fourths, eighths, sixteenths; or it is multiplied by 12 to get a foot, by 36 to get a yard; and a foot, by 5,280 to get the mile? It is my earnest hope that one day the inch, the foot, the yard, and the mile will all fade into oblivion, go the way of the cubit and the ell.

The French government in 1889 established an international bureau of standards and constructed a "standard meter" from a platinum-iridium alloy (known to maintain its length unusually well under conditions of varying temperature). In the 1960s a more exacting standard was introduced, offering precise reproducibility in scientific laboratories around the world. Based on the orange-red emission of the atom of Krypton-86, the meter was defined as the total distance comprising $1.650\ 763\ 73 \times 10^6$ wavelengths of this

radiation of wavelength $6.057\ 802 \times 10^{-7}$ meters. Finally, with the advent of atomic clocks the measurement of time became so accurate that an alternative approach was taken to defining the standard meter. In this scheme the speed of light in a vacuum, c, is taken as the precise measuring unit, and fixed at exactly $299\ 792\ 458$ m/sec. The meter is then defined as the distance traversed by light during a time interval of $1/_{299\ 792\ 458}$ of a second.[12]

A simple rule of thumb is that the yard is the distance between the tip of the right middle finger (on the extended right arm) and the right ear, the person looking straight ahead and not at the fingertip. The meter is the distance between the tip of the middle finger on the right hand and the tip of the nose. The meter is approximately nine centimeters longer than the yard. But an inch is *exactly* 2.54 centimeters, enabling one to convert longer distances readily into exact metric equivalents, for example,

$$1\ mi = 5280\ ft \times 12\ in/ft \times 2.54\ cm/in \times 10^{-2}\ m/cm \times 10^{-3}\ km/m$$
$$= 1.609\ 344\ km \qquad (Exact)$$

For very large distances, well beyond the kilometer, there exists a host of other units. For relative distances in the solar system, a useful calibration stick is the astronomical unit (AU), defined as the mean distance between the sun and earth. For greater distance still a far more convenient unit is *light-time*, or the distance that light travels in a specified time—a light-second is thus 3×10^8 meters, a light-year is about 10×10^{15} meters (or ten trillion kilometers). On this scale, the distance from the sun to the earth is 500 light-seconds or about 8 light-minutes. The distance from the sun to Saturn (10 AU) is 80 light-minutes (or 1.3 light-hours).

MASS

The concepts of mass and weight are distinguished in Newton's second law. Newton, in formulating this universal law of monu-

mental significance, recognized that a direct correlation exists between acceleration (the rate of change of velocity) of a body and the force applied on the body, $F \propto a$. But whenever a proportionality symbol appears, it can be removed by supplying a constant and an equality sign. In this case, the proportionality constant, representing impedance to acceleration, is the mass, or *inertia*, of the body, and signified by m. In the metric system, where force is measured in units of newtons (N), mass would be in kilograms (kg), and acceleration in m/sec². For a constant force, the mass and the acceleration are inversely proportional. Thus a 10-N force would accelerate a 1-kg mass by 10 m/sec²; it would accelerate a 2-kg mass by 5 m/sec², a 5-kg mass by 2 m/sec², and a 10-kg mass by only 1 m/sec², respectively. If it happens to be gravitation that is applying the force, then the acceleration would be $a = g = 9.8 \ m/sec^2$, a value peculiar to the earth. In this instance, Newton's second law, $F = ma$, can be replaced by $W = mg$. A body that has a mass of 100 kilograms would have a weight of 980 newtons. Originally the gram was defined as the mass of $1 \ cm^3$ (formerly called a "cc"), and accordingly, the kilogram as the mass of $1,000 \ cm^3$ of water. Presently, the standard for the kilogram is a specified mass of an alloy of platinum-iridium in the possession of the International Bureau of Weights and Measures in Sevres, France.

In the imperial system of units, force (or weight) is measured in pounds, acceleration, in ft/sec², (with $g = 32$ ft/sec²), and mass, in *slugs*. The expression "sluggishness" has its roots in the *slug*. In nations using the metric system, most people have come to mistake the kg as a unit of weight.

In the metric system a *tonne* (spelled in its French form) is defined as 1,000 kg. This is a unit of mass, with a weight of 9,800 newtons, or 2,205 pounds. In distinction to the tonne, the ton used in the imperial system is actually a weight of 2,000 pounds. Thus the metric tonne weighs about 10 percent more than the imperial ton.

If they disparage me as an inventor, how much more they, who never invented anything but are trumpeters and reciters of the works of others, are open to criticism. Moreover, those men who are inventors are interpreters of nature.

—Leonardo da Vinci

Chapter 4

The Nature of Science

Leonardo was a master scientist and a master engineer-inventor. In his scientific investigations he often used technology, anticipating a process that was to begin over a century later, but not coming to full realization for several hundred years. The investigations of water pressure, the phenomenon of friction, the trajectories of projectiles, and countless others are all experimental in nature, all carried out using the apparatus he designed for each experiment.

The discovery of fire and the chipping of stones in order to create cutting tools are monumental developments in early technol-

ogy, dating back to our distant ancestors roaming the savannas of Kenya and Tanzania or dwelling in caves of South Africa 70–80,000 years ago. At the end of the last Ice Age (10,000–9000 B.C.) in Asia Minor and the Middle East farming and domestication of animals were just emerging. Several thousand years later followed the landmark innovations of ceramics, metallurgy, and writing. Each of these developments, each an example of technology *sans* science, was critical for the birth and rise of civilization. Technology once learned is rarely unlearned.

In contrast to technology, science is a system of knowledge—the orderly and systematic comprehension, description and explanation of natural phenomena, constrained by logic and mathematics. Pure science was an invention of the Pre-Socratic Ionian Greek philosophers. According to Aristotle's own explanation in the fourth century B.C., the first great philosopher was Thales of Miletus, who had flourished two to three centuries earlier. Thales and his followers had practiced natural philosophy, working with the conviction that there exist natural laws governing the behavior of natural processes, and that future physical events could be predicted by understanding these laws. One did not have to examine animal bones and chicken entrails in order to understand the vagaries and whims of the gods who ultimately determined these events. The only certain date we have for Thales is a solar eclipse that he predicted in 585 B.C.

Echoing the message of Thales, the pre-Socratic philosopher Protagoras (485–415 B.C.) wrote "Man is the measure of all things . . . of the being of things that are and [the] nonbeing of things that are not."[1] In Athens of the fourth century B.C., however, empirical science held little appeal (although Aristarchus and Eratosthenes in Alexandria, and Archimedes in Sicily were still to continue to comply with Thales's dictum, putting more emphasis on observation and logic than speculation and introspection). Socrates had an aversion to natural philosophy. Plato celebrated mathematics but opposed any

form of experimentation in natural philosophy. Aristotle was far more receptive to natural philosophy but practiced minimal experimentation or observation.

Science, unlike technology, has progressed in fits and starts, its course sometimes entirely retrograde in direction. The Romans were technologists and made little contribution to pure science; then from the fall of Rome to the Renaissance science regressed. Through these times science and technology had clearly evolved independently, and to a large extent one could have science without technology, and technology without science.

In the Renaissance science was reinvented, and in the Scientific Revolution of the seventeenth century, science and technology began a courtship. The full-scale coupling of the two systems became permanent in the next two centuries. By the nineteenth century electricity and magnetism were developed both at the technological and the scientific levels. Electric generators, motors, and transformers could be created, and the underlying physics could be invoked to explain why they worked and how to improve them. The peak in the coupling, however, came in the atomic age of the twentieth century. Ultimately, it is the interaction of science and technology that led to unprecedented acceleration in the progress of both. The Industrial Revolution, beginning in the eighteenth century, can be regarded as one of the most significant fruits of this interaction. The cross-fertilization between science and technology produced the nuclear, aerospace, and computing revolutions of the twentieth century. Modern science cannot be carried out effectively without technology, and modern technology cannot proceed very far without science.

In the stratified structure that exists in the sciences, physics—the most fundamental and mathematical of the sciences—underlies chemistry, which in turn underlies the life sciences. Astride them all are the social sciences—including psychology, sociology, and anthropology. There are even interfaces such as physical chemistry, biochemistry,

psychobiology, and other fields that suggest a seamless progression among the sciences. Evocative of the dynamics of a tree, the nutrients move upward. This simple paradigm explains why the physicist generally lags behind the mathematician in invoking the newest mathematical tools; why chemists adopt some of the techniques of the physicist a generation or two after the physicist has developed them, and indeed why the biologist gets to these tools after the chemist. (To be sure, each science develops some of its own techniques, but the more fundamental concepts flow upward from the more mathematical strata below.) In the first quarter of the twentieth century the preeminent experimental nuclear physicist, Lord Rutherford, expressed his disdain for those sciences higher in the strata than his own, when he made the pronouncement, "In science, there is only physics. The rest is stamp collecting." By 1953, when x-ray diffraction was being applied to biology to decipher the structure of the DNA molecule, biology would have earned Rutherford's respect as a legitimate science. Finally, underlying the entire structure is mathematics, not a science itself, but essential for the sciences, providing them with both a powerful tool and a language. Its function is to lend rigor, effectiveness, and predictability to the scientific theories explaining the behavior of natural phenomena.

Archimedes, the greatest scientist and mathematician of antiquity, had made significant strides in connecting mathematics and physics. One hears among historians of mathematics that if the Greeks had possessed a better mathematical notation, Archimedes might have invented calculus eighteen centuries before its formal development in the Europe of the Scientific Revolution. The Greeks lacked the zero, yet new evidence has surfaced of Archimedes having achieved familiarity with infinite sets, at the other end of the numerical spectrum from the zero.[2]

The publication by Copernicus of his monumental book *De revolutionibus* in the mid-sixteenth century signaled the real beginning of the revolution. In a more consistent and comprehensive manner

the connection of mathematics and natural law came to full fruition in the seventeenth century, starting with Galileo and Kepler, and culminating with Newton.

The journey that brought us to our present understanding of science has taken over two and a half millennia. Experimental and theoretical research are ongoing, with the unification of physical laws—those governing the submicroscopic universe (quantum mechanics) and those governing the large scale universe (general relativity)—representing the ultimate quest of physics.

Leonardo discovered anew some of the scientific principles first developed by the ancients and subsequently forgotten, and he invented entire fields of science and technology that would not be reinvented for centuries. He may have been a prisoner of his time, but his restive mind wandered over scientific and technological problems encountered by the natural philosophers of the distant past and still to be faced by the scientists of the distant future.

Those who fall in love with practice without science are like pilots who board a ship without rudder or compass.[1]

—Leonardo da Vinci

Chapter 5

The Nature of Art

T hroughout history certain numbers and ratios in nature have been incorporated by artists into their creations. These numbers are picked up sometimes consciously, but usually unwittingly as subliminal messages from nature. The numbers of the Fibonacci series (1, 1, 2, 3, 5, 8 . . .) are often the same ones significant in genetics and in phyllotaxis (pertaining to arrangements of the veins on leaves, and the leaves and branches on plants). The ubiquitous ratio issuing from the series $\phi = 1.618\ 034 \ldots$ is approximated in altogether prosaic items—three-by-five index cards, playing cards, postcards,

and credit cards—and also the monumental: the architecture of Bramante and Le Corbusier, the music of Mozart and Bartók, the proportions of the paintings of Velázquez and Leonardo da Vinci. To reiterate, these numbers and ratios seem to be picked up subconsciously and incorporated into works of art inadvertently, as a product of the artist's aesthetic intuition. However, in other instances, as in the case of Leonardo, they are employed after experimentation and applied with full premeditation.

Among all of the artistic creations of the distant past two monumental edifices stand out for their use of "nature's numbers," associated with "dynamic symmetry," or the divine proportion. These are the Great Pyramid and the Parthenon, creations of a pair of great civilizations separated by two millennia.

The Pyramids of Egypt

I was five years old the first time I saw the pyramids in the valley of Giza, just outside Cairo. It was January 1946, not quite five months after the end of the war in the Pacific. My father, a young major in the Turkish army, had just been assigned as the assistant military attaché from Ankara to London. Before heading off to London, my mother, father, and I sailed from Istanbul to Alexandria, where we boarded a train bound for Cairo. In the Egyptian capital we were to make a stopover of a few days, then fly on to London, but the conclusion of the war created a logistic nightmare in Cairo, which became a bottleneck with tens of thousands of British soldiers waiting there for their trip home. What was to have been a few-day's stopover for us stretched out to two months. There was no room on flights bound for London and the only ships making the transit to England were troop carriers.

My first impression of the pyramids was of their immensity, rising endlessly into the sky. I remember well riding a camel around the base of the Great Pyramid, where a street photographer shot our

picture (Plate 3, upper right), and watching a *fellah* with great admiration scramble up to the top in exchange for the *baksheesh* that my father gave him. But the source of my abiding interest in Egyptology came about much later from discussions with Kurt Mendelssohn, a professor of physics at Oxford.

Mendelssohn was a specialist in cryogenics and medical physics, and by avocation, an Egyptologist.[2] A physics education has been described as a problem-solving degree. One learns to formulate questions, cull the best approaches in order to resolve the questions, and invoke the indispensable tool of mathematics. Although Mendelssohn was not a trained archaeologist, he was applying his considerable problem-solving skills to address issues in Egyptology, and this sort of cross-semination often bears original fruit. I found his views eminently compelling. Having revisited the pyramids and made some simple calculations for myself, I am convinced more than ever of their validity—notwithstanding the fact that they may be at variance with some of the standard explanations of Egyptologists, and most certainly with anyone who attributes divine or mystical properties to the shape.

A pseudoscientific theory that can be quickly eliminated is the claim that ancient Egyptian mariners sailed across the Atlantic and taught the Mesoamericans how to build pyramids. The first pyramids appearing in Central America were in Teotihuacán, near Mexico City, and date from the first century B.C. Several centuries later the Maya built pyramids in a number of city-states, including Tikal, Uxmal, Palenque, and Kabah. Several centuries later still the Toltecs built their pyramid, known as the Castillo, in Chichén Itzá. Finally, in the fourteenth and fifteenth centuries the Aztecs built a number of pyramids in their capital, Tenochtitlan, on the site of modern-day Mexico City. Pyramid building in Central America spanned fifteen hundred years. None of the structures even slightly resemble the Egyptian pyramids, and most importantly, the Egyptians

had long been out of the pyramid-building business by the time it was taken up in the New World.

"Pyramid power"—attributing special properties to the pyramid shape for preserving food, retarding aging, and maintaining the sharp edge on razor blades—has gained legitimacy as an element of popular culture. No scientific evidence exists to confirm such mysterious properties, and no physical principle can possibly confer any validity to such claims. Pyramid power belongs in the same family of pseudosciences as astrology, numerology, and palm reading, and no self-respecting scientist would accept its claims. Nonetheless, a number of remarkable mathematical relations exist in the Egyptian pyramids that *can* be supported by science.

"The pyramids of Egypt are immensely large, immensely ancient, and, by general consensus, immensely useless," so Mendelssohn liked to say.[3] They were built at the dawn of civilization, beginning about 4,700 years ago. So old are they that among Egyptians there is a common saying, "Man fears time, and time fears the pyramids." In all, there exist approximately fifty pyramids spanning a millennium, and most of them are quite unremarkable. The first seven, however, built in an astonishingly brief time of a little over a century are monumental. But they outnumber the pharaohs of the Third and Fourth Dynasties who reigned during that time, rendering unlikely the generally accepted view that the exclusive purpose of a pyramid was to serve as a burial tomb or mausoleum for a pharaoh.

For a century and a half after Egyptology was conceived in the late eighteenth century, the theories regarding the building of pyramids were based largely on the writings of the Greek historian Herodotus, who had visited in the fifth century B.C. and interviewed local inhabitants. These theories had posited that the pyramids were built by slave labor; that 100,000 slaves worked simultaneously on the Great Pyramid of Khufu (or Greek, Cheops); that a giant ramp had been built in order to elevate the stones to the

upper levels of the structure. When he wrote his *History* the pyramids were nearly as distant in time from Herodotus as Herodotus is from us. It is not difficult to see where he went wrong.

The maximum surface area of a pyramid would have been achieved just as the pyramid reached its completion. That area divided into a population of 100,000 would place approximately thirty workers in each five square feet of space along with the two-ton cubic stone that they were dragging up with them. (If only one-third of this number actually worked on the pyramid itself, that would put ten workers—plus the rock—on each five square feet of the surface.) Highly improbable! It is also highly improbable that a colossal mud-brick ramp was built in order to raise the stones. As the pyramid rose in place, the slope of the ramp would have to have been changed continuously. There would have been frequent occurrences of workers falling off the edges of the ramp. Indeed the edges themselves would have caved in frequently from the traffic, and the volume of the ramp would have to have been greater than the pyramid itself. This is simply not a cost-effective technique.

An alternative theory that makes more sense is to have a set of four mud-brick ramps, coiled around the pyramid, and rising as the pyramid itself takes shape within the square-cornered helical structure. Each ramp would start from one corner of the base, and together with the other three, spiral upward in the same direction. Three of the ramps could have been used for the workers to haul up the stones and the fourth for the workers to descend with their equipment. After the completion of the pyramid the coiling ramps would have been removed, leaving a polished limestone surface with no trace of the scaffolding. That this may have been the best method certainly does not guarantee that it was the one employed. The builders, although lacking modern technological devices, were no less clever than modern engineers and architects.

Finally, it is also unlikely that the pyramids were built with slave labor. It may have required as many as 20,000 soldiers to keep

100,000 slaves in line. And who was to feed this mass of people? Fortunately, a number of clues exist to resolve the critical issues of who built the pyramids and why, and the lesser question of the number of workers required. Until the emergence of the dynastic system around 3000 B.C., a jumble of tribes occupied Upper and Lower Egypt, making invasions and threats of invasion common. The trend toward unification began with the dynastic system, but was not fully achieved until around 2650 B.C. with the reign of Djoser (2668–2649 B.C.), the second pharaoh of the Third Dynasty.

THE FIRST SCIENTIST:
THE ARCHITECT OF CIVILIZATION

When kings of the First and Second Dynasties died, they were buried in tombs located below *mastabas,* one-story slab-like buildings. These monoliths, characteristically rising with a slope of 3:1 (3 parts rise to 1 part run), were not especially difficult for grave robbers to penetrate. Then suddenly with the reign of Djoser the unification of Upper and Lower Egypt was complete. A powerful army was formed; the sun god Ra became overwhelmingly prominent, and pyramids became the preferred burial tombs for pharaohs. What better way to worship the sun god than by building a man-made mountain in the form of a sunburst effect—a pyramid. The farmers, working seasonally (according to the rise and fall of the flooding Nile), might have been encouraged to come to work on the pyramid project as a way of buying indulgence for the afterlife, the next life being far more important than this ephemeral one. Thus, rather than a reviled project of slave labor, a pyramid would have been a public works project, a labor of devotion. This could all be a stretch, but the improbable ideas of the 100,000 laborers, 20,000 guards, and the need to feed them all, makes this stretch a little less unappealing. In the last decade of the twentieth century, the eminent Egyptologist Zahi Hawass reported the discovery of workers' houses near the base of the pyramids, replete with accoutrements

of ordinary subjects, pointing to the validity of Mendelssohn's hypothesis of free men being employed on the project. Hawass estimates that 20,000 workers were employed on the Great Pyramid at any given time, and that they worked for about two months before returning to their villages, when another group of 20,000 took their place.

Can anyone really be identified as the first scientist, or deserve the accolade "architect of civilization?" In fact it is not difficult to make a case for a legendary character by the name of Imhotep being accorded both of these astounding mantles. Djoser's step pyramid in Saqqara was the first ever built, and the architect of the project was known to have been Djoser's chief vizier, Imhotep, a medical sage, astronomer, mathematician, and architect. Imhotep came to be revered as a god of healing and was in time identified by the Greeks with their own Asklepios. Isaac Asimov in his biographies of scientists singled out Imhotep as the very first, and added: "there was not to be another for over two thousand years."[4] Moreover, if the hypothesis is valid that the building of the first pyramid served as the catalyst for the unification of Egypt, and if the project was masterminded as a public works project by one man—Imhotep—then he is indeed deserving of those honorifics.

The step pyramid, rising to a height of two hundred feet—comparable to a twenty-story building—is not a true pyramid, rather it resembles a set of six mastabas, gradually decreasing in footprint and height, stacked one on top of the other. In its internal structure, however, there is most likely a tower rising with a slope of 3:1, buttressed by the series of mastaba-like steps, each rising with the same slope. Without dismantling the pyramid it would be impossible to confirm this, but a clue is offered by the second pyramid, built in Maydum, thirty-five miles south of Saqqara, and otherwise known as the "collapsed pyramid" (Plate 3, upper left). This failed structure had initially been designed as a step pyramid modeled after Djoser's. The lowest two courses are still present, and these reveal a finished

surface, suggesting that it was not until the pyramid's completion as a step pyramid that the builders returned to modify it, indeed, to convert it into a true pyramid. The rubble of the collapsed structure presents a silhouette very much resembling a colossal chocolate kiss. The desired angle of slope of the "true pyramid" was 52°, a point that will gain significance later on. A number of factors conspired to bring about the rockslide of the collapsed pyramid: the angle at which the additional blocks were stacked; the polished surfaces of the finished steps failing to give these blocks sufficient adhesion; the relatively small size of the blocks, and the fact that the blocks were not adequately squared or precisely fitted.[5] For a pyramid the size of the collapsed pyramid, composed of limestone, the pressure on stones at the base would be of the order of 50 kg/cm² (710 lbs./sq. in.) if the stones were precisely squared. And the pressure at the base would be around 1,000 kg/cm² (over 14,000 lbs./sq. in.) on the protruding edges if the stones were *not* precisely squared. Whereas limestone can withstand 50 kg/cm² pressure, it would crumble when subjected to 1,000 kg/cm². Candy makers have long known that a cone-shaped chocolate candy, when placed on a baking sheet and heated, assumes the shape of a chocolate kiss as a result of *plastic flow*. And it is the classic effect of plastic flow that the collapsed pyramid displays. Moreover, the collapse would have occurred so quickly that the workers on its surface would not have had time to escape to safety. Mendelssohn suggests that a systematic excavation of the rubble surrounding the exposed tower, the core, may well uncover a large number of buried skeletons still preserved by the dry climate.

At Dashur, not far away, the building of a third pyramid had commenced even before the completion of the pyramid at Maydum. The initial plan evidently was to make it a true pyramid with slopes of 52°. Then mysteriously midway up the sides the slope was changed to 43.5°. The prevailing theory in Egyptology is that the king for whom the pyramid had been designated passed away prematurely, and the builders decided to truncate the building to save

time. But a calculation reveals that the time saved in the process—based on the stone saved—is merely 10 percent. More likely, as Mendelssohn suggests, it was the sudden catastrophic collapse of the pyramid in Maydum that triggered the builders' desperate modification of their own pyramid. Because of its double-angle the edifice is known as the bent pyramid. As it is, the pyramid is well over 300 feet high, or higher than a thirty-story building. If the lower surfaces, rising at 52°, were to be extrapolated, however, they would meet at a point well above 400 feet, and put this pyramid into the same class of colossal pyramids as the Khafre (or the Greek, Chephren) and the Great Pyramid of Khufu in the valley of Giza.

The fourth pyramid, built also in Dashur, was again a true pyramid and had the field-tested, safe angle of 43.5° for its surfaces. This is the red pyramid, the name derived from the reddish stone used as facing on its surfaces, and is associated with the pharaoh Snefru, father of Khufu, and grandfather of Khafre. This pyramid has a height of over 300 feet, comparable to that of the bent pyramid.

Then in the valley of Giza the fifth and sixth pyramids— Khufu and Khafre—were built, climbing majestically at 52° to elevations comparable to fifty-story buildings. And finally, a seventh pyramid, Menkaure, a relative runt at twenty-five stories tall, was built in the same valley. In 1995 members of the David H. Koch Pyramids Radiocarbon Project undertook a definitive program to date the pyramids. They collected tiny bits of organic material embedded in the gypsum used for mortar in the pyramids and tested them for their carbon-14 (C^{14}) activity rates. (The half-life of C^{14} is 5,715 years, which means that in 5,715 years only half of the original activity will remain in the sample.) The building of the entire complex at Giza was determined to have lasted eighty-five years, from 2589 to 2504 B.C.[6] This marks the highest development of Egyptian pyramid building.

A dramatic decline followed this flurry of activity. And although pyramids continued to be built for another 1,500 years, they were

all vastly overshadowed by the first seven, especially numbers five and six. Indeed, by the end of the Fourth Dynasty the Egyptians were essentially out of the pyramid building business.

By the mid-twentieth century aerial photography offered archaeologists a bird's-eye view of the topography of the land and the opportunity to visualize the pattern at the site of human settlement—in the same sense that a person examining an oriental carpet from a normal standing view has a considerable advantage in appreciating the pattern of the carpet than someone examining one tiny portion of it. A little later aerial infrared photography provided additional capabilities. Materials possessing different heat capacities cool off at different rates. Since rocks cool off faster (and emit infrared radiation with greater intensity) than the surrounding earth, infrared photographs can reveal buried foundation walls even where the overlying ground is perfectly smooth. A substantial step beyond aerial photography is offered by remote sensing—satellites that provide much larger areas to view and much wider ranges of the electromagnetic spectrum. Exploration of natural resources and investigation of ecological concerns have been the greatest benefactors of this technology. Along with successes in establishing the geomorphology of various sites, hitherto unsuspected ruins have been discovered. Lying deep below shifting sand dunes in Saudi Arabia the ruins of the fabled lands of frankincense and myrrh were discovered by NASA in the early 1990s.

A conjecture was presented earlier in this chapter that it might have been the sunburst effect that inspired the shape of the pyramid—a man-made mountain for the pharaoh to ascend to the sun god. In a recent paper geologist Farouk El-Baz, a specialist in remote sensing technology, offered an alternative conjecture, but also one inspired by nature.[7] Remote sensing technology had revealed below the obscuring layers of sand in the eastern Sahara the existence of dried riverbeds, meandering in wide swaths. This was offered by El-Baz as evidence of vastly different climatic conditions in the

distant past, and archaeological excavations of the area have turned up sites of human settlement. Catastrophic drought in lands west of the Nile took place around 5,000 years ago and forced the migration eastward of the nomadic inhabitants. According to El Baz's theory it is the cultural melding of desert people and the pioneer farmers of the Nile valley that ultimately catalyzed the unification of Upper and Lower Egypt. The memory the nomads brought with them of the eastern Sahara may have served six or eight generations later as the inspiration for pyramids, and even the Sphinx. Natural formations created by the action of water and wind, the latter in a well-defined north-to-south direction, may have created the models that served the generation of pyramid builders.

THE SYMMETRIES IN THE PYRAMIDS AND THE GOLDEN PYRAMID

Earlier we saw that King Djoser's step pyramid comprised six mastabas stacked on top of one another, each rising at a 3:1 slope (or an angle of 72°). That slope appeared again in the core of the collapsed pyramid, and it was speculated that most likely a tower of the same slope was embedded in the structure of the step pyramid. Extrapolating the sides of the tower creates the "golden triangle"—the isosceles triangle with the angles 36°—72°—72° (Plate 3, upper left). Had Imhotep, the mastermind behind the step pyramid, recognized the golden triangle? Most likely not. He simply knew from the design of mastabas that a slope of "three parts rise to one part run" was a safe angle, and a healthy design to incorporate into his design.

The second pyramid to be built—the collapsed pyramid—was initially completed as a step pyramid with 72° slopes, but then a drastic modification was applied in an attempt to convert it by way of a casing into a true pyramid. The angle chosen for this casing was 52°. Though the pyramid collapsed due to fatal design faults discussed earlier, that 52° angle has a special significance. If a circle were to be laid out using a prescribed radius the circumference

would of course be 2π times the radius. If that circle is formed into a square so that the circumference of the original circle and the perimeter of the square are exactly the same, the sides of a pyramid constructed on that base, with a height equal to the radius of the original circle, would have a slope of 52°. The simplicity of that scheme may have been the inspiration in the choice of the angle, or it may have had some magical connotations. We do not know.

In the bent pyramid the lower portion of the pyramid was built at 52°, but midway up, the angle was changed to 43.5°. Following Mendelsohn's conjecture, the builders in desperation changed the angle to stave off the collapse of the structure, having just witnessed the collapse of pyramid two. The ratio of the perimeter-to-height of a 43.5° pyramid happens to be 3π, lightening the load and again suggesting a preoccupation with π. The fourth pyramid in the series, the red pyramid, was also built at the safe angle of 43.5°. The bent and red pyramids have survived the better part of 5,000 years.

In the case of the Khufu the parameters are well known: 230 meters (or 500 cubits) on each of four sides, and a height of 146.4 meters originally (which has since been reduced to 137 meters by erosion or clandestine quarry activity). The ratio of the full perimeter 4×230 meters = 920 meters divided by the 146.4-meter height is 2π. The stones or blocks used are much larger than those used in the earlier pyramids (of the order of 1 meter on an edge) and very precisely shaped. In building the pyramid a circle with a circumference of 4×230 meters (or 920 meters) was laid out using rope. The circle was then physically "squared" by teams of laborers tugging at diametrically opposite points on the rope, achieving the required right angles at the corners by making sure that the diagonals were precisely the same length.

For the original measurements, the ratio of one edge of the base to altitude is 1.57, fairly close to the golden ratio of 1.62, and if one were to inscribe the Khufu in a golden rectangle, the tip of the pyramid would stick out only slightly. More importantly, focusing on

just the triangular shape of one face, the ratio of the altitude of a face to one-half the length of the base is exactly 1.62. But what is far more intriguing is a computation involving the areas of the facades and the base, first recognized by the mathematician and astronomer Johannes Kepler (1571–1630). The base has an area $\Psi = 52,900$ m², the four sides have a combined area $\Delta = 85,647$ m². These values can be related as follows:

$$\frac{\Delta + \Psi}{\Delta} = \frac{\Delta}{\Psi} = \phi \; (= 1.618...)$$

This is a restatement of the law of divine proportion.

The unexplained question here is one of a "chicken and egg." What came first for the ancient Egyptian architects who designed the pyramids at Giza? Were they attempting to build imposing structures whose surface areas satisfied the relationship described above? Did they wish even before the first stone was laid in place for the final product to relate in some way to the divine proportion? Did they know that for a pyramid shape to reveal the law of divine proportion its edges must rise at an angle of 52° (Plate 3, center left)? In other words, were they fully aware of the implications of their design? Did they know what they had accomplished in this regard? The answer to all these questions is, "probably not." Most likely the builders simply wanted to have the height of their pyramid defined by the radius of a circle the circumference of which equaled the perimeter of the pyramid. It was fortuitous that such a pyramid would also exhibit the properties of divine proportion. Whether these precise symmetries are intentional or accidental, we are justified in describing the Khufu and Khafre as golden pyramids.

The Divine Proportion in Antiquity: Classical Greece

The Greek army in 479 B.C. defeated the Persians at Plataea, ush-

ering in a period of peace and prosperity, the Golden Age of Greece. The period saw an unprecedented explosion in artistic creativity that included the development of the Athenian Acropolis in honor of the city's namesake and patron goddess Athena. In 447 B.C. work on the temples astride that massive stone outcropping commenced. Fifteen years later in 432 B.C. the Parthenon was completed, although work on the other buildings continued for another thirty-five years. By any measure the Parthenon is the most sublime of all extrovert buildings ever built. Although the Greeks could make arches by fitting together wedge-shaped stones, they had not extended the idea into spanning large spaces by making domes of such stones. That would await the Romans with their Pantheon in the first century A.D. Hence the interior of the Parthenon, busy with columns to support wooden beams and a heavy roof, was anything but commodious, anything but introverted.

Collaborating on the design of the Parthenon were Athens's premier sculptor-architect Phidias and the architects Callicrates and Ictinus. The columns—fluted shafts topped with capitals of the Doric order—supported a pediment with Phidias's sculpture, carved as no stone had ever been carved before. The friezes consist of ninety-two metopes in low relief alternating with vertically fluted triglyphs. The sculpture in the pediment, depicting the Olympians after their victory over their dreaded enemies, the Titans, is meant to be emblematic of the victory of civilization over barbarism. The east and west facades of the Parthenon both form golden rectangles, or exhibit length-to-width ratios of ϕ. As for the assignment of the symbol ϕ to the golden ratio, this is an entirely modern development. It was early in twentieth century that American mathematician Mark Barr first denoted the golden ratio by Phidias's monogram.

The architects introduced several imaginative measures to eliminate unfavorable optical illusions. For example, a perfectly straight horizontal line would normally appear to sag in the middle, because

it would naturally be sighted against the horizon, which itself has a convex curvature; columns which are cylindrical would appear to be concave midway up. In order to counter these effects, the Parthenon was built on a convex base of a 5.7-kilometer (3.5-mile) radius of curvature. Columns rising perpendicular to a convex curvature, however, would diverge slightly at their tops, an effect that would be barely visible, but a source of subtle discomfort. In order to avoid a splayed appearance the columns were aimed or sighted to converge at a common point approximately 2.4 kilometers (1.5 miles) in the sky. The midsections of the columns incorporated a slight bulge, *entasis*, negating the optical illusion in the other direction. How they arrived at these happy numbers is a mystery, but the scheme clearly works! Finally, they used fluted columns, grooved vertically, as opposed to plain cylindrical columns, which would have appeared lumbering and heavy.

It is the confluence of all of these elements—the artificial constructs to correct for detracting optical illusions, unerring proportions, the majestic perch atop the Acropolis, and Phidias's immortal sculpture—all working in concert to render the edifice the epitome of classical Greek architecture. As for Phidias's carvings that once adorned the pediment and were painted in vivid colors, only a scant few remain on site. Virtually the entire original assembly was carted off to the British Museum by Lord Elgin early in the nineteenth century. The pediment in its present state offers little clue to the original beauty of the edifice. A scale model of the original carvings, however, is on display in the small museum atop the Acropolis, offering a glimpse into the Parthenon's original magnificence (Plate 3, bottom).

On a personal note, I have been to the Parthenon many times. On one occasion I was there with a friend, an academic dean.[8] At the end of the day, when we were just about to leave the site he bent over, pretending to tie his shoe laces, and picked up a loose stone as a souvenir. Clearly nervous, he confided to me his utter terror of

being discovered in stealing a piece of the hallowed edifice, "Who knows what part of the building it came from?" he mused in a whisper. But just then a large truck appeared and dumped tons of stones for tourists visiting on the next day.

Although only a single column remains of the Artemisium (temple of Artemis, or Diana for the Romans) in Ephesus, it is believed that some of the same proportions with which its builders imbued the Parthenon were also featured in the Artemisium. This Artemisium was considerably larger than the Parthenon in all of its dimensions and ranked as one of the Seven Wonders of the Ancient World, a distinction not bestowed on the Parthenon. In a painful tragedy of history a madman burned down the Artemisium in the same year that Alexander the Great was born in Macedonia. The reason the arsonist, Herostratos, gave for his deed: he wanted his name to be remembered in perpetuity. In the meandering path that he took with his armies through Asia Minor, Alexander stopped over the site and founded a new Ephesus a few kilometers away. It is the ruins of that magnificent city founded by Alexander that tourists see on their visits to Ephesus now.

That nature inspires the designs of artists and architects is inarguable. Columns and capitals are another case in point. Technically a column consists of the vertical shaft, the *stem* topped by a block, the *capital*. The Egyptians usually employed cylindrical columns with capitals modeled after flowers and pods of lotus and papyrus plants, displayed nowhere with more drama than in Luxor and Karnak. In Knossos on the island of Crete the columns are evocative of the trunks of trees, inverted so that the upper parts of the column display a widened, flange-like appearance. The capitals of the Parthenon's columns were in the Doric order, consisting of plain slabs, but two other types of capitals employed by the Greeks—the Ionic and the Corinthian—most certainly reflected patterns in nature. Capitals in the Corinthian order, the most

decorative of the lot, were embellished with acanthus leaves, and became favored by the Romans. The swirling shape of the chambered nautilus, incorporating the logarithmic spiral into the capital design, inspired the Ionic order.

Greco-Roman Sculpture

The artists of classical antiquity incorporated the divine proportion into a variety of objects, ranging from vases to eating utensils, from paintings to statuary. To the sculptors of classical Greece and Rome the divine proportion was recognized as ideal for the human anatomy: the length of the fingers to the hand, the hand to the forearm, the forearm to the full arm, etc. Among these proportions there is the ratio of one's height to the height of one's navel. In the statue of Venus de Milo (second century B.C.) the ratio of the height to the height-of-navel is close to ϕ. This can be effectively dramatized by inscribing the subject in a golden rectangle and constructing a square in the lower portion of the rectangle. The upper edge of the square will then be seen to pass very close to the navel. The interested reader could make similar observations in numerous other classical masterworks, including *Aphrodite, Eros, and Pan* (c. 100 B.C.), *Hermes and the Infant Dionysus* (c. 340 B.C.), and the father with his two sons in the *Laocoön* (first century A.D.). In that last work it is necessary to "straighten" the three figures into upright positions digitally, or employ the low-tech method of measuring the subjects in the statue directly with a pliable tailor's tape measure. Locked in mortal combat with a number of serpents coiled around them, all three figures are slightly hunched over in anguish and stress, their navels approximately 0.618 of their heights.

I recently put the hypothesis of ϕ being the ratio of one's height to the height of one's navel to the test with a group of twenty-one

university students, ten male, eleven female. The point of the exercise ostensibly was to demonstrate the statistical analysis of data, by computing averages, uncertainties, and standard deviations. In reality such a small group cannot yield meaningful statistics. Nonetheless, it was a blind test, and for the record, the results for the average and standard deviation measurements were 1.618 ± 0.04.

Any discussion of the ancient Greeks in the context of the divine proportion would be incomplete if it did not include mention of Yale University art historian Jay Hambidge. Professor Hambidge started in the 1920s to publish an exhaustive series of analyses of the Hellenistic vase. He found many of the vases he examined to be conducive to analyses in terms of the golden ratio. It was his work, rather than that of anyone else in modern times, that rekindled interest in dynamic symmetry and divine proportion in general.[9]

Mathematical Mosaics, Polygons, and Polyhedra

A figure in two dimensions has two types of symmetry. It has *line symmetry* if a line can be drawn through it so that each point on one side of the line has a matching point on the opposite side at the same perpendicular distance from the line. An equilateral triangle possesses three-fold line symmetry; a square, four-fold line symmetry; a regular polygon of n sides, n-fold line symmetry. Finally, a circle has infinite-fold line symmetry.

In discussing point symmetries in this short technical interlude, we begin by introducing a convenient unit for measuring angles: the *radian*, where π-radians corresponds to 180°. A figure has *point symmetry* if it can be rotated about a point so that it replicates its original shape (but specifically excluded is the trivial case of rotation by 2π radians (360°), thus a full turn. An equilateral triangle can be rotated

about a point at its center by $2\pi/3$ radians (120°) and by $4\pi/3$ radians (240°) in fulfilling the condition above. A square can be rotated through a point at its center by multiples of 90° ($2\pi/4$, $4\pi/4$ and $6\pi/4$ radians) in order to replicate the original picture. A regular polygon of n sides should possess *(n-1)-fold* point symmetry, with rotations by $2\pi/n$, $4\pi/n$, $6\pi/n$, ... $2(n-1)$ π/n radians, all recreating the original shape.

The expression *mathematical mosaics* refers to configurations of regular polygons which completely cover a surface so that an equal number of polygons of each kind are arranged around a regular array of points called *lattice points*, defining the vertices of the polygons. In practical terms, if a surface is to be covered by the same kind of regular polygon, the possibilities turn out to be limited: equilateral triangles, squares, and hexagons are the only figures that can form a homogeneous pattern of tiling. If the idea is extended to three dimensions, *optimization*—in this instance, minimization of material for construction of walls with an attendant maximization of the internal volume—is achieved by hexagonal tiling. Meanwhile the construction also produces unusual structural strength against compression. Such are the results of applying calculus to a geometric and engineering problem. But long before mathematicians recognized hexagons as viable shapes for flat space tiling, nature had made the discovery. Bees were constructing their honeycombs in this pattern, presumably having made the calculation intuitively!

Meanwhile, pentagons, requiring rotations by $2\pi/5$ *radians* to replicate themselves, cannot tile a flat surface by themselves. The resulting pattern displays rhombus-shaped gaps. Seven-sided regular polygons, heptagons, requiring rotations by $2\pi/7$ radians, would not be able to form a flat mosaic pattern, since adding new heptagons would result in overlapping rhombus-shaped areas. Similarly it would be impossible to tile with octagons (eight-sided regular polygons) or with decagons (ten-sided regular polygons).

Combinations of regular polygons or an unlimited number of irregular polygons can all be used for tiling, for example, paral-

lelograms, isosceles triangles, and so on. A common pattern of tiling is seen in the combination of octagons and squares in a periodic array.

Penrose Tiling

In the late 1970s an intriguing mathematical tiling pattern emerged from the drafting board of the Oxford mathematical physicist Roger Penrose. In his pattern two types of rhombuses— "skinny rhombuses" with interior angles 36° and 144° and "fat rhombuses" with the angles 72° and 108°—are assembled in the aperiodic pattern that is the heart of Penrose tiling. The skinny rhombus, bisected, would yield a pair of isosceles triangles with angles 72°—36°—72°, the golden triangle. Thus it should be no surprise that on an infinite plane the ratio of the number of fat rhombuses to the number of skinny rhombuses is the golden ratio ϕ (= 1.618 034 . . .), the irrational number generated from the Fibonacci series.

Beyond the regular polygon used in mathematical tiling are a virtually unlimited number of abstract shapes, all understood in terms of symmetry operations allowed on a flat surface. The Moors in Northern Africa and Spain, the Selçuk and Ottoman Turks in the Middle East, and the Persians raised two-dimensional abstract design and calligraphy to a level of extraordinary sophistication and beauty. The Moors adorned their special buildings with patterns revealing tacit understanding of space symmetry concepts, epitomized in the tiles of the Alhambra Palace in Granada and the Great Mosque in Córdoba.

During the Islamic Mughal rule in north central India, Shāh Jahān created an architectural masterpiece for the ages in the Taj Mahal, a mausoleum for his favorite wife, Mumtāz Mahal. Constructed wholly of white marble, the seventeenth-century edifice raises calligraphy and mathematical mosaics to a peerless art form.

Typically seen among the carved marble window traceries are aperiodic patterns of six-pointed stars, regular hexagons, and stylized tulips in two different sizes.

M. C. Escher

The twentieth-century Dutch crystallographer Maurits Cornelis Escher (1898–1972), intrigued by graphics techniques, employed symmetry operations in generating inexhaustible patterns of realistic (and sometimes mythical) figures in his graphic artwork. Some of his graphics consisted of flattened images, others incorporated perspective—stairs and lattice structures, knots, and Möbius strips. Escher often challenged the viewer with the liberties he took with one-point, two-point, three-point, and even four-point perspective, for example, ascending staircases that transform mysteriously into descending staircases. Unencumbered by religious interdicts such as the ones imposed on Islamic artists (forbidding the depiction of humans and animals), Escher utilized these figures with abandon in his symmetric musings. Dark horsemen facing the right are interposed between light horsemen facing the left. The symmetry operations that leave the pattern invariant are simple translation in vertical and horizontal directions plus reflection. In the reflection process the shading of the horsemen is also interchanged.

Earlier we saw that the different types of regular polygons that could create a homogeneous mosaic were only three in number. However, *irregular* mosaics, consisting of different regular polygons, are unlimited in number. Escher played off the same symmetry operations that characterize mathematical mosaics and created enticing, albeit simple, graphics. In light of his early training as a crystallographer, it is understandable that his art would often incorporate scientific themes. Later, in Chapter 7, we will take a closer look at one of Escher's creations.

More immediately, however, we shall examine three-dimensional bodies—regular and semiregular polyhedra—and their underlying symmetries.

Regular Polyhedra

The *regular polyhedron* is defined as a three-dimensional solid comprising regular polygons for its surfaces—and with all its surfaces, edges and vertices identical. The regular polyhedra are the four-sided tetrahedron, the six-sided cube, the eight-sided octahedron, the twelve-sided dodecahedron, and the twenty-sided icosahedron (Figure 5.1). There are only five types, a happenstance that Lewis Carroll described as "provokingly few in number." Although all five types had been identified by Pythagoras two hundred years before Plato was born, they are nonetheless collectively known as *platonic solids,* named in honor of Plato by the geometer Euclid.

For the ancient Greeks all material in nature was composed of only four elements—earth, fire, air, and water—taken in different admixtures. Atoms of fire had tetragonal shape; atoms of earth, cubic; atoms of air, octahedral; and those of water, icosahedral. The number of regular polyhedra, however, clearly outnumbered by one the number of recognized elements. To the Pythagoreans, the fifth polyhedron had monumental significance. An *omerta,* or a code of silence, was imposed regarding the dodecahedron, divulging its secret meaning—the shape of the universe—to outsiders could earn a traitor the death penalty! The Pythagorean Academy was located in Crotone, on the sole of the Italian boot. Founded by Pythagoras about the sixth century B.C., the fields of academic interest were mathematics, natural philosophy, and music. Mysticism and numerology, however, seem to have characterized the underlying philosophy of the Pythagoreans, a cult in the modern sense.

Figure 5.1. Regular and semi-regular polyhedra and the golden pyramid:
(A) tetrahedron, four sides; (B) cube, six sides; (C) octahedron, eight
sides; (D) dodecahedron, twelve sides; (E) icosahedron, twenty sides.
(F) Fifteen golden rectangles span the interior of the icosahedron (only
three of which are seen here); (G) the icosidododecahedron; (H) the
truncated icosahedron, or an icosahedron with its vertices clipped; (I)
the geodesate, or a tessellated dodecahedron, closely resembles
Buckminster Fuller's geodesic dome; (J) the stellated dodecahedron;
(K) the stellated icosahedron; (L) the golden pyramid

Intuitively it is quite easy to see how there can be only five platonic solids. The plane figure with least number of sides is the triangle. The smallest number of triangles around a point in three dimensions is three. Also, four and five triangles form polyhedra, but six tile the plane. Thus only three, four, and five can form polyhedra. With squares, three around a point form a cube, but four tile the plane. With pentagons, again only three is possible, with four going beyond the plane. Accordingly, three, four, and five triangles; three squares; and three pentagons are all that fit around a single point in three-dimensional space.

In the early seventeenth century Johannes Kepler, German-born mathematician and assistant to the Danish astronomer Tycho Brahe, succeeded in formulating the three laws of planetary motion. Before actually getting his hands on Tycho's observational data and undertaking the massive computational effort which ultimately lead to these laws, however, he ruminated on the peculiar pattern of spacing between the planets. Among a number of mathematical schemes that he considered was the notion of using the five regular polyhedra as the spacers, and the task as he saw it was to identify the order in which they were to be employed (Figure 5.2).

Salvador Dali's Last Supper

An intriguing encounter with the dodecahedron takes place in Salvador Dali's *Sacrament of the Last Supper*. In the painting in the National Gallery of Art in Washington, the Twelve Apostles, heads bowed, are seen flanking the figure of Christ. In the background is the setting sun, and on the tabletop, the shadows cast by the apostles, the piece of bread, and the glass of wine. The figure of Christ, somewhere between transparent and translucent, casts no shadow. At the top of the scene of Dali's *Last Supper* are the sheltering and protective arms of God, face unseen. But just below God's arms, and framing the scene,

Figure 5.2. Johannes Kepler's geometric construction employing the five regular polyhedra as "spacers" between the orbits of the known planets (Courtesy History of Science Collections, University of Oklahoma, Norman)

is the unmistakable shape of a dodecahedron. The painting possesses almost perfect bilateral symmetry, one side mirroring the other. The positions of Christ's arms are not symmetrical, nor is the configuration of the islands in the background (a view thought to be from Dali's house in Catalonia). The painting reflects some of the artist's experiences from the late 1930s and 1940s. Dali, like many other artists and intellectuals of the time, including Picasso, sided strongly against the fascists in the Spanish Civil War. During this time he was profoundly influenced by a meeting with the elderly Sigmund Freud. After a period of agnosticism he returned to Christianity and abandoned the

themes of anarchy in his art. Finally he found inspiration in examining anew Renaissance art of the early sixteenth century.

Dali's *Last Supper* exudes a dreamlike quality (a clear influence of Freudian psychology) and a classical perspective (the influence of the Italian Renaissance and, especially, Leonardo da Vinci's *Last Supper*). Dali, a superb technician with a brush, created this surrealistic work in 1955. It is pleasantly puzzling. In both works Jesus Christ is backlit—in Leonardo's mural, by a window immediately behind him, and in Dali's painting, by the setting sun. Of course, Dali's *Last Supper* does not begin to approach the psychological drama and power captured in Leonardo's *Last Supper* (which we will look at in more detail in Chapter 9). Regarding the dodecahedron incorporated in the composition, Dali explained: "I wanted to materialize the maximum of luminous and Pythagorean instantaneousness, based on the celestial Communion of the number twelve: twelve hours of the day—twelve months of the year—the twelve pentagons of the dodecahedron—twelve signs of the zodiac around the sun—the twelve Apostles around Christ."

The ratio of the painting's length to width is 1.603, close to the golden ratio $\phi = 1.618$. Whether this choice of proportion was a conscious attempt to employ that classical ratio, a product of his intuitive artistic sensibilities, or a simple coincidence, he did not explain. But it would not be wild speculation to presume that Dali—a numerologist with a deep mystical bent—would have been euphoric had he known that he had unwittingly incorporated in his painting the Pythagorean Academy's closely guarded secret—the dodecahedron—emblematic of the universe.[10] It is unlikely that he knew about the significance, for he would have mentioned it in his explanation of the painting.

Semi-Regular Polyhedra

By mixing a variety of regular polygons, while adhering to the

requirement that at all vertices the arrangement of polygons is the same, one obtains the solid figures called *semiregular polyhedra*. For example, the icosahedron with twenty equilateral triangles, in having its vertices cropped, becomes a truncated icosahedron, a figure characterized by two hexagons and one pentagon at each vertex. The modern soccer ball is a truncated icosahedron, usually with the hexagonal leather patches dyed white and the pentagonal patches, black.

Another semiregular shape, the cuboctahedron, has fourteen faces—eight equilateral triangles and six squares—each vertex surrounded by the sequence of a triangle, a square, a second triangle, and a second square (classified by the scheme 3-4-3-4). Here a physical significance is to be found: the arrangement offers the model for close-packing of identical spheres in space, which is of considerable interest in crystallography. In the following section the classification of crystal structure will be presented within a more general topic about patterns in nature.

A subtle connection exists between the icosahedron and the golden rectangle. Close examination of this polyhedron, supporting twenty triangular sides and thirty edges, reveals the existence of golden rectangles spanning opposite pairs of edges. Each pair of diametrically opposite edges forms two shorter sides of a golden rectangle, and since there exist thirty edges on an icosahedron, there must exist a total of fifteen embedded golden rectangles in all. The relationship between numbers of vertices, faces, and edges for any convex polyhedron—regular or irregular—was given by the great Swiss mathematician Leonard Euler (1707–1783): the number of vertices plus the number of faces equals the number of edges plus 2.

There also exist classes of solid objects that are neither regular nor semiregular, but are familiar to most individuals, for example, pyramids (triangular sides with a variety of polygonal bases), prisms (cylindrical shapes with a variety of polygonal cross-

sections), the frustum (a cone with its pinnacle truncated parallel to its base). The tetrahedron encountered earlier is a pyramid with a triangular base. Certainly the most familiar of pyramids is the square-based pyramid employed by the ancient Egyptians and discussed at length earlier in this chapter. As the number of sides of the base increases, the resulting figures become the pentagonal pyramid, hexagonal pyramid, and so on—indeed, in the limit when the number of sides reaches infinity, the pyramid transforms to the familiar cone. In this context one special square-based pyramid discussed earlier was the pyramid whose base perimeter exactly equals 2π times the height of the pyramid itself. The condition, of course, created the pyramid rising at 52° and incorporating the divine proportion. (Recall this relationship was displayed in the Khufu and the Khafre pyramids.)

Most individuals can readily visualize the simpler regular polyhedra, such as the cube and the tetrahedron, and even the octahedron. The more complicated of the regular polyhedra (the dodecahedron and the icosahedron) and semiregular polyhedra (the truncated dodecahedron and the truncated icosahedron) require considerably more cogitation. Here mentally rotating the body around various axes may be required in order to examine the underlying symmetry. But at the beginning of the twenty-first century, it is more convenient to write equations and computer code and have a high-speed computer draw the polyhedra. In the stellated dodecahedron there exist pentagonal pyramids protruding from each of the twelve surfaces, and in the the stellated icosahedron, triangular pyramids or tetrahedra protrude from each of the twenty triangular faces. Finally, in the dodecahedral geodesate, the surfaces of a dodecahedron are tessellated onto the surface of a circumscribed sphere. This is the geodesic sphere of Buckminster Fuller (1885–1983), patented in 1954. The best-known dome built in this style is the sixty-five meter (200 foot) high dome at the United States Pavilion in Expo '67 in Montreal. An

inner layer of hexagonal elements are connected to triangular elements on the outside, and those, in turn, are overlaid by a transparent plastic skin.

Designs by Leonardo

Dispersed among Leonardo da Vinci's manuscripts, along with drawings, notes, doodles, and computations, are also a variety of polyhedral creations, products of what Leonardo called his "geometric recreation." With possibilities for endless variation, these regular and semiregular polyhedra seem to have been a source of fascination for him. Leonardo was born at approximately the same time as Johannes Gutenberg's publication of the first book in movable type in Europe—the Bible—and participated in the publication of only one book, *De divina proportione* (Venice, 1509). *De divina proportione* was the product of collaboration between Leonardo, the Franciscan priest and mathematician Fra Luca Pacioli, and the artist Piero della Francesca, although inexplicably it is Pacioli who appears as the sole author. In addition to explanatory text, the book offers sixty illustrations—including a variety of polyhedra and the design of the letters for a new font (Vitruvian letters). There is also one drawing that examines the proportions of the human face seen in profile. An equilateral triangle has been constructed with a vertex located at the base of the skull. The original drawings for the book are housed in the Biblioteca Ambrosiana in Milan (Figure 5.3).

The "official" author of *De divina proportione*, Pacioli, was a talented mathematician who is held in reverence in the field of accounting as the patriarch of the double-entry bookkeeping system. He had introduced the system in a treatise on mathematics in 1494, giving credit to "Leonardo of Pisa" (Fibonacci), who had introduced it three hundred years earlier in his *Summa*. Contemporary Islamic scholars, however, point out that the double-entry system had been known to

Figure 5.3. A sampling of Leonardo's illustrations from *De divina proportione* (Courtesy of the library of the National Gallery of Art)

medieval Islamic mathematicians. Although no documents have survived, this claim may be quite correct. It is certainly reminiscent of the applied mathematics and science known to have come down from medieval Islamic scholars.

There is in the foregoing a wider connection in mathematics, aesthetics, and science that draws the two Leonardos—da Vinci and Fibonacci—under the same intellectual umbrella. Ultimately, however, there is also the powerful image of intellectual tributaries rising much earlier: in ancient Egypt, India, Babylon, and classical Greece, but its full confluence not occurring until much later. Along with some remarkable discoveries there are also some fundamental mistakes, especially in natural philosophy, that had been perpetuated. Full reckoning was to come after the medieval times of the Islamic scholars, and even after the Renaissance. In the High Renaissance Leonardo da Vinci would first begin to challenge Aristotelian, Ptolemaic, and Galenic errors in natural philosophy

and the entrenched misapprehensions of the Church (a topic of Chapter 10). In the sixteenth century the works of Copernicus and Vesalius would signal a turning of the tide in the prevailing intellectual order, the high tide appearing early in the seventeenth century with Galileo finding himself locked in struggle with the Church. Although Galileo would lose his battle, the process, moved to the new venue of northern Europe, would establish its own inexorable course and make unprecedented progress.

The wisest and noblest teacher is nature itself.

—Leonardo da Vinci

Chapter 6

The Art of Nature

Leonardo carried out a lifelong love affair with nature—he studied it, wrote about it, drew it, painted it. He captured its nuances as no other. Nature provides inspiration for both the artist and the scientist. Although both are interested in describing nature, their expressions take distinctly different tacks: the artist is interested in interpreting the visible world, the scientist in explaining why and how nature operates. The style and modus operandi of the artist is to glean information about nature directly with his senses, to seek its subtle qualities, and he may even be susceptible to sub-

liminal messages presented by nature that can be expressed as numbers. The artist is unlikely to measure angles, slopes, proportions, or to count branches, but rather to seek abstract qualities, the "soul" of the subject, and to produce a piece of work that captures the essence of the subject's appeal to the viewer. Ultimately, the work has to satisfy the abstract requirements imposed by the artist, and to look "just right." In Christopher Tyler's words, "'looking just right' is as much a resonance with the psyche of the viewer as it is getting at the *ding an sich*. So art looks inward while science looks outward."[1] Historically the Renaissance artist, especially in the unique persona of the artist-scientist Leonardo da Vinci, preceded the Renaissance scientist in learning to observe nature, and especially how to ask the right questions, not just to hypothesize and introspect. In that sense, except for a small number of natural philosophers of antiquity, the Greeks and Romans were not engaged in empirical science. And science in the modern sense did not experience a rebirth in the Renaissance. It was born in the Renaissance.

The modern scientist makes systematic observations with instruments more sensitive than the senses and generates explanations that have internal consistency and universality; in the process some of the sources of those subliminal messages and subtleties are revealed. The artist works subjectively with full artistic freedom; the scientist is constrained by objectivity, facts, and data. But it is not just facts and data that dictate the operating mode of the scientist, there is also intuition, inspiration, and imagination. Paleontologist Stephen Jay Gould, a gifted expositor of science, described this process, especially for those scientists who are credited with transformative theories: "Science is not a heartless pursuit of objective information. It is a creative human activity, its geniuses acting more as artists than as information processors. Changes in theory are not simply the derivative results of new discoveries but the work of creative imagination influenced by contemporary social and political forces."[2] Moreover, although the realms of the artist and the scientist seem opposed,

throughout history evidence abounds of correlations in their visions, with the artist sometimes foreshadowing discoveries of the scientist. Such a theme is trumpeted by Leonard Shlain, who offers various parallel developments in art and science: for example, the works of Manet, Monet, and Cézanne at the end of the nineteenth century intuiting the coming upheaval in physics with Einstein's theory of relativity.[3] This is a fascinating thesis, but one that requires proper perspective.

In the accelerated progress of abstraction in art beginning in the mid-nineteenth century, the unmistakable catalyst was Louis Daguerre's concoction of photographic emulsion, laying the groundwork for photographic technology. The camera could capture realistic images with detail even more minute than any paint applied to canvas. The precision displayed in the paintings of Delacroix and Géricault began to lose their appeal, with artists conceding precision to the camera. Indeed, a generation of brash new painters emerged with new styles of expression ignoring that precision and detail while embracing color and texture. By then parallel revolutions in art and music were underway, with Monet ushering in impressionism in art and Debussy, its counterpart in music. In addition, an entirely new art form was born in photography, with its own branches—portrait photography, landscape photography, and photojournalism.

The great French photographer Henri Cartier-Bresson (b. 1908) is also regarded as an eloquent elucidator of photography as an art. In a career that spanned virtually the entire twentieth century, Cartier-Bresson created a legacy of some of the finest photographic images ever produced (especially in the surrealist style) and, in his thoughtful introspection, he successfully blended art, insightful psychology, and good literature. He called photographic portraiture "the one domain that photography had wrested from painting." In light of the evolution of both media during the past century and a half, few would disagree with that assertion. "Of all the means of

expression," he wrote, "photography is the only one that fixes a precise moment in time," echoing an earlier age, when Leonardo made the same pronouncement about painting.

Cartier-Bresson also wrote in his advanced years, "The only joy in photography is geometry. All the rest is sentiment." We feel compelled to take seriously any statement by someone so long lionized in the field, even if we have to agonize over the meaning of a missive that reeks with ambiguity. At first pale, the statement appears to stand at odds with other statements he made in his photographic heyday—to dismiss photography for anything beyond its graphic beauty—and represents perhaps a soulful yearning to return to drawing. He seems to be saying that elements of composition (the geometry of photography) hold the only interest for him—that the moral, political and even emotional agenda that is crowded into photojournalism (in particular) bore him. But an entirely different, and I think correct, interpretation is that it means that form without feeling or feeling without form is incapable of producing good art. If indeed that is what represents his true sentiment, then it parallels roughly Leonardo's words, "Where the spirit does not work with the hands, there is no art."[4]

At the turn of the twenieth century the scientific air was entirely unsettled, with one pair of issues prominently beckoning resolution. First, an incompatibility existed between the two great edifices of physics: classical mechanics and electrodynamics. Second, there was the question of whether *aether* (ether) existed in interstellar space as a medium for the propagation of light across great distances. These two issues served in tandem to make the time extraordinarily ripe for the formulation of relativity, and the prevailing restlessness is what these artists may have mirrored in their artwork. It would, of course, be an unreasonable stretch to presume that the great postimpressionists had the slightest inkling of how to resolve the problems within the purview of physics. And

the restlessness in physics was only a part of the late-nineteenth-century Zeitgeist, the intellectual milieu prevailing in European culture. Perhaps a better characterization than saying that art foreshadowed discoveries in physics would be to say that art paralleled them.

Unhappily, the artist and the scientist rarely speak to each other. Changes in both art and science, however, have the same root—the realization that things are not as we are accustomed to viewing them, that there is more to them than what our standard representations can portray. In physics, quantum mechanics represented an approach to physical problems from an entirely new point of view. The formulators of quantum mechanics were not representing reality in the customary Newtonian way, but in an abstract and more "essential" way. The parallel in the visual arts is exemplified by Pablo Picasso or George Braque in their Cubism. Picasso's celebrated painting *Les Demoiselles d'Avignon* (1907) represents an abstract look at women, reflecting their essence rather than their appearance.

Symmetries and Patterns in Nature, Symmetry in Physical Laws

Earlier, in Chapter 3, a mathematical progression had taken us from the Fibonacci series to the golden rectangle, from the golden rectangle to the logarithmic spiral, from the logarithmic spiral to the golden triangle. The discussion of these shapes was followed by the introduction of mathematical mosaics (tiling with polygons) in flat space, and then polyhedra, in which polygons were assembled into solid figures in three-dimensional space. The interconnections among these patterns had all emerged from a simple logic that dictated the flow. It is the nature of art that these mathematical shapes and figures in two and three dimensions find their way inexorably into works of art, and conversely it is the art of nature that these shapes and figures are displayed by nature's own creations.

The key to the patterns and regularities in nature lies in space-filling (mathematical mosaics), as well as in biological and physical dynamics. Ultimately, it is physical forces that give the creations of nature—both animate and inanimate, and both at the microscopic and macroscopic scale—their symmetries and shapes. And forces in turn are determined by their own underlying symmetries.

Nature's Own Mathematical Shapes

A simple figure that emerges from exercises in geometric construction based on the golden triangle is the five-pointed star (the pentagram). Nature has its own pentagram in the starfish. Technically the animal is not a fish but an *echinoderm,* a member of a group that also includes the sea urchin, sea cucumber, and the sea lily. Most starfish have five arms; others resemble pentagons, and still others strut many arms; the creatures inhabit all of the world's oceans. As one goes back and forth between the shapes described by mathematics and those encountered in nature, a sense emerges that the shapes that mathematics can describe have already been replicated by nature, and conversely the shapes that nature can produce can also be described mathematically.

An entirely different pattern in nature, the spiral or coil, is encountered at dramatically disparate scales, and in basically three different forms—the hyperbolic, the Archimedean, and the logarithmic. The hyperbolic spiral, quite rare in nature, resembles the logarithmic spiral initially, but as it unwinds, the spiral opens up and becomes a straight line. Fronds of the sago palm and the fiddlehead, both types of fern, resemble hyperbolic spirals in that they leave the stem straight and only become coiled at their tips. The Archimedean spiral, a little less frequently encountered in nature, appears similar to a strip of material of uniform thickness, coiled tightly around a central axis. It is a spiral that replicates the

grooves of the old fashioned phonograph record, or a roll of tape wound on a spool.

The Logarithmic Spiral: Spira Mirabilis[5]

The key to spiral formation in the organic world is the different growth rates of cells on the two sides of a tissue, with the slower growing surface being gradually enclosed by the faster growing surface on the outside. If the cells are of uniform size their linear arrangement forms a cylinder; winding the cylinder uniformly will generate an Archimedean spiral. But if the cells are gradually increasing in size—the cell diameters defining a cone—then winding the cone will give rise to the logarithmic spiral. This simple rule offers a connection between a number of strikingly different phenomena. A dramatic example is the shell of the chambered nautilus, *Nautilus pompilius*. The chambered nautilus is called a "living fossil" because its close ancestors, the *ammonites,* appeared at least 400 million years ago. The creature, however, has been anything but inert in its evolution, changing continuously and rapidly during the timeline of geological epochs. The animal inside the shell extends and enlarges its home while forming a continuous rolled tube. As it grows in size, the animal inhabiting the shell secretes material to create a wall behind it, then moves on (Plate 4, center left).

Peter Stevens points out that the difference in growth in the successive chambers automatically causes the coiling to take place, thus no gene needs to remember or plan the final shape of the shell, rather, it needs only to facilitate a difference in growth between inner and outer surfaces of the shell.[6] Other examples of the logarithmic spiral in the organic world abound: the tusks of a mastodon, the horns on a ram, the shavings from a wood plane, the claws of a cat, the fangs of a saber tooth tiger, the dried leaf of the poinsettia, the myriad gastropods, the cochlea in the inner ear, the

Figure 6.1. The proportions of the DNA molecule

human lip curved gently outward—all manifestations of the inner tissue growing faster than the outer.

The DNA molecule (deoxyribonucleic acid), the agent of the genetic code, is a macromolecule in which a pair of columns of sugar and phosphate molecules are intertwined (Figure 6.1). The unequal lengths in their edge bonds result in that helical shape of the structure. Thus it is ultimately skewed molecular units that give shape to the double helix. The projection of the three-dimensional structure exhibited by the double helix onto a flat two-dimensional plane, the process that chemists call "graphing," creates a pair of intertwined sine curves. The Israeli biophysicist Harel and his colleagues, in measurements of the DNA molecule,[7] found for each cycle of the sine curves a length-to-width ratio of ϕ (≈ 1.62). Astonishing!

The logarithmic spiral pattern of the chambered nautilus, expanded by a factor of five million, could represent the swirling cloud patterns in a hurricane that stretches up to five hundred miles across; magnified another sixty million million times, the arms of a spiral galaxy that typically stretches 100,000 light years across (Plate 4, center and lower right).

The long-range force that locks celestial bodies in their eternal orbits is gravitation, and the dominant interaction at the level of atoms and molecules is derived from the electromagnetic force. Both interactions are called "inverse square forces," but is that the key to formation of spiral shapes? In the case of those solids among spiral patterns—the chambered nautilus, the horn of the ram—the spiral pattern emerged with cells on one side of a plane growing faster than on the other, and the interactions are short-range and internal, such as cohesion and adhesion. In the swirling clouds of a hurricane or in the vortex of a whirlpool, on the other hand, external forces are operating. First there exist pressure gradients in the atmosphere that generate the winds, then there is the coriolis force generated by the spinning earth. In fact, the spinning of the earth causes hurricanes (and whirlpools) in the northern hemisphere to rotate counterclockwise, and in the southern hemisphere to rotate clockwise.

But what are the forces that cause spiral galaxies to assume their characteristic shapes? In *irrotational motion,* the inner parts of the galaxy rotate faster than the arms. Then why does a spiral galaxy not just wind up into a knot? How is it that galaxies preserve their spiral integrity for billions of years? Physical intuition would suggest that the astrophysicist seek solutions to these questions in dynamics (classical mechanics) and gravitation. Reality, however, has the solution flowing from a cross-fertilization of disciplines, where population biology has to be blended with dynamics and gravitation, but requires a mathematical explanation beyond the scope of this book.

Spiral Phyllotaxis

Any discussion of spirals in nature would be incomplete without special attention directed to the spiral growth pattern in plants. The area of botany known as *phyllotaxis* comprises the arrangements of petals on flowers, leaves on stems, and branches on trees. This is a field in which the curious appearance of the Fibonacci numbers has long

been recognized. Intervals measured in arcs between branches in the poplar tree, intervals between thorns on a rosebush, as well as intervals in the delicate network of veins (such as in the leaves of the hardy ivy plant) are among the examples of plants associated with the divine proportion. While the proportions enhance the beauty of the plant, the geometry is found to be manifestly functional, enabling the plant to obtain maximum exposure to the sun and maximum nutrients for its cells. In short, nature almost always knows best. Stevens investigated numerous plant patterns, ranging from branches of trees to delicate petals of the most ephemeral flower.[8] In an examination of the cross section of the celery just above the meristem (the conical mound of solid tissue at the base of the plant), he reported finding the stalks of the celery to be packed together closely, creating the swirling pattern of a pair of spirals—a clockwise spiral was countered by a counterclockwise spiral. Closer scrutiny revealed a more general scheme: when leaf bases develop in succession around the stem apex they fit between each other in a manner that composes a helical pattern, with each stalk riding above the older member of the pair of stalks in the preceding whorl. Variations of the helical pattern appear with stalks of one whorl interpenetrating and making contact with stalks of the previous whorls.

A bunch of broccoli exhibits spirals in two different directions. The spirals appear at first sight to be quite nebulous in structure, but with careful examination the organization in logarithmic spirals can be identified. Pinecones viewed from their base exhibit logarithmic spiral patterns in their scales. The clockwise-to-counterclockwise ratio in all of these pinecones is 8:13. The chrysanthemum exhibits a phyllotaxis of 13:21. Sunflower seeds form spirals that are considerably easier to identify than those in broccoli. Here the phyllotaxis—the ratio of clockwise to counter-clockwise spirals—turns out to be an unequivocal 21:34.

Similarly, when one examines the helix of thorns of a young hawthorn tree, one finds in two full circles around the stem a total

of five thorns, an arrangement characterized by 2:5. Apple, oak, and apricot exhibit a similar 2:5 pattern of phyllotaxis. As for sedges, beech, and hazel, a phyllotaxis of 1:3 is found; for plantain, poplar, and pear, 3:8; for leeks, willow, and almonds, 5:13. When the double helix of the pinecone is flattened in the direction of its axis of symmetry, compound logarithmic spirals are seen to emerge. The pineapple, just like the pinecone, exhibits an 8:13 spiral phyllotaxis. The daisy displays a clockwise-to-counterclockwise ratio of 21:34. Sunflowers, depending on their species, can have phyllotaxis of 21:34, 55:89, or 144:233. In each instance, the terms in the ratio are members of the Fibonacci series.

The reason for the occurrence of the Fibonacci numbers in such a diversity of plants turns out to be a necessary consequence of the growth pattern inherent in all of them. This is demonstrated by an analysis offered by Stevens, which begins by plotting the tips of a bunch of celery stalks. Through the points it is possible to draw a continuous logarithmic spiral. The circular arc between any two consecutive points is found in a precise measurement to be 137° 30' 28" (=137.5077°). This angle divided by the angle in a full circular turn (360°) represents the ratio 137.5077°/360°= 0.381 966, a value equal to the square of the inverse of 1.618 034, (or 0.618 034^2 = 0.381 966). Therein lies the spiral's relation to the golden mean. More significantly, Stevens draws all the possible smooth spirals through these points, both clockwise and counterclockwise. The results are compound spirals with phyllotaxis of 1:2, 2:3, 3:5, 5:8, 8:13, 13:21. The array of points not only generates all Fibonacci fractions, it generates *only* Fibonacci fractions!

Finally, examination of many species of trees reveals that a tree trunk, in rising, branches off at a certain elevation; then at a slightly higher elevation, *one* of these two branches divides again, but not the other. At this juncture, there now exist three branches. At a higher elevation still, two of three branches simultaneously appear to branch, but not the third. At this point the branches number five

in all. The next time a branching occurs, the number is most likely eight. Thus at any given elevation the number of extant branches is seen to be a Fibonacci number: 1, 2, 3, 5, 8. . . . This pattern appears frequently, but is not universal. That pattern of compliance to the Fibonacci scheme should be considered in the proper perspective. The plant is no more enamored of the golden mean than it is in applying mathematical computation before sprouting a stalk. Rather, it puts the stalks where they have the most room, where they can make the most of the nutrients and the sunlight available. As Stevens observes, "All the beauty and all the mathematics are the natural by-products of a simple system of growth interacting with its spatial environment."[10]

FLEETING AND ILLUSORY SPIRALS

Among artificially created spirals, it is the Archimedean that is by far the most frequently encountered. The storage of a variety of materials of uniform thickness, including most varieties of tape, can be achieved in the most compact and convenient form when wrapped around a spool. The hyperbolic spiral, which appears initially as a straight line that near its tip curls up into a spiral, is seen much less frequently than the Archimedean spiral in works of art and in the artificial world in general. The logarithmic spiral, like the hyperbolic, is not seen frequently in artificial creations. But a helical shape, such as an ordinary circular staircase, when viewed along its axis will appear to converge in the manner of the logarithmic spiral. The view looking downward from the top of the double intertwined circular staircase of the Vatican Museum, built according to a design by Leonardo da Vinci, offers a dramatic illustration of this shape (Plate 5, top). The rifling inside the muzzle of a cannon has the function of imparting a precisely reproducible spin to cannonballs (and consequently a reproducible trajectory). When the muzzle is viewed along the cannon's axis, the rifling will appear as a number of intertwined logarithmic spirals.

Mario Livio describes the tantalizing problem faced by the peregrine, a falcon that can fly at the blinding speed of two hundred miles per hour, but has the impediment of having its eyes on the sides of its head. If the falcon were to cock its head at an angle of 40 degrees relative to its body axis (never looking away from its prey), it could in fact fly to it in a straight line, but then the air resistance would slow the falcon's speed substantially and increase its time of flight. It chooses instead to keep its head pointed along its body axis, peering sideways, keeping its prey in its sight continually, its trajectory describing a collapsing spiral. During its approach to its target its body axis makes a 40-degree angle relative to a purely circular trajectory (the same as the angle made by the vector of its actual trajectory and the vector joining the falcon and the prey). The falcon manages to optimize the time of flight to the prey while minimizing the air resistance *and* the length of trajectory; maintaining that constant angle results in the equiangular or logarithmic spiral.[10] As in the case of the bee that created the honeycomb in contiguous hexagonal cylinders (achieving minimum wall material and maximum volume), the falcon's solution derives from form following function. We could solve both problems readily by applying calculus, but nature in both instances has achieved the correct results by imbuing the creatures with the correct instinctive behavior. Finally, a fleeting spiral pattern also develops in the trajectory of a missile with a faulty engine nozzle. The unbalanced torque in the thrust causes the missile to spin end-over-end, producing in a distinct logarithmic spiral for a contrail (see Plate 4, bottom left).

The Divine Proportion and Human Anatomy

The space between the slit of the mouth and the base of the nose is one-seventh of the face. . . . The space from the mouth to below the chin will be a quarter part of the face, and similar to the width of the mouth. . . . The space between the chin and below the base

of the nose will be a third part of the face, and similar to the nose and the forehead. The space between the midpoint of the nose and below the chin will be half the face. . . . If you divide the whole of the length of the nose into four equal parts, that is to say, from the tip to where it joins the eyebrows, you will find that one of these parts fits into the space from above the nostrils to below the tip of the nose, and the upper part fits into the space between the tear duct in the inner corner of the eye and the point where the eyebrows begin; and the two middle parts are of a size equivalent to the eye from the inner to the outer corner.[11]

—Leonardo da Vinci

Leonardo was neither the first nor the last to quantify ideal facial proportions, although with obsessive precision he wrote more than eight hundred words describing the proportionality of the face alone, before going on to describe the proportions of the rest of the body. Since the Golden Age of Greece, proportions in the human figure have been a source of considerable preoccupation among artists. In examining sculpture of classical Greece and Rome, we had seen one special case—the ratio of total height to the height of the navel as ϕ. In the twentieth century Le Corbusier made a systematic study of these proportions and found connections to the divine proportion, or golden mean.

Born Charles-Edouard Jeanneret in the town of La Chaux-de-Fond, Switzerland, in 1887, Le Corbusier adopted the name he made famous only after he left Switzerland and settled in France. Trained initially as an engraver of watches, he became an architect and developed a special vision for simplicity, functionality, space, and proportion. A house he designed in the suburbs of Paris and now serving as the headquarters of the Le Corbusier Society is a play on the golden mean. But whether applying his imagination to design-

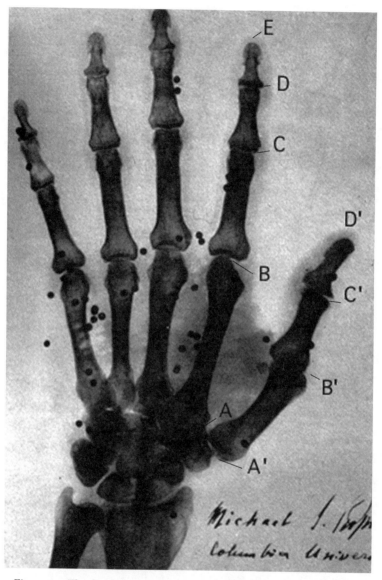

Figure 6.2. The divine proportion in the hand. Wilhelm Röntgen's x-ray of the hand of a hunter wounded by birdshot (1896, Berlin). The inscription below the photo is an entry by Professor Pupin at Columbia University, a contemporary of Röntgen.

ing furniture, buildings, or an entire town, his quest was always the search for salient proportions and harmony. Le Corbusier created a graphic known as *Modulor* illustrating the parts of the human body. The golden ratio, ϕ, occurs over and over again in the graphic: the height of the head of the figure to the height of the navel, the distance from the navel to top of the head to the distance from top of the head to the end of his outstretched hand. The inescapable conclusion from examining all of Le Corbusier's designs is that this man was totally preoccupied with the divine proportion.

A fascinating demonstration of the prevailing proportions in the human body is found in the bones of the hand. This is exhibited dramatically in an early x-ray image produced by Wilhelm Röntgen, who first discovered x-rays, invented the x-ray machine, and, indeed, was awarded the first Nobel Prize in Physics for his work (1901). The product of a technology in its infancy, the image—morbid in its content in revealing the presence of birdshot in the hand of a victim of a hunting accident—shows the bones with exceptional clarity (Figure 6.2). The bones of the wrist are known as the carpals and those in the hand, as the metacarpals. The first metacarpal, connected to the thumb, has a length we shall designate by $A'B'$. The bones in the thumb are the proximal and distal phalanges, the lengths of which we shall designate by $B'C'$ and $C'D'$, respectively. In the case of the index finger, the second metacarpal (of length AB) is connected to the bones of the finger—the proximal, medial, and distal phalanges (the lengths of which will be designated by BC, CD, and DE, respectively). The inherent proportions of these bones on average are surprisingly close to the law of divine proportion. For the bones of the thumb:

$$\frac{A'B'+B'C'}{A'B'} = \frac{A'B'}{B'C'} = \frac{B'C'+C'D'}{C'D'} = \phi = 1.618$$

For the bones of the index finger:

$$\frac{AB+BC}{AB} = \frac{AB}{BC} = \frac{BC+CD}{CD} = \frac{CD+DE}{DE} = \phi = 1.618$$

In the first century B.C. the Roman artist-architect Vitruvius formulated an architectural theory inspired by proportions in the human body, and indeed it is this message that Le Corbusier's architectural theory echoes in the twentieth century. For Leonardo, deriving inspiration from natural design was always compelling. Accordingly, when a new edition of Vitruvius was considered for publication in 1511, who better could there have been than Leonardo to illustrate the Greco-Roman canon of perfect human proportions. Leonardo created one of the most familiar drawings in Western art, the Vitruvian Man (Figure 6.3). His arm span equals his height. When he does a spread eagle with his arms and legs he is inscribed in a circle, the center of which is located at the man's navel. The ratio of his height divided by the height of his navel is the classic golden ratio, $\phi = 1.618...$

A contemporary clinical orthodontist, Robert Ricketts, has spent his career correcting a wide variety of congenital and accidental disfigurations.[12] His systematic investigations into the growth pattern of the lower jaw (mandible) suggest that the best description of the growth pattern is in terms of a smooth spiral curve. Specifically, he points to the eruption of the lower teeth and their forward migration during two periods of growth—between ages three and eight, and between thirteen and eighteen—as showing a remarkable similarity to the shape of the logarithmic spiral. His diagrams are reminiscent of the shape of the human ear, and so too of the shape of the human embryo at about six weeks—also logarithmic spirals. Leonardo during his Milanese period had undertaken anatomical studies of animals, and while performing a dis-

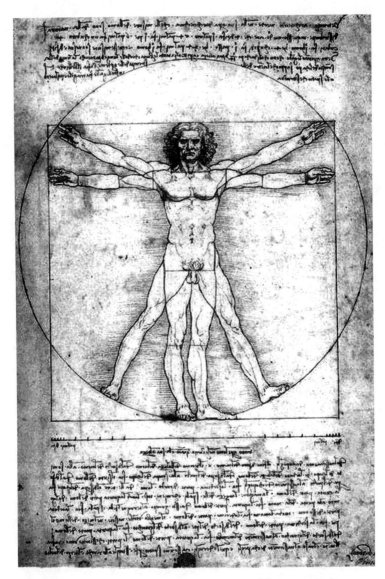

Figure 6.3. Leonardo da Vinci, *The Proportions of the Human Body According to Vitruvius (The Vitruvian Man)*. Pen and brown ink, brush and wash over metalpoint, Gallerie dell'Accademia, Venice

section on a cow, sketched the embryo, also revealing that unmistakable logarithmic spiral (in the *Codex Atlanticus*).

DIVINE PROPORTION IN FACIAL AESTHETICS

The ratio of the height of an individual to the height of the navel and the proportions of a variety of contiguous bones in the hand were seen to be related by the golden ratio, and artists since classical times to have been cognizant of those proportions. In his aesthetic and orthodontic surgery, Ricketts has made his own extensive studies on this topic, and uses his patented "Golden Divider," a caliper with three prongs (instead of the usual two), with the prongs designed always to maintain spacing between the prongs of $1:\phi$ (Figure 6.4) .

In one special study, Robert Ricketts reports the results of measurements on a number of female photographic models, posited as "physically beautiful women." The technical terms used by the aesthetic surgeon to identify a number of points on the face are indicated in the pencil sketch.[13] These are, clockwise from the top right: a point located very close to the hairline, *trichion*, T; temporal soft tissue, TS; the outer corner of the eye, *lateral canthus*, LC; the center of the curve on the outer edge of the nostril, *alar rim*, AL; the lip embrasure or the lateral edge of the mouth, *chilion*, CH; the lower border of the soft tissue of the chin, *menton*, M; the outer edges of the nostrils, *lateral nares*, LN; the cheek prominence, ZP; and the lower border of the curve of the eyebrows, EB.

For a variety of distances measured vertically on the faces of the ten models, Ricketts reports the following average values:

AL–CH 21.3 mm	T–LC 52.1 mm	T–AL 88.6 mm
CH–M 33.7 mm	AL–M 54.5 mm	LC–M 89.3 mm
LC–AL 34.7 mm	LC–CH 55.6 mm	T–M 144.3 mm

All of these values are surprisingly close to the ninth, tenth, eleventh, and twelfth terms of the Fibonacci series (i.e., 21, 34, 55,

Figure 6.4. Superimposed on a pencil sketch of Rochele Hirsch by the author are the sites on the face identified by the aesthetic surgeon: trichion (T), lateral canthus (LC), chilion (CH), etc. Without the smile a golden triangle can be visualized with the acute angle (36°) located at the bridge of the nose and the 72° angles defining the chin. With the smile, however, the golden triangle transforms into a pentagon that can be discerned in the drawing. The left inset illustrates Dr. Robert Ricketts's patented Golden Divider.

89, 144). The fact that the unit of measurement used, the millimeter, yields these values so closely approximating the Fibonacci numbers is just a happy coincidence, alleviating the need to normalize them to an arbitrary dimension. Three of the distances measured—trichion to lateral canthus (T–LC), alar rim to menton (AL–M), and lateral canthus to chilion (LC–CH), and two other distances, chilion to menton (CH–M), and lateral canthus to alar rim (LC–AL)—are no more than 3 to 4 percent at variance with each other. The values appearing in the preceding table yield within reasonable accuracy the law of divine proportion:

$$\frac{T\text{-}M}{T\text{-}AL} = \frac{T\text{-}AL}{AL\text{-}M} = \frac{AL\text{-}M}{M\text{-}CH} = \phi$$

For horizontal proportions on the photographers' models, Ricketts reports relationships between the width of the nose, the mouth, the eyes, and the temple. The width of the nose, defined by the distance between the lateral nares (LN) displays an average value of 28.4 mm. The width of the mouth, defined as the distance between the right and left chilion (CH) measures on average 45.4 mm, or 1.60 times the width of the nose. The distance between the outer edges of the eyes (LC) has a mean value of 75.3 mm, or 1.66 times the width of the mouth. The distance between the temples (TS) is on average 118.2 mm, or 1.57 times the distance between the outer edges of the eyes. The value 1.57 happens to very nearly equal $\pi/2$, or the average girth of the head. It is a noteworthy happenstance that the distance between the outer edges of the eyes is equal to one-fourth of the circumference of the head. As for the numbers given above for left-to-right measurements, TS_L–TS_R, LC_L–LC_R, CH_L–CH_R and LN_L–LN_R, the relationships can be summarized roughly by

$$\frac{TS_L\text{-}TS_R}{LC_L\text{-}LC_R} = \frac{LC_L\text{-}LC_R}{CH_L\text{-}CH_R} = \frac{CH_L\text{-}CH_R}{LN_L\text{-}LN_R} = \phi$$

Aesthetic dentists have a formula for reconstructing the teeth for a "beautiful smile."[14] First, the teeth should be symmetric on the two sides of the midline, with the each of the central incisors displaying the length-to-width ratio of 4:3 (or 1.33). Another formula has the two front incisors together forming a golden rectangle configured horizontally, each incisor then having a length to width ratio of approximately 5:4 (1.25). Then, inspired by the golden ratio, this formula calls for the central incisors to be 1.62 times wider than the pair of lateral incisors bracketing them. As the teeth curve away from the viewer, the lateral incisors should *appear* to be 1.62 times wider than the next pair of teeth, the cuspids, which in turn should appear to be 1.62 times wider than the first bicuspids bracketing them. These values for the relative width of teeth, measured from the midline, comprise the series ϕ^0, ϕ^{-1}, ϕ^{-2}, ϕ^{-3} . . . (*1, 0.618, 0.382, 0.236, . . .*).

MARQUARDT'S MASK

Stephen Marquardt, a retired oral and maxillofacial surgeon at the UCLA Medical Center, has done impressive research on the types of proportions and symmetries observed in human aesthetics. He has performed surgery on individuals who desire a different, generally more attractive look, and he has operated to restore the appearances of individuals who have been injured in accidents. His work has culminated in a series of beauty masks replete with a celebration of the divine proportion. Overlaying a subject's photograph with a properly scaled mask is tantamount to applying a mathematical test on the subject's physical looks—the separation of the eyes, the relative lengths of the forehead and nose, and so on, all coming into play. Marquardt's original mask represented the proportions of an ideal face in frontal repose (FR). Subsequently, he extended his beauty mask to reflect Frontal Smiling (FS), gender differences, race, and indeed even age differences.

In the FR-mask there is the appearance of a golden triangle (with characteristic 72°—36°—72° angles) around the nostrils, and a transformation into a pentagon around the mouth and chin when the subject presents a broad smile. Marquardt is currently engaged in creating three-dimensional versions of the mask that could be rotated and viewed in the manner of virtual reality. This would allow the mask's superimposition on portraits depicting subjects in half or three-quarter profile.[15]

Marquardt's Web page illustrates his "ϕ–Mask," as it is superimposed on a selection of six legendary beauties spanning thirty-two centuries—from Queen Nefertiti to Marlene Dietrich and Marilyn Monroe (Plate 6).[16] The portrait of each woman has been paired with the same portrait overlaid with the ϕ–Mask. The near precise fit in each instance appears to make a compelling case for the mask's validity as a gauge for human pulchritude. Facial features related to the divine proportion are precisely the ones our species associates with beauty, and indeed appear timeless. The modern codification is a further refinement of the proportions specified by Leonardo.

The first intention of the painter is to make a flat surface display a body as if modeled and separated from this plane. . . . This accomplishment . . . arises from light and shade. . . . Perspective, with respect to painting, is divided into three parts . . . the first is the diminution in the size of bodies at various distances; the second part is that which deals with the diminishing in color of these bodies; the third is the diminution in distinctness of the shapes and boundaries which the bodies exhibit at various distances.[1]

—Leonardo da Vinci

Chapter 7

The Science of Art

According to physics, with receding distance the intensity of light from the scene (the source) drops off as the inverse square of the distance. There is additional attenuation of this intensity from the absorption and scattering of light by the atmosphere interposed between the subject and the viewer. This scattering or dispersion of light by the atmosphere also causes degradation in the resolution of the image as well as dilution or smearing of the wavelengths defining colors—a process that also leads to the blue appearance of the sky. Since the rays of light, traveling in straight lines, are *all*

received by the eye at a point, the size of the image must drop off *linearly* with distance.

Leonardo's observations in that opening quote are entirely compatible with the principles established by science. Dust particles, microscopic pollen, and water molecules suspended in the air cause light to scatter and change frequencies. The effect is to add "white light," washing out the vividness of the spectrum of colors from the source. As for the "blue of the sky," it can be explained by the Rayleigh scattering phenomenon, demonstrated mathematically almost four hundred years after Leonardo made the pronouncement.

A property of light that is crucial to the scientist, but inconsequential to the artist, is its finite speed, rendering the scene viewed a composite image in time. It is essential for the astronomer to take into account that in the image of the night sky some stars lie a few light-years away, while others are hundreds, thousands, or millions of light-years away. It may be interesting, although, entirely irrelevant for the portrait painter, that in the image of his subject, light from the sitter's cheeks and ears may be "older" by a fraction of a nanosecond than light from the tip of his nose (depending on how the subject is turned). And it is also irrelevant that in the image viewed by the landscape painter, light from the distant mountains and valleys is older by a few microseconds than light from objects in the foreground.

Perspective, Symmetry, and Shape

The theory of linear perspective is of central importance as a tool for the painter to create an illusion of depth—the appearance of three dimensions on a two-dimensional plane. It was already present in the works of Agatharchus, scene painter for the great tragic dramatist, Aeschylus, in the fifth century B.C. Indeed, so effective were Agatharchus's scrims (backdrops) that they gained Plato's

enthusiastic praise of the illusion of reality presented. Although no perspective paintings from classical Greece have survived, Pompeii, that veritable time capsule from A.D. 79, offers a window onto Roman architectural drawing and most likely a window onto the earlier Greek as well. Neuroscientist Christopher Tyler, an authority on human vision and separately on the theory of perspective in painting, suggests that it may even have been Greek artists who painted those architectural murals in Pompeii in which a measure of perspective is displayed.[2]

Euclid (325–270 B.C.) formalized geometry, but the use of perspective in ancient art was based on the artist's intuition rather than on any mathematical authority. In the architectural drawings in Pompeii, for example, there are unrelated vanishing points along a pair of parallel horizon lines, whereas the correct picture in the one-point perspective scheme calls for a single horizon line and a single vanishing point. Medieval and even early Renaissance artists had been content to represent their subjects symbolically. Since their subjects were usually religious, the backgrounds were generally flat gold leaf, as far removed from reality and perspective design as heaven is from earth.

Projective geometry, the mathematics underlying the rules of perspective, was born in the Renaissance and indeed may have ushered in the art of the High Renaissance. One-point perspective appeared first in the works of Masaccio and Masolino in the first half of the fifteenth century, coming to full fruition in the works of Leonardo da Vinci in the second half of the century. Although the scheme was firmly established with Leonardo, it saw further refinement in subsequent centuries with the introduction of two-point perspective a century later and three-point perspective much later—after cameras with tiltable lenses for architectural renditions were invented in the twentieth century.

The actual timeline of the development of projective geome-

try so closely parallels the development of the rules of perspective in art that it strongly suggests an all-pervasive interaction, the interdynamics between art and science. It was the Renaissance artist who insisted on the need to represent nature as it actually appeared, not as it was thought to appear. This vision turned out to be a transcendent gift of the artist to the scientist. The role of Leonardo in this context cannot be overstated. One of the most significant drivers in the development of the theory of perspective was Leonardo, the paragon of the artist-scientist: a consummate artist doing science, a consummate scientist doing art. Later we will see three portraits of women that Leonardo painted at fifteen-year intervals. With each portrait Leonardo returned to painting having done little art in between, but each time showing astonishing growth as an artist, not just starting where he left off, but at an astoundingly higher level. In the time between paintings he did everything else—the mental inventions, the sketches, the anatomical studies, designs of bridges, spring driven vehicles, thoughts of human flight and experiments with optics. Painting alone was simply too easy, and slavishly producing canvas after canvas without substantial experimentation was the lazy way out. He berated and cajoled other artists: "Those who fall in love with practice without science," he wrote, "are like pilots who board a ship without rudder or compass."[3] Leonardo was bridging the two fields of art and science, and creating as he went along. Raphael, on the other hand, superb draftsman, practiced exquisite, flawless composition and perspective, but was not "a driver" in the same sense.[4] He applied established rules but did not discover any new ones.

If one is to seek an answer to why the artist in the Renaissance became aware of issues of perspective, one has to look no further than the extraordinary serendipity that saw the artist as an architect and engineer. The image of the Renaissance man as one fre-

quently preoccupied with philosophy, literature, poetry, music, mathematics and natural philosophy (science), as well as with the skills of the artist-architect, is not just an empty metaphor. The cross-semination of the variety of interests he brought to his work and the presence of enlightened patrons willing to listen served as key ingredients in the remarkable intellectual and artistic blossoming of the period.

In a number of instances there are opportunities to see how the artist started the work and how a painting was thought out or abstracted. In some cases detailed studies for a final painting have survived as cartoons. In others, a sketch can be seen on the canvas of the unfinished work. Modern technologies such as stereoscopic microscopy, infrared reflectography, or x-radiography can be applied to the finished works, making overpainted details visible. Before painting the *Adoration of the Magi* the twenty-nine-year-old Leonardo produced intricate perspective and compositional studies for his design. The painting itself was left unfinished, but it became one of the gems of the Uffizi in Florence. This is a work we shall revisit in Chapter 9.

Meanwhile, Leonardo's northern contemporary, Albrecht Dürer, was so preoccupied with understanding the issues of perspective that in his works of art he adhered strictly to the system he was developing independently, but he also created works of art, mostly woodcuts, demonstrating actual techniques for achieving error-free perspective. In one woodcut the artist is seen observing his subject from a fixed point of perspective through a frame onto which a grid has been scored. As he observes his subject through the scored frame defining his plane of view, he painstakingly maps out the image on the drawing board on his table, similarly scored. In another woodcut we see mounted within the frame a pane of glass (with a scored grid). The pane of glass is hinged in the style of a window that can swing outward, so that the angle it makes with the plane of view can be adjusted (Figure 7.1). The artist seeks to

correlate the intersection of rays of light from his subject with the angled pane and the visual plane defined by the frame itself.

Projective Geometry

The quest of the Renaissance artist was to formulate theorems that would assist in precisely mapping a three-dimensional scene observed (or imagined) onto an imaginary pane of glass, or specifying exactly how a scene would appear on the two-dimensional pane. Obviously, the canvas itself is not transparent, but the scene, properly visualized on that imaginary pane, would then be recreated on the canvas. The questions that the Renaissance artist raised and the theorems he deduced became seminal issues for a new branch of mathematics, projective geometry.[5] In the hands of the professional mathematicians the field blossomed into an elegant, general, and powerful geometry, with applications to physics, crystallography, and chemistry.

A square at a distance will have different appearances depending on the vantage point of the observer—an intuitively obvious result, and one that can be proven by ordinary Euclidean geometry. What assists the artist in deducing the proper shape is that transparent plane interposed between the observer's eye and the subject, the square. A single square floor tile viewed directly from above will have a square appearance with the normal 90-degree vertices and sides of equal length. But observed at an oblique angle, an array of square tiles will have the shapes of quadrilateral figures, with parallel lines, defined by the edges of the tiles, appearing to converge at vanishing points. Nonetheless, the impression they create will be precisely that of square tiling.

The Dutch genre artists of the seventeenth century, especially Pieter de Hooch and Johannes Vermeer, are known for those impeccable lines of perspective with floor tiles, doorways, and walls all defining lines of one-point and two-point perspective. Vermeer's

magnum opus, *The Art of Painting* (Plate 7), shows that the appearance of the individual tiles on the flat space of the painting is anything but square, but the pattern conveyed is clearly that of square tiling. Parallel lines extrapolated from opposite edges of the tiles lead off into infinity, where they converge at a pair of vanishing points on the horizon line, thus demonstrating two-point perspective.

Vermeer created tantalizingly few paintings—approximately three dozen, only two dozen of which have survived—half a painting for each year of his short lifetime, and half as many as Rembrandt's self-portraits alone. He created some of the most compelling works in the history of art, yet his personal life is shrouded in mystery. Common to nearly all his paintings are the unerring perspective and the nature of the scene—set in his studio with a female subject. After his father died when the artist was twenty, he was left to live with his mother and sister. When he took a wife, Catharina Thins, he moved into a rent-free house provided by his mother-in-law, again making his immediate companions women. When Catharina had children, a business at which she was beyond

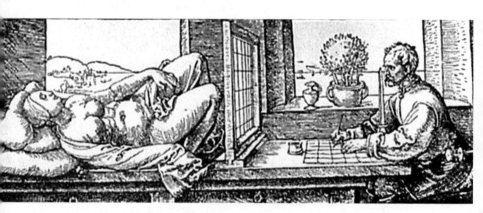

Figure 7.1. Albrecht Dürer, *De Symmetria Partium Humanorum Corporum (Draftsman Doing Perspective Drawings of a Woman)*, 1532. The Metropolitan Museum of Art, Gift of Felix M. Warburg, 1918. (Courtesy The Metropolitan Museum of Art, New York)

prolific—bearing fifteen children, eleven of whom survived—there was again a preponderance of girls. This sea of females that surrounded him may have colored his choice of subjects for his paintings. In all but two of his single subject paintings the subject is a woman. Yet he has portrayed these women so sensitively, in works that still confound and amaze us, works described as "serene and unnerving, sensuous and disembodied."[6] They appear mellifluous, placid, and always timeless.

As a favorite son of the Dutch school Vermeer is second only to Rembrandt, who had a prodigious output. Although some of Vermeer's Dutch contemporaries, especially Rembrandt and even Franz Hals, may have painted more forceful and dramatic psychological characters, their subjects are distinctly seventeenth-century Dutch contemporaries of the artists. With Vermeer's subjects there is a timeless character to their visage; they could be our contemporaries. Except for a few resplendent outdoor scenes of Delft, the background is almost always the same: the artist's studio, simple props chosen for the occasion, subdued light from a window at the left.

Phillip Steadman, an architect by training, who analyzed Vermeer's paintings painstakingly for two decades and tracked down the few houses in which Vermeer lived, recently published a theory about Vermeer's use of a camera obscura, or a type of "perspective box" similar to the one used by Samuel van Hoogstraten, in planning out his composition and achieving impeccable perspective (the simple optics involved consists of a pair of double convex lenses mounted in the aperture of the box).[7] Steadman's theory is vigorously disputed by art historian Walter Liedtke. Focusing on one painting, *The Milkmaid*, Liedtke writes, "It is not photographic, nor even materialistic effect, but an illusionistic device that works splendidly in that small, intensely colored picture. . . . Vermeer achieved an effect similar to that seen in a camera obscura (or a photographic reconstruction of how they work), but he was also enhancing effects of light that had been described by Dutch artists

a few decades earlier (for example, Franz Hals)." Moreover, according to Liedtke, Vermeer may be unusual in his talent but is not really apart from the prevailing Delft school in technique, and "extraordinary talents can only come into being if they have the blood of such a community in them." [8] Without jumping headlong into the fray, I believe from my personal perspective as a scientist-artist there is most likely some truth to Steadman's claim as well as Liedtke's counter. Vermeer was indeed extraordinarily talented, and the fascination with new instruments was part and parcel of the Dutch Golden Age.

The controversy regarding whether and to what extent Vermeer may have used optical artifices to achieve the beguiling effects in his paintings may never be resolved. One undisputed fact, however, is that Vermeer did have access to the finest lens makers of the time. His closest friend was Antonie van Leeuwenhoek, inventor of the microscope. The refracting telescope was invented in Holland, and the exceedingly successful wave theory of light still used in elementary physics was developed by another Dutch compatriot, Christian Huygens. The inarguable fact is that there was evolving around Vermeer optical theory, and applications for art and science, and he was both a generous contributor to and a grateful benefactor of them.

While Vermeer and the Dutch masters were plying their trade in Holland, a self-taught French architect-engineer, Girard Desargues, formulated a powerful theorem in projective geometry, still known as "Desargues's theorem." The theorem—complicated conceptually and difficult to prove mathematically—pertains to points of convergence for lines in a geometric construction. In a number of works by acknowledged masters, including those serene and sublime indoor scenes of Vermeer and perhaps in the trademark Venetian panoramas of Canaletto, there appears intuitive compliance with the tenets of Desargues's theorem. And much earlier still, Leonardo, in composing the *Last Supper*, had displayed thorough

understanding of the derived perspective of the theorem. The perspective underlying the *Last Supper* is seen in the upper left inset of Plate 8.

One-, Two-, Three-, and Four-Point Perspective

Rather than getting mired further in the mathematical aspects of perspective, I shall examine the notions of one-point, two-point, three-point, and four-point perspective graphically with my own work, some of it created for my book of lithographs, *Oxford and the English Countryside*.[9] In one-point perspective a convenient artifice an artist might use is a perfectly clear cube, with minimal refraction, or light bending. The opposing faces of the cube are parallel to each other; the edges can be extrapolated to a vanishing point on the horizon line. Depending on whether the cube is viewed from above or from below, the horizon line will descend or ascend accordingly—but each time with the lines of perspective converging on the horizon line. The cube can represent a model for the interior of a room or, just as effectively, a street scene with the fronts of facing buildings parallel to each other (Figure 7.2).

Among the finest treasures of the Vatican are the series of monumental frescos Raphael executed between 1509 and 1511. In one, the *School of Athens*, Raphael integrates three elements of interest to us here. First is the breathtaking demonstration of one-point perspective, which had come into full fruition at the turn of the sixteenth century (Plate 9). Then we have a group portrait of the great natural philosophers of antiquity, a historical composite spanning approximately eighteen centuries—from Heraclitus (active sixth century B.C.) to Averroes (active twelfth century A.D.). Finally there are Raphael's contemporaries—other artists, who serve as models for the philosophers. The mural offers an extraordinary real-life group portrait.

Figure 7.2. Diagrams of (A) one-point perspective; (B1, B2) two-point perspective; (C) three-point perspective

The sprawling character in the light blue toga in the lower center is Diogenes (c. 412–323 B.C.). In the lower left the man scrawling mathematics on a tablet, with two observers looking over his shoulder, is Pythagoras (c. 560–480 B.C.). At the bottom right, engaged in a geometric construction with a compass, while four young men watch intently, is the figure of Euclid, the geometer (c. 325–270 B.C.). At the top of the stairs and just below the colossal statue of Athena is the likeness of Socrates (479–399 B.C.). For the foregoing philosophers the artist-models are not known, although the model for Euclid is thought to be the architect Bramante. The brooding, dark, lonely character near the bottom of the mural, leaning on his elbow and seemingly in deep concentration, is meant to be

Heraclitus, for whom the model is Michelangelo (1475–1564). The orthogonals (radial lines) of the one-point perspective employed converge on the two central characters seen at the top of the stairs: on the right, Aristotle (384–322 B.C.), and on the left, Plato (427–347 B.C.), for whom the model was Leonardo da Vinci. In the extreme lower right a cluster of four men engages in conversation, one representing Zoroaster (fifth century B.C.) and another, Ptolemy, each holding a globe. The second man from the right in that group, serving as host for the viewer, is the artist himself, Raphael. Historically the Renaissance artist, especially in the unique persona of Leonardo da Vinci, artist-scientist, preceded the Renaissance scientist in learning to observe nature, and especially how to ask the right questions, not just to hypothesize and introspect.

In two-point perspective there exist two vanishing points, and generally the subject, perhaps a building, is seen edge on. The center of gravity of each scene is the cube in the foreground. The upper and lower horizontal edges are extrapolated into the distance where they converge on a horizon line. The lines of perspective from four of the parallel edges of the cube converge at one of the two vanishing points, and the lines of perspective from four other edges (perpendicular to the first set) converge at the other vanishing point. In one instance the observer is above the top surface of the cube (Figure 7.2 B2); in the other the observer is below, looking upward at the bottom surface of the cube (Figure 7.2 B1). It is readily seen that if the cube is rotated about a vertical axis passing through the center of the cube, the vanishing points move horizontally along the line of sight, the horizon line.

An example of two-point perspective is seen in my own ink sketch (Figure 7.3). The scene is the northwest corner of the Supreme Court Building in Washington, D.C., where columns with ornate Corinthian capitals stand below the pediment. It is apparent that by rotating the subject around a vertical axis, one of the two vanishing points can be rotated to a point behind the cube, but then

VP-1 **VP-2**

Figure 7.3. Two-point perspective illustrated in the detail of the United States Supreme Court Building, Washington, D.C. (ink sketch by the author)

the other vanishing point will recede further into the distance on one side or the other. In the drawing, if the lines of perspective (drawn along the edges of the building) are extrapolated far enough, they would be found to converge at two separate vanishing points. These vanishing points VP-1 and VP-2 are located on the horizon line.

Figure 7.4. Three-point perspective illustrated in a view of Tom Tower, Christ Church, Oxford (lithograph by the author)

In three-point perspective three separate vanishing points are utilized in giving the scene depth, while emphasizing the height of a subject. The scene depicted is either looking down from a great height (such as an aerial perspective of skyscrapers), or looking up to a considerable height from ground level. As in the preceding cases the "center of gravity" of the scene is the cube. A normal, or perpendicular vector is constructed at the center of the bottom surface of the cube (dotted line) in order to define the direction of the third vanishing point, or where the lines extrapolated from the vertical edges of the cube all converge (Figure 7.4). The three vanishing points are VP-1, VP-2, and VP-3.

Finally, in four-point perspective, there are four vanishing points: two converge on the horizon line, and the other two, at a pair of points far above and far below the subject. A simple scenario can be invoked in order to visualize the vanishing points at the top and bottom: an observer is placed at the fifty-first floor of a building across the street from the 102-story Empire State Building. As the observer views the building, the top will appear to converge at a vanishing point far above the building, and so too the bottom of the building, which will appear to converge at a point far below ground level. (Four-point perspective has not been illustrated among these figures.)

The Golden Rectangle and Graphic Composition

So far, we have seen the golden rectangle and the law of divine proportion first as geometric constructions and subsequently as the generator of the logarithmic spiral, the pentagram, and the pentagon. In the last chapter we noted that many of the patterns and regularities encountered in nature were seen to parallel those mathematical constructs. The pyramids and the Parthenon were found to be related to the golden ratio. In the context of graphic art, the

Figure 7.5. The composition of the author's lithograph *Church Lane, Ledbury, England,* is based on the subdivision of the golden rectangle seen in the inset figure, the "sweet spot" located in the lower portion of the rectangle.

golden rectangle becomes an artifice to organize artistic composition. And indeed there is evidence that, whether consciously or unwittingly, artists often imbue their works of art with this proportion, select their vantage points accordingly, and wherever possible site their subjects so that certain lines emerge as especially natural. Many of these lines coincide with the geometric construction lines partitioning the rectangle, and many of these lines also coincide with the lines of perspective.

Initially a canvas with length-to-width ratio approximating the proportion of the golden rectangle is selected: a pair of sequential numbers of the Fibonacci series, for example, 21 by 34 inches on the imperial system or perhaps 100 by 162 centimeters (about 40 by 66$\frac{1}{2}$ in.). Although this scheme can be used equally effectively with the canvas configured horizontally or vertically, only the latter case will be demonstrated. The canvas positioned vertically has a full-width square delineated either in the upper part of the rectangle or in the lower part. The former is especially conducive to portrait composition, the latter to street scenes. The quadrilateral area formed by the intersection of the diagonals defines the "sweet spot" (akin to that on the face of a tennis racket), inviting placement of an especially salient part of the scene.

I used this scheme when I did my ink drawing *Church Lane at Ledbury, England* (Figure 7.5). The scene has considerable bilateral symmetry, one side virtually mirroring the other. The simple network of diagonals of the golden rectangle closely resembles the intricate lacework of perspective lines in the one-point perspective scheme examined earlier. The representational artist has artistic freedom—to select the angle, pick the correct time of day for proper lighting, lower or raise branches of trees, add people, and subtract people, but not to redesign a building. The use, at least by the author, of the technique described above,

reflects a belief that doing so will optimize the chance of rendering justice to the scene depicted and to the abstract requirements of art.

Fechner's Data

H. E. Huntley, writing about experimental aesthetics, reported studies by a number of German psychologists of the late nineteenth and early twentieth century regarding preferences for rectangles of different proportions.[10] In 1876 Gustav Fechner made an inventory of thousands of common rectangular shapes—from windows to playing cards, from book covers to writing pads—and found an unusually high occurrence of rectangles reflecting the shape of the golden rectangle. Subsequently, he canvassed large groups of people and tabulated their preferences for rectangles of different length-to-width ratios: 1:1, 6:5, 5:4, 4:3, 10:7, 3:2, $\phi = 1.618$, 23:13, 2:1 and 5:2. The results Fechner tabulated are presented as a table for ten different rectangles as 1, 2, 3, 4, . . . 10, respectively, and the associated histogram plotted as a bar chart (Figure 7.6). In the chart there appear bars at each ratio to indicate the actual preference in percentage of the individuals surveyed. As the bar chart shows quite clearly, the golden rectangle with length-to-width ratio of ϕ, is the overwhelming favorite among all the rectangles, having garnered 35 percent of the vote.

The results of similar studies by a number of other late nineteenth- and early-twentieth-century researchers—among them Adolf Zeising in *Der Goldene Schnitt* (1884), Witmar (1894), Lalo (1908) and Thorndike (1917), according to Huntley point unambiguously to a popular preference for rectangles approximating the golden rectangle.[11] Helen Hedian reported an analysis—within the framework of the golden ratio—on four hundred paintings "of accepted excellence."[12] According to Hedian, all but a few of the artworks yielded to

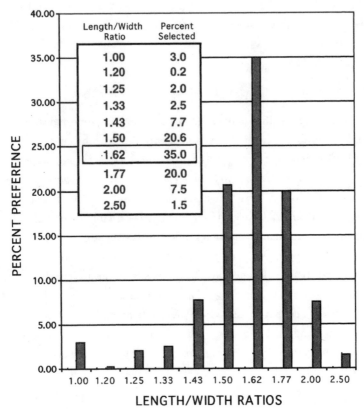

Length/Width Ratio	Percent Selected
1.00	3.0
1.20	0.2
1.25	2.0
1.33	2.5
1.43	7.7
1.50	20.6
1.62	35.0
1.77	20.0
2.00	7.5
2.50	1.5

Figure 7.6. Chart of Gustav Fechner's 1876 study revealing human affinity for the golden rectangle

such an analysis, with the majority of the works yielding $\phi = 1.618$ and a variation the $\sqrt{5}$-rectangle, i.e., 1:2.236 066. These and other values associated with the golden ratio and tabulated earlier (see Chapter 3) were found among the works she analyzed.

Hedian's inventory includes from the early Renaissance Giotto's *Ognissanti Madonna* (c. 1310) in the Uffizi. This painting displays lines of perspective and divisions of the golden rectan-

gle highly reminiscent of some of the geometric constructions encountered in Chapter 3. From the eighteenth and nineteenth centuries, she cites J.M.W. Turner's *Bay of Baise* (Tate Gallery, London) and George Romney's *Lady de la Pole* (1786; Museum of Fine Arts, Boston) as being susceptible to analyses in terms of the golden rectangle and its subdivisions. Among the paintings that she cites as having ratios close to 1:2.236 are Cézanne's *Still Life with Peppermint Bottle* of 1894 (National Gallery of Art, Washington, D.C.); Seurat's *Fishing Fleet* (c. 1885, The Museum of Modern Art, New York); Picasso's *Lady with a Fan* (1905; Harriman Collection, National Gallery of Art, Washington, D.C.); and Matisse's *Variation on de Heem* (1915). Finally, she cites a number of ancient works, among them an Egyptian stele (c. 2150 B.C.), an Assyrian winged demigod from the ninth century B.C., and the *Dying Lioness* from Nineveh, seventh century B.C., for inviting analyses in terms of the golden rectangle.

In the following pages I shall present my own sampling of masterworks incorporating geometric figures—polygons, polyhedra, the golden rectangle, logarithmic spiral, and others. The creators of these works have all been dominant figures of their respective times.

The Adoration of the Magi and the Golden Point

Spain can boast among its favorite sons El Greco, Diego Velázquez, Francisco Goya, Pablo Picasso, and Salvador Dali, some of the most influential artists in the history of art. Diego Velázquez's *Adoration of the Magi* (see Plate 7, left), displays a height-to-width ratio very close to ϕ. Moreover, as a near golden rectangle it can be neatly subdivided, delineating a square in the lower portion, with the upper portion again forming a golden rectangle. The rectangle in the upper portion is subdivided again, creating a square in the upper left and another golden rectangle on the upper right. The intersec-

tion of these lines, defining the golden point, is at the place between the infant Christ's eyes.

The Circus Side Show

Until the late eighteenth and early nineteenth centuries creative artists saw themselves as having an abiding task—to reflect nature. That was the message in Leonardo's words: "The most praiseworthy form of painting is the one that most resembles what it imitates." And a century later that sentiment was echoed by Shakespeare in *Hamlet* III: ii, "the purpose of playing . . . was and is, to hold as 'twere the mirror up to nature." In the Romantic period in England—in the poetry, first of Wordsworth and Coleridge, then Keats, Shelley, and Byron— the artist began to illuminate nature rather than to reflect it. (A similar transformation took place in music with the emergence of the Romantic composers—Beethoven, Schubert, and Chopin.) Impressionist and Post-Impressionist art would not have burst forth without this metamorphosis in outlook, nor Cubism a little later.

The postimpressionist artist Georges Seurat attempted to render the effects of artificial light at night using Pointillism, a technique that he personally invented. Inspired by a French translation of a lecture on artificial light by American artist James Whistler, Seurat formulated a scientific theory paralleling the ideas of Charles Henry (1859–1926), in which he cobbled together aesthetics and the physiology and psychology of the senses. Seurat, in describing his thoughts, wrote: "Art is Harmony. Harmony is the analogy of contrary and similar elements of tone, of color, and of line, considered according to their dominants and under the influence of light, in gay, calm, or sad combinations. . . . Gaiety of tone is given by the luminous dominant; of color, by the warm dominant; of line, by lines above the horizontal."

Seurat's works frequently incorporated the golden ratio, but none as prominently as *Circus Side Show* (*La Parade*) (Figure 7.7).[13]

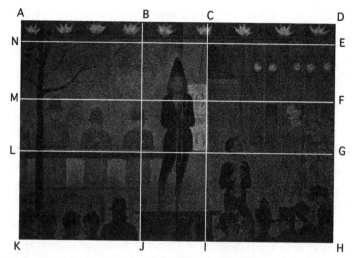

Figure 7.7. Geometric diagram overlaying Georges Seurat, *Circus Sideshow (La Parade)*, 1887–88. Oil on canvas, 39 ¼ × 59 in. The Metropolitan Museum of Art, Bequest of Stephen C. Clark, 1960.(Courtesy Metropolitan Museum of Art, New York)

Created near the end of his brief life, the painting describes the scene at the entrance to a traveling theater—free entertainment offered for the purpose of attracting audiences to attend the main event. Demarcations in color and texture offer clues to subdividing the canvas with vertical and horizontal lines, such as NE, CI, LG, etc. The rectangle defined by NEHK in the painting displays the ratio of length-to-width of approximately ϕ, making this portion of the canvas a golden rectangle. NCIK defines a square, rendering CEHI another golden rectangle. ϕ, in fact, is found at a minimum in the following four ratios:

$$\frac{MK}{AM} = \frac{KL}{ML} = \frac{AB}{BC} = \frac{CD}{BC} = \phi \; (=1.618...)$$

The multiple occurrence of the ratio is most likely a product of

Seurat's artistic intuition, a reflection of Fechner's findings. If he had been formally applying the law of divine proportion, he would most likely not have remained mute in describing the process, after all, he had not been shy in articulating his "scientific theory."

Circular Paintings, or Tondi

In Europe of the Middle Ages the circle had been regarded as a symbol for the divine or for heaven (as it was also regarded, for centuries, by Chinese philosophers). The reason for this may be that the circle is seen as an infinite-sided polygon with no beginning and no end. The earth, represented by a square with its sharply defined features, was symbolically subordinated to heaven by having the square circumscribed by the circle. The square, in turn, helps in generating equilateral triangles of angles 60°—60°—60° or isosceles triangles of angles 45°—90°—45°. By the time of the Renaissance the earth had risen to greater prominence, and man was the measure of all things. A triangular organization of composition circumscribed by a circular boundary was often used in the High Renaissance, for example in two prominent paintings: Michelangelo's *Holy Family* and Raphael's *Alba Madonna* (Plate 10).[14]

In Michelangelo's tondo, the artist's only known work to have been executed on canvas or panel, a geometric construction is found in a pair of interlocking triangles, evocative of the Star of David. (The horizon line defines one side of the star's lower triangle.) An intriguing feature of the painting is that the figures exhibit a porcelain-like translucent quality. But then Michelangelo, by his own claim, was first and foremost a sculptor. The figure of the Virgin Mary exhibits a helical shape used to produce depth and dynamism, first introduced by Leonardo. As for Raphael's *Alba Madonna*, embodying one of the finest pictorial compositions of the Renaissance, the painting was part of a collection purchased from the Hermitage in the early 1930s—the seller being the cash-strapped

Stalin, who never had much use for art. The three figures in the painting are organized in a triangular scheme—of a right isosceles triangle with the 90-degree angle at the top. An even more precise organizational structure that the trio exhibits, however, is three-dimensional pyramidal form, again influenced by Leonardo. Finally a helical twist in the Virgin's body, also a Leonardo influence, produces a sense of dynamism.

Dynamic Symmetry in Architecture, the Second Millennium

Dynamic symmetry was employed in antiquity—in the Egyptian pyramids 4,700 years ago, in the temples of Karnak and Luxor 3,300 years ago, in the Greek temples of the Age of Pericles 2,400 years ago and in Roman buildings a few centuries later—and persisted for several hundred years.[15] In great art and architecture in disparate times the scheme seemed to be reinvented—developed independently (notwithstanding the Greek influence on the Romans). The defining Byzantine architectural gem, the Hagia Sophia, was built in the mid-sixth century on a model of an interlocking hemisphere and regular polyhedra. Five hundred years later still the great Gothic cathedrals in western Europe were constructed, in some instances incorporating dynamic symmetry. In the Renaissance dynamic symmetry was rejuvenated as an accompaniment to interest in the scholarship and art of the classical world. In the following section we examine a pair of edifices—the cathedral of Notre-Dame in Paris, a masterpiece of medieval architecture, and the pair of Petronas Towers in Kuala Lumpur, a cathedral to commerce—both reaching upward toward heaven, built nine hundred years apart.

The Cathedral of Notre-Dame and the Petronas Towers

The years 1163 to 1250, virtually coinciding with Leonardo Fibonacci's lifetime, saw the erection of the most famous Gothic cathedral in all

of Christendom—the cathedral of Notre-Dame in Paris. Architectural historians offer elegant artistic and structural explanations for virtually all aspects of the remarkable edifice, rising so high toward heaven, with flying buttresses seemingly introduced as adornment instead of for the critical purpose of supporting immense walls weakened by colossal windows. But one can only speculate about how the architect chose the proportions of the various external sections—was it by chance, the aesthetic judgment of the artistic eye, or the application of the Fibonacci series? We may never know. The Fibonacci series was, however, just being formulated in Pisa, although the divine proportion derived from ϕ had long been known. What is

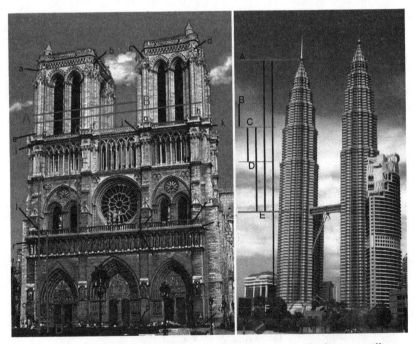

Figure 7.8. Two prominent works of architecture, built almost a millennium apart, both illustrating the recursive use of the golden ratio: *(left)* Notre-Dame-de-Paris; *(right)* Petronas Towers, Kuala Lumpur

clear is that the facade of Notre-Dame features the proportions embodied in the golden ratio (Figure 7.8, left). The various segments indicated as adjacent pairs of lines exhibit ratios close to that magic ratio, 1:1.618. Specifically, the following proportions are surprisingly accurate for the great medieval cathedral:

$$\frac{ab+bc}{ab} = \frac{ab}{bc} = \frac{de+ef}{de} = \frac{ef+fg}{ef} = \frac{ef}{fg} = \frac{fh+gh}{fh} = \frac{fh}{gh} = \phi$$

The surface *abfe* defines a square. With the rectangle *bcjf* added to it, the resulting surface has the shape of the golden rectangle. Similarly *cdqh* forms a square, but with the rectangle *bcjf* added to it, the resulting surface becomes a golden rectangle. Of course, *bcgf* itself is a golden rectangle. In the second course *ijml* forms a square, and with the golden rectangle *jknm* added to it, the resulting figure becomes a golden rectangle. The mirror reflection of these figures on the right hand side also satisfies the divine proportion. In the lower course *rspo* forms a square, but with the golden rectangle *stqp* added to the square, the resulting figure becomes a golden rectangle. The mirror reflection on the right also satisfies the divine proportion. Finally the entire west facade including the towers, displays proportions very close to those of the golden rectangle.

Applying the principle to new structures became a driving force behind Le Corbusier's architecture in the first half of the twentieth century. Other modern architects have also invoked elements of dynamic symmetry in their own creations. In the Halliburton Tower, at Rhodes College in Memphis, Tennessee, architect H. Clinton Parrent has used the proportions given by sequential terms of the Fibonacci series to arrive at the heights of the various courses. In the closing years of the twentieth century a far more imposing edifice than that tower—indeed a pair of towers connected by a bridge—was erected in Kuala Lumpur (Figure 7.8, right). The national oil company of Malaysia, Petronas, commissioned the twin towers that exceed the

height of the Sears Tower in Chicago, the previous holder of the title of the world's tallest building. The Petronas Towers (1998), designed by Cesar Pelli and Associates, rise 1,470 feet to proclaim Malaysia as a rising economic world power. In its structural design the base of each building is an octagon—a shape formed by an interlocking pair of squares, emblematic of the union of heaven and the earth. Massive columns of high-performance concrete and steel rise from each point of intersection of the squares in order to give structural integrity to the massive edifices, which are, on the surfaces, clad in stainless steel and glass. Then new sections appear to rise, reminiscent of the sections in a telescope, with a semblance of a mathematical pattern. A measurement of the segments reveals their proportions to fall into the scheme

$$\frac{AF}{AE} = \frac{CE}{DE} = \frac{DE}{CD} = \phi$$

reflecting the law of divine proportion.

Mirage, Image, Camouflage

In physics one proceeds by describing microscopic and macroscopic reality in terms of models at a tangible scale and writing equations for these models. By solving these equations one can hope to comprehend how and why nature behaves as it does. Physics can handle collisions of galaxies and collisions of individual atoms. But including all of the interactions extant may make the equations insoluble, or mathematically intractable. Ignoring some of the interactions and parameters may allow the equations to be solved. However, neglecting certain crucial interactions—such as gravitation in a problem at the cosmic scale or electromagnetic forces in a problem at the atomic scale—may make the mathematics relatively simple, but the associated physical description will no

longer reflect reality. One may end up describing a soap bubble instead of a boulder. A number of models exist to describe one phenomenon or another associated with the atomic nucleus—the liquid drop model, optical model, unified model, single-particle shell model, etc.—but no single model hitherto developed has been able to explain all the phenomena, all the processes. Moreover, such models are rarely the sources of revolutionary change in our fundamental understanding of the nucleus.

In contradistinction, truly transformative changes in science most often follow from inspiration received from unlikely sources and from viewing reality from different and original vantage points. Viewing nature in an entirely different manner may lead to radical syntheses. Einstein, by considering the speed of light as absolute while relegating the notions of length, mass, and time to relative status, launched the special theory of relativity. A generation later Louis de Broglie's suggestion that particles—molecules, atoms, nucleons—display a *dual* particle/wave nature turned out to be a pivotal hypothesis in launching quantum mechanics, the most successful picture of the world at the atomic scale.

So it is in art. When nature is observed in entirely different ways, and the description takes on entirely distinct styles, the possibility exists for a transformative revolution. The discovery of linear perspective launched the Renaissance in art, and in a much broader sense—by observing and pondering nature rather than idealizing it—planted the seeds of modern science. These were revolutionary in outlook and result. The impressionist movement in art was launched when the artist/observer in late-nineteenth-century France saw a need to capture the essence of the subject, rather than merely to reflect it. These movements in art compare in their significance in radical reductionism to the relativistic and quantum mechanical revolutions in physics. They showed the seminal and enduring qualities necessary to qualify as transformative revolutions.

Ultimately, the scientist and the artist, both in the business of describing nature, are receptive to shapes and patterns—to real images, static or fleeting, as well as to optical illusions. In the following pages we shall consider a few instances of how nature might have presented itself to the artist, and the bold manner in which the artist has dealt with the subject. The works are those of M. C. Escher, Bev Doolittle, and Frederick Hart. Their work is not revolutionary or transformative. Rather they each exemplify a single, even a narrow and confined manner, of modeling and representing nature. And like the physicist's models of the nucleus, each method of representation is by no means all-inclusive or all-embracing. They successfully show us, in a way similar to the physicist's tangible scale models, how some, but not all, of the phenomena of perception work on us. This short catalogue also presents some minor musings by Leonardo da Vinci, and the techniques that these ruminations appear to have inspired.

M. C. Escher wrote about having received inspiration for his graphic art in part from viewing the tile work of Islamic artists in Spain, but reflected, "What a pity it is that Islam did not permit them to make *graven images.*" Unencumbered himself by such religious interdicts, he utilized animate as well as inanimate, realistic as well as mythical figures with abandon. Many of Escher's symmetrical musings were tantamount to mathematical mosaics. In his well-known woodcut *Horsemen* we see figures on horseback in white appearing to travel to the right, and similar figures reflected and darkened, heading leftward. In a different period of his career Escher unveiled graphic art in which the figures undergo gradual evolution, a style he dubbed "metamorphosis."

Camouflaged Art: Cryptotechne [16]

I think that to find meanings you have to look at things from different directions.[17]

—Bev Doolittle

Bev Doolittle's pronouncement is as pertinent for the scientist as it is for the artist. This contemporary Western artist displays a distinctive style—seamlessly blending animate life in the foreground with the inanimate background. White pintos with brown blotches are set against patches of clay amidst pristine snow, other horses with native riders astride are seen through clumps of aspen trees, or a grizzly bear is barely visible, camouflaged by dense thicket. Gestalt psychology, the subject of which is shape recognition, describes how the human mind is able to process an image with little difficulty and to distinguish the foreground from the background (Plate 11, bottom). Computers, programmed to scan the scene for color differences and shapes, would have a virtually impossible task identifying the horses. This is mimicry in nature celebrated in art. Doolittle's work displays simultaneously a realistic and abstract quality, and rarely is it clear whether to classify it as one or the other. What is evident, however, is that it always engages the viewer, forcing him to take a second and a third look, and indeed to become a participant in the scene. Doolittle's works radiate an unequivocal message that things are rarely what they seem—an unfaltering missive also for scientists practicing their art.

Mimicry in nature manifests itself in physical characteristics developed by animals to camouflage them against the background— the predator to become more effective as a hunter, and the prey to blunt the effectiveness of the predator. The mighty polar bear, unchallenged in its position at the top of the food chain, nonetheless optimizes its hunting prowess by virtually fading into the ice and snow of its background. On a different scale the praying mantis similarly dissolves into its background—blades of grass or green twigs on which it perches in wait for its food. The viceroy, a butterfly that is a delicacy to some birds, has evolved to resemble closely the monarch, a butterfly entirely unpalatable to the same birds. Unwilling to take a chance, birds steer clear of the viceroy. But then there is the puzzling case of the zebra. The bold black and white

stripes make the zebra as inconspicuous as a lavender hippopotamus or, worst still, a *zebra*. Has nature blundered in this instance? Not at all! A herd of agitated zebras melds into a vast terrifying monolith, generating clouds of dust and galloping thunder, the individual animals virtually indistinguishable in the maelstrom, thereby confusing predators.

Even in the category of hidden images we recognize a Leonardo connection. A man of great personal charm and humor, and eager to interject some irony in his works, Leonardo planted hidden ironies and double entendres in his paintings and drawings. The portrait of Ginevra de' Benci at the National Gallery of Art in Washington (which we will take up further in Chapter 9) is a double-sided painting—the portrait of the young woman on the recto and flora on the verso—a laurel and palm framing a juniper twig. In Italian the word for juniper is *ginepro*, clearly a play on the subject's name. Among the anatomical drawings in the *Codex Windsor* is the detailed drawing of a cow embryo. Leonardo must have had a smile on his face when he invoked some subtle "cryptotechne," inserting the inverted image of a cow in the drawing. The image is unmistakable once it is pointed out, but subtle it is. Meanwhile, prepossessed by the exquisite shapes of nature, perhaps even cognizant of their mathematical connection, Leonardo must have noticed the smoothly arched, ever-widening curve of the logarithmic spiral describing the shape of the embryo itself. It has a similar shape to the human embryo at about six weeks.

ANAMORPHOSIS

Perspective, as we saw in the last chapter, helps to project a three-dimensional image onto a two-dimensional plane. It assists in rationalizing the relationship of the objects within the scene, and simultaneously the relationship between the viewer and the scene. One-point perspective had its birth among artists in the Renaissance, and in subsequent centuries developed in the hands of artists and

mathematicians. The mathematical formalism underlying perspective is found in projective geometry.

Having opened this chapter with an examination of perspective, we shall close it with a discussion of perspective carried to an extreme, the artist observing his subject from an altogether unusual vantage point, sometimes a well-defined peephole. The result is anamorphoses. The etymology is not entirely clear—the word may have its roots in *ana* (again) and *morphe* (shape), suggesting that the viewer has to take an active part in the realization of the image, or it could be derived from *an* (meaning absence of or without) and *morphe*, thus "shapeless." Although the root of the word is not unequivocal, the description of the work itself is correct in both senses. The image certainly appears "shapeless," and it clearly requires the active participation of the viewer, looking again and again

The first known work utilizing anamorphic art dates from 1485. At first glance it looks like a puerile drawing depicting an infant (Figure 7.9). An infant the subject is, but puerile this artist is not. The slit of the eye is much shorter and the slope of the chin more pronounced on the right, with the distortion increasing gradually as one moves to the left. That asymmetry offers a clue—the picture is meant to be viewed from a grazing angle, from the right edge of the sheet. The sketch is introduced unobtrusively and without explanation among the pages of Leonardo da Vinci's *Codex Atlanticus*.[18] Having invented anamorphic art, Leonardo most likely produced

Figure 7.9. Leonardo's anamorphic art. The image of the face appears to "float" above the page.

other examples. Francesco Melzi, Leonardo's assistant and heir to the Leonardo manuscripts, described having seen a drawing of a "[D]ragon and lion in combat . . . a wonder to behold"—the illusion created by this graphic distortion. This work, however, has not survived.

In the sixteenth and seventeenth centuries other prominent artists, including Caravaggio and Annibale Carracci in Italy and Hans Holbein in the north, experimented with anamorphic art. The Venetian Giovanni Battista Tiepolo, known for his magically illusionistic ceiling and dome paintings, became an unrivaled master of the style, but then the technique seemed to lose its appeal, except as a source of fascination for scientists examining optical themes or experimenting with virtual reality. Often this art is seen in the form of a swirl of color, entirely unrecognizable in form and perspective. But when the proper reflector—the one specifically used in creating the painting in the first place—is placed in the designated spot, the painting regains proper perspective and springs to life.

Optical Illusions versus Gestalts

In Chapter 5 we encountered the remarkable lengths to which the builders of the Parthenon—Phidias, Callicrates, and Ictinus—went in order to obviate detracting optical illusions. Among various tricks employed was the convex curvature that the base of the building was given as an artifice to eliminate the "sagging" look that a straight horizontal base would normally present when viewed against the convex curvature of the horizon. They had also aimed the axes of the columns to converge far above the building, partly to negate the splayed appearance of the columns rising from a con- vex base and partly perhaps to create an illusion of great height. This is reminiscent of three-point perspective—which would not appear formally for another two-and-a-half millennia.

During the classical period of Greece, along with the notion of

the divine proportion, optical tricks were skillfully applied. The Greeks knew a good deal about detracting optical illusions and how to counterbalance them, and they are believed to have known about perspective, at least intuitively. Optical illusions were most likely recognized, however, long before the classical Greek period. With optical illusions our senses deceive us, and we can only confirm that this is so if we make measurements. The effect of lines or colors judiciously arranged throws off one's perspective.

A rectangle ABCD and a parallelogram A' B' C' D' have been constructed, each with the convenient long-side to short-side ratios of 1.618:1 (Figure 7.10). Indeed, the former is a golden rectangle; the latter is reminiscent of a golden rectangle seemingly distorted by a pair of horizontal shearing forces. In the rectangle the segment MN bisects the segment AD, and the diagonals AN and ND help to generate the isosceles triangle AND. These diagonals are of equal length. In the case of the parallelogram, the segment M'N' certainly does not bisect A'D' and the segment A'M' certainly does not equal the segment M'D'. And at first glance the diagonals A'N' appears to be shorter than the diagonal N'D'. In reality, however, A'N'D' also defines an isosceles triangle as did AND. *Thus A'N' does in fact equal N'D'*, as a measurement would immediately confirm. Indeed, it is an optical illusion that makes A'N' appear to be shorter than N'D'. In distinction to optical illusions there are Gestalts, which are the visual perceptions of shapes and patterns of natural formations—permanent or ephemeral—and their inadvertent association with familiar phenomena.

Inspiration in the Clouds

It is unusual that a pattern as frequently seen in nature as the logarithmic spiral has not found more frequent application by artists. Earlier we saw how the logarithmic spiral was generated geometrically from the golden rectangle, and subsequently the ubiquitous

Figure 7.10. Example of an optical illusion. The segment $A'N'$ appears to be shorter than the segment $N'D'$, although they are precisely the same length.

quality of the spiral was seen in patterns in nature, "accidentally" in man's creations, or in an entirely different phenomenon, in the trajectory of the malfunctioning Trident missile (see Plate 4).

In classical antiquity the shape inspired the basic designs of Ionic capitals, and, emulating the horns of rams, it was used in women's jewelry. I have personally encountered only two modern works prominently featuring the spiral, and both created within a few years of each other, both in the National Cathedral in Washington, D.C. The first, a window created in 1974 by stained-glass artist Rodney Winfield, commemorates NASA's Apollo XI, which in 1969 made its way to the moon and returned with lunar samples (see Plate 2, right). In the *Space Window* an elongated figure 8 embodies simultaneously a double connotation—the trajectory of the spacecraft and the symbol for infinity. Indeed, the work, according to its creator, is rife with symbolism: a melding of the infinitesimal and the infinite scales of space, and the fleeting and

the eternal scales of time. The lower circle on the right is at once the earth and the moon (seen in total eclipse); the lower circle on the left alludes to vast galaxies (including the Milky Way) and to star-gobbling black holes. In the mode of many abstract works, it invites subjective interpretation. There is the obvious allusion to manned space exploration. The space engineer gazing at the image might see the lunar-lander separating from the spacecraft, leaving the lunar-orbiter aloft, and spiraling onto the lunar surface; the physicist would recognize representations of escape velocity and orbital velocity—subjects of Newtonian mechanics. Ultimately, it is art celebrating cutting-edge science and technology. Aside from that aspect, there is for me one additional intriguing element in the window: the occurrence of a perfect logarithmic spiral—not Archimedean, nor hyperbolic, nor any other kind. It is in the upper circle that the logarithmic spiral is seen, converging on a piece of moon rock—3.5 billion years old—embedded in the window, and creating a virtual eyepiece to the mysterious.

The second example—subtle and exuding extraordinary power—is *Ex Nihilo* (see Plate 5, bottom) by Frederick Hart, who employed the logarithmic spiral intuitively in organizing his composition. In 1974 the sculptor, then thirty-one years old, was awarded the commission for three friezes in the cathedral's west facade—it is perhaps the most significant religious sculpture of the twentieth century. In architectural terms, the description of the sculptural program comprises the three portal tympana, each supported by a central column figure—one of Saint Peter, another of Adam, and a third of Saint Paul. A carving representing the creation of humans, *Ex Nihilo*, was to be located in the central portal and the creation of day and night, respectively, in the two flanking portals.

Hart's friend, the author Tom Wolfe, described the frieze as "depicting mankind emerging from the swirling rush of chaos."[19] "Swirling rush" is indeed an appropriate description for that maelstrom of eight bodies seemingly issuing forth spontaneously from

bedrock. But perhaps the inspiration for the composition was in the subliminal messages we receive from nature and its patterns in sunflowers, hurricanes, and chambered nautiluses. The inset (see Plate 5, bottom) presents the mathematical logarithmic spiral, the cross-section of the chambered nautilus, digitally overlaid on *Ex Nihilo*, Hart's masterpiece.[20] In organizing the composition a "best fit" can be made with the curve passing through the elbows of at least five of the figures.

Born in 1943, Hart, at just fifty-four, suffered a stroke in the right hemisphere of his brain, leaving him partially paralyzed on the left side, and at least temporarily curtailing his prodigious pace. Even though he was a right-handed sculptor the damage to the emoting, nonverbal side of the brain had put limitations on his ability to perceive objects in space, although "he was still able to conceptualize, formulate ideas, process the sensual underpinnings of those ideas, and create an expression of those ideas in a newly created image."[21] With heroic will and intensive physical therapy he regained some of the use of his left arm. Overcoming the reduction in spatial perception—the ability to perceive (not just to see) both his subject and his rendering required additional effort. He made progress in this area by concentrating harder and using mirrors as well as a specially modified camera.

Eighteen months after his stroke, in August 1999, Hart was diagnosed with cancer, and just three days later succumbed to the ravages of the disease. He was two months shy of his fifty-sixth birthday. Although I knew and admired him immensely, I never got the chance to discuss with him the logarithmic spiral that appears to organize the composition of the frieze. But I am convinced it was decidedly not a conscious exercise; in his own words he once explained, "I saw *Ex Nihilo* ('out of nothing') as a single expression of creation, as the metamorphosis of divine spirit and energy. The figures emerge from the nothingness of chaos, caught in the moment of eternal transformation—the majesty and mystery of

divine force in a state of becoming." His widow, Lindy Hart, explained that it had been a swirling pattern "in a formation of clouds" that inspired her husband, but added, "Rick would have been captivated to see the [logarithmic] spiral superimposed." Tradition has it that Michelangelo similarly received his vision of the Creation scene for the Sistine Chapel from an ephemeral cloud formation.

As for the episode of Hart's stroke, it parallels the effect of a similar stroke that the left-handed Leonardo suffered in the left hemisphere of his brain, partially paralyzing his right arm, and, in his case, effectively ending his career as a painter. For artistic creativity to thrive, the conjoining of both hemispheres of the brain appears to be important, or perhaps the various functions are not altogether the exclusive domain of one side or the other—at least in the examples of these two artists.

Putting φ into Perspective

Regarding the significance of ϕ in works of art there are both unbridled enthusiasts and outspoken detractors, each group ready to offer uncontestable evidence to corroborate its views. Each, to me, is correct on one level, and incorrect at another. Among the enthusiasts ϕ is attributed to successful schemes in virtually every creative enterprise—in art, musical composition, poetry, even investing in the market. And indeed, if we look hard enough, we are bound to find an unlimited number of examples among man's creations in which the golden ratio occurs. One has to assess each piece separately, and guard against reading between the lines. Among detractors (especially among a number of mathematicians) there is strident protest: the Parthenon's end facades do not display exactly 1:1.618, but rather 1:1.71; the outline of the Great Pyramid, makes a length-to-width ratio of 8:5 (translating to 1.60). Both buildings are, nonetheless, *close* to 1.618 in their proportions. And

in the case of the Great Pyramid rising at 52°, it is not the ratio of length-to-width that is unusually intriguing, but rather the ratios of the areas of the sides. (The analysis indeed suggested that it was a happy accident, a result of the convenient scheme of taking the pyramid's perimeter to be 2π times its height that produced the recurrent ratio 1.618 in the variety of area measurements.)

As a scientist and artist, however, I am convinced that there is a subliminal message that the artist picks up from nature that provides the basis for a sense of proportion, and it is this sense of proportion that manifests itself in so many artists' works. That is the simplest and most likely explanation of the ratio's appearance in paintings by Velázquez, Dali, and Seurat. The evidence of our affinity for the ratio is unmistakable in Fechner's data. The codification occurs formally only in a limited number of "systems" such as in the music of Bartók, Debussy, and Schillinger,[23] in the architecture of Vitruvius, Bramante, and Le Corbusier, in the paintings of Mondrian, possibly also those of Seurat. But the single artist that most likely cobbled together mathematical form and artistic design consciously is the scientist-artist Leonardo, and even he does not speak explicitly about the subject. The evidence is in the grand mélange of the mathematical musings, studies in perspective, formal drawings, illustrations in De divina proportione, quick sketches, and the finished paintings—all forming pieces of an elaborate puzzle.

The eye is the window to the soul.

—Leonardo da Vinci

Chapter 8

The Eye of the Beholder

and the Eye of the Beheld

*A*mong all his scientific and artistic studies, Leonardo allotted disproportionate attention to light and the body's detector of light, the eye. He experimented with the optical phenomena of reflection and refraction, created reams of drawings of geometric optics in order to understand the behavior of light incident on multifaceted as well as uniformly curved surfaces, and performed exquisite anatomical dissections on the eye itself. Unhappily, he accorded little attention to the structure and function of the brain (unless such work was presented in his missing manuscripts, for we only have one-third of the origi-

nal volume he produced). When he created his astonishing portraits, the eyes of the subjects spoke (or withheld) volumes in accordance with its artist's own vision and perfect artistic control. The ambiguity portrayed in the Mona Lisa's mesmerizing visage represents Leonardo's insight into light and optics, as well as psychology.

The quality of art one produces is as much a function of how one observes as of how one wields a pencil, a paintbrush, or a chisel. Observing is a collaboration of the eye sensing and the brain processing. In childhood, drafting skills continue to improve until we are around ten years old.[1] But then 95 percent of the population begins to display regression in their drawing prowess. Rather than focusing on their subject—that is, consciously observing—they summon subconscious preconceptions and transfer to their drawing boards what they *think* their subject looks like. By their middle years, in the unlikely case that they actually pick up a pen and pad to sketch the face of an individual, they have generally fallen into the habit of placing their subject's eyes higher and higher in the face. The eyes belong on the equator. The remaining 5 percent continue to improve, drawing what they observe. They comprise the roughly one person in twenty whom we characterize as possessing some measure of artistic ability. In teaching nonartistic adults how to draw, Betty Edwards in a modern classic, *Drawing on the Right Side of the Brain*,[2] suggested a remedy: take a photograph of the subject and mount it upside down. Then, draw what you see.

Workshops using Edwards's ideas endeavor to teach students techniques enabling them to access the nonverbal, spatially oriented right brain, best suited for observing and drawing. The question that arises here is whether there is any evidence of physiological and functional differences in the brains of artists and nonartists.

The Painter's Eye[3]

That artistic talent could be detected scientifically might have sounded

absurd until a series of experiments in the 1990s revealed that perhaps it is not such a laughable notion after all. The gifted English representational artist Humphrey Ocean and a personal friend, scientist John Tchalenko, collaborated in a series of studies. As reported by writer Alan Riding, while Tchalenko and his camerawoman, Belinda Parsons, were videotaping Ocean, Ocean was creating a portrait of them.[4] In the early 1990s the documentary film produced by Tchalenko and Parsons, along with Ocean's artwork, were shown in exhibitions at a number of leading galleries in the United Kingdom. Near the end of the decade, Tchalenko revisited the time-encrypted videotapes produced almost a decade earlier and discovered a pattern in Ocean's artistic technique previously overlooked. The discovery inspired Tchalenko to undertake further experimentation.

In 1998 he drafted neuroscientists from Oxford University and Stanford University who used state-of-the-art biomedical imaging technology. These new experiments on Ocean focused on the interactions between his eyes, hand, and brain. Moreover, they involved his conscious as well as unconscious responses. These results were compared with test results of nonartists performing similar tasks and were presented together in 1999 at the National Portrait Gallery exhibition *The Painter's Eye*. The three scientific sections of the exhibition carried the titles "The Eye Captures," "The Hand Implements," and "The Brain Processes." "The Eye Captures" experiment examined the actual process of observation exercised by the artist and was performed by the team headed by Christopher Miall of the physiology department at Oxford. The regularities and other patterns Tchalenko had observed in viewing his old tapes were in fact what had fueled this aspect of the new study. Using a special eye-tracking camera, the researchers performed measurements on the artist's eye movement while he was selecting a subject and while he was actually executing his art. In choosing a subject from four candidates, Ocean was found to perform rapid eye fixations, as often as 140 times in one minute, focusing on each candidate's features—the nose, the eyes, the coun-

tenance, and other abstract requirements that the artist might envision for his work. In commencing with the drawing he altered his pace, glancing up at his subject on the average of 12 times per minute, taking mental snapshots of one-second duration. Thus 20 percent of his working time was spent in observing his subject. During the five hours Ocean spent producing his drawing, one hour was invested in looking at his subject. When nonartists were tested, no regular patterns in their observations were found. Their fixations were simply far less methodical in manner.

The second experiment, "The Hand Implements," examined eye-hand correlation as Ocean toiled on a sketch. He had been given a finite amount of time—just twelve minutes—to complete his drawing of a subject's face. A sensor measured motions of his pencil on and off the paper and determined that his hand would practice strokes with his pencil just millimeters above the paper before actually landing the pencil on the paper to create a line. As Ocean characterized this procedure, "In all my work, I'm after precision. 'Detail' means where the line lands, and if it lands a millimeter to the right or a millimeter to the left, it changes the weight, in some way, or the shape that it is describing. So when the line lands, you want it to land in the right position, whatever that is."[5]

The third section of the exhibition, and the one that involved the latest biomedical imaging technology, also revealed the most unexpected differences between the brains of the artist and the nonartist. The Oxford researchers had made quantifiable correlation in hand-eye activity for the artist and nonartist, but producing brain images was not part of their experiment. Ocean and Tchalenko were to find the last bit of their puzzle at Stanford University, where functional magnetic resonance imaging (fMRI) tests were carried out on Ocean and two nonartists by Robert Solso and his team. Each of the subjects, including Ocean, was provided with small sketch pads and a set of five abstract figures to reproduce on their sketch pads while they were lying in the confines of the machine.

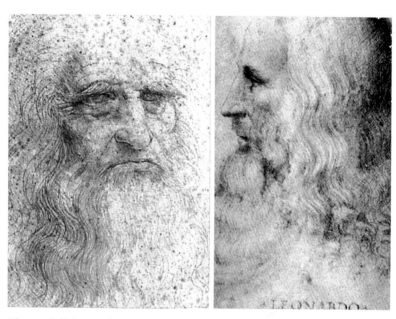

Plate 1. *(left)* Leonardo da Vinci, *Self Portrait*, c. 1512–1516. Red chalk on paper. Biblioteca Reale. *(right)* Pupil of Leonardo da Vinci (possibly Francesco Melzi), *Portrait of Leonardo da Vinci*. Red chalk on paper, The Royal Collection, H. M. Queen Elizabeth II, Windsor Castle. (Windsor Castle, Royal Collection © Her Majesty Queen Elizabeth II)

Plate 2. Examples of geometry in stained glass. *(top)* Marc
Chagall, stained-glass window for the United Nations
Building, New York. *(center left)* Roy Miller, stained-glass
chandelier in the shape of a truncated icosahedron (con-
sisting of hexagons and pentagons, subdivided into trian-
gles); *(bottom left)* Roy Miller, Penrose tiling; *(bottom right)*
Rodney Winfield, *Space Window*, 1974. (Chagall stained
glass, © 2004 Artists Rights Society (ARS), New
York/ADAGP, Paris. *Space Window*, photo by the author,
permission of the National Cathedral, Washington, D.C.)

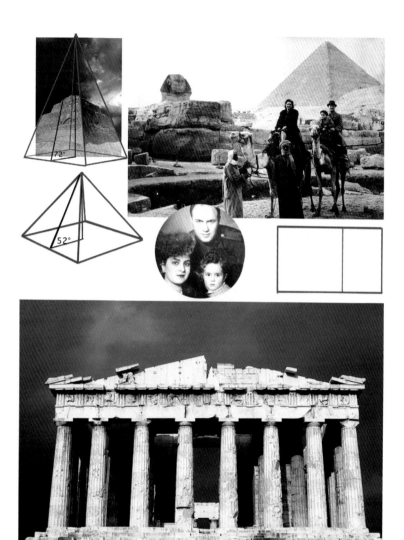

Plate 3. *(top left)* The collapsed pyramid in Maydum. The sides of the tower (or core), when extrapolated, form a 72°—36°—72° triangle—a golden triangle. *(top right)* Photograph of the author as a child with his family on a visit to Cairo in front of the Great Pyramid of Khufu (Cheops). *(center left)* The golden pyramid, in red outline, rising at a 52° angle on its sides; *(center right)* The golden rectangle, in red outline; *(bottom)* The Parthenon viewed from the southwest

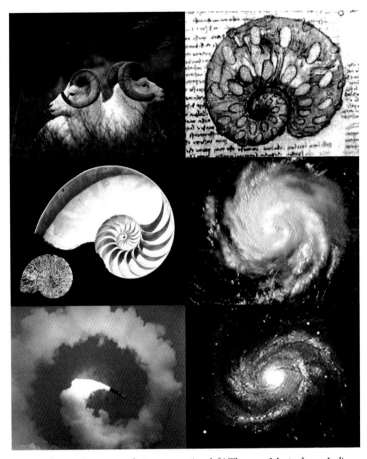

Plate 4. Logarithmic spirals in nature. *(top left)* Thomas Mangelson, *Indian Summer —Dall Rams; (top right)* Leonardo's drawing of cow embryo with a hidden image of an upside-down cow, 1506–8, *Codex Windsor* 52 recto, The Royal Collection, H.M. Queen Elizabeth II, Windsor Castle; *(center left)* The shell of the chambered nautilus; *(small inset, center left)* a fossilized ammonite, a distant ancestor of the chambered nautilus; *(center right)* Hurricane Andrew (1992); *(bottom left)* The launch of a Trident Missile, but with malfunctioning engine nozzle. *(bottom right)* Spiral Galaxy "Whirlpool," M51. (*Indian Summer— Dall Rams* © Thomas D. Mangelsen / Images of Nature; *Codex Windsor*, Windsor Castle, Royal Collection, © Her Majesty Queen Elizabeth II; Chambered nautilus and inset ammonite, photographs BIA, Hurricane Hugo, satellite image, National Oceanic and Atmospheric Administration (NOAA). Galaxy M51, Hubble image, NASA. Trident Missile, photograph by Bill Sikes, © The Florida Times-Union.)

Plate 5. Logarithmic spirals in art and architecture; *(top)* The double circular staircase in the Vatican Museum, designed by Leonardo da Vinci; *(bottom)* Frederick Hart, *Ex Nihilo*, Washington National Cathedral *(center right inset)* with a logarithmic spiral superimposed. *(Ex Nihilo* photo by author, permission of Washington National Cathedral)

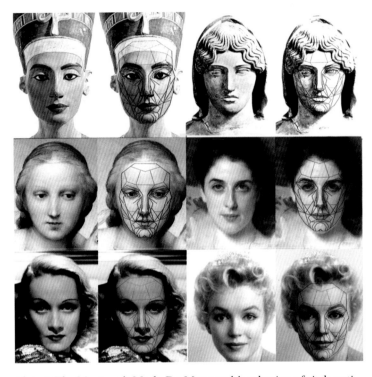

Plate 6. The Marquardt Mask. Dr. Marquardt's selection of six beautiful women from history, seen alone and overlaid with the ϕ–Mask. *(top left)* Portrait of Queen Nefertiti (c. 1350 B.C.); *(top right)* head from the statue of Aspasia, mistress of Pericles (fifth century B.C.) *(center left)* the portrait of the Virgin in Raphael's *Cowper Madonna* (1505); *(center right)* John Singer Sargent's *Portrait of Lady Agnew* (1893). *(bottom left)* Marlene Dietrich (1936) *(bottom right)* Marilyn Monroe (1957). (Matrix, Courtesy Stephen Marquardt. Monroe photograph, permission Milton H. Greene Estate)

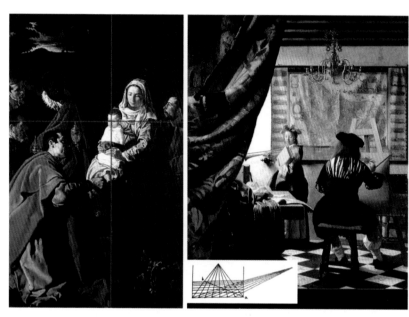

Plate 7. *(left)* Diego Velázquez, *Adoration of the Magi*. Oil on canvas,
Prado, Madrid. The entire canvas forms a golden rectangle. *(right)*
Johannes Vermeer, *The Art of Painting*, c. 1666–67. Oil on canvas,
Kunsthistorisches Museum, Vienna. *(inset, center bottom)* Leonardo's
perspective construction for tiling

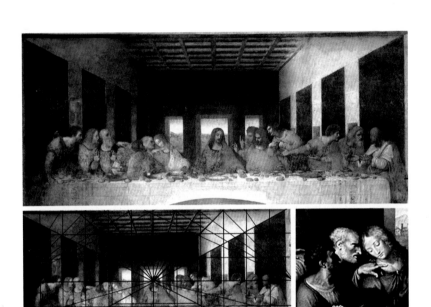

Plate 8. *(top)* Leonardo da Vinci, *The Last Supper*, 1498. Oil with tempera grassa, refectory of Santa Maria delle Grazie, Milan. *(bottom left)* This perspective study closely parallels the analysis by art historian Martin Kemp. *(bottom right)* A detail of Raphael Morghen, *Last Supper*, c. 1800, engraving inspired by Leonardo's mural. (Leonardo da Vinci, *Last Supper*, © Alinari/Art Resource, New York. Copy by Morghen, courtesy private collection)

Plate 9. Raphael, *School of Athens*, c. 1510, *Stanza della Segnatura*, Vatican
Palace, superimposed with the lines of one-point perspective. Proceeding
clockwise, the two central figures on the top step are Plato (depicted in
the likeness of Leonardo da Vinci) and Aristotle (model unknown); just
below Aristotle and sprawled on the steps is Diogenes. The quartet of
standing characters on the bottom right are Ptolemy, Zoroaster, Sodoma,
and Raphael. Just to their left and hunched with a compass in hand is
Euclid demonstrating geometric proofs to his students. Near the front
center the pensive, dark, brooding figure with an elbow on a chest is
Heraclitus—the model, Michelangelo. Just to his left, with scroll in hand,
is Parmenides, to the left of Parmenides, scribbling on a drawing board, is
Pythagoras, and looking over his shoulder, the Arabic scholar Averroës. In
the lower left are Epicurus and Xeno ("the Skeptic"). Finally, one trio on
the top step in the upper left comprises Alexander the Great, Xenophon,
and Socrates. (© Erich Lessing/Art Resource. New York)

Plate 10. *(top)* Raphael, *The Alba Madonna*, c. 1510. Oil on panel transferred to canvas, National Gallery of Art, Washington, D.C. *(bottom)* Michelangelo, *The Holy Family with the Infant Saint John the Baptist (the Doni Tondo)*, c. 1503–10. Tempera on panel, Galleria degli Uffizi, Florence (Raphael, *Alba Madonna*, photo courtesy National Gallery of Art, Washington, D.C.)

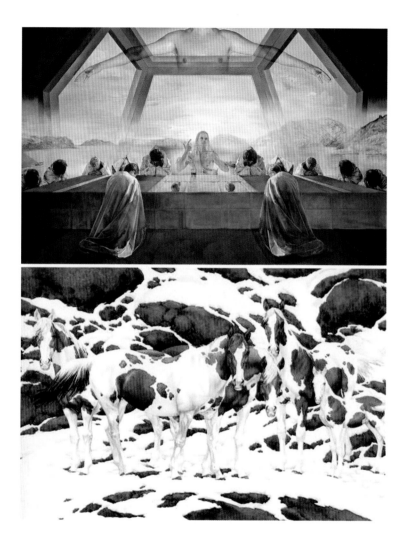

Plate 11. *(top)* Salvador Dali, *Sacrament of the Last Supper,* 1955. Oil on canvas, National Gallery of Art, Washington, D.C. *(bottom)* Bev Doolittle, *Pintos,* 1979. Watercolor, private collection (Dali, photo courtesy National Gallery of Art, Washington, D.C.; Doolittle, courtesy Bev Doolittle.) Doolittle's original image has been cropped here to fit the plate.

Plate 12. Christopher Tyler's center-line principle, illustrated *(top)* by his matrix of nine classic single-subject portraits spanning five centuries and *(bottom)* Jamie Wyeth, *Portrait of John F. Kennedy*, 1967. Oil on canvas, collection of the artist. The vertical line divides the width of the canvas in a proportion of 1:1.618 (portrait of Kennedy, by permission of James Wyeth)

Plate 13. Six self-portraits by Rembrandt van Rijn. The artist painted about sixty self-portraits. These six reflect the 5:1 disparity in a left-cheek preference over the right in all of his self-portraits (remember: the "left" cheek reflected in the artist's mirror is actually his right). *(top, left to right)* as he appeared at age twenty-three (1629, Mauritshuis, the Hague); at twenty-eight (1634, Galleria degli Uffizi, Florence); and at fifty-eight (1658, Frick Collection, New York); *(bottom left to right)* the artist at age sixty-three (1669, English Heritage, Kenwood House, London); at sixty-six (1669, National Gallery, London); and at fifty-three (1659, National Gallery of Art, Washington, D.C.)

Plate 14. Leonardo, *Virgin of the Rocks*. Oil on wood, transferred to canvas, Musée du Louvre, Paris. Commissioned in 1483 to hang as the altarpiece of the Immaculate Conception in Milan. *(inset, top right)* The golden pyramid superimposed on the four figures. Viewed as a flat image, however, the outer edges of the pyramid form two sides of an isosceles triangle of angles 45°—90°—45° (Permission Musée du Louvre)

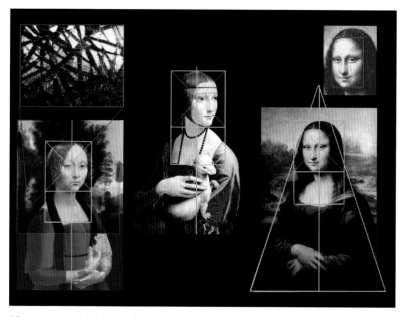

Plate 15. Leonardo's three famous portraits of women: *(left) Ginevra de' Benci,* (shown with the missing right edge and the lower third of the panel restored digitally). Oil on panel, National Gallery of Art, Washington, D.C.; *(center) Lady with the Ermine (Portrait of Cecilia Gallerani),* 1491. Oil on panel, Czartoryski Collection, Kraków. *(right)* The *Mona Lisa.* Oil on panel, Musée du Louvre, Paris. In each of the portraits a golden rectangle has been superimposed incorporating the head and upper chest (down to the bodice) of the subject. Subsequently, a square has been delineated in the upper portion of the rectangle, the height of the head determining the size of the square. The diagonals of the squares intersect at the "compositionally dominant" eye of the subjects. The vertical line bisecting each portrait passes through or very close to an eye, in accord with Christopher Tyler's center-line principle. *(inset, top left)* The site of Leonardo's fingerprints. *(top right)* One simple interpretation has just the *Mona Lisa's* face framed by a golden rectangle. Her figure is organized by the golden triangle (72°—36°—72°) (Photograph of Leonardo's fingerprints in *Ginevra de' Benci* by David Bull. Permission National Gallery of Art, Washington, D.C.)

Plate 16. Telescopes spanning five hundred years. *(top left)* Leonardo's study of light rays reflected from a concave reflector, and on the same sheet, a cylindrical tube mounted on an adjustable mount, *Codex Atlanticus; (top right)* The Hubble space telescope, a descendant of Newton's reflector; *(bottom left)* One of Galileo's refracting telescopes, Museum of the History of Science, Florence; *(bottom right)* Replica of Newton's reflecting telescope, Museum of the Royal Society of London. (Hubble telescope, courtesy NASA)

With *f*MRI one can pinpoint the areas of the brain where various mental functions are being carried out. Blood rushes to the parts of the brain requiring oxygen to process a particular function, a particular operation, performing a mathematical calculation, or creating a work of art. The *f*MRI studies on artist Humphrey Ocean and on the nonartist are wonderfully revealing. During the drawing sessions in which the nonartist made drawings while inside the machine, the parts of his brain involved in accomplishing the task were revealed to be located primarily in the rear of the brain, in the visual cortex. The brain process for the nonartist consisted of seeing and copying, but distinctly did not involve abstract thought. Producing art involves the process of abstraction. When artist Ocean was working in the confines of the *f*MRI the areas of his brain that "lit up," or where oxygen-carrying blood saw a surge, were found to be in the frontal part of the brain. This presents a crucial difference. In Tchalenko's words, "For Humphrey, the real transformation was taking place in the front, where you find emotion, previous faces, painting experience, intentions and so on. In essence, the control subject was simply trying to slavishly copy what he saw. But Humphrey was creating an abstracted representation of each photograph. He was thinking the portraits."[6] And according to neurophysiologist Robert Solso, for Ocean there was "less activity in the face area, the *fusiform gyrus* in the right parietal area, than in the nonartist, but more activity in the right frontal areas—the 'thinking' part."[7]

Humphrey Ocean is an immensely talented figurative artist with no fewer than five paintings (and two drawings) hanging in London's National Portrait Gallery.[8] Tchalenko, although neither a physiologist nor a psychologist (he is a trained seismologist), is certainly familiar with scientific methodology. As for those teams of scientists at Oxford and Stanford, they operate two of the finest laboratories of their kind in the world. The limitations in the scope of the experiment notwithstanding—studies on a single artist—the

results are fundamentally simple and intuitive, though they clearly invite expanded study. Further study, however, will have to wait. Tchalenko notes that it is difficult to raise money for such an interdisciplinary art and science project, as "science bodies think this is art, and art bodies think this is science."[9]

The Eye of the Beheld

If I could write the beauty of your eyes
And in fresh numbers, number all your graces,
The age to come would say, "This poet lies;"
His heavenly touches ne'er touch'd earthly faces.[10]

—William Shakespeare

"Is it the eyes?" wrote Guy Gugliotta, "The light? The sort of smile? What is it that makes the *Mona Lisa*—one of history's most memorable portraits—so compelling, even in its creation, that the young Raphael sat at Leonardo's knee just to watch him paint it?"[11] Christopher Tyler, a neuroscientist in San Francisco, and independently, Michael Nicholls and fellow psychologists in Melbourne, compiled complementary evidence of particular symmetries and asymmetries, a lateral bias, in portraits spanning the past five hundred years.

In 1998 Christopher Tyler began to explore the possibility that the asymmetric functions of the two hemispheres of the brain may have somehow manifested themselves differently in artists' works. It was an unusual approach, although decidedly simple in conception, in which he constructed a vertical line bisecting the frames of each of the portraits. Tyler accepted only seated or standing, but not reclining figures; in all, 282 artists were represented in his study. After he discovered that a preponderance of the center lines passed through one of the eyes of the subject, a "compositionally

dominant eye," he expanded his study to a much larger universe of Western portraiture spanning 2,000 years and ever-changing styles and schools.

For his statistical analysis Tyler tested four hypotheses: the major axis hypothesis, the golden section (divine proportion) hypothesis, the head-centered hypothesis, and the one-eye centered hypothesis. At first glance most observers would agree that the eyes in portraits are generally located near the center of the canvas, but Tyler's study revealed a subtler element. One eye, either the leading or the trailing eye, was found to lie in a gaussian distribution (bell curve) about the center line with a narrow standard deviation of ±5 percent of the frame width. One-third of the portraits displayed one-eye coincident with the center line and fully two-thirds of the portraits displayed one-eye within 5 percent of the center line. Vertically, Tyler found, the eye height distribution peaked not around the horizontal center line, but rather around the golden ratio of 61.8 percent of the height of the canvas, with only a negligible number of eyes found below the vertical center.[12]

Tyler published a matrix of nine masterworks of Western civilization, portraits spanning the past five centuries (Plate 12, top). These were chosen to illustrate the variety of compositional asymmetries, yet all have an eye right on the center line. Even Picasso, the ultimate creator-rebel of twentieth-century art in his *Portrait of Dora Maar* (1937), succumbed to this unwitting, unwritten norm for artists to put an eye at or near the vertical center line (third row, third column). Until the end of the twentieth century, common American currency—from George Washington on the one-dollar bill to Benjamin Franklin on the hundred-dollar bill—had one eye of the subject coincident with the centerline. But then in the last years of the century new United States currency bearing values beyond one dollar were issued placing the head and the compositionally dominant eye off-center. In the self-portrait drawn by Leonardo da Vinci

gazing in a mirror, an engaging exercise for the reader would be to return to the drawing, construct a vertical bisector, and view its position on the face (Plate 1, left).

Rules are made to be broken, especially if they are promulgated formally. But those unwritten rules that are generated subconsciously, perhaps inherent in the artist's psyche, appear less susceptible to violation. And so the center line principle, falling into the latter category, has demonstrated remarkable resilience. Artists, who are otherwise compelled to excavate new ground, much like scientists, appear unlikely to stray from the principle. Nonetheless, examples of "symmetry breaking" obviously exist, a third of the eyes falling in the tails of the peak plus-or-minus one standard deviation of Tyler's eye-distribution histogram.

Although no clear pattern outside the gaussian is discernible, ϕ, the ubiquitous ratio resonating through past chapters, is found in a contemporary painting. It appears in the work of artist Jamie Wyeth, of the distinguished family of artists. In 1967, then not quite twenty-one years old, he painted a penetrating psychological portrait of John F. Kennedy (Plate 12, bottom). On the canvas Kennedy's face is distinctly offset from the vertical bisector of the frame,[13] appearing to comply generally with the artist's "rule of thirds." But when a vertical line is constructed to divide the canvas 1:1.618 parts, it is seen to pass surprisingly close to Kennedy's left eye. The canvas itself does not form a golden rectangle (possessing instead the proportion 1:1.78); thus it is the horizontal span that is divided according to the golden mean. On viewing this painting in an earlier version of my manuscript, Christopher Tyler offered an incisive comment: "It is clear that Wyeth's intent was to create a view of Kennedy in a reflective mood, disengaged from the viewer. [The painter] has thus avoided the salience of the center line to enhance the sense of disengagement."[14] There is no evidence that the artist chose the position of the eye based on any

mathematical strategy. He was simply following his artistic instincts.

A Leftward Bias

As Christopher Tyler's serendipitous discovery indicates, the artist frequently places one of the subject's eyes at the center line of his frame, imbuing the portrait with a hidden symmetry. But immediately the question arises: "Is there a directional bias? Is there a preponderance of one eye, one cheek—left or right—over their opposites?" Although Tyler's eye-centered principle emerged in 1998, the issue of a directional bias had been investigated a quarter century earlier. In addition, the more recent observations by Michael Nicholls are entirely compatible with Tyler's results and also offer compelling reasons toward resolving why the bias exists.

A 1973 paper pointed out that in a sampling of 1,474 single-subject portraits, 68 percent of female and 56 percent of male subjects presented more of the left side of the face than the right.[15] Another study examining portraits by Francisco Goya alone cited a turning bias of left cheek over right cheek for female subjects, and a less pronounced disparity of right cheek over left for male subjects.[16] Subsequently, an examination of 4,180 single subject portraits in a variety of media—paintings, drawings, lithographs and photographs—revealed again that an asymmetry existed, with a preference for the left cheek over the right.[17] Yet another study of 127 portraits of scientists, all members of the British Royal Society, revealed no leftward or rightward bias at all.[18] Moreover, a separate pair of studies found an overall preference of artists to light their subjects from the left side.[19] Finally, there was Tyler's 1998 study which led to the center line principle, pointing out that bilateral symmetry in the presentation of the face was relatively rare. With

the center line passing through or near one eye, the subject was usually presented with one eye and one cheek compositionally dominant over the opposite eye and cheek, but with no lateral bias in the distribution.

With the aforementioned studies, some seemingly contradictory, serving as backdrop, Michael Nicholls carried out additional studies—some alone (2000) and others in collaboration with colleagues in the department of psychology at the University of Melbourne (1999). A number of issues were addressed: (1) Does the right or left-handedness of the artist influence the direction of the subject's pose in a portrait? (2) How is the left-cheek bias reflected in a self-portrait? (3) Is there a difference in bias when the subject attempts to convey a different emotion? (4) Is there a gender factor in any of these results?

A preponderance of portraits dating from the Renaissance displays illumination of the subject from the artist's left side (the subject's right). Although left-handers are disproportionately represented among artists, right-handed artists still slightly outnumber their left-handed counterparts. And one would assume that artists, holding their paintbrushes in their preferred hand and their palettes in the other, would benefit from having the palette illuminated by the light falling from the illuminated side, thus reflecting the greater number of right-handed artists preferring left-hand lighting. Another hypothesis put forth by Nicholls: the right-hander, just by the musculature of his arm and shoulder, would find it more natural to draw or paint a subject with a left cheek bias, and a left-hander just the opposite. Yet an inventory of the portraits by two prolific known left-handers—Raphael and Hans Holbein the Younger—does not reflect these artists' preference for illuminating their subjects from the left, or for displaying the right cheek/eye as the compositionally dominant one. For Raphael fully two-thirds of his single subject portraits show a left-cheek bias, for Holbein the number is three-fourths, these numbers reflecting roughly the statistics for all artists, regardless of whether

they are right- or left-handed. Thus the handedness of the artist determining the side of the face featured appears to be a red herring.

Nicholls's investigation of 137 Renaissance portraits, ignoring gender differences in the subjects, revealed that 129 of them display the center line passing through or near one eye,[20] in line with Tyler's discovery of just a year earlier. But then he found that 63 percent of the 129 portraits displayed the subject turned, exhibiting a prominent left cheek, left eye.

How does the left cheek bias exhibit itself in self-portraits? Nicholls performed statistical analyses on self-portraits as well as portraits of others, and the differences were dramatic, although in retrospect not surprising. For portraits of others, the featured side of the face was the left side in 57 percent of male subjects and 78 percent of female subjects. In contradistinction, in self-portraits it was the right side that was featured prominently—in 61 percent of portraits with male subjects and 67 percent of portraits with female subjects. These proportions for the portraits of others *versus* self-portraits are virtually inverted. But then, when an artist works with a mirror, the right and left sides become inverted: the left cheek becomes the right, and the right, the left! Leonardo's self-portrait (see Plate 1) featured the right side of the artist's face, which we again know to be his left! In the fifty-seven known Rembrandt self-portraits, those unparalleled psychological studies, spanning the Dutch master's lifetime, forty-eight of them feature the right cheek, only nine the left. But in all those forty-eight self-portraits Rembrandt was gazing in the mirror at the left side of his face (Plate 13).

The next hypothesis Nicholls tested was the effect of the emotional frame of mind of the subject on the direction in which he or she turns. (In this experiment the premise is that it is the subject and not the artist/photographer who selects the subject's direction of turn.) The subjects were 165 psychology students, 122 female and 43 male. An integral aspect of the study was the subjects' initial prepping with one of two directives—actually a pair of hypothetical

scenarios with differing emotional content. With neither the subject nor the proctor alerted about the left-right connotations of the study, the proctor would photograph the subject with a video camera positioned two meters in front of them. One statement prompted the subject to pose for a photograph designated for a loved one; the other prompted, "You have been invited to become a member of the Royal Society and a portrait of you is to be submitted." After being told *not* to face the camera directly and to take thirty seconds to strike a pose, each subject was photographed. The first statement had been designed to generate a sense of warmth, endearment, and emotion; the second to generate a desire to suppress emotion, to exude a sense of rationality and power. Neuropsychologist Michael Nicholls offered an explanation: the right side of the brain—the hemisphere associated with emotive functions and the hemisphere controlling the left eye and cheek—impels the subject of the portrait to subconsciously turn toward the right, *exposing prominently the left side.* Mona Lisa, desiring to appear loving and loyal, bares her left cheek. Conversely, when immersed in the second hypothetical scenario, "to pose for a portrait to hang with portraits of other powerful and intelligent scientists in the Royal Society," the subject of the portrait shows off the right eye (and cheek), the side controlled by the rational, expressive, confident left hemisphere of the brain. As a general principle, Nicholls's explanation is compelling and, like the Ocean/Tchalenko experiments discussed earlier, beckons further research, if possible, with brain imaging technology. The numbers certainly suggest a correlation with differing functions of the right and left hemispheres of the brain. Moreover, the gender factor is quite minimal, and so is the handedness of the artist.

O marvelous science, you keep alive the transient beauty of mortals and you have greater permanence than the works of nature, which continuously change over a period of time, leading remorselessly to old age. And, this science has the same relation to divine nature as its works have to the works of nature, and on this account is to be revered.

—Leonardo da Vinci

Chapter 9

Leonardo, Part-Time Artist

Leonardo wrote entire tomes on how painting was a science, how music was "the younger sister of painting," and how painting was superior to all other forms of art —poetry, music, and sculpture—as a medium for describing nature. He wrote that painting could capture a fleeting moment, the subject never aging beyond the time of execution of the subject's likeness. Meanwhile, he seemed to take special delight in denigrating sculpture—an understandable prejudice, considering his greatest rival specialized in that medium: "Sculpture is not a science but a very mechanical

art . . . generally accompanied by great sweat which mingles with dust and becomes converted into mud. His face becomes plastered and powered all over with marble dust, which makes him look like a baker."[1] In the hierarchy of intellectual pursuits, however, science maintained an unrivaled perch. Even as an apprentice, when he first took up a brush, Leonardo was already infusing his paintings with elements of his beloved nature, its secrets revealed by his unrelenting scientific inquiries. Thus his paintings are rich in anatomical, botanical, geological, and psychological overtones, and also rich in the geometric shapes and patterns, employed for either organizing his subjects or giving them depth and dynamism.

The shapes and patterns were extraordinarily enduring, recurring in his works again and again. As a teenager he painted a small section of Verrocchio's *Baptism of Christ*. The contours and highlights of the curls in the angel's hair are signature touches of Leonardo, reminiscent of the vortices in his drawings of the flooding Arno. The curls again appear in his *Ginevra de' Benci*, executed when he was about twenty-one. A gentle helical twist imparts a sense of dynamism to the angel's body in *the Baptism of Christ*; this is seen again in three of the four figures in the *Virgin of the Rocks*, painted when he was in his early thirties. Again, in the portrait *Lady with the Ermine*, created when Leonardo was in his late thirties, and in the *Mona Lisa*, painted when he was past fifty, the same helical contour imparts dynamism to the subjects.

Among paintings attributed to Leonardo's first Florentine period is the unfinished painting *Saint Jerome in the Wilderness* (Vatican Museum). Jerome, who was identified so closely with nature, must have been a favorite of Leonardo's, for his own psyche was inseparable from nature. In this early work depicting the old hermit, the figure of Jerome can be framed within a golden rectangle. Leonardo, who was later to illustrate Luca Pacioli's *De divina proportione,* was of course intimately familiar with the divine proportion (and the golden rectangle), as well as with regular and semi-

regular polyhedral figures, which he depicted in rough sketches in his notebooks and presented formally in Pacioli's book. Thus it was most likely more than a coincidence for Leonardo to frame the figure of Saint Jerome within a golden rectangle.

In order to dramatize the proportions of the kneeling figure of Saint Jerome, I have digitally superimposed the golden rectangle on the painting; then in the upper inset figure, reproduced a postcard with precisely the same proportions. The postcard I chose for the demonstration happens to bear the image of a classical Greek vase (crater) that fills the postcard precisely (Figure 9.1). The simple exercise of juxtaposing objects from different ages—from antiquity, the Italian Renaissance, and contemporary culture—in the same figure is meant to dramatize the timelessness of the golden rectangle, a shape more often than not chosen inadvertently but, by Leonardo, probably with careful premeditation.

In Milan Leonardo was a boarder in the house of the de' Predis brothers, both painters. On April 25, 1483, he was commissioned to paint an Immaculate Conception altarpiece for a small church. The presumptuous officials dictated their own idea for a composition and even the choice of colors: "the cloak of Our Lady in the middle [is to] be of gold brocade and ultramarine blue . . . the gown . . . gold brocade and crimson lake, in oil . . . the lining of the cloak . . . gold brocade and green, in oil. . . . Also, the seraphim done in sgrafitto work. . . . Also God the Father [is] to have a cloak of gold brocade and ultramarine blue."[2]

Indeed, the details of the colors and design required from Leonardo for this work continued another fourfold beyond those specified above. But Leonardo, after agreeing to the terms of the contract, went on to produce his own version. He organized the composition as a pyramid with the Madonna's head at the vertex, her right arm draped over the infant John the Baptist, whom she is poised to bless; the infant Christ is immediately below her left hand. At the lower right corner is a kneeling angel pointing

Figure 9.1. Leonardo da Vinci, *Saint Jerome and the Lion* (unfinished), 1482, Vatican Museum, Rome. *(inset, top right)* The image of an ancient Greek vase with the proportions of a postcard, the postcard itself in the shape of a golden rectangle.

toward Saint John. Rugged stalactites and stalagmites, all immersed in a thick mist but punctuated by bright light, provide a surrealistic backdrop to the quartet of characters. The painting, known today as the Louvre's famous *Virgin of the Rocks* (Plate 14), measures 198.1 by 122 centimeters, thus it has a height-to-width ratio of 1.62, or ϕ. Twenty years later, Leonardo, collaborating with his housemate Ambrogio de' Predis, produced a variation of this painting for the church of San Francesco Grande in Milan. This painting, the London National Gallery's *Virgin of the Rocks*, has overall proportions very close to its predecessor, but the backdrop of stalactites and stalagmites has been brought forward slightly, the Virgin and the two infants have halos, Saint John holds a cross of reeds, and the angel is not pointing.

The Last Supper

In 1495 the forty-three year old Leonardo was commissioned to paint a mural in the dining room of the small church of Santa Maria delle Grazie in Milan—the theme, Christ's last meal with his disciples. On the wall of the refectory for which it was planned, the natural light enters the room through windows on the left-hand side, and the work is appropriately customized for the setting. The right side of the scene is illuminated far more than the left, and the left sides of the individual figures are lit while the right sides are in gradations of shadow (see Plate 8). Artists of the Renaissance, in paintings depicting the Last Supper, would often separate Judas from the other disciples, placing him alone on one side of the table, separated from the rest of the disciples seated on the other. His full face was never presented, lest the viewer gaze inadvertently into the eye of evil. Leonardo has integrated Judas into one of four groupings of disciples, but made sure that his face is in shadow, and only one eye can be seen. In that moment, rife with electricity, when

Christ has just made his announcement of the betrayal, Judas recoils in terror, knocking over the saltcellar.

Leonardo's preliminary sketches reveal the intensity of the moment, the individual and group conflict, the psychological drama at that dinner table, in the faces and hands. Indeed, hands as much as faces represent a powerful instrument to convey passion. Verrocchio had already exposed his pupils to the emotive power of gesture in his figures. But Leonardo informed his *Last Supper* with much greater artistic currency than could his master—he had deeper insight into psychology, superior skills with his medium and composition. And as admonishment meant for young artists, he identified in the *Libro di pittura* pitfalls to avoid in multiple subject works: "Do not repeat the same movements in the same figure, be it their limbs, hands, or fingers. Nor should the same pose be repeated in one narrative composition."

Leonardo, characteristically running late in completing the work, was called to task by a prior: "Why is it taking so long?" Leonardo responded that he was having a difficult time finding a model for Judas, and suggested to the prior that perhaps he might serve in this capacity. The prior departed, foaming with indignation, but refrained from further badgering the artist. In the mode of a modern director seeking just the right actor for his cast, Leonardo spent months observing, sketching, searching for just the right countenance he envisioned for each disciple. The casting for the model of Jesus Christ was evidently not unusually difficult. He found Jesus in a handsome and muscular young man, exuding confidence and an unmistakable air of piety. Several years later, Leonardo lore has it, he found his Judas in a Roman prison. From a close friend, who had also been on the lookout for the Judas character, he heard the description he was after. When he personally visited the prison and saw the bedraggled convict brought out for his viewing, Leonardo accepted the man without hesitation—only to

find, to his shock and horror, that this broken wretch was the very man who had served as his Jesus!

When Leonardo finally finished the *Last Supper*, the mural was revolutionary in its composition, grouping the apostles in four groups of three, and isolating Christ. In this, the most dramatic of all of his paintings, Leonardo had captured that instant when Christ had just announced to the bewildered and distraught guests at dinner table, "Verily, verily one of you will betray me." That moment of despair is said to reflect in Jesus' face Leonardo's own feeling of betrayal twenty years earlier in Florence.

Normally in painting a fresco, water-based paints are applied to wet plaster, thus penetrating and becoming a part of the plaster. Leonardo used oil-based paint along with varnish, and these, applied to a dry wall, never achieved sufficient penetration. Unproven techniques and materials, coupled with the salts leeching from the upwelling groundwater, caused the paint to gradually flake off. Over the centuries a number of attempts were made to restore the great mural, most of them expediting its decay. The most recent effort to restore the mural, a project that lasted seventeen years, may have finally succeeded in decelerating further degradation. Removal of almost all of the past restorers' over-paint also revealed Leonardo's original vivid palette.

Among the legion of artists who have tried to copy or produce variations of Leonardo's *Last Supper* was Raphael Morghen, who produced arguably the best engraving based on the work (c. 1800) and served to disseminate the image. It is this engraving that reveals some of the details of Leonardo's symbolism. Among the group immediately to the left of Christ is Judas, face in shadow and clutching a sack of silver in one hand (see Plate 7, bottom right).

Just as Leonardo was about to leave Urbino after three disappointing years in the employ of Cesare Borgia, Machiavelli helped

him to secure a commission from the city of Florence. He and Michelangelo were each to paint on facing walls of the Great Council hall of the Palazzo del Signoria (now the Palazzo Vecchio) massive murals celebrating a pair of successful military campaigns carried out by Florence. Leonardo was to depict the Battle of Anghiari, which led to the defeat of Milan in 1440; Michelangelo, the Battle of Cascina, which led to the defeat of Pisa in 1364. Thoughts began to take shape in both artist's notebooks, and each created full-size cartoons that were displayed and greatly admired. Sadly, just as the work commenced, Michelangelo was ordered to Rome to complete the tomb of Pope Julius II, and the commissions were withdrawn.

Leonardo had gone so far as to do an underpainting on the wall; it was covered by Vasari when he received a commission in 1563 to remodel the room. And although this cover-up was all too success-ful, defying even modern attempts to locate the unfinished mural using high-tech equipment, at least some of Leonardo's sketches of battling warriors and horses can be found in his notebooks. Neither Michelangelo's nor Leonardo's cartoons have survived. Yet a hun-dred years after Leonardo first conceived its design, a copy of the cartoon, albeit by a poor artist, was still in existence. In 1603 the Flemish Baroque master Peter Paul Rubens replicated that cartoon in the "style of Leonardo" (Fig. 9.2). In view of Rubens's skill and his abiding reverence for Leonardo, it is likely that he reproduced as faithfully as possible what he thought Leonardo had in mind. If so, the cartoon reflects Leonardo's personal aversion to the horrors of combat, notwithstanding his employment as a designer of engines of war. Some of Leonardo's sketches of battling warriors and horses can be found in his notebooks; the faces are highly rem-iniscent of those of some of the warriors and horses in Rubens's car-toon. As for the general shape and composition, the cartoon can be seen to invoke the golden pyramid to frame the subjects.

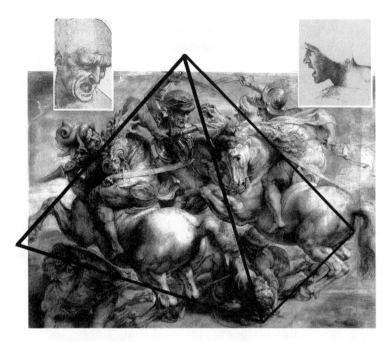

Figure 9.2. Peter Paul Rubens, drawing after Leonardo's cartoon for the *Battle of Anghiari* (1603), Musée du Louvre, Paris; *(insets, upper left and right)* details of two sheets with studies of heads of soldiers for the *Battle of Anghiari*, both in the collection of the Szépmüvészeti Múzeum, Budapest

The Three Women

Therefore make the hair on the head play in the wind around youthful faces and gracefully adorn them with many cascades of curls.

—Leonardo da Vinci

Leonardo painted only three portraits of women, approximately fifteen years apart, but each painting became a pivotal work in the history of art. In each instance he took a routine commission

for a portrait of a woman of neither prepossessing beauty nor overwhelmingly lofty stature and bestowed immortality on his subject. These are the *Ginevra de' Benci, Cecilia Gallerani,* and the *Mona Lisa.*

The only painting by Leonardo outside Europe is also his only known double-sided painting (Plate 15). It portrays Ginevra de' Benci, the daughter of the wealthy Florentine banker Amerigo de' Benci, on the obverse side, and a combination of symbolic flora on the reverse. In early 1474 Ginevra had married Luigi de Bernardo Nicolini, a prominent magistrate, and the portrait was created shortly thereafter. It is thought to have passed from the Benci family, which had died out by the early eighteenth century, into the hands of the princes of Liechtenstein, whose red wax family seal can be seen in the upper right corner of the reverse. In 1967 the National Gallery of Art in Washington acquired the painting from the Principality of Liechtenstein.[3]

Ginevra, with her hairline and eyebrows plucked to accentuate "a smoothly domed forehead" emblematic of her intellect, is seen in front of a juniper *(ginepro)* bush, a symbol of virtue and a play on her name. In the distance is a pair of church spires, presumably representing her piety. On the reverse juniper appears again—this time a sprig cupped by a laurel on one side and palm branch on the other. The relatively limited palette and the precisely delineated curls of her hair are evidence of the painting having been executed in the artist's youth: he was just five years older than his sixteen-year old subject.

The painting is on a poplar panel, measuring 38.8 by 36.7 centimeters (15¼ by 14½ in.); in other words, the overall shape of the portrait is virtually a square—or is it? When we carry out a simple geometric construction—inscribing the subject from the top of her head down to her bodice within a vertically configured golden rectangle, the head defining a square in the upper portion of the

rectangle—we find that her chin rests almost directly on the lower edge of that square.

Painting the reverse side of the wooden panel had a salutary effect, for it has kept the panel perfectly flat for over five hundred years. Warping is caused by the cells on one side of a wooden panel absorbing more moisture than cells on the other (a less extreme case of the spiral pattern). This panel was hermetically sealed; however, even that cannot stop discoloration of the painting's protective varnish, which yellows over the years. In 1992 the painting underwent thorough cleaning and restoration, and what emerged was even more beautiful than expected. Of course, the yellow filter of a varnish converts the blues to green and reds to orange. Removing the yellowed varnish from the portrait restored Leonardo's original blue hues to the sky. It also revealed the rich undertones and overtones Leonardo used in painting the girl's aristocratic complexion, much paler and more porcelain-like than had been evident. Women of the Renaissance were physically and figuratively sheltered, and suntanned skin was anything but fashionable.

The square shape of the *Ginevra de' Benci* has long been a source of speculation, as this was a rare format for paintings in the Renaissance. Is there a missing part of the painting, and if so, what was there? Two of its edges, the right and the bottom, display evidence of damage and of having been sawed. We have also observed that for Leonardo the hands were as expressive as the face—that was the case in the *Last Supper,* and as we will see, that is the case with each of the three portraits. David Brown and National Gallery staff have digitally reassembled a study of hands by Leonardo (a drawing in Windsor Castle) and the portrait of Ginevra with remarkable results. The clue to how they should be aligned was on the reverse side, where the juniper twig was found to be offset by 1.3 centimeters in the direction of the damaged edge. Operating under the hypothesis that the juniper twig had been aligned at the

center of the original panel, the first step was to add 1.3 centimeters to that, and then fill in the space digitally. The branches embracing the juniper were propagated downward to converge near the bottom of the panel. Then, on the obverse, the hands were digitally overlaid at the bottom of Ginevra's image and manipulated—translated, rotated, and rescaled—until Brown achieved what he was convinced was the artist's style and intent. But the digital colorization process leaves the colors of the hands and dress somewhat flat. Moreover, distinctly missing, especially in the hands, are the softness and grace with which Leonardo would have normally imbued his subject in an oil portrait. At least, however, we have an opportunity to see Ginevra's position as it might have appeared in the original portrait (Plate 15, bottom left).

In 1482, eight years after he completed the *Ginevra de' Benci*, Leonardo moved from Florence to Milan, having secured a post as court engineer for Duke Ludovico Sforza (Il Moro). Problems in civil and military engineering consumed his time, but frequent experimentation, studies in optics, sketches of mental inventions, and the systematic recording of results continued undeterred. On the infrequent occasions when he returned to painting, evidence of this intellectual ferment would be manifest in his art, and each new commission brought his work to a level of refinement far above the last. In 1491, when he painted the *Lady with the Ermine (Portrait of Cecilia Gallerani)*, the cultivated mistress of Il Moro (Plate 15, center) fifteen years had passed since he had painted *Ginevra de' Benci*, and there was an astonishing growth in sophistication. As in the *Ginevra*, this is a full-on portrait at a time when people were used to seeing only profiles of women, and it is rife with psychological overtones—the sideways glance, the delicate fingers. In fact, Leonardo's *Ginevra de' Benci* and *Cecilia Gallerani* were arguably the first psychological portraits ever seen.

On the painting of Cecilia Gallerani a golden rectangle is delineated, framing the area from the top of the head to the top of the

bodice. A square is portioned off in the upper part of the rectangle, leaving a golden rectangle in the lower portion. The result is just as in the *Ginevra de' Benci*.

In 1503, in Florence, Leonardo accepted another commission for a portrait—again after a fifteen-year hiatus from portrait painting—this time he was to paint the wife of the wealthy merchant Francesco del Giocondo. Indeed Leonardo had done very little other painting, having left a number of works unfinished. But his studies in everything else continued unabated, with notes recorded in two types of notebooks—one for daily observations and rough sketches and another for distillations of the best of the daily notebooks and more finished drawings. With the *Ginevra de' Benci*, he had been a young artist just trying to get established, and Verrocchio may have passed on the commission to him. With the *Cecilia Gallerani*, the mistress of Ludovico Sforza, he probably just wanted to impress the duke. But with the wife of del Giocondo, it is a mystery why he even accepted the commission. We can speculate that perhaps he needed money. But one thing is certain: with the *Mona Lisa*, he produced a miraculous psychological portrait—spellbinding, hypnotic, timeless. You know this woman, and yet you don't. She is looking directly at the viewer, but what is on her mind is the real enigma. She exudes confidence and uncertainty at the same time, with an expression that is both inviting and frightening. In a sense it is a universal statement about women, albeit by a man whose attitude toward the opposite sex was highly problematic. It is no wonder that her countenance and that partial smile have launched more wild speculations than all other works of art, among them: "She is pregnant," "She is suffering from a tooth ache," "It's a self-portrait by Leonardo."

After each fifteen-year hiatus from painting portraits, Leonardo returned with immensely greater knowledge and insight, and a more refined technique. This is not difficult to understand: it is quintessential Leonardo, his interests inseparable, all organic components

of the same mind. Leonardo accepted the commission for the *Mona Lisa* in 1503 but did not complete it until 1507. For whatever reason— either because he had not completed it in a specified time or because he had become too fond of it and could not part with it—he never turned it over to Francesco del Giocondo. Leonardo left Florence with the painting in 1507 and kept it with him through his subsequent travels. He took the painting with him in 1516 when he moved to France, and it was still in his possession at his death in Amboise (south of Paris) in 1519. It was in Amboise that Francis I acquired the *Mona Lisa* for his local chateau. At different times afterward, the painting surfaced at three different locations: Fontainbleu, Paris, Versailles. At some point the painting found its way into the collection of Louis XIV, and after the Revolution it found a home in the Louvre, then Napoléon Bonapart commandeered the painting and hung it above his bed. Later, when Napoléon was sent into exile, the *Mona Lisa* returned to the Louvre, where it has been ever since.

In its five-hundred-year history the *Mona Lisa* has survived appalling ordeals. According to Leonardo scholars, at an undetermined time in the past a pair of columns framing the subject on a terrace were cut out. Then early in 1911 the painting was stolen and taken to Florence, where it was kept hidden under a bed by an Italian nationalist. In 1956 it was damaged by a madman who threw acid on it, and again in the 1960s by another who slashed it. But let us hope all this traumatic experience is in the past. Majestically it hangs in the Louvre (as *La Gioconda* or *La Joconde*), restored, shielded by bulletproof glass, and since the 1980s protected by a law that prohibits all future travel abroad.

The proportions of the *Mona Lisa* panel are about 1:1.45, not particularly close to the golden ratio of 1:1.618, though the earlier trimming of the painting on its sides makes this test meaningless for us. When the columns were still present and the painting was wider, its length-to-width ratio would have been smaller than 1:1.45. Other interesting geometric constructions, however, can be seen (Plate 15,

lower right). As in the *Ginevra de' Benci* and the *Cecilia Gallerani,* we first construct a golden rectangle enclosing the area from the top of her head down to the top of her bodice. A square delineated in the upper portion of the rectangle leaves her chin resting on the bottom edge of the square and her left, or "leading," eye located at the center of the square. This was also true for the *Ginevra de' Benci* and the *Cecilia Gallerani,* although in those paintings it was the right eye. Finally, the torso of the *Mona Lisa*—slightly turned, her right shoulder and her right cheek set back relative to the left shoulder and left cheek, respectively—can be inscribed in a golden triangle (with angles 72°—36°—72°). There is a question that begs an answer: Was this all a coincidence for Leonardo—just a manifestation of his unerring eye, as it most likely had been for the architects of the pyramids—or was it a conscious exercise? In the work of any other artist, we would assume these manifestations to be coincidental. For Leonardo, who seamlessly integrated mathematics, science, and art, and spent his life seeking unifying principles, perhaps not!

When Leonardo painted his earlier works of art such as the *Adoration of the Magi* and the *Annunciation,* the theory of one-point perspective had already been known for fifty years, and Leonardo had mastered it. By the time he painted the *Mona Lisa,* Leonardo had already learned how to manipulate it in order to produce special effects. For a painting's image to be "lifelike" in the Renaissance meant the conveying of a feeling of being alive, rather than rendering an exact physiognomic or photographic likeness of the subject. Indeed, since no other images of del Giocondo's wife exist, no one knows how she really looked. But from the canvas she is ready to speak: the outer edges of her eyes (the lateral canthus) have been painted purposefully blurred, creating a sense of ambiguity. Moreover, the landscape forming the backdrop behind her is higher on one side than on the other. Therein lies Leonardo's trick: his artifice causes the observer's eye to inadvertently oscillate back and forth across the subject's eyes, creating an optical illusion of animation.

In the last chapter we examined Christopher Tyler's serendip-itous discovery of the central-line phenomenon, his observation that in a preponderance of single-subject portraits the vertically bisecting line of the canvas passed very close to one eye, whether the leading eye or the trailing eye. In one element of the matrix of portraits reproduced from Christopher Tyler was the portrait of Mona Lisa. Here we apply the center-line principle to the other two Leonardo portraits of women, the *Ginevra de' Benci* and the *Lady with the Ermine (Portrait of Cecilia Gallerani)*. The center line in the *Ginevra* has been drawn to bisect the existing panel and not the cor-rected version extended on the right by 1.3 centimeters, following David Brown's reconstruction (the discrepancy in the position of the line is a negligibly small 2 percent). The center line is seen to pass convincingly close to the leading eye—the right eye for the *Ginevra de' Benci* and *Cecilia Gallerani* and the left eye for the *Mona Lisa*. The left-cheek bias in Renaissance portraits pointed out by Nicholls is evident in the *Mona Lisa*, but not so in the *Ginevra de' Benci* and the *Cecilia Gallerani*. But then three portraits are just too small a sample on which to make a sweeping generalization.

As the United States began to prepare for the five hundredth anniversary of the discovery of America in 1992, many museums around the nation launched programs to commemorate the event with exhibitions of their own. The National Gallery of Art, cus-todian of the *Ginevra de' Benci*, planned *Circa 1492*, an exhibition of works from the era of Columbus, with aspirations of including Leonardo's *Lady with the Ermine*, painted in 1491. The curators of Poland's national Czartoryski Collection in Krakow were extremely reluctant to lend the priceless work, without a doubt the most important artistic treasure of the nation. The argument they offered was that the painting was too fragile. At that junc-ture, President George H. W. Bush appealed directly to President Lech Walesa, who was not entirely unreceptive to the idea. In expressing conditional agreement, he was conveying the tacit

gratitude of Poland for American support in the struggle to break off from the Soviet Block.

Conservator David Bull of the National Gallery of Art went to Krakow to ascertain whether the painting was sound enough to travel. He examined the painting with a magnifying glass for four hours. To the stunned Polish curators' delight, he pointed to one area and pronounced "there is Leonardo's fingerprint,"[4] something that no one had ever noticed. This discovery, and the assessment that the *Lady with the Ermine* was in condition to travel, helped the negotiations proceed to a successful conclusion. Four months later the painting was transported to the United States for a three-month visit amidst unprecedented security. *Cecilia*, accompanied by David Bull and two Polish curators, flew first class on a Pan Am flight to Washington, D.C. In the agreement that brought the work to the United States, it was also decided that after the three-month exhibition of the painting, David Bull could spend another week examining the painting with high-tech equipment in the National Gallery's conservation laboratory. There on his Formica table, side-by-side he had the "two girls." Bull had spent his professional life examining, cleaning and restoring masterworks by Bellini, Titian, Raphael, Rembrandt, van Gogh, Cézanne, Manet, Monet, and Picasso, "But two Leonardos at once...! In the rarefied world of art masterpieces such a moment is without compare."[5] The FBI was called in to photograph the fingerprints on both the *Ginevra de' Benci* and the *Lady with the Ermine* using a specialized camera. The fingerprint images are stored—along with those of distinguished and notorious individuals of twentieth century—in the data banks of that institution.

In his investigations of the two portraits by Leonardo Bull relied mainly on the two basic techniques of x-radiography and infrared reflectography, along with the nowadays more common tool of the stereoscopic microscope. With x-radiography, x-rays are used to probe deep into the paintings with a view toward ascertaining the

beginnings and the structure of the work. In the *Ginevra de' Benci*, the images on the two sides of the panel are compressed, as both sides are visible simultaneously. This technique also reveals overpainting on previous images. On the reverse side of the *Ginevra*, underlying the Benci family motto "Beauty adorns Virtue" is another, "Virtue and Honor" (the motif of Bernardo Bimbo, who was Ginevra's platonic lover and perhaps the person who commissioned Leonardo to do the painting). Thus Ginevra's own motto was overpainted. On the *Lady with the Ermine*, x-radiography revealed that Leonardo had experimented with Cecilia Gallerani's hands, altering their position after initially painting them.

David Bull found that infrared reflectography was most helpful for his needs when investigating the two portraits. This technology utilizes infrared radiation, which is much less penetrating than x-rays, to investigate the surface (and just below the surface) of paint. The infrared radiation reflects off the white gesso ground that lies between panel and paint, and the image is recorded by camera and made visible on a computer monitor. Bull's examination of the two paintings with infrared reflectography revealed an underlying drawing outlining the subject. With his sitter before him, Leonardo would make a drawing on paper. He would take the drawing back to the studio and make pin pricks outlining the drawing, carefully going around the nose, the eyes, the lips. Then he would take the drawing with the holes punched through, essentially now a stencil, and lay it down on the gesso, then lightly dab the perforated study with a muslin bag of charcoal dust to transfer his design. The resulting outline of the figure was visible again in the infrared reflectography.

The *Ginevra de' Benci* and the *Mona Lisa*, painted thirty years apart, each have pastoral background landscapes; and their astonishing chiaroscuro and sfumato keep them in perfect harmony with the subject. Chiaroscuro is a technique of painting in which the figures portrayed have somewhat nebulous outlines, seen emerging into the light from shadows. With sfumato, believed to have been invented by

Verrocchio, the objects in a picture are coated with layers of very thin paint to soften edges and blur shadows, creating a dreamlike effect of atmospheric mist or haze. Leonardo had already exhibited his mastery of these techniques in the *Virgin of the Rocks* (1483).

The study of the *Lady with the Ermine* revealed another dramatic surprise. Painted midway in that thirty year span, it features a flat (albeit dramatic) black background that is out of character with the other two portraits. Art historians had long suspected that the original background had been painted over sometime in the past. Bull's infrared reflectography studies revealed the background indeed had been altered, he speculates, in the nineteenth century. The obvious guess would be that the painting had once had a symbolic landscape similar to the other two, but Bull's examination revealed none. It was a subtle iridescent blue-gray, somewhat evocative of the metallic paint one encounters on some cars, unusual for the Renaissance and unusual even for Leonardo. But then every innovation this man introduced broke new ground and left the medium much richer.

For both his works of art and scientific investigations, Leonardo personally developed and practiced a technique that is evocative of modern scientific methodology: careful experimentation, meticulous observation, copious recording of data, and a synthesis in the form of an explanation—a theory. But he did not publish! It is clear from the notes he left behind, however, that he approached everything with consummate open-mindedness. His art, whether religious or secular, was informed by the fruits of his scientific investigations—linear perspective, mathematics, optics, mechanics, anatomy, geology, even psychology. His subjects are depicted not just as photographic likenesses, but integrated into a canvas teeming with psychological overtones. In single-subject paintings they communicate with the viewer, and in multiple-subject paintings, also with each other.

Inquiry in any human endeavor, scientific or artistic, cannot proceed without experimentation, but experiments can go awry.

Once Leonardo painted with oils onto a stone wall; then he applied heat to the wall in order to fix the paint. The paint melted and the creation was destroyed.[6] A more serious failed experiment occurred on the *Last Supper*, where instead of simply using a proven mural technique, he introduced a method that was not conducive to the environmental conditions of the room and building, and the great mural began its inexorable deterioration process by the time it was finished.

Finally, there is one other Leonardo work that we must revisit—*The Adoration of the Magi*, long regarded as one of the gems of the Uffizi, hanging on an honored wall in the great museum. Although an unfinished work, the *Adoration* shows the perspectival studies made by Leonardo to be a prelude to a final painting. In spring 2002 a tragic discovery was made when the work was moved for restoration and conservation into the museum's laboratory. A painstaking scientific analysis revealed to everyone's horror that, although the underdrawing is indeed by Leonardo, the work was overpainted—possibly a century later—by an artist of modest talent. The museum staff subsequently took a sad but necessary decision, moving the painting not back onto its lofty perch in the museum, but into a storeroom where it has remained since. Perhaps the overpainting will be removed in the near future and the work can be exhibited as a Leonardo.

High Technology as a Tool for Uncovering Forgery

The high technology applied to Leonardo's paintings has been revealing. Issues of color, composition, technique and especially provenance all make more sense. They eliminate wild speculation and guesswork, anathema to Leonardo. Moreover, since it had been the Renaissance artist who first taught the scientist to make careful observations, and ultimately to help launch modern science, we might regard high technology as a return favor by the scientist. The

plethora of modern technical tools routinely resolve questions that in another age would have been accepted or rejected according to one's intellectual prejudices. Among questions resolved by carbon-14 testing has been the authenticity of the Shroud of Turin (it turns out to be less than a thousand years old). High tech medical imaging—computer-assisted tomography (CAT-scan) and MRI—has been performed on Egyptian mummies, determining, among other things, the diseases to which various pharaohs ultimately succumbed. Cosmic radiation was employed in searching for hidden chambers, and ultimately mapping out the internal structure of the Chephren Pyramid (there were no hidden chambers). Radiography, with highly penetrating gamma radiation, was used in revealing an anachronistic internal wire structure in a Greek statue of a horse—a forgery! Among unresolved questions is the date of the occipital bone and right arm purportedly belonging to John the Baptist. (The Byzantine emperor Justinian with virtually unlimited resources had acquired them in the sixth century, a time when he was transforming Constantinople into an unmatched Christian reliquary.) The bones displayed now in the Topkapi Museum, Istanbul, have not yet been tested. The seedy side of the art and artifact business would be far more active than it is if some of the high tech tools did not exist to discourage the practice.

I offer an example of how the technology—even in its relative infancy almost sixty years ago—exposed an astonishing hoax. The story resonates with ironies, the artist claiming the forgery, the skeptical authorities rejecting his claims. Han van Meegeren, prewar Dutch artist of not entirely inconsequential talents, was far more creative as forger than as artist. Van Meegeren produced a number of "authentic" Vermeers, including works from hitherto unknown periods of the artist's life. His recipe—mixing paint scraped from old paintings, painting over period paintings of little value, cooking and causing crackling—produced works of sufficiently convincing quality to fool most art experts.

After the war Meegeren was arrested, not for producing forgeries, but for trafficking with the enemy. While on trial for selling national treasures to the Nazis, specifically to Reich Marshal Hermann Göring, he was forced to admit the works were all of his own creation. Asking to have the paintings x-rayed, van Meegeren first revealed details of the underlying paintings. To buttress the claim, he set up an easel in front of six witnesses and an armed guard, and produced a ninth and final pseudo-Vermeer. Van Meegeren even claimed the highly acclaimed "Vermeer" *Christ with His Disciples at Emmaus,* which had found an honored spot in the Rotterdam Museum, to be his work. The definitive test of provenance for this work had to await the development two decades later of sophisticated new radioisotope technology. The determination of the precise ratio in the paint of the radioactive isotopes Ra-226 and Pb-210 revealed the painting to have been created in the twentieth century and not in the seventeenth.

Poetic justice and irony abound in the van Meegeren–Vermeer case. First, van Meegeren, who had planned and toiled to produce work that would fool the critics, had to turn around and convince them of his forgery. Second, the same critics who had panned van Meegeren for lack of talent, accepted the works by van Meegeren as authentic Vermeers, uncontestable creations of genius. Third, absolved of charges of treason, van Meegeren was convicted of forging Vermeer's signature. Fourth, despite the conviction, van Meegeren became a national hero as, "the man who had duped Göring." Fifth, just before beginning his term, a one-year sentence, van Meegeren had a heart attack and died. Finally, the ultimate irony emerged: the purchaser, Göring, had paid for the paintings with counterfeit money.

Human subtlety . . . will never devise an invention
more beautiful, more simple or more direct than
does nature, because in her inventions, nothing is
lacking, and nothing is superfluous.

—Leonardo da Vinci

Chapter 10

The Manuscripts of the

Consummate Scientist

W ith his small entourage in tow, at the invitation of the newly
crowned Francis I, in 1516 Leonardo journeyed to Amboise,
where he would spend his final three years. The belongings he had
with him in that move included his treasured collection of books,
two or three paintings, among them the *Mona Lisa,* and chests
bursting with his papers. It has been estimated that he had pro-
duced 13,000 to 14,000 pages, less than a third of which have sur-
vived. He may have left some of the papers in Milan and Florence.
But he must have retained a substantial portion of the original

papers when he arrived, considering he still entertained notions of writing as many as "120 books." The papers bound as notebooks or bundled together as loose sheets reveal the depth of Leonardo's thoughts and the dizzying range of his interests, especially in science, mathematics, and technology. It is there that we find the evidence of his extraordinary talent for identifying critical questions regarding nature and the physical intuition to design proper experiments to answer these questions. There, too, we see his unflagging dedication to open-mindedness and intellectual honesty, quintessential assets for anyone engaged in scientific inquiry. For Leonardo there were no defined parameters, no boundaries. These manuscripts represent no less than detailed maps of previously uncharted territory in science and technology.

Leonardo's early teacher, Verrocchio, had instilled in his apprentices the need to know anatomy, but the levels of investigation that Leonardo would undertake far transcended what he would need in order to inform his works of art. We know that in his own lifetime Leonardo's patrons had little patience for his frequent retreats into science. The almost idolatrous admirer, the artist and biographer Giorgio Vasari, in 1550 singled out Leonardo and Michelangelo for the sublime quality and power of their works of art. But clearly he felt an obligation to explain that Leonardo's artistic output had been limited because of what he described as Leonardo's frequent "dalliance with science." In writing that Leonardo "could have been a great scientist [if that was all he did]," Vasari revealed that he had little idea of the quality of Leonardo's science. Could have been?

Leonardo's work in science and technology might not have been known to us had the caretakers of the various manuscripts not begun to realize what they had on their hands. In the late nineteenth century, with the development of photography, there was a major effort to produce facsimiles, specifically of the *Codex Atlanticus*. But it was not until a hundred years later that high-qual-

ity facsimiles of the anatomical studies in the *Codex Windsor* appeared.

Unhappily, Leonardo's inventions and scientific discoveries were to come to light long after so much that he had investigated was rediscovered independently, long after entire fields that he had invented were reinvented. One cannot avoid the nagging notion that some of the questions and methods that he introduced might have been handed down by word of mouth, or that some of the pages of his dismembered notebooks might have become available to others, considering how much of Leonardo's manuscripts were lost. There were the detailed dissections and drawings of the human body that Vesalius undertook half a century after Leonardo. And there was also the fleeting annotation about the sun Leonardo left in a notebook— "The sun does not move"—the keystone of the Copernican helio-centric system. I have in mind also the experiments with the pendulum and with falling bodies that Galileo repeated with resounding success a century later. There is on one page of the *Codex Atlanticus*, admittedly with little explanation, a study of the reflection of light from a concave reflector mounted at the bottom of a vertical tube, with the angle of the tube completely adjustable. Are these the rudiments perhaps of a reflecting telescope, constructed by Newton nearly two centuries later? Finally, I have in mind Leonardo's conclusions in the *Codex Leicester* regarding the existence of geological strata chronicling the earth's great age, and that fossils found in the strata represented once living animals.

The traditional view of the birth of modern science is that it dates from 1543 with the publication of two important books. There was the inspired treatise by Copernicus of *De revolutionibus orbeum coelestium,* arguing on behalf of a sun-centered universe. And the same year saw the publication of Vesalius's first accurate anatomical atlas, *De humani corporis fabrica.* By the seventeenth century the scientific revolution was in full bloom with Galileo, Harvey, Boyle, Kepler, and especially Newton. Leonardo's manuscripts, however,

offer compelling reason to accept him as having foreshadowed modern scientific methodology by a full fifty years before Copernicus and Vesalius produced their works. Though Leonardo never disseminated his discoveries, it is not difficult to make a case for Leonardo being the first modern scientist, and indeed that theme is asserted in the title of a recent book.[1]

He kept two different kinds of notebooks. There were the daily notebooks containing an admixture of snapshot-like sketches of faces in the crowd, ideas for inventions, and mathematical calculations and doodling. He also included in these notebooks profound observations intermingled with the prosaic and the perfunctory. The sense one gets in viewing these pages is that of a broad cross-semination taking place among all the components of his world. The image evoked is of a circuit board with each site wired to all others, signals flashing between sites, until they pause and a finished idea emerges. Then they start all over again until the conception of another new idea.

In the second kind of notebook were the finished drawings, including the anatomical drawings produced from multiple angles, designs for machines replete with precise specifications and operating instructions, drawings demonstrating the results of reflection and refraction, experiments in optics, and so on. The text, in vernacular Italian, was written in that otherworldly mirror text from right to left. At one level, there is of course the astonishing content, an unsurpassed artist illustrating unsurpassed science, recording it all in exquisite detail. But at another level, and in the vernacular of our time, even these manuscripts represent a masterpiece of sorts in the modern publisher's art of layout drawings executed with clarity and precision, and text wrapped skillfully around the drawings, every last sheet a frameable piece of art.

The first attempt to put some order into the papers came from Melzi, a man of unremarkable intelligence and limited artistic talent, who proved to be well short of the Herculean task. Melzi spent

fifty years of well-meaning travail trying to organize them, and achieved little success. According to Sherwin Nuland, Leonardo's loyal assistant was able to assemble only 344 brief chapters into a collection, and unhappily even these remained in a state of confusion; none of it was ever to get published in Melzi's lifetime.[2] And the worst was still to come. Upon Melzi's death in 1570 his nephew Orazio became heir to the wondrous collection. Orazio, a lawyer, proved to be a man of lesser wit than his uncle; moreover, he was entirely unencumbered by the devotion that his uncle had shown to his immortal mentor. He quickly lost all interest, losing some papers, selling others, and tragically dispersing the collection. Among those helping themselves to the treasure was the tutor of Orazio's children. What and how much this man took and whether any of it remains among the surviving works will never be known.

Near the end of the sixteenth century the sculptor Pompeo Leoni managed to recover a large assortment of the manuscripts, and by cutting and pasting, grouped some of these into ten lots, or codices, with the rest remaining a potpourri of unrelated papers. The organizing principle of Leoni's collation was general subject areas, but without any order in the dates in which the individual leaves were conceived. The collection was assembled for sale to Phillip II of Spain. Phillip, however, died in 1598 before even taking possession. Meanwhile, the manuscripts made the trip to Madrid, but with the failed sale Leoni returned to Florence, taking back with him only the *Codex Atlanticus,* dealing mostly with mechanical inventions. The rest he left behind in Spain.

The 1,119-page *Atlanticus* passed through the hands of various wealthy families, eventually finding its way into the Biblioteca Ambrosiana in Milan. A large part of the collection left originally in Madrid made its way to England. This included the corpus of the six-hundred-page Windsor collection, dealing with anatomical studies; a third group, the *Codex Arundel,* ended up in the British Museum; a fourth group of only seventeen pages, the *Codex on the Flight of Birds,*

is in the Biblioteca Reale, Turin; a fifth group, *Codex Forster,* is owned by the Victoria and Albert Museum in London; a sixth group was purchased by a wealthy Oxonian, who subsequently bequeathed it to Christ Church, Oxford University, where it is periodically put on exhibition. Also included in the transfer to England was a seventh group of sixty-five sheets, the *Codex Leicester,* owned for centuries by the Leicester Family. The *Codex Leicester* was purchased from its English owners by the American industrialist, Armand Hammer, under whose ownership it became known as *Codex Hammer.* Then in the early 1990s this codex was purchased by Bill Gates at an auction of Hammer's estate. With the change of ownership, the name of the collection reverted to the *Codex Leicester.*

The Gallerie dell'Academia in Florence, the Gallerie dell'Academia in Venice, the Uffizi in Florence, the Vatican Library in Rome, the Louvre in Paris, and the Institut de France all own collections of the manuscripts. The last institution listed owns both the *Codex Ashburnham* and the *Codices of the Institut de France.*

In 1651 a French publisher with deep reverence for Leonardo's works culled from a jumble of Leonardo's general writings just those pertaining to art. A critic at the time had characterized the notebooks as "a chaos of intelligence." The publisher brought some organization to that chaos. After commissioning the French seventeenth-century artist Nicolas Poussin to illustrate the writings, he simultaneously published French and Italian editions of the *Treatise on Painting—Traité sur la peinture* and *Tratatto di pittura.*

Finally, in the 1960s a pair of volumes of Leonardo's manuscripts was discovered in Spain, where they had been lost for 180 years in the Biblioteca Nacional. The caretakers of the collection had even pasted some of the "less useful" pages together in order to fortify others, then promptly misfiled the books. After painstaking restoration the glued pages were separated in the late 1960s and 1970s, and the 192 pages of the notebooks became available for study by Leonardo scholars as the *Codices Madrid I* and *II.* Volume

I comprises Leonardo's writings on classical mechanics; Volume II, a looser assortment of writings on mathematics and optics.

Glimpsing the Future

The mechanical designs of Leonardo can be loosely classified as machines for industrial engineering; machines for commercial application; tools for civil engineering; devices for locomotion on land, air and sea; and military engines for defense and offense. The mental inventions were sometimes accompanied by reflection on the fundamental science underlying the technology. How and why does nature behave as it does? The finite space that we can devote to reviewing the technical component of Leonardo's legacy will allow only a partial inventory of these mostly mental inventions. We shall take a different tack and seek the wider connections among his endeavors rather than presenting a comprehensive catalogue. This approach should assist in understanding the immense value of Leonardo's cross-fertilization of ideas, as well as his prescience, that genius for anticipating future science and technology. It will also serve to launch discussions of modern developments, some that Leonardo could have envisioned as extensions of his own, and others that even he could never have foreseen but would have found fascinating.

Leonardo's preoccupation with the flow of rivers and the catastrophic movement of land (such as in earthquakes) now defines the fields of hydrology, geomorphology, seismology, and a host of other specialties within geology. In his early days in Florence he once wandered into a cave teeming with bats and the all-pervasive rancid mist repugnant even for spelunkers. He also came across the fossils of an extinct creature. The memories of those early encounters remained with him throughout his life; he contemplated the age of the earth, and became deeply skeptical of the time horizon for the age of the earth taught by the Church. He concluded that the

earth was much older. He also wondered about the large-scale changes in the topography of the land as the overwhelming weight of the mountains bore downward. Those experiences are reflected in some of his paintings, as in the *Virgin of the Rocks,* where the background is provided by the cave with stalactites and stalagmites, permeated by the heavy mist. His geologic interests are also in evidence in the *Mona Lisa,* where the distant landscape includes a stream running through the undulating hills and valleys, all formed by the forces of nature.

Leonardo labored on the dynamics of vortices in water. The sketches in his notebooks of these circular, spiral, and cascading flow patterns would reappear in his paintings as gentle swirls in the hair of the subjects of his portraits. He preoccupied himself with problems of hydrostatics and hydrodynamics, examining the relationship between water depth and water pressure. Indeed, there is evidence that he anticipated discoveries made by his latter-day countryman Torricelli, and by the great Swiss family of scientist-mathematicians, the Bernoullis.[3] He explained that it was the weight of the water that determined the pressure at different levels. His experiment in this instance called for holes of equal size drilled at different levels in a cylindrical water container. The water gushed out at different speeds from holes at different heights, revealed by the different ranges of the water's trajectories, and was due to the pressure at different levels. He then extended this idea to explain the existence of different atmospheric pressures at different altitudes as evidence of the weight of the air itself. He designed variations of water pumps and made significant improvements in the hydraulic designs of Heron of Alexandria (first century A.D.)

Leonardo designed a side-wheel paddle assembly for propelling boats. In some versions of the design, a heavy flywheel builds up angular momentum and delivers the power uniformly to the paddles. The power is supplied by one or more people turning cranks. In the nineteenth century, with steam supplying the power, stern

and side-wheelers were navigating the waterways, most prominently on the Mississippi River. Leonardo also designed a double-hull structure for ships that in the twentieth century became the standard design for oil tankers.

In the 1860s, during the American Civil War, the Confederate navy built the submarine the CSS *H. L. Hunley,* reminiscent of a design by Leonardo, powered by men cranking stern or side paddle wheels. By the early twentieth century, with diesel-powered engines, submarines became devastating engines of war.

Leonardo envisioned "floating shoes" that would allow an individual to walk on water, flotation rings that would keep him afloat, and he designed diving suits that would allow a submerged person to breath through hoses. He left behind drawings for equipment that could dredge silted waterways. One device consisted of a floating double-pontoon boat with vertically mounted rotating scoops, scraping silt and depositing it on a floating barge towed between the pontoons. This design is similar to the equipment used in the dredging of the Panama Canal at the turn of the twentieth century, except the latter was steam-powered.

Among his drawings is the design for a turbine to harness hydrodynamic power. Water flowing or falling from a higher elevation rotates a turbine, which in turn drives other devices, such as mills, drills, and saws. With the harnessing of electricity in the nineteenth century, the turbine became a device to power the electric generator, which in turn provided the electrical energy to run the mills, drills and saws, and to run homes, cities, and factories.

In addition to countless designs for original devices, there are also present designs for "derived tools." It is clear these are ideas that have been inspired by others' inventions, but Leonardo's versions rarely lack improvement over previous designs. There are his variations on the Archimedean screw—one design involving a single helical coil, another a pair of intertwined coils.[4] The screws are turned by cranking a handle, raising the water uphill. In still

another version a helical hollow coil wrapped around an axle is rotated manually with a crank.

Lock, Stock, and Barrel

Among the pages of the *Codex Atlanticus* are ideas for the mortar and the howitzer, shooting multiple cannonballs. The military engineering aspect aside, there is a subtle observation here of the inherent physics. That realistic depiction of the array of cannonballs reveals in their curvilinear motion the smoothly arched trajectories, a circumstance that no single cannonball frozen in space and time could reveal by itself. (This is in the manner of a stream of water propelled from the nozzle of a hose. No droplet alone frozen in space and time reveals the path as the stream itself does.) It is clear that Leonardo already had a more realistic understanding of the trajectory of a projectile than the instructors of natural philosophy (physics) who were still teaching Aristotelian physics in academic institutions. That archaic view, which prevailed into seventeenth century, had the projectile rising in a straight line at some oblique angle, and upon losing energy, plummeting vertically, the two straight lines of the rise and fall connected by a short semicircular curve. Among Leonardo's drawings appears a set of trajectories of projectiles launched at different angles. These trajectories are recognizably parabolic in shape.[5] In the parabola there exists a right-to-left symmetry about the midline, lacking in the trajectories depicted by the Aristotelians (Figure 10.1).

The mathematics describing the shapes of curves (analytic geometry) awaited formulation by Descartes a century later. Leonardo was unable to demonstrate the parabolic trajectories with mathematical rigor. Almost a century after Leonardo's death Galileo established the exact trajectories of projectiles to be parabolic curves. Such measurements and calculations are revealed in one of Galileo's lab books of 1608.[6] In a first-year physics laboratory

course in high school or college similar experiments are routinely duplicated by seeking the relationship between the vertical and horizontal distances projectiles travel.

Leonardo contemplated other weapons of much greater effectiveness, such as a machine gun. Multiple muzzles are arranged in splayed configuration and when fired spray projectiles in a wide horizontal plane. There is little chance of precision aiming with this

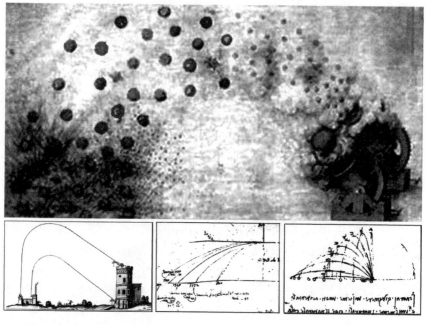

Figure 10.1. *(top)* Leonardo's drawing of bursts of mortars, revealing smooth arched trajectories, *Codex Atlanticus. (insets, left to right)* Illustration from a military treatise published in the early seventeenth century reflecting the prevailing Aristotelian notion of a projectile's trajectory. *(inset, center bottom)* Galileo's discovery of the parabolic trajectory (1608). *(inset, right bottom)* Leonardo's drawing of the trajectories of projectiles fired at a variety of angles

weapon, depicted in the *Codex Atlanticus,* but then it is the scatter-shot effect that appears to be the goal. There is no evidence that the weapon was ever built in Leonardo's time, but late in the nineteenth century the Gatling gun was invented with muzzles in a circular arrangement around a central axis.

One is struck by the precision and detail in the drawings, and indeed in the transparency of their function. Every manner of spring, every manner of gear—worm gears, reducing gears, the variable transmission, and even the mechanism for converting reciprocating motion into circular (and conversely, circular into reciprocating) has been conceived and masterfully drawn, each a general solution awaiting a special problem.

In other instances solutions are presented for well-defined problems. There is, for example, the design of odometers to determine distances. For odometers he envisioned variations of a device reminiscent of a modern wheelbarrow that would be rolled along the path to be measured. There is a gearing down process with thirty revolutions of the main wheel resulting in one revolution of an intermediate wheel. Then thirty revolutions of the intermediate wheel result in one turn of the last wheel; followed immediately by the release of a bead into a collector. Even this collector/counter is arranged so that the beads form a regular array, which at a quick glance reveals the total distance covered by the odometer. For example, a 4-by-5 array of beads represents $30 \times 30 \times 20 = 18,000$ revolutions of the main wheel of precisely known circumference. This apparatus is so simple and practical that Leonardo very likely constructed it to use in his civil engineering tasks.

It was mainly during his Milan years, from 1482 to 1500, that Leonardo's thoughts ran to urban planning, revealing prescience regarding the communicability of diseases. He wrote about the intolerable squalor of certain sections of the city, and saw a threat of the spreading of "the seeds of plague and death," perceiving a

need for the population to be more uniformly spread out. To that end, he drew a plan to create a city of concentric circles of ten zones, and a zoning system that would distribute the population of 300,000 evenly among the ten zones. Unhappily his employer, the duke Ludovico Sforza, never saw fit to implement the plan, which, as Sherwin Nuland observes, could have served as a model for many European cities also suffering the tribulations of congested population densities. It was an idea of human settlement, *ekistics*, centuries ahead of its time.

In his original letter to Sforza seeking employment, Leonardo had offered his services as a military engineer—to build devices for defending walls as well as other devices to tear them down. His notebooks from this period reveal many of the proposed instruments of war having attained design stage, but rarely the level of production. There were shielded ladders and portable bridges to be used in attacking the enemy, or conversely, for retreating. There were cannons of unusual efficacy, among them a design to propel cannonballs with steam pressure. Also among the mental inventions in his arsenal was the design of a particularly grisly machine, a chariot-driven scythe that could mow down enemy soldiers (but as much a hazard to the attacker as the attacked). There was the design for a colossal bow that could breach fortified castle walls. The scythe is most likely derived from earlier Renaissance inventors, and indeed, the massive crossbow idea harks back to the Romans. Finally, Leonardo has the design of an improved trebuchet, the medieval war engine designed to catapult boulders or marble balls several hundred kilograms in mass into castle walls. The Mongol armies were known to have used the trebuchet to launch animal carcasses (and even plague-ridden human corpses) over city walls. This early application of biological warfare unhappily did not elude Leonardo, who also included in his notes the sketch of a trebuchet armed with its projectile: the carcass of a horse.

Operating a machine that is virtually invulnerable to the enemy while your warriors are attacking is a fantasy as old as the concept of warfare itself. Leonardo's solution, an armored vehicle, prefigures the twentieth-century tank by more than four centuries. A gang of four men, providing power for the vehicle by cranking handles, does not make for efficient locomotion, but there is improvement in another design where he introduced oxen as the source of power. Once diesel-powered locomotion became available in the late nineteenth century, the feasibility of a tank blossomed fully in time for the First World War. It became an overwhelming offensive force in warfare through the twentieth century.

One device that was produced in his own lifetime following his design was the wheel lock. As a precursor to the flintlock, the wheel lock represents a significant development in the history of weapons, making possible portable guns—pistols, muskets, the blunderbuss, and ultimately the modern rifle. Leonardo's designs for a door lock and a wheel lock both appear in the *Codex Madrid;* his designs for a variety of leaf and coil springs appear in the *Codex Atlanticus.*[7] Springs and small connecting chains are used in cocking and releasing component parts. When a trigger is pulled, a cocked mainspring sets a steel flywheel spinning. A piece of iron pyrite, a flint, held in place by a small vise is brought into contact with the rim of the spinning wheel, resulting in the release of a stream of sparks. These ignite the gunpowder interposed in the barrel between the wheel lock and a bullet. Also required is a stock heavy enough to reduce the recoil when nestled in the gun-bearer's shoulder, allowing the weapon to be held safely and comfortably, and aimed with ease. The necessary components of the rifle yield the common expression in English conveying the entirety of a system—"the lock, stock, and barrel."

It is no surprise that Leonardo, who contemplated a variety of devices to harness energy, spent time designing a spring-driven horseless carriage. Leonardo's crude sketch for the spring-powered

cart appears in the *Codex Atlanticus*. As depicted, his machine would have lurched forward and traveled a short distance. Four hundred years later, after the discovery of the Otto cycle and invention of the gasoline-powered engine and the diesel engine the car became more than a viable means of transportation—it became indispensable. At the threshold of the twenty-first century the question is not whether such vehicles will be around into the distant future, but rather what will be their future sources of power—battery, fuel cells, hybrid?

In the book *The Unknown Leonardo*[8] Ladislao Reti presents the marvels of the *Codex Madrid*, a pair of notebooks dating from Leonardo's peak productive period, 1491 to 1505. This is a period coinciding with the years of his artistic masterpieces, the *Lady with the Ermine*, the *Mona Lisa*, and the *Last Supper*. The bicycle evolved during the nineteenth century—from a pair of wheels which a man straddled and took for a walk, to the unicycle, to a pair of wheels with varying sizes, and so on. There was experimentation with a small wheel in front and a large one in back, then vice versa, until the optimum general design finally emerged toward the end of the century. The modern bicycle—replete with two equal wheels, a handle bar, seat, pedals, a pair of gears and, connecting the gears, a chain-drive—dates to the 1890s, but the identity of its inventor depends on who is making the claim. According to French tradition Ernest Michaux, a blacksmith in Paris, created the first bicycle; according to the Germans it was Baron Drais von Sonnerbronn who had that honor. We are not in a position to resolve the debate. Or are we?

Leonardo's *Codex Madrid* contains the vision of a bicycle, complete with two equal-sized wheels, a handle bar, a seat, pedals, a pair of gears and a connecting chain-drive.[9] Displayed in the drawing is a tacit understanding of the mechanical advantage obtained from driving the smaller gear in the rear with the larger one in the front. Another figure appearing in the codex depicts the details of a bicycle chain complete with sprockets. Leonardo's vision in this instance

hurdled four centuries of technology, including the entire span of the Industrial Revolution.

Human Flight

> Why should man not be able to do what the birds do?
>
> —Leonardo da Vinci

Leonardo was in love with every facet of nature but reserved a special veneration for birds. He regarded birds as nature's splendid flying machines. In their case form had followed function magnificently. He spent his life virtually fixated on the mechanics of the flight of birds, bats, insects, creatures all clearly heavier than air— and dreamed of human flight. He reasoned that if birds could fly, then with some help so could humans. His notebooks are filled with sketches of wings, their anatomy, their mechanical motion, and his own designs for a variety of *ornithopters,* pairs of strap-on wings resembling those of bats. His assistants may have been mortified by the notion that he might appear at work some morning and ask one of them to test-fly one device or another.

When Leonardo eventually concluded that achieving flight by flapping wings in the manner of birds was less than promising, he began to think of achieving elevation with a spinning helical foil. In his art, especially in the portraits, the helical shape had been used to create dynamism in his subjects. In the Archimedean screw it was used as a mechanical device to elevate water. He must have connected that shape and the memories of watching *samaras* descending gently from trees while spinning.[10] Could the helical screw be rotated to achieve lift? Leonardo's design for a helicopter called for a large helical foil, a massive screw, which would be powered by two (and in another version by four) men. A horizontal torque generated by cranking handles was converted into a vertical torque

with one of the gear assemblies sketched out in his notebooks, operating in a manner reminiscent of the differential or rear end of an automobile.

Leonardo may have built miniature scale models of some of the inventions he had visualized, as it is generally believed he built models of the polyhedra presented in *De divina proportione*, but none have survived. Many of the machines he designed would have worked just as they were depicted. Others would have worked in principle, but not in practice. And others still would not have worked as they were conceived. The boat with side-paddles, the submarine, the car would not have had sufficient power if the energy came from humans exerting muscle power only. His aerial screw could never have generated sufficient "bite" powered by humans; moreover, it would have needed a stabilizer and a steering mechanism to become a practical flying machine. The Russian-American aeronautical engineer Igor Sikorsky claimed to have been inspired by Leonardo's aerial screw when he created the first successful helicopter in the 1930s, powered by a gasoline engine with a stabilizing propeller in the rear.

Among the pages of the manuscripts there is an unusually rough sketch, a fleeting idea for a parachute, a pyramid-like four-cornered fabric structure and a man hanging from lines attached to each corner. An annotation by Leonardo explains its purpose: "If a man have a tent made of linen of which the apertures have all been stopped up, and if it be twelve braccia across and twelve in depth, he will be able to throw himself down from any great height without suffering any injury." Even in our day we might find the design problematic, interesting, but unlikely to work as depicted, certainly unlike the billowing hemispherical sail, replete with a small stabilizing hole at the top, and the cords made of lightweight nylon that we are accustomed to. But in December 2000, five hundred years after Leonardo had created his sketch of a parachute, a National Geographic Society photographer captured the spectacle of a man sailing down from the skies above South Africa with a parachute

created in the image of Leonardo's own design and built to his spec-
ifications.

A Bridge for the Sultan

In 1500 Leonardo traveled to Florence for what would be a short
second Florentine period. And although he was received with def-
erence, he was not accorded the adulation of Michelangelo, the
younger and exceedingly talented sculptor and painter who man-
aged to finish projects. He came very close to relocating to Con-
stantinople (today Istanbul), ostensibly to take up a position as
court engineer similar to the one he had held in Milan, and to do
a portrait of the Ottoman sultan Bayezid II. In his application for
a job he had contemplated preliminary designs for a bridge over the
Golden Horn, and a pontoon bridge across the far more expansive
Bosporus. As events unfolded, however, Bayezid did not take him
up on the offer, and Leonardo took instead a position in Urbino,
under the patronage of the city's new leader, Cesare Borgia.

There is a tradition among many in Istanbul that the father of
Sultan Bayezid, the legendary Mehmed the Conqueror, had earlier
invited Leonardo to Constantinople to paint his likeness. But with
Leonardo being unavailable at the time, the commission had gone
instead to an older contemporary, the Venetian Gentile Bellini, who
made the journey to the Ottoman capital and produced the only
known likeness of the legendary conqueror of the city. The portrait,
created in 1480, a year before the Sultan's death, is now in the
National Gallery in London. It is certainly possible that Leonardo,
then twenty-eight, could have been offered the commission, but
there does not appear to be sufficient basis in fact to accept the
story's veracity.[11]

As for a bridge spanning the Golden Horn, a floating bridge
was finally built 350 years later, and a pair of bridges spanning
the Bosporus, five hundred years later (in 1973 and 1982, respec-

tively). But Leonardo's original design, combining function, structural strength and artistic elegance, but somewhat scaled down, was brought to fruition in 2001 in the far north—Ås, Norway.

Replicas of the "Mental Inventions"

Replicas of Leonardo's mental inventions were ultimately created from the sketches that he left in his notebooks. The best known set of the replicas came in the late 1930s, when Benito Mussolini commissioned Roberto Guatelli, an Italian modeler/engineer, to create scale models from the sketches. Shortly after the replicas were completed they were shipped to Tokyo, where they were put on exhibition. But like so much else, they became victims of the war, destroyed during aerial bombing of the city. In 1951 IBM hired Guatelli to create a new set of replicas, finally completed in the late 1950s. The replicas are now owned by the Gallery Association of New York State (GANYS) and are lent out to museums and other institutions for display. Among Guatelli's creations based on Leonardo's drawings are the *ornithopter*, the parachute, and the aerial screw. Also there are the double-hulled ship, the paddle assembly for the side-wheeler boat, the mechanism for a water powered turbine, a transmission, variations of the odometer, a scale model of Leonardo's tank, a printing press, the spring-powered cart (Leonardo's automobile), an anemometer to measure wind velocity, and a hydrometer to measure moisture, among other inventions.

After the discovery of the two volumes of the *Codex Madrid* in 1967, Guatelli examined the books, uncovering the design of a machine closely resembling another sketch appearing in the *Codex Atlanticus*. Using the two designs in tandem, he created the replica of a machine that convinced him that he had a crude mechanical calculator on his hands. With thirteen gears connected in series, and a ratio of 10:1 between each pair of gears in sequence, Guatelli surmised that the

machine was capable of registering up to 10^{12} (i.e., 10^0–10^{12}). A panel of engineering faculty at MIT convened to study the machine and became convinced that the inherent friction between so many gears in series would render the machine unworkable as depicted, but that its intended function was that of a "ratio machine." In 1971 Guatelli and chief assistant Joseph Mirabella, his stepson, left IBM and founded their own workshop in New York in order to continue producing replicas of Leonardo's mental inventions.

Leonardo Timekeeper

Questions regarding the nature of time have baffled philosophers and physicists since ancient times, and it would have been surprising if Leonardo had not contemplated the problem. His concerns about the nature of time may have been fueled by his desire to build an accurate mechanical clock. But whether the concerns actually occurred to him in that order or in the reverse (i.e., pondering the nature of time, then addressing the engineering problem of designing a clock) may never be known. Over the ages scholars have grappled with notions of a circular time, with cosmic history repeating itself, and a linear time progressing irreversibly. The passage by Leonardo quoted at the beginning of Chapter 1, which compares the passage of time and a flowing river, is a reflection of the man's interest in this enigmatic phenomenon of nature. His metaphor suggests that in his view time progressed according to the latter model. These prefigure twentieth-century cosmology's debate between the validity of an always existing, steady-state universe versus an expanding universe that had a beginning in time (with a big bang). If the latter, will the universe keep expanding forever—making this a one-time universe—or will its expansion slow down and stop; and if this is the case, perhaps there would follow a collapse (a big crunch), followed by the endless repetition of the process. These are issues we shall examine later.

During his investigation of time and timekeeping, Leonardo examined the behavior of the simple pendulum. A weight is suspended by a string, and put into oscillation by being displaced to one side and released. The weight or pendulum oscillates back and forth, between a maximum displacement on one side (the amplitude) and the maximum displacement on the other. The period of the pendulum is defined as the time for the pendulum to go from one amplitude to the other and then to return to its original position, one full back and forth motion. The pendulum at its maximum displacement will momentarily stop before moving in the other direction, its maximum speed attained at the lowest point of its swing. In the ideal case, where air resistance is absent, the oscillation will continue unabated. In reality, air resistance creates a drag and eventually stops the oscillation of the pendulum. What is remarkable about the behavior of the simple pendulum is that the period of the oscillation turns out to be very nearly constant, even while the amplitude of the oscillation decreases.

Leonardo left a crude sketch of the simple pendulum. As it appears in the *Codex Atlanticus*, however, it has a confusing aspect to it. The pendulum is shown in successive images, but with the highest density of images occurring near the lowest part of the swing. If a modern strobe light were illuminating the swinging pendulum, the highest density of images would occur at the extreme points where the pendulum is in its slowest stage. Thus Leonardo appears in that sketch to be using greater density of images to represent the areas of greatest speed.

Leonardo's notebooks also contain the rough sketch for a machine with a pair of flat springs twisted into shapes reminiscent of the horns of a water buffalo, and weights hanging from a pair of brackets on the machine's sides. What Leonardo had in mind for this machine was a quandary until a German engineer replicated the machine recently, hoping to resolve the question of its purpose.

It turned out to be the design for a mechanical clock driven by springs and fine-tuned with the adjustable weights.

Among Guatelli's replicas is an apparatus to determine the curvature of the surface of the spherical earth, with a device somewhat evocative of the scheme used by the ancient Alexandrian astronomer Eratosthenes. With his technique of sighting a distant celestial body at two points on earth that are separated by substantial distance, Eratosthenes had measured the radius and circumference of the earth. Indeed, the notion of a flat earth was preposterous to Leonardo, even more so than an earth-centered universe. In speculations about the sun-centered universe he was echoing the sentiments of Aristarchus of Samos, another astronomer of antiquity (but a notion not to resurface until Copernicus published his book in 1543). The views of Aristarchus and Eratosthenes may or may not have been available to Leonardo. Never having received the sanction of the Church, these views were most likely not available in Italy, although the success of Columbus's trip of 1492 had gone a long way toward confirming the shape of the earth prescribed by both scientists.

The Anatomical Studies

Whereas the dates of so many of Leonardo's technical works have been obscured by Pompeo Leoni's questionable sorting technique, the anatomical drawings can be traced mainly to two well-defined periods in his life when he is known to have undertaken such studies. His first Milanese period (1482–1500) saw some limited dissections of corpses, but more of animal carcasses than of human cadavers. Leonardo's early beliefs had been shaped by the writings of the second century A.D. Greek physician Galen. He still accepted the Galenic view that blood originated from the liver, and a healthy body required a critical balance of the four humors—blood, black bile, yellow bile, and phlegm—together with the proper admixture

of hot, cold, wet, and dry. His drawings of the heart of a calf and the embryo of a cow are exquisite in their detail, but not overwhelmingly significant for the understanding of the human machine, or that of any other mammal. He had little access to human cadavers in this period and his understanding is accordingly rife with errors.

Leonardo's second Milanese period (1506–1513) turned out to be a time of bounty for his anatomical studies, and conversely, a time of austerity for his artistic productivity. Although the *Mona Lisa* may have been completed around 1507, few other works of art are known from the time. His new patron in Milan was the French King Louis XII, whose hegemony extended over Milan and who entered the city personally in 1507, shortly after Leonardo. For the inhabitants of the city the presence of the formidable French forces brought a life relatively secure from invasion at a time in Italy when the fear of invasion was one of the constants of life. Louis recognized Leonardo for his gifts and granted him regular compensation, allowing him to operate his own veritable "think tank." There were seemingly no requirements to produce anything. Leonardo's fertile imagination could explore untrammeled. For the first time in his life Leonardo had the opportunity to devote himself to his beloved science, unencumbered by the need to scrounge about for patronage.

A catalyst for his mastery of anatomy came with his meeting the prodigiously talented young anatomist, Marcantonio della Torre, who had recently transferred from the University of Padua to the University of Pavia. The former was one of the few Church-sanctioned seats of anatomical studies, including dissections, and the latter was aspiring to build up a program. The collaboration with della Torre, half his age, galvanized Leonardo's intense dedication to the pursuit of knowledge. There is some disagreement among Leonardo scholars as to whether della Torre was the driver, directing Leonardo's dissection procedures, or an equal partner deriving as much from Leonardo's work as he contributed. A fair assessment five hundred years after the fact might be that della Torre

indeed gave Leonardo's methods of anatomical probing some structure, but that Leonardo—with his immense gifts of innovation, the dexterity of a supreme artist, and above all his independence of thought—took it from there. Just as he had always been a scientist doing art, here he was the artist doing science. The collaboration with della Torre, however, was to last no more than three or four years; in 1512 the young physician died, a victim of the plague.

The Leonardo scholar and professor of surgery Sherwin Nuland, to whom all scholars of Leonardo as an anatomist may safely defer, recounts a pair of back-to-back dissections that Leonardo performed. The first was carried out on a recently deceased old man who had claimed to be a hundred years old, on whom Leonardo was able to perform an autopsy almost immediately after death. Leonardo concluded that the cause of death was "a weakness through failure of blood and of the artery that feeds the heart and the lower members which I found to be very parched and shrunk and withered."[12] He found in a subsequent autopsy on a two-year-old child the same vessel to be clear of obstruction and the vessel walls to be supple. What Leonardo had described in the coronary arteries of the old man was "atherosclerosis of the aorta and perhaps even artery obstruction, hundreds of years before either was recognized by physicians."[13] The dissections he had performed on these two freshly deceased cadavers stood in dramatic contrast to others he had performed—mostly in fetid chambers—on cadavers in various states of decay, though also described copiously. The descriptive narrative, however, in those earlier cases is of less significance than the detailed anatomical drawings presented from multiple angles. Anatomical drawings of the female body that existed in the literature of Leonardo's time could have been mistaken for schematic drawings of a frog's anatomy (Figure 10.2).

One organ in the human body fascinated Leonardo beyond any other. His "window to the soul," the eye, as the instrument of sight, had to be understood at all levels: its structure, its connections to

Figure 10.2. "The Great Lady," *Codex Windsor.* Anatomical drawing of the female torso by Leonardo. *(inset, upper right)* Anatomical drawing of the female torso appearing in a contemporary work, *Fasciculus Medicinae*

other organs, and its precise operation as light traversed it. In order to understand the anatomy of the eye—this aqueous, mysterious organ—he had to perform minute dissections. But this is an organ uncommonly difficult to cut accurately because of its fluid interior. Leonardo invented the technique of holding the eyeball fixed in a glutamate formed by a hard-boiled egg (the eyeball would be

immersed in egg white and hardboiled within it). The technique of embedding the eyeball in a coagulum such as paraffin for purposes of accurate slicing is routinely used today.[14]

Also to be mastered in this connection was the nature of light itself. Thus the anatomy (biology) of the eye was only half the story; it had to be augmented with the other half, optics (physics), which also required examination at a fundamental level. He studied the science of perspective, just coming into its own, and he made significant contributions. He recorded his observations on light falling on the sides of multifaceted polygons in order to understand the nuances of the shading, the scattering of light. This was invaluable for informing his paintings, especially the portraits. The faces of both the Virgin and the angel in the *Virgin of the Rocks* exude otherworldly and divine qualities because Leonardo was able to illuminate them with just the right light. The enigmatic visage of the *Mona Lisa* similarly reflects its creator's surpassing mastery of light.

Studies in optics in the context of reflection and refraction of light are found in more than one codex—the *Atlanticus*, the *Arundel*, the *Madrid II*. On a page of the *Codex Atlanticus* (c. 1490) there is an entry, "making glasses to see the Moon enlarged," proposing the idea of a refracting telescope, which was ultimately patented by the German-born Dutch optician Hans Lippershey in 1608. In a refracting telescope a pair of semiconvex lenses (a primary and a secondary) are used to magnify the object viewed, most of the actual magnification being performed by the larger primary lens. Less than a year later Galileo, having been presented approximate specifications of Lipershey's marvelous invention by a close friend, created his own refractor (Plate 16, lower left).

One drawing that has fascinated me since I first came upon it several years ago in the *Codex Atlanticus* is a study of reflected rays from a concave mirror. On the same leaf also appears a cylindrical tube, possibly to house the concave reflector/mirror, and a hinged structure to allow the tube to be "aimed." There is no annotation

regarding that tube with the hinged base, but I cannot not help wondering—was Leonardo contemplating a rudimentary design for a reflecting telescope (Plate 16, upper left)? Finally, my suspicions regarding the purpose of that concave reflector's function were further reinforced more recently when I came across an article by O'Conner and Robertson.[15] Almost a quarter of a century after his entry in the *Codex Atlanticus* referring to the possibility of a *refractor*, Leonardo had written: "[I]n order to observe the nature of the planets, open the roof and bring the image of a single planet onto the base of a concave mirror. The image of the planet reflected by the base will show the surface of the planet much magnified" (*Codex Arundel*, c. 1513).

In a successful reflecting telescope, the reflecting surface—the mirror—would have to be parabolic in its shape rather than circular for parallel light rays entering the tube all to be reflected to the focal point of the parabola. A small diagonal mirror located at the focal point would then gather these converging rays and reflect them all to an eyepiece. James Gregory in 1633 first described the correct structure of a reflecting telescope, but never constructed the apparatus. Then around 1668 Isaac Newton, after independently deriving the associated mathematics, created the first functional reflecting telescope. More than three hundred years later the Hubble Space Telescope (HST), a far more sophisticated version of the reflecting telescope, was placed into orbit by a space shuttle. Free of the obscuring atmosphere of the earth, the Hubble Telescope is able to peer into the distant edges of the universe (Plate 16, upper right).

Along with the telescope and the pendulum a number of Leonardo's other concerns—the problem of friction between surfaces of moving bodies, the notion of center-of-gravity, and the behavior of bodies in free fall—are all concerns of physics. Leonardo designed a machine exclusively to study the phenomenon of friction, which is a practical problem, but does not rise to the level of fundamental physics. In one of his drawings *(Codex Leicester)* two

men are seen on a seesaw in a manner suggesting the tacit under-
standing of balanced torques. In another drawing pairs of balls of
different sizes are shown contiguously, hung from a nail in the ceil-
ing. Depending on their relative sizes (presumably their weights),
the center of gravity is identified by a vertical line—for two equal-
size balls, the line passes through the two balls' point of contact;
when one ball is larger (more massive than the other), the line
passes through a point inside the larger ball, the point of contact
having shifted in the direction of the smaller ball. In still another
set of drawings, Leonardo depicts the spherical earth with a con-
centric shell-like structure, explaining in his own words that heav-
ier masses have gravitated toward the center of the earth, echoing
the modern understanding of twentieth-century geophysics. As for
the phenomenon of falling bodies, Leonardo first sowed the seeds
but did not follow through to the harvest. One hundred years later
Galileo established firmly the constancy of acceleration in free fall.
More significantly, the problem led to Newton's formulation of the
universal law of gravitation, and ultimately Einstein's general the-
ory of relativity. That it would take Galileo, Newton, and Einstein's
entry into the fray, and the emergence of entirely new areas in
physics and mathematics, to bring us to our present understanding
attests to the problem's importance. In the five hundred years since
Leonardo framed his question there has been astonishing progress.
But the final synthesis of the physics of the very large and the
physics of the very small, a sort of Holy Grail of physics, still re-
mains elusive. For the first time, however, the formulation of a "the-
ory of everything" (TOE) seems within striking range. We shall
devote the next two chapters to following the drama that brought
us to this point in our understanding.

He who is fixed to a star does not change his mind.

—Leonardo da Vinci

Chapter 11

Unifying the Physics of Heaven and Earth

*A*t one level, the statement quoted above could be regarded as Leonardo's derogation of astrology as an indicator of one's fate; certainly it reflects his sentiment that one has to keep an open mind. Like other anatomists of his time, Leonardo had begun his studies from a Galenic frame of reference, but unlike the others, he was far more open to modifying his views when his observations appeared to contradict the prevailing understanding in the field. In astronomy, he started out with the earth-centered Ptolemaic view, but where intellectual honesty required revision of the accepted

theory, he sought evidence presented by nature. In physics there existed Aristotelian formalism, but again Leonardo demanded proof before he could accept the tenets of that formalism. Coleridge's words, "A man convinced against his will is of the same opinion still," could not have rung with more truth for anyone else.

In the fourth century B.C. Aristotle, the most influential of all philosophers, taught that heavy bodies fall faster than light ones.[1] In one passage Leonardo echoes this observation verbatim. But with systematic experimentation and observation, and with a quintessentially open mind, Leonardo established for himself that acceleration for a falling body was constant and independent of its weight. It was that extraordinary personal code of intellectual honesty, the skills to ask just the right questions of nature, that gave him the astonishing ability to extricate her secrets.

Regarding the Ptolemaic picture of the solar system, in which the sun orbits the earth, there is no doubt that Leonardo was engaged in a recurrent struggle to search out the most logical picture. In one geometric construction he depicts the earth orbited by the moon, and at a much greater distance, also by the sun—the geocentric picture. But in another instance he confronts Ptolemy head on, saying the sun "stands still." He asserts the heliocentric picture: "The earth is not the center of the circuit of the sun, nor the center of the universe." Unhappily, he left no other reference to this issue, but what other treasures must have been hidden in the original mass of manuscripts? Perhaps further ruminations regarding a sun-centered solar system? Or thoughts about what keeps the moon locked in an eternal orbit? We can only speculate.

The irrecoverable loss of two-thirds of Leonardo's manuscripts leaves one with the same sorrow and frustration as the loss of the works stored in the library of Alexandria in the great fire of the late fourth century A.D. Among the works destroyed then were hundreds of thousands of scrolls from classical antiquity—including the original teachings of Aristarchus, Archimedes, and Eratosthenes,

and of Herophilus, an Alexandrian physiologist who had firmly established the brain in distinction to the heart as the seat of reason. There were also the works of Berosus, the Babylonian historian whose accounts referred to a primeval flood, as well as events as far back as a hundred thousand years earlier. So many abstractions and discoveries—the idea of a spherical earth, the sun-centered universe, atoms, elements, democracy, and the recognition of the brain as the organ for reason—had had their origins in antiquity and had to be rediscovered in modernity. Leonardo's manuscripts represent a similar treasure. So many of the insights and inventions of the notebooks prefigure the developments and discoveries of the following three hundred years. Had they been available to others in Leonardo's time, the progress of science and technology would have been accelerated dramatically.

It would be more than a century after Leonardo that the law of falling bodies would be codified, expressed mathematically by Galileo.[2] Almost another full century would pass before the physics of heaven and earth would be unified by Isaac Newton; and two centuries later still that in the hands of Albert Einstein a comprehensive theory of the mechanics of the cosmos would be formulated as the general theory of relativity. Perhaps because of their connection to human flight, Leonardo performed experiments related to free-fall. His conclusions turned out to be only partially correct. But in introducing a particularly resourceful approach, he was on the same track that led to the ultimate resolution of the problem. This draws him into the pantheon of physicists with Galileo, Newton, and Einstein. We shall examine here the history of this quest, and present the analysis in mostly qualitative terms. To eliminate all vestiges of what are mathematical theories, however, would undermine their essence as physical laws, and produce only dogma. A few very simple equations will be introduced, but relegated to the endnotes. To reiterate a frequently resonating message of this book: the universe is expressible in mathematical

terms—a feature to be savored. In order to gain a deeper insight, however, one would need familiarity with that magnificent mathematical invention of differential calculus—formulated in the second half of the seventeenth century by Newton (and independently by Leibniz), but lying outside the scope of this book.

To reiterate a second message of this book: there is beauty in nature, beauty in the universe. For the scientist the prospect of uncovering a deep mystery of nature holds almost hypnotic allure. Mathematical models that help us to visualize physical phenomena are created and tested. Theories are formulated and are proved and accepted, disproved and abandoned, or (more often) modified to conform more closely with observations. Theories that rise to the level of the transformative are rare. George Bernard Shaw, in introducing Einstein at a banquet, had this refinement process in mind when he quipped, "Newton created a universe that lasted two hundred years. Einstein created a universe, and we don't know how long [his] will last." But before we can begin to see how we came to our present understanding of the underlying logic behind the universe and the significance of that understanding, we must first appreciate the dizzying scale of space and time.

The Scale of Space and Time

The earth is a spherical ball 12,800 kilometers (8,000 mi.) in diameter, slightly more oblate (fatter at the equator) than strictly spherical. In the beginning of the third century B.C. the circumference and radius of the earth were determined with surprising accuracy by the astronomer and mathematician Eratosthenes of Cyrene. Head of the great library of Alexandria, Eratosthenes carried out a series of measurements. He knew from his predecessors that at noon on the longest day of the year (the day of the summer solstice) the sun would be directly overhead in Syene (today Aswan). A vertical post erected in Syene would have no shadow at that moment,

whereas a post in Alexandria 800 kilometers (500 mi.) north of Syene would have a measurable shadow. It is this shadow that Eratosthenes measured with exquisite precision on that day. He determined the difference in the angles between the axes of the two posts to be 7 degrees. These axes, he reasoned, if extrapolated downward, would meet at the center of a spherical earth. That 7 degrees happens to be approximately one-fiftieth of a circle. Multiplying the 800-kilometer (500-mi.) distance between the two posts by 50, Eratosthenes obtained the circumference of the earth as 40,000 kilometers (25,000 mi.). Finally, dividing the circumference by π, he calculated the diameter of the earth to be 12,800 kilometers. If Columbus had known Eratosthenes's value in 1492, he would not have been deluded into believing that he had reached India or Asia, and the islands of the Caribbean would not have been dubbed the "Indies." He had no idea that the much more expansive Pacific lay to the west of the continent he had discovered.

An older contemporary of Eratosthenes, Aristarchus of Samos (c. 320–250 B.C.), had theorized just a generation earlier that the shape of the earth was spherical, offering as evidence a three-part argument: the field of stars changes with the latitude of the observer; the mast of a ship comes into view before its hull as the ship approaches the shore from a distance; and the shadow of the earth cast on the moon during a lunar eclipse is always round. Aristarchus, however, is not known to have attempted to measure the size of the earth.

In another project still, Aristarchus tried to compare the distances from the earth to the moon and the sun. When the moon is illuminated by the sun as a half-disk, he reasoned, the angle made by the line connecting the earth and moon and the line connecting the moon and sun would be exactly 90 degrees. Accordingly, he constructed a pair of similar triangles, and found the relative distances for those lines to have the ratio of 1:19. His method was correct, but his instruments were much too crude. The correct ratio is 1:395.

That value, 1:395, is also virtually the same ratio as the diameter of the moon to that of the sun, a happenstance that explains why, in viewing a total solar eclipse, we see the disk of the moon to fit almost precisely over the disk of the sun. The size and distance proportions of the sun and moon appear to have been known to Leonardo, who in a drawing in the *Codex Leceister* demonstrated that geometry. In a vertical cone representing light, the sun is a sphere at the opening of the cone, the moon is within the cone, and the vertex of the cone falls on a point on the surface of the earth. Indeed, this juxtaposition creates similar triangles in geometry.

But even more dramatic than Aristarchus's assertion of the spherical shape of the earth and his attempts to measure the relative distances from the earth to a pair of heavenly bodies was his heliocentric (sun-centered) theory of the solar system. A full eighteen hundred years before Copernicus, he advanced a model of the solar system with the earth as a planet orbiting the sun along with the other planets. A few centuries later much of the erudition handed down by Aristarchus and Eratosthenes fell into disfavor in the eyes of the early Church. A geocentric (earth-centered) picture, placing mankind at the center of the universe, became the model of choice. Indeed, in time the teaching of the alternate theory would be deemed heresy punishable by death. It would not be until Copernicus in 1543,[3] and Galileo and Kepler in the early seventeenth century, that the heliocentric picture would return. But only late in the seventeenth century, when Newton published the *Principia*, would it gain final acceptance.

Astronomical distances are expressed in a variety of units, each selected for its convenience of purpose. The distance between the earth and the sun is approximately 150 million kilometers (93 million miles); this distance also defines an astronomical unit (AU). For the first several planets the distances from the sun are 0.4 AU (Mercury), 0.7 AU (Venus), 1.0 AU (Earth), 1.6 AU (Mars), 5.2 AU (Jupiter) and 10 AU (Saturn).[4] A more convenient unit, especially

for longer distances than those encountered within the solar system, is "light-time." It takes sunlight about 500 seconds, or about 8 minutes, to reach the earth. This distance is called "8 light-minutes." On this scale, the distance to Saturn is 80 light-minutes, and the distance to the outermost planet, Pluto, is 5.3 light-hours. The closest neighboring star, Alpha Centauri, is 4.3 light-years away.

Spots in the night sky that appeared as nebular or diffuse stars were speculated to be "island universes" by the philosopher Immanuel Kant in the eighteenth century and first catalogued in Kant's time by the French astronomer Messier. The catalogue of galaxies now honors Messier, in, for example, the designation M51 (or Messier 51), otherwise known as the celebrated Whirlpool galaxy, or M100, a magnificent spiral galaxy visible from the southern hemisphere (Plate 4, bottom right). Our galaxy, the Milky Way, with a population of approximately 400 billion stars, measures close to 120,000 light-years in diameter, and, as a spiral galaxy, it resembles the galaxy M100. The sun, with its array of planets, is approximately half way out from the center—28,000 light-years— on one of the spiral arms of the galaxy.

The entire galaxy rotates, not in the manner of a rigid pinwheel, but rather in differential *irrotational* motion, the inner parts turning much faster than the outer. At the radial distance from the center of the Milky Way, where our solar system is located, it takes about 200 million years to make one turn. Since the solar system (accompanied by the earth) has been around for about 4.5 billion years, it has made this giant galactic orbit approximately twenty-two or twenty-three times. The last time the solar system was in its present location, the dinosaurs were just emerging. And since they became extinct sixty-five million years ago (at the end of the Cretaceous Period), the entire era of the dinosaurs spanned two-thirds of one galactic orbit.

The Milky Way belongs to a small cluster of galaxies held together by their mutual gravitational field, all orbiting a common center of

mass. One of these neighboring galaxies is the giant Andromeda galaxy (M31), approximately 2.2 million light-years away, with over a trillion stars. Although the universe is expanding, with most galaxies, and certainly clusters of galaxies, all moving away from each other, there are some galaxies that are drawing toward each other. For example, in about ten billion years the Milky Way and Andromeda will collide and merge, creating an even larger galaxy. The universe contains tens of billions of galaxies, each containing hundreds of billions of stars, producing a ballpark figure of 10^{23} stars for the entire universe. The size of the universe is around 14 billion light-years, and its age is 14 billion years. There is, however, no coincidence in these numbers: In the prevailing big bang theory of the universe, space and time have a simultaneous origin, with the universe growing at the speed of light for the past 14 billion years.

The Copernican Revolution

Shortly before his death in 1543 Copernicus published his treatise *De revolutionibus orbeum coelestium*, reviving the long-dormant heliocentric picture of the universe, and effectively repudiating the Ptolemaic (geocentric) picture upheld by the Church. Though this conjecture might remove mankind from the center of the universe, he was not interested in challenging the authority of the Church. He was just hoping to set astronomical matters straight. However, his system, which seems obvious and irrefutable to us now, is not entirely correct. As it will be seen, Copernicus's orderly picture of a sun-centered solar system with orbits describing perfect circles does not predict future positions of planets even as accurately as those given by the Alphonsine tables, based on a Ptolemaic picture.[5] Accordingly, Copernicus's conjecture could have simply been judged as poor science, originating in the scientific backwater of northern Europe. Also for Copernicus, living in Poland, considerably removed from the epicenter of the Inquisition sweeping Italy

and Spain, one would have thought him to be somewhat safer. Moreover, an introduction to the book written by an anonymous author explained that Copernicus's system represented an alternative method for determining positions of planets, rather than a fundamental shift in the paradigm representing physical reality. Finally, as a priest working within the Church, one also would have thought he might have been more sheltered than the secular scholars who were disseminating thoughts on the heavens. But this was not the case. The Church by then had already been shaken to its core by Martin Luther, the far more threatening heretical priest in Germany. But just to be safe from persecution, Copernicus took a pair of precautionary steps: he dedicated his book to the pope, and he waited until he was on his deathbed before publishing.

Neither the brilliance nor the foresight of Copernicus characterized another priest, Giordano Bruno, a Dominican friar born near Naples in 1547. Although Bruno would have deserved not even a footnote for his contributions to science, as a catalyst for bringing scientific progress in Italy to a halt, his negative significance cannot be overstated. His first and most important work, *La cena de le ceneri*, published in 1584, was actually about the Last Supper and the Eucharist, the Christian ceremony of Holy Communion. Bruno was a Copernican, but operating with a hidden agenda. He was a disagreeable man, regularly turning off hosts and patrons alike with his comportment. Moreover, he never quite understood the mathematics of Copernicus, but invoked scientific jargon and analogy as tools for his arguments, and was actually taking aim at the authority of the Church. He believed in demoting the Earth to a planet, thereby removing it and its human inhabitants from their hallowed position at the central eye of the universe, and then bestowing souls *on them all*—humans, planets, stars—drawing no distinction among them. He was a proponent of an "ancient true philosophy," Hermeticism.[6] And within the tenets of his own dubious version of

this philosophy, he could equate Catholicism and Protestantism. But most flagrant and egregious of all of his beliefs was his denial of the divinity of Christ.

For his poor science the Church might have simply dismissed him, but for his heresy he could not be tolerated. He had formed some of his ideas at Oxford and London, and it was there he first published them. But when he unwisely visited Venice in 1592, he was arrested on a trumped-up charge and imprisoned for a year. The following year he was moved to Rome, where the Inquisitors tried him for heresy. At his trial and during his seven-year imprisonment he still could have saved himself simply by recanting his heretical notions. But he remained intransigent to the end. Given one last chance to disavow this heresy, he again renounced the authority of the Church. It is said that he made the pronouncement that the other planets were also inhabited, and "the inhabitants are looking down and laughing at us." Unfortunately the Church had the last laugh, as Bruno was burned at the stake as an example to other heretics. Thus he became an unfortunate example of publish *and* perish! Ironically, at the Piazza Campo dei Fioro in Rome, indeed at the spot where Bruno met his death in February of 1600, there now stands a statue of the hapless Dominican monk in full habit.

Meanwhile on the island of Hven (today Ven) in the Baltic Sea, the Danish astronomer Tycho Brahe was gathering data on the movements of the planets, hoping to confirm the geocentric picture of the universe. The king of Denmark had bestowed on him the deed to the island, along with authority over the inhabitants—the local peasants—to do with as he wished. The peasants became his servants, helped him to build his observatory, and assisted him in his observations. In this pretelescope age his principal observational tools were a number of large astrolabes along with massive brass disks with holes in them—holes through which he could peer and track the movements of the planets. The servants were rou-

tinely assigned the task of lifting him up bodily, chair and all, and moving him from disk to disk.

A colorful nobleman, in his youth Tycho had lost his nose in a duel over a mathematics problem. He wore a silver-gold prosthetic nose secured by ties fastened behind his ears, similar to the manner in which Venetian masks are worn at Carnevale. Fortunately, his skills as an astronomer were far superior to his skills as a swordsman. Over almost four decades Tycho compiled extensive data on the heavens. Though he toiled assiduously, he was never able to reconcile his observations with the geocentric picture, and as an honest scientist he never fudged his data. His numbers awaited a far more clever and open-minded mathematician to determine the proper order behind planetary motion.

Johannes Kepler (1571–1630), a German-born mathematician, astronomer, and astrologer to royalty, plying his various trades in Prague, turned out to be that mathematician. In an effort to ascertain the laws of planetary motion, among his mathematical musings had been one in which the five regular polyhedra were regarded as spacers between the orbits of the six planets (see Figure 5.2). The scheme bore little fruit. By then it was general knowledge that Tycho possessed the most accurate data extant, but when Tycho realized that Kepler was a superior mathematician, he became excessively possessive of the planetary data he had collected, resolving to keep it out of the younger man's hands at all cost.

Fortunately for science and unfortunately for Tycho and the Brahe family, calamity struck at a banquet given for the visiting Danish king when Tycho sustained a burst bladder and died. For a period afterward Tycho's family felt a moral obligation to continue to keep his priceless data out of Kepler's hands. Frustrated, Kepler simply stole the data and immediately started the task of trying to sort it all out. His attentions were focused on Mars, which with its pronounced retrograde motion turned out to be a propitious choice. As he analyzed the data he found that the orbits of the

planets, including that of the earth, were not circular, as asserted by Copernicus, but elliptical, with the sun located at one of the foci, or focal points, of the ellipse. This statement, Kepler's first law of planetary motion, resolved once and for all the controversy surrounding the geocentric versus the heliocentric picture.

A second law formulated by Kepler from Tycho's data was that the area swept out on the plane of a planet's orbit by the radial vector of the planet is the same for any equal period of time. As a consequence, during its elliptical motion around the sun a planet travels faster when it is close to the sun than when it is farther away. Mathematically speaking, the rate of change of area is constant. Kepler published his first two laws in his *New Astronomy* in 1608.

Finally, Kepler gleaned the third of his planetary laws approximately a decade after he had discovered the first two. He found that the period for each planet (that is, its year, or the time for it to revolve around the sun) was indeed proportional to its distance from the sun, but that this was not a linear relationship. Rather, he found that the square of the period for a planet varied directly with the cube of its mean distance from the sun, thus $T^2 \propto R^3$, or $T^2 / R^3 = C$, a constant.

As a simple example of the application of the third law, we can compute the period for Jupiter. The mean radius of Jupiter's orbit is approximately *5.2 AU*, compared to the earth's *1.0 AU*. With the earth's period of $T = 1\ year$, Kepler's third law yields for Jupiter a period of 12 years.[7] Saturn, revolving around the sun at a distance of *10 AU*, takes approximately $\sqrt{(10^3)}$, or about 31.6 years. In retrospect, the circumstances of Kepler's theft of Tycho's papers could be regarded as an example of how crime sometimes pays. But perhaps in this instance it is not an egregious crime. Tycho's final pronouncement, so scientific lore goes, was to Kepler: "Don't let my life seem to have been in vain."

The scientific achievements of Copernicus, Tycho, and Kepler were all concerned with heavenly bodies and their motion. In south-

ern Europe Galileo, Kepler's contemporary and a confirmed Copernican, performed science on two separate fronts—terrestrial experimentation and celestial observation. Traditions regarding Galileo abound in his hometown of Pisa, for example there is a story that a seminal experiment with the pendulum was inspired by an oscillating chandelier in the cathedral following an earthquake.

A far more fundamental law that Galileo formulated just a short time later—by studying balls rolling down inclined boards—was the law of translational equilibrium: "a body placed in motion will continue in that state of motion forever unless a force is applied to stop it." He rolled balls down one incline that was smoothly connected to a second, adjustable incline. No matter what angle the second incline made relative to the first, the balls would ascend until they reached exactly the same height from which they had been released. The line connecting the point of release and the point of final ascent was always a horizontal line, parallel to the ground. Galileo concluded that if the second incline were lowered to a horizontal position, the balls would have to keep rolling forever in order to reach the level at which they had been released; in geometry "parallel lines meet at infinity." (The ball rolling down and increasing in speed, then rolling up and losing speed, can be effectively explained in terms of the constancy or "conservation" of mechanical energy: the kinetic plus the potential energy at every point in its motion remains the same.) Galileo's law of motion contradicted the Aristotelian "law" proclaiming that bodies placed in motion would stop of their own accord unless a force were continually applied to them. Aristotle's law certainly appears closer to everyday experience until one realizes that it is the force of friction that serves as the applied force slowing down traveling bodies. Although Galileo was the first to promulgate the law formally, it is now generally called Newton's first law. Newton's second law, that "force equals mass times acceleration," is far more general. It accommodates the first law as a special case when the net force on a body is zero.

The use of a gently inclined board for measuring acceleration, however, was a particularly ingenious idea, and one that even Leonardo had not conceived, and explains why Galileo was able to collect data that was superior to Leonardo's for accelerating bodies. The motion of a body could be slowed down to the point where precise measurements could be made while always maintaining the same relationship between acceleration and velocity and between velocity and displacement.

The Law of Falling Bodies—Rectilinear Motion

In the last chapter we also encountered "curvilinear motion" in the context of the trajectories of projectiles in two-dimensional space. Here we shall start out by examining "rectilinear motion," or motion in a straight line. In the late sixteenth century natural philosophers still believed that the acceleration of heavy falling bodies would be greater than that of light ones. Even before Galileo, scholars had attempted to explain this acceleration, but no one had been able to properly quantify the phenomenon. A hundred years before Galileo, Leonardo da Vinci made his own study. Rather than ask how fast the body was descending, Leonardo sought to answer how far the body would descend in successive intervals of time. His conclusion was that the distances could be expressed as sequential integers: 1 unit of distance in the first interval, 2 units in the second, 3 units in the third, and so on. For example, after ten intervals the total distance the body would have dropped, according to Leonardo's theory, would be given by $1 + 2 + 3 + 4 + \ldots + 10$ (55 units of distance. The sum of the values Leonardo obtained in his experiment of falling bodies, after time t, $1 + 2 + 3 + \ldots t$, is the average value $\frac{1}{2}(1 + t)$, multiplied by the number of terms t, or $s(t) = \frac{1}{2}t + \frac{1}{2}t^2$ units of distance.

A century later, when Galileo began to grapple with the problem of free-fall, he used precisely the same method Leonardo had

Figure 11.1. Pisa. *(left)* The chandelier in the cathedral of Pisa that inspired Galileo to investigate the behavior of the pendulum. *(right)* Next to the cathedral is Pisa's famous Leaning Tower, its campanile, or bell tower. The tower is used here as a backdrop to illustrate the data obtained by Leonardo and Galileo, who both investigated the law of falling bodies.

used, namely to measure the distance a body falls in successive intervals of time. The young Galileo, according to Pisan tradition, dropped objects from the top of the campanile, or bell tower, which provided a convenient shape for his free-fall experiments (Figure 11.1). There is no historical basis for this tradition, and most likely Galileo made his discovery while serving as a professor at the University of Padua (1592–1610). We shall use the same

tower, however, to demonstrate the sequence of distances for free-fall: the distances according to Leonardo (column L) and those according to Galileo (column G). In both columns the time intervals between the horizontal lines are the same. Unlike Leonardo, who had concluded that the distance covered in successive intervals were given by the sequence of integers (1, 2, 3, 4, . . .), Galileo determined these distances to be the sequence of odd integers only: 1, 3, 5, 7, . . . , his celebrated odd numbers rule. Thus after the first interval of time the distance would be 1 unit; after the first two intervals the total distance covered would be $1 + 3 = 4$ units (or 2^2); after the first three intervals, $1 + 3 + 5 = 9$ units (or 3^2) units, and after 4 intervals 16 units (or 4^2). The conclusion that Galileo reached was that the total distance a free-falling body would drop in t seconds would be given by $s(t) = t^2$ units of distance. This equation differs from Leonardo's expression describing free-fall.[8]

In 1604 Galileo observed in the night sky a new star, invisible one moment and shining bright the next (which we now realize was a supernova, or exploding star). The observation of a supernova is a rare event for the unaided eye, but far more common when telescopes are used. Indeed, since 1604 another such event has been seen only once—in 1987—from the southern hemisphere. From the perceived parallax effect Galileo knew that this was a member of the region of immutable stars, far beyond the sublunar region where phenomena were believed to be susceptible to change, according to Aristotelian astronomy. He gave a set of special lectures in Padua about the new star, pointing out the alarming evidence of Aristotle's mistake.

In 1609 Galileo received the portentous news of the German-Dutch lens maker Hans Lippershey's invention of the telescope just a few months earlier. Galileo immediately undertook the construction of a more powerful instrument for his own use. In making his own lenses he tried both Florentine glass and Murano glass

from Venice; he found the former superior for its optical properties. Taking his telescope to the top of the campanile in Venice, he offered the rulers of the city a tool that would enable them to see approaching enemy warships and the merchants a means of obtaining advanced notice of arriving goods. When he turned his instrument to the heavens he observed unexpected wonders: the night sky teeming with hitherto unseen stars, sunspots (blemishes on a celestial body beyond the moon), and further evidence against Aristotelian astronomy. He saw mountains and valleys on the moon and a set of four moons around Jupiter. Galileo published his observations in a 1610 treatise, *Sidereal Messenger*. The book was dedicated to the Medicis, his new patrons in Florence, and indeed, he named the four satellites of Jupiter the Medicean stars (Figure 11.2).

In 1613 Galileo observed the phases of Venus—evidence that Venus was orbiting the sun—and immediately published his findings. In 1615 the inquisitors summoned him to Rome. There he pleaded, "Please . . . look through my telescope." "It is not necessary," suggested the Church, "you have faulty vision! Only the Earth can have a moon." As for those mountains he claimed to have seen, "As a heavenly body, the moon has to be a perfectly smooth sphere!" Galileo was ordered "to abjure, curse and detest . . . and to recant the heretical teachings!" Remembering well the tragic lesson of Giordano Bruno, he swore, in effect, that he was mistaken, and that the sun revolved around a stationary earth. With the mediation of powerful friends, especially the Medicis, he was released with a stinging reprimand, but without incarceration or physical torture.

In 1623, when his old friend and patron Cardinal Mafeo Barberini was made Pope Urban VIII, Galileo might have hoped for better days. In 1624 he even had a series of six audiences with Urban, receiving tacit permission to write a book about the plausibility of the Copernican system, but only "if he would treat it as a hypothetical and mathematical possibility . . . not one to endorse over the accepted Aristotelian view." But in 1632, eighteen years after his

Figure 11.2. *(top)* Detail of title page of Galileo's *Sidereal Messenger* (1610). This rare presentation copy of the book is inscribed "To the most illustrious Sig. Gabriel Chiabrera," and signed "Galileo Galilei." *(bottom)* Excerpt showing Galileo's own annotation in his personal copy of the *Dialogue on the Two Chief World Systems*. (Courtesy History of Science Collections of the University of Oklahoma, Norman)

first brush with the Inquisition, Galileo's controversial book *Dialogue on the Two Chief World Systems—Ptolemaic and Copernican,* was published. The superiority of the Copernican view was more than evident in Galileo's treatment. Moreover, depicted in the frontispiece in his own skillful hand were the three characters: Simplicio, the Aristotelian simpleton; Sagredo, the sagacious and reflective thinker; and Salviati, the intelligent layman serving as the interlocutor. Galileo, a talented artist, in creating the cartoon, had evidently drawn Simplicio in the likeness of the pope—or so the pope was led to believe by his advisors. In reality, the pope may never have seen the book.

Again Galileo was invited to Rome for an audience with the inquisitors. Although he recanted readily this time, no amount of apology and penance could save him. After a lengthy trial, Galileo, then sixty-nine years old, was convicted and condemned— although spared the fate that had befallen Bruno. He would thereafter live under house arrest. He was never to write another book, and no publisher was ever to print any of his heretical works. Meanwhile, the pope displayed neither the patience nor the political courage to come to his aid, being mired in his own troubles with the Thirty Years' War. The year turned out to be Galileo's *annus horribilis.*

In 1638 while he was under house arrest and suffering from a number of debilitating maladies, his most important book was published. *Two New Sciences* distilled Galileo's years of experimentation and analyses on problems of physics and strength of materials. The manuscript had been smuggled out to a friend, the publisher Louis Elzevir of Leyden, Holland. As with his other books, the language was Italian rather than the usual scholarly Latin, and just as with the *Sidereal Messenger* and the *Dialogue on the Two Chief World Systems,* there were three characters engaged in a philosophical dialogue. In one typical exchange, Simplicio declares, "When two objects of different weight are dropped simultaneously, the heavier object hits the ground before the lighter—displaying greater acceleration."

Sagredo's riposte, "If you tie the two bodies together, creating a heavier body still, will the aggregate fall faster still, or will the lighter component impede the motion of the heavier one?" completely confounds Simplicio. The Interlocutor's facetious comment, devoid of a decision on who had offered the more compelling argument, is "Oh, yes, I see."

Galileo's physics had gotten him into a great deal of difficulty with the Church. But ultimately it was not the physics of free-fall, nor any of the other aspects of his classical mechanics that contradicted Aristotelian mechanics, rather his endorsement of the Copernican view of the heliocentric universe that was manifestly unacceptable to the Church.

A recent book by Dava Sobel offers an account of the extraordinarily warm relationship that existed between Galileo and his eldest daughter, presented against the backdrop of his less than congenial relationship with the Church.[9] It is evident that Galileo had a warm human side while dealing with his daughter, but there is little doubt that he did not suffer fools easily. The attitudes of humanists and theologians who were guided by old teachings and dogma, rather than by observation and reasoning, bedeviled him. He wrote, "I do not feel obliged to believe that the same god who has endowed us with sense, reason, and intellect has intended us to forgo their use." The Church, however, saw him as a reincarnate Giordano Bruno, although never quite the equal of the reviled and defrocked priest. Nonetheless, he had become a thorn in their side, gaining a reputation for being ambitious, quarrelsome, and arrogant, and demonstrating an endless appetite for antagonizing former patrons and friends.

Galileo died in 1642, a broken man, blinded by the ravages of an eye disease, likely caused by damage to the fovea (part of the retina) that he had sustained in repeated observations of the sun through his telescope. A poignant meeting in his last years was with a visitor and ardent admirer, John Milton, who would himself go blind

a few years later. In his great epic poem Milton would refer to the wonders revealed by Galileo's telescope:

> his ponderous shield
>> Etherel temper, massy, large and round,
> Behind him cast; the broad circumference
>> Hung on his shoulders like the Moon, whose Orb
> Through Optic Glass the *Tuscan* Artist views
>> At Ev'ning from the top of *Fesole,*
> Or in *Valderno,* to describe new Lands,
>> Rivers or Mountains in her spotty Globe
> —*Paradise Lost,* 1667, I:284–91

"The Tuscan artist!" What reverence, what veneration for the great scientist from the great poet, accepting him as a fellow artist.

Some of the lenses that Galileo personally ground, as well as a number of his own telescopes, are on display in the Museum of the History of Science in Florence. When his body was moved from the chapel of Saint Cosmas and Damian to Santa Croce for reburial in 1737, an admirer removed the middle finger of his right hand—now a relic, mounted in a glass case in the same room as the one housing the telescopes. And those four satellites he had discovered orbiting Jupiter are now known to astronomers as the Galilean moons.

The last great creator of the Italian Renaissance had been a scientist who established an enduring modus operandi for the modern scientist. And in reality Galileo's technique of scientific inquiry had been little different than Leonardo's, except in one critical respect. Unlike Leonardo, Galileo saw an urgent need to disseminate news of his discoveries, the effect of which would be to immediately influence the course of future research. Ironically, the publication of his results, especially those refuting misapprehensions of the Church, brought terrible personal consequences for him. And

indeed, with the persecution and death of Galileo serious scientific inquiry in Italy and most of the rest of Catholic Europe came to an end, as scientific inquiry's center of gravity shifted to the north.

Galileo's *Dialogue* was placed on the list of banned books, the *Index librorum prohibitorum*, in 1633, where it remained until 1821. Finally, in 1992 Pope John Paul II courageously convened a commission to revisit the case of Galileo's persecution by the Church. What was at stake was the issue of papal infallibility—a possible misjudgment by a predecessor who had sanctioned the trial some 360 years earlier. When the commission returned with its findings, there was no apology on behalf of the Church, no judgment that Galileo had been wronged. However, the final pronouncement that was published— "Galileo was a great man!"—was a tacit vindication of Galileo Galilei and a final closure to loose ends that had prevailed for all those years. The statement read, "Galileo sensed in his scientific research the presence of the Creator who, stirring the depths of his spirit, stimulated him, anticipating and assisting his intuitions."

Just as 1564 had been a transitional year, with the death of Michelangelo and the birth of Galileo and Shakespeare, so too was 1642. Galileo died on January 8, and Isaac Newton was born on Christmas Day in Woolsthorpe, a village in the county of Linconshire in England. Only a numerologist might assign significance to the coincidence of those years, but certainly the coincidence of the dates makes them easier to remember. Nature operates with conservation laws—conservation of momentum, conservation of angular momentum, conservation of energy/mass, conservation of charge, and so on—but there is no conservation law for genius. When an individual of towering genius dies, talent of similar magnitude does not have to be born. There is always the possibility, however, that the prevailing intellectual climate is especially conducive for individuals with inherent gifts to step forward. Galileo spent his lifetime in combat against the prejudices of the past—the dogma and the intellectual tra-

dition that had taken two millennia to become entrenched. Newton could ignore all that, taking dead aim at the future.

The Universal Law of Gravitation:
 Unifying the Physics of Heaven and Earth

Demonstrating early on in his life that he would make a less-than-effective farmer, in 1661 Isaac Newton was sent off to Cambridge University. There is no evidence that he knew any more mathematics in 1661 than anyone else, but there is plenty of evidence of his possessing transcendent gifts for mathematics and analytic reasoning just four years later. In his final year as an undergraduate at Cambridge in 1665 he had already developed the binomial theorem, a mathematical expression to raise the sum of a pair of terms to a constant power—a power that could be positive or negative, integer or fraction. Just about the time he completed his studies at Cambridge, the bubonic plague that had been ravaging the Continent crossed the English Channel and began to decimate the population. The universities were closed, and the scholars sent home.

Sixteen months later, when the plague subsided the scholars were called back to the universities, and academic activities resumed. Isaac Newton, on his return to Cambridge, reported to his mentor Isaac Barrow with a list of his "mental inventions" (theories). The list included (1) applying the binomial theorem to determine the slopes of continuous curves, (2) the formulation of the "method of fluxions," (3) experiments in optics and the invention of the reflecting telescope, (4) the formulation of the "inverse method of fluxions," (5) the formulation of the three laws of motion (now known as Newton's laws), and as a crowning glory, (6) the formulation of the universal law of gravitation. In that sixteen-month period he laid the foundations for optics and classical mechanics and for the unification of classical mechanics and astronomy.

The invention in mathematics of "fluxions" and "inverse fluxions," as differential and integral calculus, respectively, earned for him the mantle of the greatest mathematician in history. It was Einstein's opinion that Newton's greatest single contribution was in developing the differential law, or showing that the laws of the universe could be expressed as differential equations. The period from 1665 to 1666 is referred to as Newton's *annus mirabilis*—his miracle year.

Two years later Newton's mentor, Isaac Barrow, holder of the first Lucasian Chair of Mathematics at Cambridge, resigned his professorship to take a position as a professor of theology; he recommended Newton as his successor. The episode is evocative of Leonardo's mentor Verrocchio, putting down his paintbrush permanently upon seeing Leonardo's work on the angel in the *Baptism of Christ*—Barrow and Verrocchio, each a distinguished master, recognized staggering, inscrutable genius.

It was not until 1687 that Newton, at the behest of his friend Edmund Halley (whose namesake is the famous comet), published his theories on classical mechanics in a book entitled *Philosophia naturalis principia mathematica* (mathematical principles of natural philosophy), or simply, the *Principia*. In synthesizing classical mechanics and astronomy the book unified the physics of terrestrial and celestial phenomena. The work is unrivaled in its significance in the history of science. As for Newton's reasoning of the universal law of gravitation, an integral topic of the book, the great twentieth-century theoretical physicist Richard Feynman described it as "the greatest achievement of the human mind."[10]

Newton asked the question, "What keeps the moon in its orbit?" The prevailing explanation of monks in monasteries had been "angels flapping their wings with great vigor." Most popular renditions of Newton's discovery of the universal law of gravitation include an apple: "Newton saw an apple fall," "Newton was struck by an apple." A century after Newton's death, Lord Byron in *Don*

Juan alluded to the connection with the apple, when he wrote: "And this is the sole mortal who could grapple / Since Adam, with a fall or with an apple." There may or may not have been an incident with an apple, but in Newton's explanation an apple does figure prominently, if just as an example of a mass. Newton sought to compare the distance an apple fell in the first second with how far the moon "fell" in that second. The notion of the moon falling simply refers to the distance its trajectory has deviated from a straight line. The information he had available was (1) the distance between the earth and the moon, measured center-to-center, is about 240,000 miles; (2) the radius of the earth, 4,000 miles; (3) the period of the moon, about 28 days; and (4) the distance an apple falls in the first second after it has been released, 16 feet. In the hands of Newton this data sufficed. From his second law of motion, Newton knew that the acceleration of a body was proportional to the force applied on the body, and that it was the mass of the body that represented the constant of proportionality. But since the distance a body travels depends on its acceleration (and time), Newton's question reduced to comparing the distance the moon fell toward the earth (or deviated from a straight line) with how far the apple fell in the same time.

With the use of similar triangles Newton showed that in the first second, while the apple falls 16 feet, the moon falls $1/19$ of an inch. The ratio of the two distances is close to 3,600. Meanwhile, the ratio of the distance between the apple and the earth (measured center-to-center) and the distance between the moon and the earth is $1/60$. In correlating these, Newton arrived at his result: the dependence of the gravitational force on distance must be $1/60^2$ (= $1/3,600$). Finally, the general relationship—the universal law of gravitation, describing the gravitational attraction between two masses—is obtained as an inverse-square law. Specifically, the law says the force is the product of the two masses, m and m', divided by the distance of their separation squared (a proportionality constant G, the universal gravita-

tional constant, appears as a multiplier of the expression).[11] The value of G was determined experimentally at the end of the eighteenth century by the Cambridge physicist Henry Cavendish, who published a paper entitled "Weighing the Earth."

Newton's third law states succinctly, "For every action (force), there is an equal and opposite reaction (force)," these forces acting on separate or contrary bodies. Applied to the apple and earth, the force with which the earth attracts the apple (action) exactly equals in magnitude the force with which the apple attracts the earth (reaction). Since the magnitudes of these forces are the same, we can then invoke Newton's second law: the mass (of the apple) multiplied by the acceleration (g) of the apple downward equals the mass of the earth multiplied by the acceleration (a) of the earth upward. Accordingly, if the apple is held out at arms length and released, it descends with the normal acceleration $g = 9.8 \, m/sec^2$, and simultaneously the earth ascends with an acceleration of $9.8 \times 10^{-25} \, m/sec^2$—approximately a millionth of a millionth of a millionth of a millionth of a meter/sec/sec—in order to meet the apple.

Applying this result to celestial bodies, we can specify the force in Newton's second law as that of gravitation, and the acceleration as centripetal (center-seeking). The velocity of a body in orbit can then be computed. In the frontispiece of the *Principia* a cannonball is fired horizontally from a mountaintop at v, its range depending on the velocity (Figure 11.3). Fired at 30,000 km/hr (18,000 mi/hr or 5 mi/sec), the cannonball achieves a low-earth orbit. A velocity of approximately 3,700 km/hr (2,300 mi/hr) is sufficient to keep the moon in its orbit. The trajectories are all elliptical, and indeed the parabolic trajectories—illustrated by Leonardo and described mathematically by Galileo—are actually small-scale approximations of Newton's and Kepler's parabolic trajectories.[12] The Newton formulation also shows that, fired at 42,000 km/hr (25,000 mi/hr or 7 mi/sec), the cannonball possesses "escape

velocity"; it can reach the moon. Two hundred and seventy years before a Sputnik became the first artificial satellite, Newton had already computed the velocity needed to achieve orbit or to visit the moon and outer planets. It was the technology that had to catch up with the science.

Newton's explanation of gravitation was much more powerful than its application to just the apple, the moon, and the earth. It

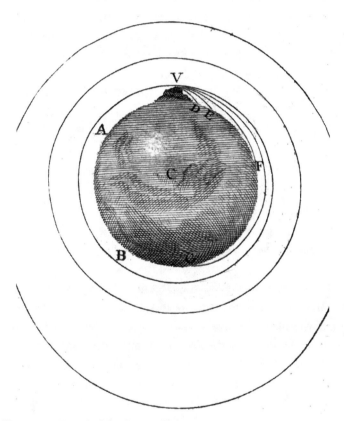

Figure 11.3. Detail of the frontispiece of Newton's *Principia,* showing elliptical trajectories of cannonballs fired from the top of a mountain at V (Courtesy History of Science Collections of the University of Oklahoma, Norman)

applied to every particle of mass in the universe, thus the expression "universal law of gravitation." Now if the expression for orbital velocity is set equal to the distance the satellite travels divided by its period, also a measure of its speed, what emerges is Kepler's third law—demonstrating that the square of the period of a satellite is related directly to the cube of the orbit's radius.

The *Principia* synthesized astronomy and classical mechanics, in effect unifying the physics of the heavens and the earth. It gave a consistent mechanical system for the operation of the universe with mathematical precision. The calculus, as the mathematics of change, initially developed to solve problems in physics, proved to be the most powerful tool in every quantifiable field of intellectual endeavor. By 1687, however, Newton was essentially finished with his scientific queries and concentrated on two other fields at loggerheads with science—alchemy and religion, both of which he pursued with greater tenacity than he had science or mathematics. In 1693 he had a debilitating nervous breakdown, taking several years to recover before reverting to the reclusive, taciturn, and irascible man he had always been. The cause of the breakdown has been a puzzle for generations of psychologists, historians, and physicists. What was the reason for his personal crisis? The clues in his notebooks from that period suggest that the cause may have been his poor laboratory practices. In the early 1980s locks of his hair from that period—maintained in the Royal Society Museum—were tested with neutron activation (a sample of hair or fingernails are irradiated in a reactor, then analyzed for their gamma ray spectrum). The culprit was revealed. Newton had indeed damaged his brain by ingesting heavy elements, especially mercury, during his alchemical experiments. A pair of ironies presents itself in this connection: one of the most brilliant brains in history had destroyed itself; and the science he spawned more effectively than anybody else had explained how he had done it. But the revelation was three centuries too late to help him.

Newton was honored first by his countrymen, and then beginning in the Enlightenment of the eighteenth century, by all intellectuals—scientists, philosophers, and enlightened monarchs alike. William Wordsworth, ruminating on the view from his Cambridge room, wrote in his epic poem, the *Prelude:*

> Near me hung Trinity's loquacious clock,
> > Who never let the quarters, night or day
> Slip by him unproclaimed, and told the hours
> > Twice over with a male and female voice.
> Her pealing organ was my neighbor too;
> > And from my pillow looking forth by light
> Of moon or favoring stars, I could behold
> > The antechapel where the statue stood
> Of Newton with his prism and silent face,
> > The marble index of a mind for ever
> Voyaging through the seas of Thought, alone. . . ."
> > —*Prelude,* 1850, III: 53–63

In molding Western civilization, Cambridge University casts a shadow rivaled by few other institutions. The ancient university boasts scholars who have left monumental impact in virtually every field of intellectual endeavor: Christopher Marlowe, John Milton, John Harvard, William Harvey, Oliver Cromwell, Henry Cavendish, William Wordsworth, Samuel Taylor Coleridge, Lord Byron, Charles Babbage, Charles Darwin, Lord Tennyson, Rupert Brooke, James Clerk Maxwell, Robert Walpole, Lord Kelvin, Srinavasa Ramanujan, Bertrand Russell, Ludwig Wittgenstein, John Keynes, Paul Dirac, C. S. Lewis, Alan Turing, Louis Leakey, James Watson, Francis Crick, Jane Goodall, Freeman Dyson, Steven Hawking, and a list that includes seventy-nine Nobel Prize winners (twenty-nine from the Cavendish Laboratory alone).[13] During the 1930s one college at Cambridge claimed that it was "home to more Nobel Prize winners

than France." In the antechapel of Trinity College the two facing long walls are lined with some of the busts of the great sons of Cambridge—all turned toward the end of the hall, all gazing with veneration at a full size statue—Newton staring out the window. The inscription: *Newton, qui genus humanum ingenio superavit* (Newton, who surpassed human genius).

The French have never been quick to praise the English. But Voltaire, a man of uncommon wisdom and intellectual integrity, excoriated France's own scientists, "You have confirmed in these tedious places what Newton found without leaving his room." When Newton died in 1727 at the age of eighty-five, he became the first scientist to be buried in Westminster Abbey. And for the occasion a contest was held to choose a suitable epitaph to place over his tomb. The entry that won the contest is lengthy, and not particularly memorable. The one that is best remembered, however, is the couplet by Alexander Pope from his *Essay on Man*: "Nature and Nature's Laws lay hid in night. / God said, 'Let Newton be!' and all was light."

In 1987, when institutions of science throughout the world celebrated the three-hundredth anniversary of the publication of the *Principia*, I was in Washington, D.C. with some of my students to tour an exhibit of Newton memorabilia—manuscripts, spectacles, a lock of hair, and a priceless copy of the first edition of the *Principia*—all on display at the National Museum of American History. As I stood before a geometric proof posted on a wall, admiring its conciseness and precision, I glimpsed a guide sweep right through the room with her charges, a group of visitors. When they paused momentarily in front of a case in which some of Newton's manuscripts lay, she announced, with the air of authority bestowed on her by her position, "This collection is to commemorate the work of Sir Isaac Newton, author of a famous book published exactly three hundred years ago." She continued, "He

was a famous English scientist. He may have been gay, but we are not quite sure." Newton, who invented calculus, formulated the universal law of gravitation, unified the physics of terrestrial and celestial mechanics, and perhaps even had a hand in sowing the seeds of the Industrial Revolution, *". . . he may have been gay, but we are not sure!"* Her remark, delivered in passing, seemed to echo endlessly in that room. This was all she could say about Isaac Newton. And right across from the National Museum of Natural History on the Mall, the grassy rectangular patch lined with great museums, stands the National Air and Space Museum—exhibiting satellites that orbit the earth, space capsules, replicas of the rocket ships that took astronauts to the moon, and indeed samples of rocks these astronauts brought back with them. That is the real monument honoring Isaac Newton.

Leonardo realized early that mathematics comprised the very firmament of science, the pillars on which science stood. "Oh, students," he wrote, "study mathematics and do not build without foundations." How prescient he was in that intuitive conviction. But it would be Newton who finally demonstrated the mathematical nature of the universe, inextricably melding mathematics and physics. In the eighteenth and nineteenth centuries physicists refined the formulation of Newton's classical mechanics and went on to develop the sciences of heat, light, electricity, and magnetism. In 1864, while the Civil War was raging in North America, the great Scottish physicist James Clerk Maxwell, then a professor at Cambridge University, succeeded in synthesizing the laws of electricity and magnetism, reducing them to what today are written as just four equations. Few physicists would argue that Maxwell was the finest physicist from the time of Newton to the time of Einstein, characterized by a notable contemporary as "incapable of making a mistake in solving a physics problem."

By the end of the nineteenth century many physicists, with Lord

Kelvin and Henri Poincaré as the most vocal proponents, were convinced that most of the significant questions in physics had been answered and all that remained was to tweak things here and there, just refine some of the measurements. Ironically, physics was poised at the threshold of a pair of revolutions—one leading to relativity, the other to quantum mechanics.

No human inquiry can be a science unless it pursues its path through mathematical exposition and demonstration.

—Leonardo da Vinci

Chapter 12

The Greatest Collective Piece of Art of the Twentieth Century

To our utter frustration, Leonardo produced only a few paintings—although all are miraculous in quality. He may well have been the greatest painter, but painting was not his first love. It is likely, as many art historians have conjectured, that painting was too easy for him. His first love was science, fueled by an unquenchable passion to understand nature. Accordingly, it would have been in the science and technology developed in the past five hundred years that he would have found deepest fascination. He frequently argued that painting was a science. At one

level, at least, there exists truth of the converse of Leonardo's claim—science is a form of art—and he especially would have appreciated the beauty it can reveal.

There is an elegant beauty in science as well as in the scientist's view of the universe that few laymen experience, reality at this level often presenting itself as abstract solutions to arcane equations. Paralleling the development in art, the description of nature given by modern physics in the twentieth century is more abstract than in the paradigms that prevailed earlier. Leonard Shlain remarks, "the epiphany that inspired the book *[Art and Physics]* was a connection between the inscrutability of art and the impenetrability of new physics," an event, he says, "that occurred at the same instant."[1] My own feeling is that both became more abstract, perhaps even counterintuitive, but that the mathematical "impenetrability" he ascribes to physics (even for the enlightened layman) was there from Newton's time onward. In the eighteenth century the Lagrangian and Hamiltonian formulations of Newton's classical mechanics; and in the nineteenth century, the mathematical descriptions of electricity and magnetism, were as hopelessly inaccessible to the layman as the mathematical machinations of modern physics are today. Although the mathematical beauty of the universe may remain esoteric and inaccessible, some aspects of its physical beauty—made visible by the complex instruments of the scientist as well as the largely qualitative descriptions by a number of uncommonly good facilitator scientists—are accessible to everyone.[2] It is unfortunate that such elucidation was not available at the time when D. H. Lawrence wrote in *Pansies: Poems*:

> I like relativity and quantum theories
> because I don't understand them
> and they make me feel as if space shifted about
> like a swan that can't settle,
> refusing to sit still and be measured;

and as if atoms were an impulsive thing
always changing its mind.

Reading God's Mind

Albert Einstein, with his faith in the mathematical underpinnings
of natural law as well as in the internal consistency of his own
mathematical derivation, displayed from the start a deep convic-
tion of the validity of relativity. But in 1922, while commiserating
about the realities of nationalism that pervaded even the world of
science, Einstein pronounced: "If my theory of relativity is proven
successful, Germany will claim me as a German and France will
declare that I am a citizen of the world. Should the theory prove
untrue, France will say that I am a German, and Germany will de-
clare that I am a Jew."[3]

The year 1905 proved to be Einstein's *annus mirabilis*, witness-
ing the publication of five papers, three of which were of Nobel
Prize quality. The special theory of relativity was published that
year with the arcane title "The Electrodynamics of Moving Bodies."
Einstein, in attempting to establish the generality (and universal-
ity) of the laws of physics for all inertial frames (or frames of ref-
erence in uniform motion), postulated a pair of relatively simple
principles. The first, also known as the principle of relativity and
accepted since the seventeenth century, posited that an observer in
an inertial frame could never perform an experiment entirely
within his frame to detect the motion of his frame. The second and
more daring (because of its counterintuitive nature) was: "the speed
of light is the same for all inertial observers, regardless of their rel-
ative velocities." The two postulates suggest the existence of an
infinity of equivalent frames. The consequence of the theory is that
the fundamental indefinables of physics—length, mass, and time—
all emerge as relative, and the speed of light c becomes the only
absolute. Although each of the indefinable fundamentals has a

unique correct value in its own inertial frame, measurements by observers in all other frames, using their own measuring tools, yield an infinity of different but still correct values. Specifically, length (or distance) contracts, time dilates (or slows down), and mass increases as the velocity increases. An object simultaneously contracts as its mass increases, resulting in its density increasing at a compounded rate. At 87 percent the speed of light, an object contracts to half its original length, its mass doubles, and its density is quadrupled. Along with a number of other equally startling relativistic effects, there is the equivalence of energy and mass, enshrined in the simple formula $E=mc^2$.

The publication of the special theory effectively threw down a gauntlet, challenging all other theoretical physicists and mathematicians to formulate a general theory—a theory valid for accelerated frames as well. It is the formulation of the general theory by Einstein (1915) that attests to the man's transcendent genius and his recognition as the rightful heir to the mantle of Isaac Newton. It is general relativity that establishes the equivalence of gravitation and acceleration.

The underlying postulate of the general theory of relativity is that the effects of gravitation and those of accelerated frames are the same when observed locally, a principle known as the "equivalence principle." In two enclosures—one a stationary elevator on earth, and the other, an identical enclosure located in a rocket ship accelerating in interstellar space (far from the gravitation of celestial bodies)—a number of simple thought experiments, *Gedankenexperimenten,* are performed. We shall assume that the acceleration of the rocket ship is exactly 9.8 m/sec^2, just as it is for bodies free-falling on the earth. The occupant of the stationary elevator can stand on a bathroom scale and look down to determine his weight. The occupant of the rocket ship accelerating at 1G would determine his weight to be identical to his weight in the stationary elevator. In a second *Gedankenexperiment* the observer in

the stationary elevator could hold a pair of apples in his out-stretched hands, and when he released them, watch them accelerate downward at 9.8 m/sec^2. And the occupant of the elevator or enclosure in the rocket ship could release a pair of apples from his hands and watch the apples "fall" (in reality, watch the floor ascend) at 9.8 m/sec^2. From his vantage point, or "frame of reference," the effects observed would be the same—or *almost* the same. A subtle difference would exist, in that the trajectories of the apples in the rocket ship would be precisely parallel all the way down, whereas the trajectories of the apples in the gravitational field, the "parallel lines," could be extrapolated and found to converge at the center of the earth, 6,400 kilometers below the floor (just as in the case of Eratosthenes's posts used in determining the radius of the earth).

Einstein's field theory equations predicted that a curvature of space-time would occur with mass as the cause of the curvature, or "warping." Light passing in the vicinity of a celestial body traverses the area with a curved trajectory, following the curvature of space-time.[4] The path that light takes is found to be the one that minimizes its time of travel. Within two years after the publication of the general theory of relativity, English and German scientists collaborating under the leadership of the Cambridge astrophysicist Sir Arthur Eddington journeyed to South Africa to perform an experiment testing the predictions of the general theory. A total solar eclipse was due in that area, and a star hidden by the solar disk was predicted by relativity to become visible as the result of the light-bending effect of the sun's gravitational field. Right on cue the moon blocked the disk of the sun, and the star directly behind the sun became visible on the periphery of the solar disk. The star's light rays passing by the sun had been bent and redirected to the predicted spot in South Africa where the eclipse occurred. Of course, extrapolating that image of the star's observed location put the star trillions of miles away from its actual known location. A

massive body, deflecting light in this manner, operates as a "gravitational lens."

In 1986 Princeton University astrophysicists photographed the same galaxy at two points slightly separated from each other due to the presence of an unseen mass intervening between the earth and the observed galaxy. (In reality, the actual galaxy was hidden precisely behind the massive invisible object acting as the gravitational lens.) Ten years later, the Hubble telescope photographed a perfect gravitational lens effect—an entire circular image. A galaxy, with its light radiating in all directions, was seen as a circular image. A massive object, invisible to the telescope and positioned in line and midway between the earth and the galaxy, had focused the rays from the galaxy to one spot, the earth.

General relativity also predicted that in an accelerating rocket (a pseudogravitational field) time would pass at a faster rate in the nose than in the tail section. Similarly, in a gravitational field time would pass at a faster rate in the penthouse of a tall building than in the basement, and accordingly the occupants would age faster in the penthouse than in the basement. It was not until 1960 that Robert Pound and Hans Rebka of Harvard University performed an experiment confirming the effect of gravitation on the passage of time.[5]

Just two years after Einstein published the general theory of relativity, he began to investigate its application to cosmology. The first rigorous solution to Einstein's equation was to come from the thirty-five-year-old Russian mathematician Alexander Friedman, just a year before his death in 1925, but the solution turned out to be unsettling: it predicted an unstable universe—one that is expanding or contracting, and decidedly not static. Since no physical evidence existed at the time suggesting that the universe might be anything other than stable, Einstein felt it necessary to introduce a cosmological constant, a proverbial fudge factor, into his equation, which would assure a steady-state condition. A curmudgeon might say, "A doctor buries his mistakes, an architect hides his in ivy, and a theoretical physicist

introduces constants." In 1929 Hubble discovered that indeed all intergalactic separations were increasing, and the greater their distance from each other, the faster they were increasing. In short, the universe was expanding. Einstein realized immediately that he should have trusted the mathematics of the "bare" equation in the first place, and he rescinded the constant.

During the following decades there still remained scientists skeptical of the notion of an expanding universe—the aftermath of a primordial explosion predicted by general relativity. The most vocal opponent of an expanding universe was the British astrophysicist Fred Hoyle, who advocated a steady-state picture, or one of a constantly self-replenishing universe. Ironically, it was Hoyle who derisively characterized the picture of the expanding universe as "the big bang," introducing an expression that stuck.

Then in 1965 Arno Penzias and Robert Wilson, physicists working at Bell Laboratories in Murray Hill, New Jersey, detected background microwave radiation, as an all-pervasive relic of the primordial explosion, poetically called the "whisper of creation." The discovery of the background radiation made a compelling case for the big bang theory, but introduced a vexing new question. From this radiation that was so uniform, or monochromatic, how could a "lumpy universe" possibly evolve? Twenty-seven years passed before striations and blotches appeared out of the uniformity, the explanation for the eventual lumpiness of the universe. The Cosmic Background Explorer (COBE) Satellite in 1992 discovered variations on the order of 10^{-5} parts, or one part in 100,000. As for the most immediate of "lumps," our own solar system—the sun, the neighboring planets, the earth with all its inanimate and animate creatures, the book you are holding in your hands—was once the material of a very large star. In exploding (about 4.7 billion years ago) it dispersed its material that eventually accreted into the solar system some 4.5 billion years ago by the mediation of gravity. As the recycled material of a star, you and I are all its children!

In the past forty years data has been accumulating and removing major question marks, but at the same time spawning new questions. Is this a one-time universe with a beginning and an end? Or is it a repeating universe, continually recycling itself—expanding then contracting? (During recent times evidence has been accumulating for an ever-expanding universe—but again with a complication. For a while it increased, while decelerating; then it began to increase at an accelerating rate. This is where we find ourselves now.) Are the constants of nature truly constants forever, or can they be changing (this might explain the observed decelerated growth rate of the early universe morphing into an accelerating one). There are also other questions: Was there anything before the big bang—all evidence of an earlier universe having been destroyed by that cataclysmic event? Can there be other, parallel universes? Does extraterrestrial life exist, and if so, does extraterrestrial intelligent life exist? We have been able to detect other solar systems, but we have not yet detected any sign of extraterrestrial life.

With the launching of the Hubble telescope and other orbiting space laboratories, and indeed with the coming of age of telescopy in spectral regions far from the visible, the observational evidence is for the first time catching up with the speculative models percolating in mathematical physics.[6] Matter in the bulk—planets, stars, galaxies, and even interstellar gases—are ultimately all composed of atoms, molecules, nuclei, and nucleons (protons and neutrons); nucleons, in turn, are composed of quarks. And it is with spectroscopy that we try to understand their internal mechanisms. Spectroscopy, based on the study of radiation in a variety of regions of the electromagnetic spectrum, represents an immensely powerful probe, but one that is basically indirect. Its operation has been likened to listening to the sounds emitted by pianos dropped from a roof, and—from the sounds they produce as they come crashing to the ground—attempting to understand the structure of a piano.

Einstein's special and general theories of relativity resolved the mathematical incompatibility between the two great edifices of Newton's mechanics and Maxwell's electrodynamics, and in the process had delivered a new picture—of a four-dimensional space-time in which the dimension of time and the three dimensions of space are inextricably linked. The special theory represented a paradigm shift in describing nature; the general theory was an entire paradigm upheaval. The description of reality in Einstein's picture is so different than that of Newton's that Einstein was moved to write an apology to his great predecessor: "Newton, forgive me; you found the only way which, in your age, was just about possible for a man of highest thought and creative power."[7] Alexander Pope's little couplet honoring Newton inspired a sequel epigram by J. C. Squire to herald Einstein's contribution: "It did not last: the Devil howling, 'Ho!' / 'Let Einstein be!' restore the status quo."

The better part of a century has passed since Einstein formulated his two theories—the special and general theories of relativity—and they have proved their power and resilience repeatedly. They are established laws of nature. To use the misnomer "theories" reflects a poor habit among scientists. Conversely, labeled as "laws" are Wien's blackbody law and Rayleigh-Jeans's blackbody law, both seminal hypotheses, but neither of them correct. Together they provided salutary influences in Planck's formulation of his blackbody law that led to the birth of quantum mechanics.

The development of physics in the twentieth century is evocative of the development of art in the Italian Renaissance. Between 1900 and 1932 physics saw a Renaissance, and during a very short period spanning 1924 to 1928, when quantum mechanics was being formulated, a High Renaissance. Jacob Bronowski in *The Ascent of Man* described the scientific discoveries of this short period as "the greatest collective piece of art of the twentieth century." In the essay "What is Quantum Mechanics?" the modern physicist Frank Wilczek wrote, "the founders of quantum mechanics were guided

by analogy, by aesthetics, and—ultimately—by a complex dialogue with Nature, through experiment."[8] The context of the statement is Paul Dirac's inspired ideas in formulating the mathematical operators of quantum mechanics, and indeed introducing the axioms underlying the theory. Perhaps more than any other physicist, Dirac believed in the inherent beauty of mathematics as the fertile ground to seek the laws of nature.

The Plight of the Early Achiever

> Age is, of course, a fever chill
> That every physicist must fear.
> He's better dead than living still
> When once he's past his thirtieth year.

> —Paul Dirac (1902–1984)

This verse reflects a sentiment known to mathematicians and physicists: that unlike the practitioners of most other sciences, one's creative peak occurs early. It is echoed by Albert Einstein, who said, "A person who has not made his great contribution to science before the age of thirty will never do so." Isaac Newton was twenty-three and twenty-four during his *annus mirabilis*, Albert Einstein twenty-six during his. (Music is another field that manifests this pattern; and another is lyric poetry, as opposed to, say, novel writing.) Although the poetic legacy of Paul Adrien Maurice Dirac will never rival his scientific legacy, he was ideally qualified to make this pronouncement regarding the mathematical sciences. His scientific legacy places him among the finest scientists in history.

Born in 1902 in Bristol, England, Dirac matriculated at twenty-one in the graduate program at Cambridge University with plans to pursue research in the hot new area of relativity. But upon his arrival at the venerable institution, he switched on the

advice of his new research advisor, Ralph H. Fowler, to the newly emerging field of quantum theory. The theory had its seeds in Max Planck's paper, published in 1900, explaining the characteristics of the radiation emitted from a heated and glowing body. It had demonstrated that electromagnetic radiation, including ordinary light, is emitted in packets, called "quanta of radiation" or "photons." Slow to be recognized for its significance, this idea received legitimacy from Einstein, who invoked it in explaining the photoelectric effect in 1905, a mathematical explanation that earned him the 1921 Nobel Prize. (Planck, meanwhile, had received the Prize in 1918.)

In 1913 Niels Bohr had summoned quantum theory in explaining the workings of the hydrogen atom: electrons orbited the atomic nucleus in concentric circular orbits, each of precisely prescribed radii. When an electron dropped or decayed from one orbit to a lower one, energy would be emitted from the atom in the form of a photon. Conversely, in absorbing a photon, the atom would be "excited," with an electron jumping from a lower orbit to a higher one. In 1915 Arnold Sommerfeld refined the explanation of the Bohr model by introducing a touch of relativity into the mix in allowing elliptical orbits along with the circular ones prescribed by the Bohr model. In its refined form, the theory worked impressively for the simplest atom, hydrogen, something that neither Newtonian mechanics nor Maxwell's electrodynamics had been able to do. Planck's quantization of energy and the Bohr theory were invoked by Einstein in 1917—in this instance to predict the phenomenon of stimulated emission of radiation. With this conjecture Einstein prefigured the idea behind the MASER and LASER[9] by an astonishing four decades, the practical devices first coming to fruition in the late 1950s. Bohr received the Nobel Prize in Physics a year after Einstein, in 1922. By 1915, however, it had already started to become frustratingly evident that the prevailing theory had serious shortcomings. Now referred to as the "old quantum theory," it failed to

explain the behavior of atoms beyond hydrogen, and certainly also the behavior of molecules and atomic nuclei. This impasse was to last for the better part of a decade.

In 1924 a young student at the Sorbonne, Louis de Broglie, submitted a doctoral thesis with an intriguing hypothesis—that "matter," in the corpuscular form that we know it, could be regarded as having a dual particle/wave nature, just as had been established for light. Devoid of any substantive physical or mathematical basis, the thesis could easily have been rejected—tossed onto the pile of discredited pseudoscientific theories regularly springing up in bohemian Paris. What gained de Broglie's conjecture a second look, however, was the young man's royal birth: Louis de Broglie was a prince. And although he was a retiring and shy prince, his brother—also a physicist—was most certainly not. It was the brother, a more forceful and loquacious man, who brought pressure to bear on the head of the physics department, Langevin, to consider Louis's hypothesis carefully.

Langevin's dilemma was particularly delicate: the theory could be wrong, and its acceptance by the department would make the Sorbonne faculty the laughing stock of the international physics community. Or the theory could turn out to be correct, and their rejection of it would make them look just as silly. Fortunately for Langevin and the future of the physical sciences, his good friend Albert Einstein was passing through town, and Langevin saw an opportunity to see the dilemma resolved. "Of course, we know what to do with the thesis," he explained, "but we would appreciate your suggestions."

Einstein, like any good academic pressed to answer a problem that he was unable to answer immediately, asked for additional time. "Let me sleep on it," he replied, hoping perhaps for some delayed insight, or that the question would go away. Einstein was neither able to sleep, nor did the problem go away. He told Langevin the following day that this was indeed an "interesting hypothesis" and he would need even more time.

Einstein sent de Broglie's thesis to his friend Pieter Debye, the head of the physics department at the University of Zurich. Debye, an experimental physicist, not up to the task, passed the thesis on to Erwin Schrödinger, a young Austrian-born physicist in his department coming up for tenure. "Take this paper and evaluate it. You can discuss it at the department seminar next month." As Debye walked away, he paused, displaying clear puzzlement. Then throwing up his hands, he declared, "I don't even know what kind of wave theory this is. It has no equations." After a pause, he strode back, "See if you can write some equations." Schrödinger was not particularly eager to take on the task, but the request was coming from the head of the department. And he *was* up for tenure.

Mathematically gifted and extraordinarily colorful, Schrödinger, it is said, retired for two weeks to a mountain chalet in the resort of Arosa, Switzerland. He took along his young mistress, and two weeks later returned with the resolution: there appeared nothing wrong with de Broglie's conjecture. Schrödinger also brought back with him from the mountaintop a tablet with a pair of "Commandments"— two wave equations to mollify Debye.[10] Ironically, the theory was presented at the department seminar without unusual enthusiasm. These equations, however, soon to become known as Schrödinger's time-dependent and time-independent equations, were emerging as the starting point in solving most problems in quantum theory just as Newton's second law represented the starting point in solving most problems in classical mechanics. The endorsement by Schrödinger of de Broglie's hypothesis was transmitted with a certain alacrity to Einstein. And Einstein, in turn, dispatched a message to Langevin at the Sorbonne, "Give the boy his Ph.D. He can't do much damage with a Ph.D. in physics!"

In 1926 Schrödinger published his theory of wave mechanics. The de Broglie hypothesis was to prove so seminal that just three years after Einstein recommended the acceptance of the thesis by the Sorbonne, in 1925, he proceeded to nominate de Broglie for the

Nobel Prize.[11] In a parallel development in the same year, the twenty-three-year-old German physicist Werner Heisenberg, approaching physical reality from a different vantage point, formulated the "uncertainty principle," and with significant input from Max Born and Pasqual Jordan the next year followed up with the formulation of "matrix mechanics." The Heisenberg uncertainty principle is a quantifiable and precise mathematical statement placing a lower limit on the product of the uncertainty in position and the uncertainty in momentum (momentum is mass multiplied by velocity). In short, he demonstrated that it is impossible to know simultaneously and with perfect precision both the position and the momentum of a body. The principle finds alternative expressions, including this form: "Before the detection and measurement of a property of the system (atom, particle, photon, etc.), it does not even exist. Once a measurement has been made and a value obtained, any subsequent measurement will not necessarily yield the same value as the earlier measurement." In the sense that the measuring instrument disturbs what it is measuring, the uncertainty principle has found its way into the vocabularies of other fields, although not quantifiably. It appears as a frequently quoted and intuitively obvious principle among social scientists, especially pollsters. But the sociological interpretation is not at all the same as that in physics. Before opinion polls are taken, opinions presumably already exist, and these indeed may change when the poll results are published. Ultimately, however, in physics the uncertainty principle is couched in the wave-particle duality of matter at the ultra-microscopic scale.

By 1926 the drama heightened. There existed two alternative approaches to the physics of phenomena at the atomic scale—each describing correctly those systems more complex than the hydrogen atom. But they *appeared* to be based on entirely different fundamental principles—their success providing the only common ground. Was it a coincidence that they both worked?

That year, however, Schrödinger demonstrated the mathematical equivalence of the two forms of quantum mechanics; and again the same year, the twenty-four-year old Dirac—taciturn and reclusive, and operating independently of the cadre of continental physicists also engaged in the work—succeeding in developing a fundamental, axiomatic theory. Such syntheses of two fields had occurred only three or four times before in the history of science. In the seventeenth century Newton had synthesized the mechanics of terrestrial and celestial phenomena (1687). In the nineteenth century Maxwell had synthesized electricity, magnetism, and optics (1864); and later in that century Boltzmann and Gibbs independently formulated statistical mechanics, unifying classical mechanics and thermodynamics, the physics of heat. Finally, in the early twentieth century Einstein inextricably linked the three dimensions of space and the one dimension of time with the special theory of relativity. And ten years later, invoking non-Euclidean geometry, he offered an improved theory of gravitation with his general theory of relativity.

Quantum mechanics, called the greatest scientific theory ever formulated, represented the crowning glory of the physics renaissance. The theory's simple axioms, its internal consistency, its mathematical elegance, and ultimately its stunning success all combine to render the theory a human creation of pure beauty, an artistic masterpiece. In the formalism of quantum mechanics, physical observables—energy, momentum, position, etc.—all have associated with them a mathematical operator (itself not measurable) defined by a mathematical operation (an eigenvalue equation). The eigenvalue equation yields physical observables in the form of eigenvalues that are unique and measurable. And the equation also yields wave functions (eigenfunctions) that are again not measurable; but these eigenfunctions can be used in computing probabilities for various parameters: where the particles might be dwelling, their momenta, and so on. De Broglie's original hypothesis of par-

ticles behaving as physical waves was only partially correct, but its incomparable salutary consequence was no less than the launching of quantum mechanics. The theory abounds with perplexing implications such as particles with insufficient energy to hurdle a barrier "tunneling" through the barrier without losing any energy, of a camel passing through the eye of a needle, or even a particle being in two different places at the same time. The wave function's role as a probability amplitude, preempting de Broglie's proposal of a physical wave, came largely from the work of Born, who in 1925 had first introduced the expression "quantum mechanics." While on the Cambridge University physics faculty, Born received the Nobel Prize (1954) for his contributions to the development of the theory. Although one of the pioneers of modern physics, he is less well known in our culture than his granddaughter, actress/singer Olivia Newton-John. The probabilistic nature of the theory, as opposed to the deterministic cause and effect scheme characterizing classical physics, never sat well with the old guard in the field. Indeed, it was Einstein, who emerged as the most vociferous opponent of the new theory based on the uncertainty principle, uttering the famous vituperative, "God does not play dice with the universe." That triggered a riposte from Bohr, Einstein's close friend and contemporary, but in this instance an ardent patron of the young quantum mechanics, "Albert, stop telling God what he does or does not do!" After experience with the theory for three-quarters of a century, there is general consensus among physicists that a superior theory simply does not exist.

In 1928 Dirac formulated his magnum opus, the relativistic field equation. The solutions of this equation predicted the existence of *antimatter* as opposed to matter—of positively charged positrons, antielectrons, as the antimatter conjugates of ordinary negatively charged electrons, of negatively charged antiprotons as the antimatter conjugates of positively charged protons, and so on. Just four years after the theory was published, Carl David Anderson, a

young physicist at Caltech, detected the positron. When energy (in the form of gamma radiation raining down on the earth as cosmic radiation) passed through a steel plate, it suddenly "materialized," transforming into an electron-positron pair of particles. Conversely, an electron-positron pair—in colliding—were seen to destroy each other in "pair annihilation," with the attendant release of a pair of gamma-ray photons (in opposite direction) of total energy $E=2mc^2$. For his discovery, a confirmation of Dirac's prediction, Anderson received the 1938 Nobel Prize in Physics. It took until the mid-1950s, when particle accelerators with sufficient accelerating energy could be built, however, before antiprotons and antineutrons could also be produced.

Because of the theory's mathematical rigor, the undergraduate physics student may not even encounter Dirac's name. The graduate student, however, cannot avoid it. The idea that someone can produce work of such seminal significance and not be recognized except by professionals in the field presented no problem to the enigmatic Dirac personality. He was so retiring and shy that he contemplated turning down the Nobel Prize. Only after being advised that he might become an even greater celebrity by doing so did he relent and accept. Other great physicists have been accorded units after their names: a newton of force, a joule of energy, a pascal of pressure, and an ampere of current. Dirac, extraordinarily parsimonious with words, inspired the whimsical unit, the *Dirac*: "one word per year." Of course, there are multiples of the Dirac— KiloDiracs, and MegaDiracs, etc.—but such multiples were rarely uttered by Dirac himself. During the nearly four decades that he spent at Cambridge University, he held the chair of the Lucasian Professor of Mathematics, the same chair Isaac Newton had held, and which Stephen Hawking holds today.

A conference held in 1927 at the Solvay Institute, Belgium, had as its mission to examine the philosophy underlying this new theory—arcane, abstract, counterintuitive, and yet so very success-

ful. Toward the end of the deliberations the participants in the conference gathered for a "family portrait" (Figure 12.1). Included in the photograph is the handful of very young, very talented theoretical physicists who created quantum mechanics—de Broglie, Schrödinger, Heisenberg, Dirac. Present in the photograph also are Albert Einstein,

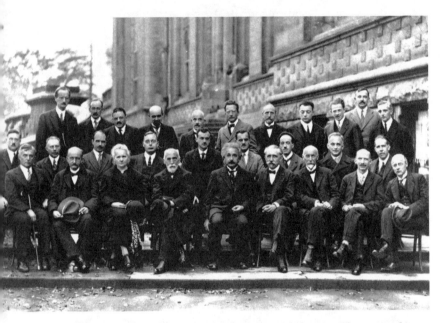

Figure 12.1. Participants in the 1927 Solvay Conference. Those seated in the front row represent mostly the old guard. Starting from the second person at the left are Max Planck, Marie Curie, Heinrik Lorentz, Albert Einstein, and Paul Langevin. Second row from left, the first person is Pieter Debye; the fifth is P.A.M. Dirac; the seventh, Louis de Broglie; next to de Broglie is Max Born, and finally, Niels Bohr. Third row, sixth from left is Erwin Schrödinger; eighth, Wolfgang Pauli; and ninth, Werner Heisenberg. (1927 Photophraphie Benjamin Couperie, Ecole Internationale de Physique Solvay; courtesy AIP Emilio Segré Archives)

the head of the counter-revolution, and Niels Bohr, serving as "Father Confessor"[12] for the young physicists. As a group picture of the pioneers of modern physics—natural philosophy—the photograph represents the twentieth century's answer to Raphael's *School of Athens*. The twenty-nine individuals in the photograph received a total of twenty Nobel Prizes, Madame Curie accounting for two (one in physics and another in chemistry).

At the threshold of the twenty-first century the refinement of the laws of physics continues. The last word on the subject is still not written. Physicists see the universe as the product of four fundamental forces: gravitational, electromagnetic, and two types of nuclear—strong and weak—forces. It is believed that in the very beginning (before 10^{-43} seconds, known as "Planck time") there was only one primordial force, and four separate forces sprang from it very quickly. In the big bang scenario an intractable course sets in, the universe expanding (at the speed of light from a point of singularity), attended by an inexorable decrease in temperature. The lyrical expression "whisper of creation" describes the leftover radiation from the big bang, now having cooled to about 3° kelvin (-270° C or -454° F). Einstein spent the last three decades of his life, including twenty-five years at the Institute for Advanced Study in Princeton, trying to formulate a unified field theory synthesizing the four forces. When he died in 1955 he was nowhere near realizing the dream. That oft-quoted line attributed to Einstein—"The Lord God is subtle, but malicious he is not!"—delivered in a lecture at Princeton University and alluded to earlier, has an appropriate sequel. Einstein, frustrated with results he was obtaining from some of his equations, commented in a letter to his friend, Valentine Bargmann, "I have second thoughts. Maybe God *is* malicious!" His meaning here is that often we are deluded into believing we have finally understood something of fundamental significance, when in reality we are far from understanding anything.[13]

Two of the four fundamental forces of nature—electromagnetic

and the weak force—were unified as the "electroweak force" by the standard model, published by Sheldon Glashow, Abdus Salam, and Steven Weinberg, who shared the 1979 Nobel Prize in Physics. At present, three of the four forces have been unified quite effectively, the rogue force avoiding unification with the other three being gravitation. A monumental obstacle still impedes further progress: quantum mechanics, magnificently successful in dealing with atomic phenomena, is incompatible with general relativity, which is spectacular in explaining phenomena on the cosmic scale. It is hoped that superstring theory (or one of its variations) may just rise to bring together harmoniously the two great theories in a holy grail theory of everything (TOE). Then gravitation will take its place with the other three forces—in a re-creation of the primordial force from which all four separated. We have reached this point after only five hundred years of scientific inquiry that began with Leonardo watching pendulums oscillating and objects falling from a tower, and a hundred years later, with Galileo repeating the same experiments, and publishing his results.

A general principle for dynamic systems exists that holds for art as well as science. In the present context one might say, "Today's physics is tomorrow's history of physics." Whatever form our present description of reality takes, there most likely will be the need to refine the descriptions again and again. Einstein's relativity represented a refinement, but there is no reason to think that even Einstein's is the final version. Certainly a theory bringing gravity into the fold will have to accommodate quantum mechanics, and Einstein's theory will have to be modified. I would like to think that if Leonardo were living now, the issues of fundamental science would still preoccupy his interests.

The Institute for Advanced Study: An Interlude

Founded in 1930 by the Bamberger family (of department store fame), the Institute for Advanced Study in Princeton, New Jersey, has

been one of the great think tanks of America. Abraham Flexner, who had earlier been a driving force in elevating the Johns Hopkins University Medical Center into a preeminent institution, was visiting the University of Oxford in the late 1920s. Oxford is a federation of thirty-odd colleges, and Flexner had come upon one college—All Souls (founded in the fifteenth century)—that had scholars but no students. He was impressed by the notion that cutting-edge scholarship could be carried out by scholars who were unencumbered by the need to teach classes, hold office hours, and otherwise perform routine academic tasks. Upon his return to the United States Flexner convinced the Bambergers of the benefits of establishing a similar institution in America. The Bambergers became enthusiastic, granting Flexner five million dollars for the enterprise and purchasing seven hundred acres of choice Princeton landscape (Figure 12.2).[14]

Figure 12.2. Einstein Drive, the Institute for Advanced Study, Princeton, seen from the intersection of Einstein Drive and Maxwell Lane (lithograph by the author, 1987)

Flexner was appointed the first director of the Institute, and one of his initial projects would be to try to recruit Albert Einstein, recognized already as the most famous living scientist. Flexner immediately journeyed back to Oxford, where he found Einstein "hanging out between jobs"[15] and offered him a position at the new institution. Einstein responded that he "had offers from Princeton University, Oxford University, and Caltech to join their faculties, but [was] still undecided." He added that he "was leaning toward the offer from Princeton University." (Princeton was the first academic institution to accept relativity.) "But then," he asked, "at your place [also to be located in the town of Princeton] I would not have to teach?" Assured that he would have no classes (Einstein was a notoriously poor lecturer) he accepted the job. Then the question of salary became an issue. "How much do you think you would require for a salary?" Flexner asked. Einstein, with his considerable mathematical prowess, answered, "Three thousand dollars a year would be just right." "That cannot be," countered Flexner, "we are paying everyone else $16,000. We should pay you at least as much." Einstein protested, "$3,000 would be satisfactory." Flexner, reluctantly agreed to pay Einstein only $3,000 a year. But fortunately for the Einstein family, Mrs. Einstein renegotiated, and Einstein started receiving the standard $16,000.

Einstein, from the very beginning of his tenure at the institute, served as a magnet to attract the finest theoretical physicists and mathematicians of his time. Over their careers many of the most original thinkers in the field—including recipients of the Nobel Prize in Physics: Bohr (father Niels and later, his son, Aage), Schrödinger, Dirac, Pauli, Salam, Gell-Mann, Yang, Lee, and numerous others—have spent time at the institute. Three of the twentieth century's greatest mathematicians, Janesh "Johnny" von Neumann, Kurt Gödel, and Andrew Wiles (who in the 1990s solved one of the longest-standing problems in mathematics—Fermat's last theorem) spent considerable time at the Institute. Now into its eighth

decade, it continues to serve as an ideal setting for members to interact with other gifted individuals in the field. String theorist Edward Witten, who has been called the "Michael Jordan of Physics," is now a professor at the institute; recently retired is another "physicist's physicist," Freeman Dyson.

In pursuit of my own modest research in theoretical physics, I was at the institute during two stints, 1974–75 and 1982–83. While there, I got to know Helen Dukas, who had served as Einstein's secretary for many years. For the opportunity to revel in "old Einstein stories," Ms. Dukas proved a treasure trove. She told me anecdotes that I had not heard before, and she confirmed or denied the ones that I had heard elsewhere. She had earlier collaborated with Einstein's one-time assistant, Banesh Hoffman, in writing an unusually good book about the great scientist.[16] The opening quote of the book reflects Einstein's unassuming and modest character. But it is a profound pronouncement of resignation that all other modern scientists would view with empathy: "One thing I have learned in a long life: that all our science measured against reality, is primitive and childlike—and yet it is the most precious thing we have."

Three hundred years ago the imperious Newton, in an unusual self-effacing mood, observed, "I do not know what I may appear to the world; but to myself, I seem to have been only like a boy playing on the sea-shore, and diverting myself in now and then finding a smoother pebble or a prettier shell than ordinary, whilst the great ocean of truth lay all undiscovered before me." In another rare modest moment, he commented, "If I have seen further it is by standing on the shoulders of giants."[17] The idea of the nature of science as a cumulative process is one that every scientist would embrace. And it would be a rare scientist who would not rush to concede his own relative insignificance in the scale of the cosmos.

Many different models have been proposed as paradigms to understand nature. Each may be useful to explain one physical phenomenon or another, but no model has risen to be general enough to

explain all physical phenomena. A single be-all, end-all model still remains the quest. But even if such a model or theory is one day formulated, it will still be just that, a theory to explain nature. It would not be nature itself. So, in our quest we will continue to approach the unfathomably large scales of time and space and the infinitesimally small subatomic world—both beyond the capabilities of our physical senses—in terms that are close to our experience. "It seems that the human mind has first to construct forms independently before we can find them in things," wrote Einstein. This sentiment was expressed especially eloquently by the poet William Blake, a humanist who ironically neither understood nor showed any fondness for science. Yet his lines from "Auguries of Innocence" could serve as a timeless credo for the scientist, and so too for the artist:

> To see a world in a grain of sand,
> And a heaven in a wild flower,
> Hold infinity in your hand,
> And eternity in an hour.

The desire to know is natural to good men.

—Leonardo da Vinci

Chapter 13

Bridging the
Cultural Divide

If an abiding message is to be gleaned from an examination of Leonardo's scientific and artistic legacy, it is the insatiable curiosity, the persistent questioning that defined his life—from resolving everyday problems to exploring grand-scale issues pertaining to the workings of nature. He observed and pondered; the commonplace became wondrous, the wondrous commonplace. "Nature is the best teacher," he wrote. "Learn from nature, not from each other." His curiosity encompassed diverse intellectual worlds: technical and nontechnical, scientific and artistic; and indeed it is

by the conjoining of these intellectual worlds that he was able to produce works of such dazzling quality and diversity.

The typical liberal arts curriculum offered in the American undergraduate education system gives students exposure to different intellectual cultures. But then the need to develop specialized skills in one field or another tends to discourage further forays across the cultural divide. The higher education systems in most other countries call for this specialization to begin even earlier. Beyond formal education, normal maturation or aging itself is sadly accompanied by the monotonic dimming of one's curiosity. Once the specialization process begins, those individuals who are more technically oriented have greater facility communicating with others who are technical, and those who are artistic or less technical similarly feel comfortable in the company of individuals with skills and interests akin to their own. In short, birds of a feather most clearly flock together, communicating with each other in their own languages.

In 1940 engineers from Indiana's Department of Highways asked the state legislators to purchase an electric calculator for their office. One of the legislators challenged the engineers: "Why would you need a calculator? You are not mathematicians." An engineer responded, "In order to build safe roads it is necessary to make precise calculations of curves and banking angles. We must factor π into our calculations; and π is an irrational number—a constant with a value of 3.141 593. . . ." The legislator was confused by the mathematical riposte. Shaking his head, he walked into his legislative meeting, taking with him the engineer's explanation for the "justification" for the expenditure. After a while the legislator emerged with an answer: "We don't have money for your calculator. But, we decided to change the value of π for you to 4." Lack of communication between technical and the nontechnical cultures pervades all levels of society. Sixty years later the faculty senate in a selective liberal arts college in the United States voted to allow a certain course taught in the college's geography department to satisfy the college's natural sci-

ence requirement, all the nonscientists in the senate voting, "aye," all the scientists, outnumbered, voting "nay." By committee vote, geography had been deemed a natural science—further evidence of the continuing malady of a cultural divide.

I opened the prologue of this book with C. P. Snow's famous pronouncement on the two disparate intellectual cultures and on the lack of communication between them. What even Snow did not realize is that the seeds of another intellectual revolution had already been planted that would complicate the picture of the two cultures. Two decades earlier the gifted British mathematician Alan Turing had published a general theory of computing.[1] Beginning in the late 1940s engineers, mathematicians, and physicists in the United States began to construct digital computers—those early mainframe machines, ENIAC and UNIVAC—and to create computer languages such as FORTRAN, COBOL, and ALGOL.[2]

In the late 1960s I was in a Ph.D. program in theoretical physics that still had a vestigial sense of a balanced liberal arts education, requiring doctoral candidates to demonstrate facility in two foreign languages. I had to write my own programs in one of the prevailing computer languages and, on the side, prepare for the language competency tests in French and German, besides the main task of mastering all the necessary physics. A year or two after I finished my degree the foreign language requirement was dropped. Ph.D. candidates would now have the option to substitute computer languages for foreign languages. Conversely, for the bachelor's degree in computer science, the natural sciences are no longer a requirement, although there may be an institutional requirement to take such courses under the category of "general education." By the late 1970s a new species had begun to propagate—"computer scientists"—with skills to write programs and create sophisticated general software packages that ran more efficiently than any program I could have conceived. And at approximately the same time there

was the birth of the personal computer—desktops, followed by laptops—not replacing the mainframes, but joining them and beginning to communicate with each other, and all spreading at pandemic speed. The first personal computer was created in 1975. By July 2002, when the world population was estimated to be 6.2 billion, the sales of personal computers reached one billion.

At the beginning of the twenty-first century we find ourselves not only with a deeper chasm dividing C. P. Snow's two cultures but also with a third intellectual culture formed by members of the seceding computer-literate "techies"—neither natural scientists nor humanists. Members of the other two intellectual cultures benefit from application programs such as word processing, mathematical computing, and cyberspace technology, developed by computer scientists. The details of the actual programs remain as incomprehensible, mystifying, and irrelevant to these two cultures as their own material is to each other. The cultural divide describing the dissociation of the first two cultures now demands a reorganization, with a "digital divide" now describing the further dissociation of a third culture.

Under the rubric "Leonardo's model" this book presented the mathematical and scientific basis underlying both science and art, and the tenets of the laws of nature, albeit all of it in an essentially qualitative manner. The interdisciplinary approach, it was seen, invited a discussion of the human side of doing science and art. Among the most creative artists and scientists—especially those who launched revolutionary transformations in the prevailing order in their fields—there abound tortured souls, baffling personalities very different from those in everyday life. There are also the historical and social conditions that made certain times ripe for such unusually creative individuals to spring up and leave their marks.

Beethoven on his deathbed reportedly raised his fist in defiance at a thunderstorm raging outside and cried, "I know I am an artist!" In the last hours before his death, Leonardo, with an air of forlorn resignation, remarked to an assistant, "Tell me, did anything get

done?" For us, these are puzzling and poignant pleas for reassurance by two of the greatest creative individuals in history. In Leonardo's case there also resonates the tone of frustration at unfulfilled ideas and unfinished work. One cannot deny that the reasoning out of solutions, especially in art, and the creating of mental inventions, especially theories in science and technology, were more important for Leonardo than bringing them to actuality. Thus his chronic problem of darting from one beckoning source of curiosity to the next was real. And as his reputation for failing to complete projects and commissions was well deserved. Through it all, however, he was always breaking significant new ground. From the threshold of the twenty-first century we can view the dizzying array and quality of his accomplishments, and we can wonder: "Could there have existed a dozen different and supremely gifted individuals all operating with the same name—Leonardo da Vinci?"

A retrospective that includes the comprehensive abundance of Leonardo's achievements must be viewed against the specter of his inventory of demons. Leonardo displayed boundless variation in his passions, unparalleled originality, a superhuman drive, and an unusual personality. And these were all steeped in paradoxes, contradictions, and ironies. But the questions "What is a cause, what is an effect?" and "What is catalytic, what is coincidental?" must all be regarded as speculative. Nothing with Leonardo is easy. Some of the issues have the ring of central significance. Others certainly do not seem as important today, but we are five centuries removed from a time when they were regarded as serious demons and adversities with which Leonardo had to grapple.

Leonardo was an illegitimate son in a society that afforded little opportunity to such an individual. He was a vegetarian who found detestable the idea of becoming "a cage for dead animals," and an animal rights activist who would purchase birds in the marketplace just to release them into the air. He was left-handed in a time when left-handedness was regarded as sinister. He may have been a homosex-

ual at a time when society, guided largely by the Church, regarded this as sinful. He seems to have had no adult involvement with women, and yet painted the most enigmatic, beguiling and timeless portrait of a woman in all of Western art. In a time when dissecting human bodies was proscribed by law he spent endless hours studying cadavers. Under the intolerable conditions of fetid chambers he dissected human bodies in various states of decay, and created reams of anatomical drawings. He was a pacifist with an aversion to warfare who was employed as a military engineer, designing devices to fortify castles and machinery to breach them, shields to protect the bearer while striking fear into the enemy, and weapons as deadly as any conceived up to that time. As for that vexing curse—the reputation for failing to finish projects—was his mercurial focus and frenetic pace somehow connected to a higher form of attention deficiency hyperactive disorder? Or was it a case of just too many ideas for a finite lifetime? Labels tend to oversimplify phenomena; in Leonardo's case, they are beyond the absurd.

Early in the book I had expressed, with some trepidation, the faith that presenting science through art and art through science would lead to an understanding of Leonardo's mind. Who could be presumptuous enough to claim to fathom the mind of someone as complex as Leonardo? Complex he certainly was, but certain components of his psyche have indeed emerged that are surprisingly simple.

In the surviving paintings and notebooks are strewn a jumble of clues. Leonardo's life can be viewed as a sort of kaleidoscope—creating art of sublime beauty and awesome power, abruptly darting to thoughts on turbulent flow in white water, the geometric patterns of polyhedra, the anatomical studies of man and beast metamorphosing into each other, human flight, spring-driven vehicles, then returning to create one more miraculous work of art. But amidst it all, there are the scattered unfinished projects, endlessly frustrating the most loyal patron.

Leonardo's unusual style, dizzying in pace and diversity, defined

his true modus operandi. The depiction of turbulent water in the daily notebooks is reflected in the golden curls of his subjects. The gently twisted helix, a product of his mathematical musings, is suspiciously evocative of the poses struck by the subjects of his portraits. Regarding painting, he wrote, "It embraces all the forms that are and are not found in nature." The Platonic solids informed his architectural drawings, were seen as rough sketches in the codices, and are formalized in *De divina proportione*. There is the golden pyramid, which he appears to have discovered independently of past civilizations, organizing the grouping of the characters in the *Virgin of the Rocks* (and most likely also in the unfinished lost mural, *The Battle of Anghiari*). In studying the flight of birds he is at once a naturalist, an aerodynamic engineer, and an artist capturing the motion of wings in serial animated drawings; but his thoughts ultimately speculated on human flight. The helical spiral used earlier to give dynamism to the subjects in his paintings returned as the aerial screw, giving lift to the Leonardo helicopter. Totally preoccupied with manned flight, he examined free-fall and gravitation, issues of fundamental significance for physics. The experiments he performed were magnificently framed, leading to conclusions of constant acceleration, independent of the weight of the falling body. In Leonardo's entire process there was total symbiosis, total synergy. His personal growth can be seen in all areas of his creativity, but also seen is the evidence of the deliberate and systematic effort, the mental exercises he performed to attain this growth. An "unlettered man," he left behind lists of daily words to be mastered, in the manner of the autodidact striving for self-improvement.

Interviewed on the occasion of the exhibition *Leonardo da Vinci: Master Draftsman* at the Metropolitan Museum of Art, Carmen Bambach explained, "As an architect, he begins to think of buildings in terms of plans, sections, elevations, three-dimensional perspectival views of form. Now that sounds to us very normal, but that's basically Leonardo's legacy! He is doing this in architecture

by 1490, precisely the moment when he undertakes his studies for the human skull, and guess what—he applies the same technique of the section, the dimensional view, and the elevation to create a consistent vocabulary for anatomical description."[3]

In this one man's works there is more cross-semination of ideas from different intellectual worlds than among the works of generations of specialists in any number of disciplines. Herein lies a timeless lesson. Dramatic progress in any field is most effectively catalyzed by cross-fertilization with others. It is certainly not the only way to achieve progress, but it is an extraordinarily effective way. Leonardo is always making connections and driving it all is the freakish trait of never outgrowing an exceedingly fertile childlike curiosity. This is a trait that was also to characterize the scientists Newton and Einstein and the composer Mozart, each at the pinnacle of his respective field. Einstein's lifelong curiosity is seen in the pronouncement: "The most beautiful thing we can experience is the mysterious. It is the source of all true art and science."

We are all impressed by the rate of learning of young children. In the parlance of psychology children exhibit steep learning curves that allow short doubling and tripling times in their knowledge, but obviously this ability attenuates with age. Along with the insatiably inquisitive intellect, Leonardo retained throughout his life that childlike, virtually vertical learning curve and an endless passion for making connections. In his late fifties he was collaborating with a distinguished mathematician, and separately with a world-class anatomist, to learn all they knew about their respective fields and to raise the quality of the research to much higher levels.

Among his faculties there is the suggestion of a preternatural vision, an ability to take mental snapshots and, in his mind's eye, to virtually freeze motion. This ability is manifested in his renditions of parabolic trajectories of cannonballs, the flapping wings of birds, and the swirling vortices in water. Although one has always to guard against the temptation to impute supernatural ability and even

omniscience to Leonardo, an endowment with such acute vision is not to be dismissed out of hand. Ted Williams, the legendary baseball player renowned for his extraordinary ability to hit a ball, used to claim that he could see the seams on a pitched baseball.

A century ago Sigmund Freud put forth a conjecture that it was the sublimated sexual energy of a homosexual Leonardo that was the source of his superhuman drive, an explanation that subsequent psychoanalysts chose to discredit. Sherwin Nuland makes a compelling case that Freud's explanation should not be dismissed out of hand. If Freud and Nuland are correct, then the hypothesis of the repressed sexual energy, coupled with unsurpassed intelligence, could also go a long way toward explaining Isaac Newton's unrivaled productivity in mathematics and physics. But all this is largely speculative; there is little rigorous science in it. So, how much have we really penetrated Leonardo's mind?

Through the ages both the arts (including the visual arts and literature) and the sciences (the natural sciences and mathematics) have generally evolved gradually, incrementally. But there have also taken place, however infrequently, fundamental changes in the prevailing order—changes of kind rather than degree, akin to a phase transition between vapor and liquid, or liquid and solid. Initiating these "revolutions" have been a finite number of artistic and intellectual revolutionaries—better characterized as transformative geniuses or "magicians."[4] Their reasoning processes do not appear to be constrained by the familiar topography of logic, a topography that includes the slopes and valleys. Rather, reaching conclusions for them is reminiscent of leaping from mountaintop to mountaintop. But their works represent no less than the periodic syntheses of the accumulated knowledge in a field; they succeed by defining human limits and elevating the human spirit. Leonardo, Michelangelo, Shakespeare, Newton, Beethoven, and no more than three or four others[5]—all magicians, all towering intellects, all consumed by a fire raging within—also appear to share one common

quality: they rarely allow any profound penetration into their psyche; their creative processes are forever steeped in mystery. One thing is clear: the more time one devotes to understanding the mind of the magician, the deeper he recedes into the mist.[6] This is a curious phenomenon that distinguishes the magician from others, including the ordinary genius.

The expression "struggling with issues of creativity," a valid topic for the psychologist, is entirely alien to the magician. He creates spontaneously without ever questioning the process personally, often unable to explain the process. There is inspiration; there is intuition. In the parlance of electronics, there may even be a special hard wiring of the brain. For example, Einstein's brain, although entirely normal in size, was missing the left parietal cortex, and the inferior parietal lobe had grown approximately 15 percent larger than it normally would be, in order to fill the area of the missing operculum.[7] The inferior parietal lobe is thought to be the site where analytical reasoning and mathematical modeling are carried out. Another noteworthy feature of Einstein's brain was the existence of an unusually shallow Sylvian fissure, a groove slicing through the brain. This feature, the researchers suggest, allows the brain cells in the area to be packed closer together, permitting more interconnections, and functionally, allowing better cross-referencing of information and ideas. This is of critical importance for analytical processing.

Leonardo, mastering virtually every discipline known in his time and inventing fields that would have to be reinvented hundreds of years later (for example, geology, aeronautical engineering, and automotive engineering), nowhere bothers with the "creativity" question. Ironically, his subjects, including his portraits of the "three women"—*Ginevra de' Benci, Cecilia Gallerani,* and the *Mona Lisa*—and the cast of thirteen characters in the *Last Supper*—are all unsurpassed psychological portraits. They speak with their facial expressions. The sense of imminent motion, which is achieved by Michelangelo with strained muscles, is achieved by Leonardo with

psychology. Leonardo and Shakespeare may well represent the greatest applied psychologists ever, just as Leonardo may well represent the greatest anatomist ever, the latter a sentiment expressed by Walter Pater and echoed by Nuland.

Sherwin Nuland, in that unusually beautiful biography of Leonardo to which I have referred a number of times, wrote a particularly stirring passage:

> If he is, as Sir Kenneth Clark so appropriately calls him, "the most relentlessly curious man in history," he is also the historical figure about whom we are most relentlessly curious. . . . The dates, the facts, the known events are far fewer than we need, if we are to understand how such a being could have existed. The enigma of the *Mona Lisa*'s smile is no less than the enigma of her creator's life force. Or perhaps the smile is in itself Leonardo's ultimate message to the ages: There is even more to me than you can ever capture; though I have spoken so intimately to you in my notebooks even as I have spoken to myself, I have kept final counsel only with the depths of my spirit and the inscrutable source that has made me possible; seek as you may, I will commune with you only so far; the rest is withheld, for it was my destiny to know things you will never know.[8]

The lore associated with the magician is spawned by our own need to understand such an individual—extroverted and intimate with us at one level, and utterly introverted and inaccessible at another. Perhaps the best explanation is also the simplest, that genius at this scale is entirely isolated by its own genius.[9] Leonardo da Vinci, paragon artist-scientist-engineer, a cynosure of the Italian Renaissance, more so than any other magician manifests that quality. Does it really matter that Leonardo will always remain this mysterious and mythical creature, who as a part-time artist produced the epitome in art? His works number so few that even the expression "part-time artist" overstates the case. But it is certainly not the

quantity that counts. Goethe's throwaway line, "In art, the best is good enough," encapsulates the circumstance. Leonardo also developed scientific methodology a century before Galileo, and anticipated future technologies centuries before they were realized. What really matters is that he demonstrated a model of supreme efficacy, a lesson for the ages: seeking connections, conjoining different intellectual worlds, is indeed the source of profound understanding and appreciation in any one of these worlds or in all of them.

What exactly can account for a creature of such transcendent gifts will most likely never be known. It is too easy to say that he was a happy accident of nature and nurture—the concatenation of his mother's and father's genes, the effects of the prevailing social, political, and intellectual winds sweeping Renaissance Florence. In Leonardo's case, there is so much self-nurture. We simply do not know much about his upbringing. He repeatedly admonished others—artists and scientists alike— to "learn from nature, not from each other." In a timeless irony, we must first learn from him, then observe, and ponder. Avoid taking anything for granted, test it before accepting it. Don't ever give up the aspiration for personal growth no matter what stage of your life you are in, read incessantly, read critically, even look up words you don't know with a view toward increasing your vocabulary. Carry a small pad with you and draw sketches (even if you have convinced yourself that you cannot draw). Creating sketches will make you more observant.[10] Observe in the manner of the scientist, savor in the manner of the artist. Record your observations. Experiment, knowing full well that some experiments will fail. But that is how to attain a deeper understanding. It is important to be curious, and important to explore different intellectual worlds, but it is essential to seek their connections. The model that worked magnificently for him will never make any of us another Leonardo, a man called by so many scholars "the greatest genius who ever lived." But it cannot fail to make us each far more creative and more effective practitioners in the intellectual world that we inhabit.

Bibliographical Essay

Definitive biographies of Leonardo are found in Kenneth Clark, *Leonardo da Vinci: An Account of His Development as an Artist* (Cambridge: Cambridge University Press, 1952) and Walter Pater, *The Renaissance: Studies in Art and Poetry* (London: Macmillan, 1917). Indispensable is the magisterial sixteenth-century biography by Giorgio Vasari contained within in his massive *Lives of the Most Excellent Italian Architects, Painters, and Sculptors* (1550), available in many editions, translations, abridged versions, and reprints.

Among the plethora of recent books about Leonardo is David Alan Brown, *Leonardo da Vinci: Origins of a Genius* (New Haven, Conn.: Yale University Press, 1998). There are some very good books that address the connection between Leonardo's art and science; among these is Martin

Kemp, *The Science of Art: Optical Themes in Western Art from Brunelleschi to Seurat* (New Haven, Conn.: Yale University Press, 1990). One of my favorites is the wonderful little book by Sherwin B. Nuland, *Leonardo da Vinci* (NewYork: Penguin, 2000); Nuland, a professor of surgery at Yale University, writes with uncommon authority on Leonardo's anatomical studies. Finally, another good book by a surgeon, not specifically on Leonardo, but addressing parallel developments in modern physics and modern art, is Leonard Shlain, *Art and Physics: Parallel Visions in Space, Time, and Light* (New York: Quill, Morrow, 1991).

There have also been a number of works on the divine proportion and its connection to art. These are more about the mathematics (specifically the geometry) rather than the science underlying proportion and symmetry. In this category are two books by Jay Hambidge, *Dynamic Symmetry in the Greek Vase* (New Haven, Conn.: Yale University Press, 1920) and *The Elements of Dynamic Symmetry* (New York: Dover, 1967), both still useful. There is also mathematician H. E. Huntley's *The Divine Proportion: A Study in Mathematical Beauty* (New York: Dover, 1970); and by artist Matila Ghyka, *Geometrical Composition and Design* (London: Alec Tiranti, 1952); and *The Geometry of Art and Life* (New York: Sheed and Ward, 1946), which is wonderfully detailed.

The quotations by Leonardo appearing at the opening of each chapter are from two main sources: Jean Paul Richter, *The Notebooks of Leonardo da Vinci*, 2 vols. (New York: Dover, 1970), an unabridged edition of the work first published as *The Literary Works of Leonardo da Vinci* (London, 1883); and Martin Kemp, ed., *Leonardo on Painting: An Anthology of Writings by Leonardo da Vinci, with a Selection of Documents Relating to His Career as an Artist*, trans. Martin Kemp and Margaret Walker (New Haven, Conn.: Yale University Press, 1989).

For the reader interested in a general history of the art of the Italian Renaissance, I would like to suggest two complementary books: Frederick Hartt, *History of Italian Renaissance Art: Painting, Sculpture, Architecture*, rev. and ed. by David G. Wilkins, 5th ed. (New York: Alpha Communications, 2003) and Evelyn Welch, *Art and Society in Italy, 1350–1500* (Oxford: Oxford University Press, 1997). Finally, on the history of art in general there are numerous highly authoritative books, including the compendious Fred S. Kliner, Christin J. Mamiya, and Richard G. Tansey, eds., Helen Gardner, *Gardner's Art Through the Ages* 11th ed. (Fort Worth, Tex.: Harcourt, 2001).

Notes

PROLOGUE

1. C. P. Snow, *The Two Cultures and the Scientific Revolution* (Cambridge: Cambridge University Press, 1959).

1. LEONARDO FIORENTINO: A LIFE WELL SPENT

1. Printing by movable type had been introduced in China and Korea long before Gutenberg, however it was made of awkward ceramic pieces, existed as a cumbersome number of characters, and was used for printing posters rather than books. Before Gutenberg, printers in

Europe had to use wood engravings; each was created to print an entire page, thus only capable of producing a limited number of copies.

2. By the time the first university was established in Europe (Bologna in 1088), there already existed two universities in North Africa—al-Qarawiyin in Fez, Morocco (879) and al-Azhar in Cairo (970). In Salerno in the mid-eleventh century there was actually a university that predated Bologna's; it was a specialized medical school.

3. Roger Bacon (1220–1292) and William of Ockham (c. 1300–1349), both connected with the University of Oxford, put reason above religious doctrine and were regarded as pariahs by the Church. Their brand of philosophy flourished in northern Europe and would be entirely hospitable to modern science, but Bacon and Ockham would have been in deep trouble had they been operating in Italian universities. Of the Italian universities, Bologna, founded as a law school, was unusually free of clerical pressures against unfettered intellectual dialogue. Two other institutions—Padua, especially famous for its medical and law schools, and Pavia, for its medical school—both accommodated anatomical studies.

4. Dino De Paoli, "Leonardo da Vinci's Geology and the Simultaneity of Time," *21st-Century Science and Technology*, summer 2001, pp. 17–33.

5. Martin Kemp, ed. *Leonardo on Painting*.

6. Marco Rosci, *The Hidden Leonardo*, English trans. John Gilbert (Chicago: Rand McNally, 1977).

2. THE CONFLUENCE OF SCIENCE AND ART

1. This description of the tools of the artist versus those of the mathematician was introduced by Leonard Shlain.

2. Richard Feynman, *Character of Physical Law* (Cambridge, Mass.: MIT Press, 1964), p. 34.

3. Eugene P. Wigner, *Symmetries and Reflections: Scientific Essays* (Cambridge, Mass.: MIT Press, 1967), pp. 222–37.

4. Eugene Wigner (1902–1995) was one of the modern heirs to the spirit of intellectual diversity. Around 1930 he and a half-dozen other young Hungarians emigrated abroad—five to the United States, one to Canada, and one to England. All had finished high school in Budapest (several were members of the class of 1920 at the Evangélicus Gimnázium); all had earned bachelor's degrees from the University of Budapest; and all doctorates from German universities. Along with Wigner, the unprecedented brain drain included his classmates, Leo

Szilard, instrumental in launching the Manhattan Project that developed the atom bomb; Edward Teller, the "Father of the H-bomb"; and Janesh "Johnny" von Neumann, one of the most important mathematicians in history and a colleague of Einstein's at the Institute for Advanced Study in Princeton. The brain trust also included Denis Gabor, winner of the Nobel Prize in Physics for developing holography; Albert Szent-Gyorgi, winner of a Nobel Prize in Physiology and Medicine; and Eugene Ormandy, conductor of the Philadelphia Symphony Orchestra in its heyday.

5. In antiquity, the Romans regarded the Alps merely as barriers keeping out the barbarians. Nowhere in Shakespeare is there a romantic allusion to mountains. As late as the seventeenth and eighteenth centuries the Alps were regarded as aberrations on an otherwise smooth, spherical earth. Beginning with the romantic period, mountains become places of beauty and spiritual significance.

6. Jacob Bronowski, "The Creative Process," *Scientific American* 199, no. 8 (September 1958), pp. 5–11.

7. A recent book in its very title heralds the notion of Leonardo initiating scientific methodology: Michael White, *Leonardo: The First Scientist* (New York: Saint Martin's Press, 2000).

8. Jacob Bronowski, *The Ascent of Man* (New York: Little, Brown, 1973), p. 113.

9. Ibid.

10. Princeton University's preeminence in physics is a legacy of Joseph Henry (1797–1878), rather than of Albert Einstein, who was actually a member of the Institute for Advanced Study, also located in Princeton. Henry, a professor of physics at Princeton from 1832 to 1846, discovered the law underlying the electric generator independently of Michael Faraday in 1830, but did not publish it. Introducing insulated wires into coils, he amplified the strength of his electromagnets. Henry also designed the electric motor, variations of which we still use.

11. Stephen Jay Gould, *Rocks of Ages* (New York: Ballantine, 1999), p. 6.

3. PAINTING BY NUMBERS

1. Suggested by Christopher Tyler (private communication).

2. Carl Boyer, *A History of Mathematics*, rev. by U. Merzbach, 2d ed. (New York: Wiley, 1991), p. 4.

3. Robert Kaplan, *The Nothing That Is* (Oxford and New York: Oxford University Press, 1999).

4. Seyyed Hossein Nasr, *Islamic Science: An Illustrated Study* (Westerham, Kent, England: World of Islam Festival Publishing Company, 1976).

5. Quatrain 24 from Edward Fitzgerald, *The Rubaiyyat* of Omar Khayyám 5th ed., quoted in M. H. Abrams, ed., *The Norton Anthology of English Literature*, 7th ed, vol. 2 (New York: W. W. Norton, 2000), p. 1308.

6. For a short and entertaining account, see Dennis Overbye, "How Islam Won, and Lost, the Lead in Science," *New York Times*, "Science Times," October 30, 2001, D, pp. 1, 3.

7. An irrational number is a number that cannot be expressed as an integer or as the ratio of two integers. $\sqrt{2}$=1.414 213 56 . . . and π (=3.141 592 65 . . .) are a pair of common irrational numbers expressed here accurately to eight places beyond the decimal. But this is not to say that one cannot specify them to a desired degree of accuracy by a ratio of integers, e.g., in the case of π the ratio 22/7, often taught to school children, equals 3.142 857 14 . . . , and is correct to just three places. An approximation correct to six places is 355/113=3.141 592 9 . . . A useful mnemonic for remembering π to fifteen places exists: "How I need a drink, alcoholic of course, after the heavy lectures involving quantum mechanics." The number of letters in each word corresponds to the successive place values in π: "How," 3; "I," 1; "need,"4; etc.

8. The Fibonacci series has as its basis three statements:

$u_1, u_2, u_3, \ldots u_n$

$u_1 = u_2 = 1,$

$u_n = u_{n-1} + u_{n-2}$

with n=1, 2, 3, . . .

Thus *1, 1, 2, 3, 5, 8, 13, 21, 34, 55, 89, 144, 233, 377, 610, 987,* . . . Now if the ratio R_n is defined by

$R_n = u_{n+1}/u_n$

one finds for R_1, R_2, R_3, \ldots

the values are 1, 2, 1.5, 1.67, 1.60, 1.63, 1.615, . . . converging in the limit:

$$\lim_{n \to \infty} R_n = \frac{1+\sqrt{5}}{2}$$

which to six places after the decimal equals *1.618 034*, a number denoted by ϕ.

The terms of the series can be computed with a recursion relation. The nth term can be computed directly from

$$u_n = \frac{(1.618034\ldots)^n - (-0.618034\ldots)^n}{\sqrt{5}}$$

The derivation of the nth term of the Fibonacci series:

Let $a_{n+2}=a_{n+1}+a_n$, so that $a_{n+2}-a_{n+1}-a_n=0$. The characteristic equation $\phi^2-\phi-1=0$, a quadratic, has characteristic solutions $\phi=(1\pm\sqrt{5})/2$.

$$a_n=c_1(\phi_1)^n+c_2(\phi_2)^n. \qquad (1)$$
$$a_0=c_1(\phi_1)^0+c_2(\phi_2)^0=1 \qquad (2)$$
$$a_1=c_1(\phi_1)^1+c_2(\phi_2)^1=1 \qquad (3)$$

From (2) we have $c_1+c_2=1$. Substituting $c_2=1-c_1$ into (3), we obtain $c_1=(1+5)/(2+5)$ and $c_2=(5-1)/(2\sqrt{5})$

and (1) can then be written

$$a_n=(1/\sqrt{5})\{[(1+\sqrt{5})/2)]^{n+1}-[(1-\sqrt{5})/2)]^{n+1}\}-(4)$$

The terms $u_1, u_2, u_3 \ldots$ in the text above, are related to a_0, a_1, a_2, \ldots in this derivation by $u_{n+1}=a_n$.

Thus

$$u_n=(1/\sqrt{5})\{[(1+\sqrt{5})/2)]^n-[(1-\sqrt{5})/2)]^n\} \qquad (5)$$

which is just the expression cited earlier.

9. Table of common values associated with the golden section:

$\phi=(1+(\sqrt{5})/2=1.618\ 034$	$\phi^{-1}=1/\phi=0.618\ 034$	$\phi^2=2.618\ 034$
$1/\phi^2=0.381\ 966$	$[1+(1/\phi^2)]=1.381\ 966$	$(1/2\phi)+1=1.309\ 017$
$(1+\phi/4)=1.404\ 508$	$\sqrt{2}=1.414\ 214$	$\sqrt{3}=1.732\ 051$
$(\sqrt{5}=2.236\ 068$	$\sqrt{5}-1=1.236068$	

10. The logarithmic spiral can be written mathematically as an exponential equation in polar coordinates. On the x-axis one marks off a unit distance. Then one proceeds in a counterclockwise direction, contracting this distance by a factor of $\phi^{-1}=1/\phi=0.618\ 034$ upon reaching 90° (or $\pi/2$ radians), by a factor of $\phi^{-2}=1/\phi^2=0.381\ 966$ at 180° (or π radians), by a factor of $\phi^{-3}=1/\phi^3=0.236\ 069$ at 270°, and a factor of $\phi^{-4}=1/\phi^4=0.145\ 898$ at 360° (i.e., a full circle), the resulting curve will define a logarithmic spiral

$$r(\theta)=r_0 e^{-\left(\frac{\ln\phi}{\pi/2}\right)\theta}$$

The evaluation is entirely evocative of the expression for the exponential decay of a radioactive nuclide,

The dependent variable N is the number of nuclei remaining at time t

$$N(t)=N_0 e^{-\left(\frac{\ln 2}{T_{1/2}}\right)t}$$

when the original number at t=0 was N_o; the 2 in the natural log (ln) comes from the inverse of 1/2; $T_{1/2}$ is the half life of the radioactive nuclide (e.g., 5,715 years for C^{14}); the independent variable is the time t.

11. H.F.R. Adams, *The SI-Metric Units*, rev. ed. (Montreal: McGraw-Hill Ryerson, 1974), pp. 9–10.

4. THE NATURE OF SCIENCE

1. We have only the fragments of Protagoras's doctrine, but they seem to question the existence of the gods. The impiety and atheistic pronouncements may have been the reason he was banished from Athens.

2. Reviel Netz, "The Origins of Mathematical Physics: New Light on an Old Question," *Physics Today*, June 2000, pp. 43–37. Until very recently mathematicians believed that the concept of infinity became a subject of interest for mathematics only in recent times. Modern classical scholars, however, in deciphering the recently discovered Archimedes palimpsest, produced a thousand years ago from Archimedes' original writings, found his claims of comparing a pair of infinite sets. A palimpsest is a book white-washed and over-written.

5. THE NATURE OF ART

1. A. P. McMahon, *Treatise on Painting. Codex Urbinus Latinus 1270* (Princeton, N. J.: Princeton University Press, 1956).

2. Kurt Mendelssohn, "A Scientist Looks at the Pyramids," *American Scientist* 89 (March–April 1971), pp. 210–20; Kurt Mendelssohn, *The Riddle of the Pyramids* (New York: Praeger, 1974).

3. Kurt Mendelssohn, private communication.

4. Isaac Asimov, *Asimov's Biographical Encyclopedia of Science and Technology*, 2d rev. ed. (New York: Doubleday, 1982).

5. Mendelssohn, private communication.

6. David H. Koch, "Dating the Pyramids," *Archaeology* 52, no. 5 (September–October 1999), pp. 26–33.

7. Farouk El-Baz, "Gifts of the Desert," *Archaeology* 54, no. 2 (March–April 2001), pp. 42–45.

8. My friend, the dean, has since passed away. I would rather not divulge his name, although for years after the incident took place he continued to joke and laugh about it.

9. Jay Hambidge, *Dynamic Symmetry in the Greek Vase* (New Haven, Conn.:

Yale University Press, 1920); Jay Hambidge, *The Elements of Dynamic Symmetry* (New York: Dover, 1967).

10. As a freshman at Georgetown University in 1959–60, I was invited to a dinner by my classmate Anil Nehru, the son of B. K. Nehru, the Indian financial ambassador to Washington, D.C., and the nephew of Prime Minister Jahawarlal Nehru. The guest of honor at the dinner was Salvador Dali. Unhappily, I did not know then of the Pythagoreans's fascination with the dodecahedron and could not ask Dali whether he had that notion in mind when he created his painting.

6. THE ART OF NATURE

1. Christopher Tyler, who made this observation in a private communication, is the discoverer of the center-line principle that figures prominently in portraits.

2. Stephen Jay Gould, *Ever Since Darwin: Reflections in Natural History* (New York: W. W. Norton, 1977), p. 201.

3. Leonard Shlain, *Art and Physics: Parallel Visions in Space, Time, and Light* (New York: William Morrow, 1991). Shlain is a surgeon who practices in San Francisco.

4. Most intellectual endeavors benefit when they conjoin complementary objective and subjective aspects. Form and feeling is one such pair. Essayist Samuel Johnson (1709–1784), captured another nuance of this principle, "Integrity without knowledge," he wrote, "is weak and useless, and knowledge without integrity is dangerous and dreadful."

5. This is the title of a book by the seventeenth-century Swiss mathematician Jacob Bernoulli, who investigated the logarithmic spiral extensively. See Mario Livio, *The Golden Ratio* (New York, Broadway Books, 2002), pp. 116–17.

6. D. Harel, R. Unger, J. L. Sussman, "Beauty is in the Genes of the Beholder," *Trends in Biological Sciences* 11 (April 4, 1986).

7. Peter S. Stevens, *Patterns in Nature* (Boston: Atlantic Monthly Press, 1974), pp. 136–66.

8. Ibid., pp. 160–61.

9. Ibid., p. 164.

10. Livio, *The Golden Ratio*, p. 120. Livio's explanation is based on the discovery by Vance Tucker et al., "Curved Flight Path and Sideways Vision in Peregrine Falcons," *Journal of Experimental Biology* 203, no. 24 (December 15, 2000), pp. 3755–63.

11. Kemp, ed., *Leonardo on Painting*, pp. 123–29.

12. Robert Ricketts, professor emeritus of Occlusion at the University of Southern California and professor emeritus of Orthodontics at Loma Linda University, California. "Divine Proportion in Facial Esthetics," *Clinics in Plastic Surgery* 9, no. 4 (October 1982). There is also his compendious work, *Provocation and Perception in Cranio-Facial Orthopedics* (1989). Of the nine books available in three volumes, the section of special interest to us is "Facial Art, the Divine Proportion and Esthetics," part I, section 1, chapter 6, pp. 169–202.

13. The pencil sketch depicts a longtime friend and former student, Rochele Hc Hirsch, née Elizabeth Stansell, at Mary Washington College of the University of Virginia.

14. For the aesthetic dentist's formula for the "beautiful smile," I am grateful to Dr. Arthur Sitrin of Miami, Florida.

15. Marquardt, private communication.

16. Marquardt's Web page is http://goldennumber.net/beauty.html. The actor John Cleese and actress Elizabeth Hurley collaborated on a television program aired on the Discovery Channel in August 2001. The episode has its own Web page: http://tlc.discovery.com/convergence/humanface/humanface.html.

7. THE SCIENCE OF ART

1. Kemp, ed., *Leonardo on Painting*, pp. 17, 52.

2. Tyler was the first to point out the attempt at achieving proper perspective in the paintings in Pompeii. The scheme in Pompeii failed because of the existence of more than one horizon line. Personal communication plus the following Web sites: http://www.ski.org/CWTyler_lab/CWT;yler/PrePublications/index.html and http://www.ski.org/CWTyler/Art%20Investigations/PerspectiveHistory/Perspective.BriefHistory.html.

3. A. P. McMahon, *Treatise on Painting. Codex Urbinus Latinus 1270* (Princeton, N. J.: Princeton University Press, 1956).

4. A compelling argument is made to this effect in Kemp, *The Science of Art*, pp. 44–52.

5. Morris Kline, "Projective Geometry," *Scientific American*, January 1955, reprinted in *Science and the Arts* (New York: Scientific American, 1995), pp. 30–35.

6. Sanford Schwarts, "Camera Work," *New York Review of Books* 48, no. 9 (May 31, 2001), pp. 6–12.

7. Van Hoogstraten's perspective box is discussed in Lisa Jardin's excel-

lent book, *Ingenious Pursuits: Building the Scientific Revolution* (New York: Doubleday, 1999), pp. 107–11.

8. Walter Liedtke, curator of European art and a specialist in Dutch and Flemish paintings at the Metropolitan Museum of Art, is primary author of the exhibition catalogue *Vermeer and the Delft School* (New Haven, Conn.: Yale University Press, 2001), p. 156.

9. Bülent Atalay, *Oxford and the English Countryside: Impressions in Ink* (London: Eton House, 1974).

10. H. E. Huntley, *The Divine Proportion* (New York: Dover, 1970), pp. 60–69.

11. Ibid., pp. 62–65. Along with Fechner, Huntley cites Adolf Zeising, *Der Goldene Schnitt* (1884), Witmar (1894), and Thorndike (1917).

12. Helen Hedian, "The Golden Section and the Artist," *Fibonacci Quarterly* 14, no. 5 (1976), pp. 406–18.

13. Two books in which Seurat's *Circus Side Show* is presented in connection with the golden ratio are David Bergamini, *Mathematics* (New York: Life Science Library, 1963), and Livio, *Golden Ratio*.

14. Another example of a circular painting with similar shapes and symmetries is Raphael's *Madonna della Seggiola* (Madonna of the Chair) of 1514 (Florence, Galleria Palatino and a second version, Dubrovnik Cathedral, Croatia).

15. Physicists among the readers should know that the expression "dynamic symmetry" as used here has nothing to do with the usual dynamical symmetry groups in physics.

16. *Crypto* means "hidden" or "secret," and *techne* means "skill" or "art," that is, something manufactured.

17. Elise Maclay, *The Art of Bev Doolittle* (New York: Bantam Books, 1990). For permission to reproduce the artist's works, I am grateful to Doolittle and her representative, The Greenwich Workshop, http://www.greenwichworkshop.com.

18. Fred Leeman, *Hidden Images* (New York: Harry N. Abrams, 1976); p. 10. (*Codex Atlanticus*, fol. 35 verso a. c. 1485), Biblioteca Ambrosiana, Milan.

19. Tom Wolfe et al., *Frederick Hart: Sculptor* (New York: Hudson Hills, 1994). This magnificent book featuring the artist's work contains essays by prominent literati and art critics, including J. Carter Brown, the late director of the National Gallery. My own cherished copy was a present in 1998 from the artist, with whom I shared an affinity for the classical style in art. The book is a must for any collector of art books who also prefers a confluence of

truth and beauty in art, and not just truth alone (as evinced by the modern art establishment). I must admit to empathizing with the pronouncements of a pair of prominent English writers: foreign correspondent Alistair Cooke, who found in *some* modern works of art "decadence in the name of originality," and British playwright Tom Stoppard, who quipped, "Contemporary art is imagination without skill."

20. I first noticed the logarithmic spiral in *Ex Nihilo* around 1984, and subsequently discussed it in lectures in the 1980s and 1990s. Indeed, I had planned to surprise Hart during a lecture I gave at the Smithsonian in October 1998 by projecting the image seen in Plate 5, but he was unable to attend the lecture. It was only after writing about it for this book during 2000–3 that I came across another author's reference to the spiral. In an incisive essay, "Evolution out of Chaos: The Creation Sculptures," Frederick Turner mentions the spiral, as well as the Fibonacci series and the nautilus, indeed, making many of the same connections I make in this book (see *Frederick Hart: Sculptor*, p. 60).

21. Lindy Hart, a good personal friend, has served as the source for much of the information regarding the sculptor's experience.

22. Among papers by detractors is mathematician George Markowksy, "Misconceptions about the Golden Ratio," *College Mathematics Journal* 23, no. 1 (January 1992), pp. 2–19.

23. That Joseph Schillinger (1895–1943) had employed the golden ratio in his musical compositions was unknown to me until recently when I came across Livio, *Golden Ratio*.

8. THE EYE OF THE BEHOLDER AND THE EYE OF THE BEHELD

1. This also appears to be a cut-off age to begin to learn a foreign language without a trace of an accent; see Betty Edwards, *Drawing on the Right Side of the Brain* (New York: Houghton Mifflin, 1979).

2. Ibid.

3. This is the title of a small exhibition held in the National Portrait Gallery, London, April–June, 1999.

4. Alan Riding, "Hypothesis: The Artist Does See Things Differently." *New York Times*, May 4, 1999, B, p. 1.

5. Ibid.

6. Robert L. Solso, "The Cognitive Neuroscience of Art: A Preliminary

f MRI Observation," *Journal of Consciousness Studies* 7, no. 8–9 (August–September 2000), pp. 75–85.

7. Robert L. Solso, private communication.

8. The five portraits by Humphrey Ocean hanging in the National Portrait Gallery include a 1983 portrait of Sir Paul McCartney.

9. Riding, "Hypothesis."

10. Sonnet XVIII: 5–8.

11. Guy Gugliotta, "Why Art Connects with a Left," *Washington Post*, October 18, 1999, A, p. 9. Raphael, born in 1483, would have been at least twenty-three when Leonardo painted the *Mona Lisa*. He may have seen Leonardo creating the portrait, musicians creating the proper mood for the subject and the artist, but it would be a stretch to have Raphael sitting at Leonardo's knee.

12. C. W. Tyler, "The Human Expression of Symmetry: Art and Neuroscience," International Conference on the Unity of the Sciences; Session: Symmetry in Its Various Aspects: Search for Order in the Universe. Seoul, Korea (February 2000). See also Web sites: http://www.ski.org/CWTyler_lab/CWTyler/PrePublications/ARVO/ 1998/Portraits/index.html and http://www.ski.org/CWTyler_lab/ CWTyler/Art%20investigations/Symmetry/Symmetry.html.

13. In a number of other portraits painted by Wyeth the center-line is found to coincide with an eye, and in many other cases simply to reflect the gaussian distribution formed by Tyler's data.

14. Private communication with the author.

15. I. C. McManus, N. K. Humphrey, "Turning the Left Cheek," *Nature* 243 (1973), pp. 271–72.

16. I. E. Gordon, "Left and Right in Goya's Portraits," *Nature* 249 (1974), pp. 197–98.

17. N. H. Robinson, *The Royal Society Catalogue of Portraits* (London: Royal Society, 1980).

18. P. R. Coles, "Profile Orientations and Social Distance in Portrait Painting," *Perception* 3 (1974), pp. 303–8; O. Grüsser, et al., "Cerebral Lateralisation and Some Implications for Art, Aesthetics, Perception and Artistic Creativity." *Beauty and the Brain: Biological Aspects of Aesthetics*, ed. Ingo Rentschler, et al. (Basel: Birkhäuser, 1988), pp. 257–93.

19. Michael E. R. Nicholls, "Asymmetries in Portraits: Insight from Neuropsychology," in *Side Bias: A Neuropsychological Perspective*, ed. M. Mandal, et al. (Dordreckt: Kluwer, 2000), pp. 313–29. Michael E. R. Nicholls et al., "Laterality of Expression in Portraiture: Putting Your Best Cheek Forward," *Proceedings of the Royal Society London* B 266

(1999), pp. 1517–22.

20. The remaining eight portraits were eliminated, having violated the center-line principle.

9. LEONARDO, PART-TIME ARTIST

1. Kemp, ed. *Leonardo on Painting*, pp. 13–46.
2. Ibid., pp. 268, 270.
3. David Alan Brown, curator of Italian Renaissance Art at the National Gallery of Art, offers an excellent history and artistic analysis of this work in his *Leonardo da Vinci: Origins of Genius*. See also the video "The Story of Ginevra" (produced by the National Gallery of Art), for which Brown collaborated with National Gallery conservator David Bull and Oxford art historian Martin Kemp.
4. Bull also found Leonardo's fingerprints on the *Ginevra de' Benci*. Based on his studies he claims Leonardo was the first artist to soften edges and achieve subtle blending by dabbing his finger in the paint. Following Leonardo, many others, including Bellini and Titian, were dabbing the freshly laid paint with their fingers.
5. Daniel Glick, "The Case of the Polish Leonardo," *Washington Post Magazine*, March 15, 1992, pp. 16–29.
6. M. J. Gelb, "Lessons in Thinking From the Inspiring Leonardo da Vinci," *Bottom Line* (January 1, 1999), p. 13; M. J. Gelb, *How to Think Like Leonardo da Vinci* (New York: Delacorte, 1998).

10. THE MANUSCRIPTS OF THE CONSUMMATE SCIENTIST

1. Michael White, *Leonardo: The First Scientist* (New York: Saint Martin's Press, 2000).
2. Nuland, *Leonardo da Vinci*, p. 114.
3. Evangelista Torricelli (1608–1647) was an Italian physicist and Daniel Bernoulli (1700–1782), a Swiss mathematician. The Bernoulli family of Basel included a dozen eminent mathematicians; perhaps the most prominent of them were the brothers Jacob and Jean, who developed the calculus of variation and the mathematical description of the curve known as the lemniscate and the formalism of differential equations.
4. Archimedes, educated in Alexandria, may have seen it used there, or he

may have invented it. It is still used on the banks of the Nile. The simplicity and efficiency of the device explains its enduring power.

5. Ladislao Reti, ed., *The Unknown Leonardo* (New York: McGraw-Hill, 1974), p. 181.

6. Stillman Drake and James MacLachlan, "Galileo's Discovery of the Parabolic Trajectory," *Scientific American*, March 1975, pp. 102–10.

7. Vernard Folley, "Leonardo and the Invention of the Wheellock," *Scientific American* 278 (January 1998), pp. 74–79.

8. Ladislao Reti, *The Unknown Leonardo*, pp. 291–92.

9. In the case of the Leonardo bicycle, however, there is considerable controversy. A number of scholars claim that the Leonardo design is a modern forgery. The drawing certainly lacks the usual quality of draftsmanship of Leonardo, but others suggest that it is a drawing by an apprentice, based on a lost drawing by Leonardo.

10. Among trees that sow seeds by way of samaras are the maple, the ailanthus, and the tulip poplar, all indigenous to Italy. The twisted foil shape and the eccentrically located seed makes the shape a natural helicopter.

11. Communication between the Turkish heads of state and Italian painters continued on to a third generation, with Yavuz Sultan Selim, the son of Bayezid, inviting Michelangelo in 1517 to visit the Turkish capital and to undertake some projects of an artistic and engineering nature. Selim, an enlightened monarch emulating more his grandfather than his father, had seen the opportunity to infuse Ottoman culture with the energy of the Italian High Renaissance. Michelangelo, however, busy painting the ceiling of the Sistine Chapel, showed no interest in the commission and the offer was withdrawn.

12. Nuland, *Leonardo da Vinci*, p. 148.

13. Ibid.

14. Ibid., p. 131.

15. J. J. O'Connor and E. F. Robertson, http://www-groups.dcs. st-and.ac.uk/~history/Mathematicians/Bernoulli_Jacob.html

11. UNIFYING THE PHYSICS OF HEAVEN AND EARTH

1. Some of his teachings on science are even more preposterous. He claimed men had more teeth than women. He taught spontaneous generation for the origin of life. He also claimed that a man reached his peak at fifty-two—to which "peak" he was referring is not clear, but he

was fifty-two years old when he made the statement.

2. The expression "falling body" to the physicist is any object that has been dropped, and "free-fall" refers to dropping in a medium devoid of drag. In the world of Leonardo, when Niccolò Machiavelli and Cesare Borgia flourished, the expression "falling bodies" could just as easily have conjured up images of cadavers, or soon-to-become cadavers.

3. Copernicus was evidently familiar with Aristarchus's work and mentioned it in the introduction of the manuscript of his great book *De revolutionibus orbeum coelestium* (1543), but decided to drop it in the published edition.

4. A simple mnemonic—Bode's law—exists to remember the distances of the first six planets. Although called a "law," it is neither a physical law nor was it Bode who discovered it. Start by taking the series 0, 3, 6, 12, 24, 48, 96 (i.e., after 0 for the first term, and 3 for the second term, double 3 to get the next term, double the next term to get the following, etc.) Then add 4 to each term of the series that has just been generated: thus 4, 7, 10, 16, 28, 52, 100. Finally, divide each term by 10, in order to obtain 0.4, 0.7, 1.0, 1.6, 2.8, 5.2, and 10. These are the distances in AU of the planets, except for the anomaly that occurs at 2.8. There is no planet there. But there is the Asteroid Belt!

5. The tables are named after King Alphonse of Portugal, who commissioned them.

6. Hermeticism was purportedly based on the mystical teachings of Hermes Trismegistus ("triple-divine"), a contemporary of Moses. It was believed to be handed down through a number of ancient philosophers, including Pythagoras and Plato, and the teachings were formally written out in the second and third centuries A.D. by a band of Neoplatonists. The "sorcerer's stone" (known in the United States as the "philosopher's stone") that alchemists believed would convert base metals into gold, had been created by Hermes Trismegistus. Of course, alchemy had a salutary effect in leading to the birth of chemistry. The expression "hermetically sealed" alludes to the enigmatic character Hermes.

7. In order to compute Jupiter's period, one can use Kepler's third law:

8. Galileo's equations describing free-fall are given by

$$T_{\text{Jupiter}} = \sqrt{\left(\frac{R_{\text{Jupiter}}}{R_{\text{Earth}}} \right)^3} \qquad T_{\text{Earth}} = \sqrt{5.2^3} \ (1 \ year) \approx 12 \ years$$

$s(t) = \frac{1}{2}gt^2 + v_o t + s_o$

$v(t) = gt + v_o$

$a(t) = g$

$s(t)$ represents the height or altitude of the body at a specified time t; $v(t)$, the velocity of the body at time t; and $a(t)$, the acceleration—which is clearly independent of time and mass—a constant!

9. Dava Sobel, *Galileo's Daughter* (New York: Walker and Co., 1999). This book portrays Galileo as a father deeply devoted to his eldest daughter, whom he had placed in a nunnery while she was still a young teenager. An unusually intelligent young woman, Sister Marie Celeste—born the love child "Virginia"—spent most of her life as a nun. She corresponded regularly with her father, and although his letters to her no longer exist, her letters to him have survived; and it was these letters Sobel pieced together in creating her endearing account.

10. Richard Feynman, the legendary twentieth-century physicist, was no slouch himself. He served on the faculty of Caltech for the better part of forty years. While still a Ph.D. student at Princeton he took a leave and worked in the Manhattan Project on the theoretical physics team creating the first atomic bomb. In the 1940s he formulated quantum electrodynamics (QED) and won a Nobel Prize for this work in 1965.

11. The universal law of gravitation reads $F = Gmm'\,r^2$. The symbols m and m' represent the masses of the bodies, r is the distance between the masses (measured center to center), and G is the universal gravitational constant.

12. The "projectile" is launched from a point (x_o, y_o) with an initial speed of v_o and at an angle $\theta_o\pi$ (measured relative to the horizon); the gravitational acceleration $g = -9.8 \text{m/sec}^2$ (-32 ft./sec.2). Classical mechanics yields, with air resistance ignored, the trajectory of the projectile to be given in terms of the coordinates x, y, and θ_o by

$$y(x) = \frac{1}{2}g\left[\frac{(x-x_o)}{v_o\cos\theta_o}\right]^2 + v_o\sin\theta\left[\frac{(x-x_o)}{v_o\cos\theta_o}\right] + y_o$$

$$x(\theta_o) = -\frac{v_o^2\sin(2\theta_o)}{g} + x_o$$

The first equation describes a downward-turned parabola, or one that "spills water." For the same initial speed v_o the highest point for a trajectory, the apogee, occurs when the projectile is launched at an initial angle of 90°. The second equation reveals that the horizontal distance, the range, is maximized when the initial angle $\theta_o = 45°$, a fact that

football quarterbacks and punters know intuitively.

13. The list of Cambridge University's graduates who have won the Nobel Prize is available through the Web site http://www.damtp.cam.ac.uk/user/ smb1001/camnobel.html.

12. THE GREATEST COLLECTIVE PIECE OF ART OF THE TWENTIETH CENTURY

1. Shlain, L., *Art and Physics*, p. 306.
2. As a sampling I suggest the following four books: Richard Feynman, *The Character of Physical Law* (Cambridge, Mass.: MIT Press, 1965); Steven Weinberg, *First Three Minutes* (New York: Basic Books, 1977); Leon Lederman, *The God Particle* (Houghton Mifflin 1993); and Brian Greene, *The Elegant Universe* (New York: W. W. Norton, 1999).
3. French press clipping, April 7, 1922, reporting on an address to the French Philosophical Society at the Sorbonne. *Einstein Archive* 35–378; and *Berliner Tageblatt*, April 8, 1922, *Einstein Archive* 79–535. See Alice Calaprice, ed., *The Quotable Einstein* (Princeton, N. J.: Princeton University Press, 1996), pp. 7–8.
4. The analogue in two dimensions of curved space derives from the difference in "predicted" and "measured" (or actual) values of a distance. For example, one can "predict" the radius by constructing a circle with a compass; measuring the circumference of the circle; then dividing the circumference by 2π. On a flat plane, the "excess radius," defined by the measured value minus the predicted value, is zero. This is the case for Euclidean or plane geometry. Yet on curved surfaces there will exist a difference between the measured and predicted radii. On the surface of a sphere the excess radius turns out to be a positive value— there is more measured radius than the predicted. On a saddle-shaped surface the excess radius turns out to be negative (or there is less measured radius than the predicted). In four dimensions general relativity gives a mathematical expression to compute the excess radius:

$$r_{excess} = GM\big/3c^2$$

where G is the universal gravitational constant in Newton's expression for the universal law of gravitation; M is the mass of the body causing the warping in space, and c represents the speed of light.
5. The Mössbauer effect discovered in the late 1950s allowed Harvard

physicists Robert Vivian Pound and Hans Rebka to demonstrate that clocks do run at different rates at different heights in a gravitational field. The "clocks" were a pair of identical radioactive samples of the element iron. The frequency in the radioactive emission of the sample located at the upper part of the tower, but measured at the base of the tower, was ever so much greater than that of the sample located at the base of the tower. This difference in the passage of time is an effect of the general theory of relativity. The special theory of relativity also predicts *time dilation*, a slowing down of time, in frames of references moving uniformly at relativistic speeds. In the early 1970s two physicists from the Naval Research Lab in Washington, D.C., took a flight on Pan American Flight 1, traveling around the world, accompanied by an atomic clock, then on Flight 2, traveling around the world in the opposite direction. In comparing the times elapsed on eastward and westward flights, and correlating their data with an identical atomic clock left back in the laboratory, they were able to confirm time dilation.

6. The optical region is the part of the electromagnetic spectrum where we can see with ordinary vision. Other regions are radio, gamma ray, x-ray, ultraviolet, and infrared.

7. The full quotation is found in Shlain, *Art and Physics*, p. 306.

8. Frank Wilczek, *Physics Today* (June 2000), p. 11. Wilczek, previously the J. Robert Oppenheimer Professor in the School of Natural Sciences at the Institute for Advanced Study in Princeton, New Jersey, and now at MIT.

9. LASER is the acronym of Light Amplification by Stimulated Emission of Radiation; and MASER, Microwave Amplification by Stimulated Emission of Radiation. Although it is in the ground state that most atoms reside, the atoms of some elements possess an affinity to have excited levels populated, or "optically pumped," with mediation from an external energy source. When this population inversion is achieved, irradiating the atoms with photons of just the right energy results in "stimulated emission"—many times more photons emitted as absorbed—with the emitted photons all in phase. It is, however, modern quantum mechanics rather than "old quantum theory" that must be invoked in order to explain the absorption and emission process fully.

10. The time-dependent and time-independent forms of Schrödinger's equation are

$$H\Psi = i\hbar \frac{\partial \Psi}{\partial t}$$

$$H\psi = E\psi$$

The symbol *H* represents the Hamiltonian or total energy operator; the upper case Ψ in the first equation represents the state function; the lower case ψ in the second equation, the eigenfunction. In the time-dependent and time-independent versions of Schrödinger's equation the symbol *H* represents the Hamiltonian or total energy operator *E*, the energy eigenvalue; *i* is the imaginary number, square root of –1; and

$$\hbar = h/2\pi$$

where h is Planck's constant 6.63 x 10^{-34} joule • sec (and "\hbar" = 1.05 × 10^{-34} joule • sec).

11. Louis de Broglie (1892–1987) received the Nobel Prize for Physics in 1929. Heisenberg (1901–1976) was awarded the Nobel Prize in 1932; Schrödinger (1887–1961) and Dirac (1902–1984) were awarded the prize jointly in 1933.

12. The metaphor comes from Dennis Overbye, "Science Times," *New York Times*, October 28, 2002, D, pp. 1, 4.

13. Calaprice, *The Quotable Einstein*.

14. Flexner, one of the great innovators of American education, was recently featured in a definitive new biography: Thomas N. Bonner, *Iconoclast: Abraham Flexner and a Life in Learning* (Baltimore: Johns Hopkins University Press, 2002).

15. Landon Y. Jones, Jr., "Bad Days on Mount Olympus," *Atlantic* 233 (February 1974), pp. 37–46. This is an excellent article recounting the founding of the Institute for Advanced Study.

16. Banesh Hoffman, collaborated with Helen Dukas, *Einstein: Creator and Rebel* (New York: Viking Press, 1972).

17. See *Brewster's Memoirs of Newton* 2: 27 (1885). http://www.quotationspage.com/quotes/Issac_Newton/

13. BRIDGING THE CULTURAL DIVIDE

1. Alan Turing, educated at Cambridge University, formulated the mathematical basis of the computer—the Turing machine. During the Second World War, Turing was a member of Enigma Project at Blechley Hall, England, commissioned to decipher secret German codes. With a machine called "Colossus," utilizing the logic of the Turing machine, the mathematicians of Blechley Hall indeed suc-

ceeded in deciphering the secret code. A few years after the war, however, the immensely gifted but altogether tormented mathematician committed suicide.

2. ENIAC is the acronym for the Electronic Numerical Integrator and Calculator; UNIVAC, for Universal Automatic Computer; FORTRAN (FORmula TRANslation); COBOL (Common Business Oriented Language); ALGOL (ALGOrithmic Language).

3. Hillary M. Sheets, "Portrait of Leonardo," *ARTnews* (January 2003), pp. 100–107. *Leonardo da Vinci: Master Draftsman*, exh. cat. (Metropolitan Museum of Art, January 22–March 30, 2003) is the definitive exhibition and catalogue of Leonardo's drawings.

4. James Gleick, *Genius: The Life and Science of Richard Feynman* (New York: Pantheon, 1992), pp. 10–11. This book uses the expression "magician" (introduced by Kac) to distinguish the extraordinarily intuitive and prescient intellectuals from the less intuitive, and perhaps more plodding "ordinary geniuses."

5. Archimedes, Bach, Mozart, Einstein.

6. This statement paraphrases a prominent Newton biographer's characterization of his subject.

7. After Einstein died in Princeton in 1955, the young pathologist performing the postmortem on the great physicist rescued the brain. It was stored in formaldehyde for about four decades before brain physiologists began to do rigorous examinations on the brain's structure. Canadian brain physiologist Sandra F. Witelson and her co-authors reported in *Lancet* 9191 (November 20, 1999) that they had discovered the peculiar abnormality in Einstein's brain.

8. Nuland, *Leonardo da Vinci*, p. 11.

9. This was also the resonating message of Wordsworth in his ruminations on Isaac Newton's statue in the antechapel of Trinity College (see Chapter 11).

10. Although he was using photography for documentation by the early 1850s, art critic John Ruskin made a plea for people to make sketches.

Index

φ–Mask, 111. *See also* Marquardt